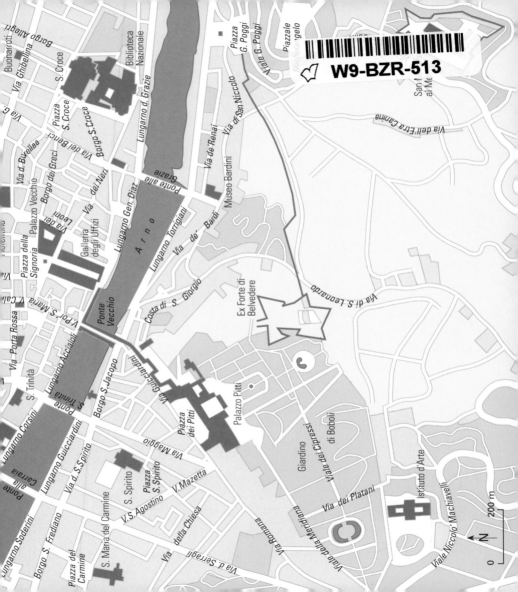

W9-BZR-513

FLORENCE

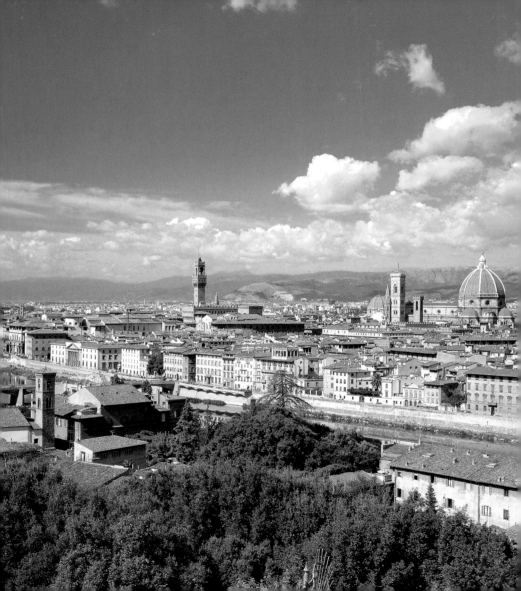

ART & ARCHITECTURE

FLORENCE

Rolf C. Wirtz

With contributions by Clemente Manenti

KÖNEMANN

Frontispiece
View of Florence from Piazzale Michelangelo

© 1999 Könemann Verlagsgesellschaft mbH
Bonner Straße 126, D–50968 Cologne

Publishing and Art Direction: Peter Feierabend
Project Management: Ute Edda Hammer,
Assistant: Jeannette Fentroß
Layout: Claudia Faber
Picture Research: Monika Bergmann
Graphics: Rolli Arts, Essen
Cartography: Astrid Fischer-Leitl, Munich
Production: Mark Voges
Lithography: Digiprint, Erfurt

Original Title: *Kunst & Architektur Florenz*

© 2000 for this English edition:
Könemann Verlagsgesellschaft mbH

Translation from German: Peter Barton, Susan Cox, and Fiona Müller
Editing: Susan James and Rita Winter in association with Goodfellow & Egan
Typesetting: Goodfellow & Egan
Project Management: Jackie Dobbyne for Goodfellow & Egan
Project Coordination: Kristin Zeier
Production: Ursula Schümer

Printing and Binding: Neue Stalling, Oldenburg
Printed in Germany

ISBN 3-8290-2662-5

10 9 8 7 6 5 4 3 2

Table of Contents

View of the city center

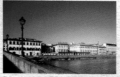
Palazzi on the bank of the Arno

Piazza Santissima Annunziata

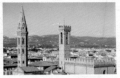
View of the Cappella dei Pazzi
and the Badia Fiorentina

View of Oltrarno from the
Campanile

View of city center from
San Niccolò

Florence through the Centuries – Notes on the City's History

Myriad myths and legends surround the origins of the city of Florence and the meaning of its name. Unlike the neighboring town of Fiesole, which was established as an Etruscan settlement in the 7th century BC, Florence was not founded until Roman times.

In the year 59 BC, Julius Caesar rewarded the loyal veterans of his army (*Lex*

The Florentine Lily – the city coat of arms

Julia) with plots of fertile land in the Arno valley. The first settlement was built on a chessboard-like plan in the form of a classical Roman castrum, or army camp, and originally incorporated only a small area extending from today's Via dei Cerretani in the north to around the Piazza della Signoria in the south. The original plot distribution can still be traced in the modern cityscape.

The city was dissected by the main streets and trading routes of the Cardo (north–south) and the Decumanus (east–west), which intersected at what is now known as the Piazza della Repubblica.

The development of the Roman colony was facilitated by the convenient location of the site near the famous Via Cassia, the road which linked Rome to the north of Italy. The city had grown considerably by the 3rd century AC and had developed into an important trade center. The first indications of the nascent Christianization by Syrian traders also appear around this time. St. Miniato is reputed to have been martyred in Florence in the year 250 as part of the persecution of Christians. Construction of the first churches began shortly after this just outside the gates of the city wall.

The centuries of progress

Florence faced uncertain times after the decline and fall of the Roman Empire. It suffered destruction and siege at the hands of a number of ethnic groups throughout the dark chaos and confusion of the migration era. Periods under Goth and Byzantine dominance were followed by a relatively peaceful intermezzo under the Lombards from 570 AD Conquest by Charles the Great in 774 resulted in Florence becoming part of the French county of Tuszien (Tuscany) which was initially governed from Lucca. The population grew quickly, trade was rejuvenated, and, in 854, Florence was united with Fiesole to form a single county.

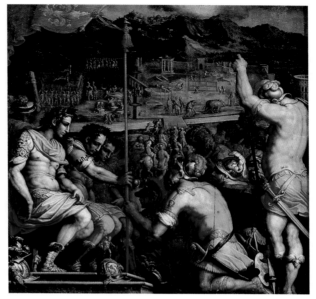

Giorgio Vasari: The Legendary Foundation of the City of Florence by Julius Caesar in 59 BC

When Count Hugo moved his residence from Lucca to Florence in 1000 AD, the city entered a historical period, during which for the first time artistic expression would bear witness to an important period of cultural growth with the exquisite architectural achievements of the Proto-Renaissance – in particular the Baptistery and the church of San Miniato al Monte. During the 11th century, Florence also became a showplace for church reform and hence a focal point in the growing conflict between papal and secular authority, which is recorded in the history books as the "Investiture Contest." Under Countess Matilda (1046–1115) – in whose castle near Canossa Henry IV surrendered to Pope Gregory VII in 1077 – Florence ultimately turned its back on the German emperor and declared its allegiance to the Pope. Loyal adherence to this position by the Florentines was rewarded in the year

1082 when the city withstood a siege by the imperial army.

Countess Matilda, the *Gran Contessa* who was held in very high esteem by the Florentines, was an unflagging supporter of all efforts to establish urban autonomy for the city and did everything in her power to pave the way for its political independence up to her death in 1115. Twelve consuls were appointed from the urban aristocracy and affluent business circles to form a city administrative body or *Commune*. This body was controlled by the Council of One Hundred and an assembly of citizens was called when important decisions had to be taken. The Florentines quickly grew tired of merely maintaining their newly won independence as a city, however, and they began to expand their political and territorial claims in the form of military forays. In 1125 the neighboring town of Fiesole was attacked and almost completely destroyed. Innumerable conquests and the subjugation of the feudal lords followed over the rest of the 12th century. As part of the expansion plans, in 1173 work was started on the construction of a new city wall, which also incorporated for the first time the area south of the river Arno.

The first signs of extensive disputes and strife within the city emerged during the second half of the 12th century. The history of the city in the 13th century was particularly overshadowed by the harsh conflict between the Guelphs (the Pope's supporters) and the Ghibellines (the

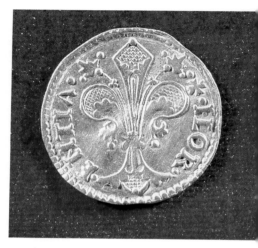

emperor's supporters). Irrespective of the ongoing battles and bitter conflict – resulting in the sensitive defeat of the Guelphs (who were largely supported by the Florentines) by the Ghibellines at Montaperti in 1260 – throughout the 12th century, the city moved toward the height of its economic boom. As a result of reform the system of guilds, traders, tradesmen, and business people had gained in influence and would soon control the highest political institutions. In terms of power and importance, the wool merchants' guild (Arte della Lana) was second only to the guild of refiners of imported woolen cloth (Arte di Calimala). The enormous wealth amassed by the city since the 12th century was based not least on the trading, manufacturing, and

Fiorini d' oro (gold florins), Bargello, Florence

refining of all kinds of textiles. The production of cloth was the city's second most important economic activity after its banking.

In 1252, the city minted its first gold coin which was called the *fiorino d'oro*, or gold florin, and it soon became the most sought-after and stable currency in the whole of Europe.

The changing face of the city

The city's physical appearance also changed fundamentally during the 12th century. Around the middle of this century, its skyline was defined by the approximately 170 towers which reached high above the houses of the affluent. These towers were primarily defensive in nature and acted as veritable fortresses during the numerous bitter struggles between groups of aristocratic families. It was not unusual for attacks to take place from one tower to the next. When the *primo popolo* attained power as the main political authority under the auspices of the guilds in 1250, this discriminatory custom, which only afforded protection to some of the people, was finally terminated with the issue of an order for the reduction of the height of all towers to a maximum of approximately 132 feet (40 meters). While this demolition work was taking place, a real construction boom got underway in the mid-13th century which saw the construction by the mendicant orders of the great churches of Santa Maria Novella (1246) and Santa Croce (ca. 1295), as well as major civic buildings, such as the Palazzo del Podestà (Bargello, started in 1255) and the Palazzo Vecchio (ca. 1300). In 1294, work also commenced on the construction of the city cathedral of Santa Maria del Fiore while the erection of a new city wall had already been completed in 1284. The vast dimensions of all these buildings was accompanied by an explosion of the city's population to almost 100,000 by 1300. At the turn of the 14th century, therefore, Florence was not just one of the richest cities in the Christian world but was also regarded as the biggest city in Western civilization. Such was its status that Pope

Bonifatius VIII believed that the city should be added as a fifth element to the traditional four, in other words water, earth, air, fire, and Florence.

A time of contradictions

The rise of Florence did not follow a completely unhindered linear course during the 14th century. Indeed, the development of the city was increasingly clouded by crass contradictions during this period. On the one hand, the work of literary and artistic geniuses, such as Dante Alighieri, Boccaccio, and Giotto, is indelibly linked with the notion of a golden age of the arts, while the undiminished building activity – projects begun at this time include the Campanile and Orsanmichele – was a reflection of the city's considerable affluence. At the same time, however, the city was hit by a number of devastating crises throughout the 14th century. As well as suffering the ravages of the Arno flood of 1333, the population fell victim to famine with gruesome regularity. However, it had yet to face its toughest challenge which came when the city was once again devastated by the plague, this time the Black Death in 1348/49. Almost two-thirds of the city's population died as a result of this epidemic. These unavoidable natural catastrophes were also accompanied by man-made disasters. Military defeats against Pisa (1315) and then Lucca (1325) weakened Florentine hegemony in the region. In 1346, the collapse of the important banks of Peruzzi and Bardi plunged the city into a serious economic crisis.

The internal political wrangling and social unrest arising from the constantly changing balance of power throughout the 14th century reached their culmination in 1378 with the revolt of the wool workers (*Tumulto dei Ciompi*). In 1382, Florence once again formed an oligarchic government, within which the Albizzi family rose to leadership and would soon face the tenacious opposition of the powerful Medici family. In the early 15th century, Giovanni de' Averardo de' Medici (known as di Bicci) succeeded in consolidating the social and economic position of his family while attempting to assume power within the city's political structure. From 1413, the Medici assumed the lucrative and prestigious role of official papal bankers. This laid the foundations for the unparalleled rise of the famous family dynasty. The Medici would soon govern the city of Florence and, with only a few short interruptions, would continue to influence the history and art of the city for almost three centuries.

The Medici family

During the 15th century, Florence embarked on a period of artistic and cultural glory without parallel, now known as the Renaissance. This was the century of humanism, whose scientific and spiritual-philosophical achievements continue to influence the Western world-view even up to the present day.

Starting with Masaccio, Brunelleschi, Donatello, and Botticelli, the list of outstanding artists who matured in 15th-century Florence is almost endless, and it culminates in the great geniuses of Leonardo da Vinci and Michelangelo Buonarroti. Their works still feature among the most famous in the entire history of art. It would be difficult to name another place which hosted such a variety of artistic talent as Florence did, starting in the 15th century and continuing down through the generations. The credit for

Donatello: Marzocco, 1419–20, Museo Nazionale, Florence

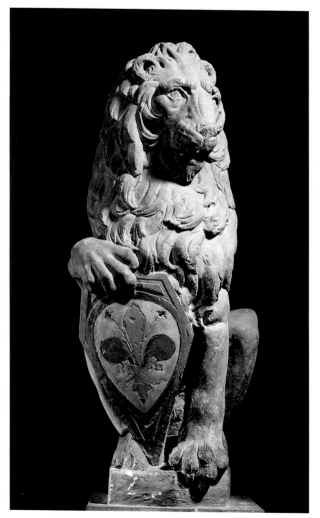

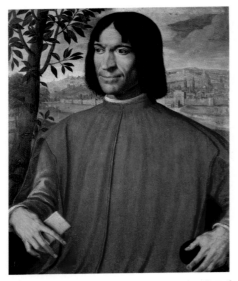

Anonymous Florentine Master: Portrait of Lorenzo de' Medici, Museo Mediceo, Florence

center of humanistic erudition and made enormous donations toward the construction of innumerable buildings and memorials. In this, he established a tradition to be continued by all the Medici family heads who succeeded him.

The house of Medici experienced its most glorious period in the late 15th century under the rule of Cosimo's grandson Lorenzo (1449–1492), who, owing to his extreme fondness for pomp and ceremony, was known as Lorenzo the Magnificent (*il Magnifico*). Good luck deserted the family a few years into the reign of Lorenzo's son Piero when, owing to his political failure, the French army of Charles VIII invaded the city in 1494 and he was expelled with his family.

During the dramatic years of the late 15th century, the charismatic repentance preacher Girolamo Savonarola became the most influential man in the city. He aimed to determine the city's destiny by means of a theocratic form of government. His unmistakable fanaticism brought him into increasing conflict with the Pope in Rome. At the end of his radical period of influence, the Dominican monk was finally executed for heresy in the Piazza della Signoria.

creating the conditions necessary to enable the unfolding of this unique cultural climate must go to the artistic awareness and generous patronage of the Medici.

Cosimo the Elder (*il Vecchio*), who was one of the most outstanding and fascinating figures of this period, attained the unofficial rank of lord of the city in 1434. Up to his death in 1464, he dominated the political, social, and cultural development of his native city. As a mark of their respect and esteem, the Florentines gave him the title of *pater patriae* (father of the fatherland). He turned Florence into a

From the Medici to the Risorgimento

After Savonarola's death in 1498, Florence tried to establish a free-republican form of government. In 1502, Piero Soderini was

elected as lifetime head (*Gonfaloniere*) of the republican government. However, Giovanni de' Medici, who later became Pope Leo X, managed to bring about the fall of Soderini as early as 1512, thus enabling his family to return to Florence. Following the sack of Rome (*Sacco di Roma*) by the troops of Emperor Charles V, the Medici were driven from the city once again. However, as soon as peace was established between Emperor Charles and Clemens VII – the second important pope to be recruited from the ranks of the Medici – the family was able to return to its native city and assume power there once again with the support of the Holy See. This marked the definitive end of republican government in Florence. Up to his murder in 1537, the unscrupulous and extremely unpopular Alessandro de' Medici headed a brutal tyranny and paved the way for the absolutist rule of the subsequent period. Cosimo assumed the role of city ruler at only 18 years of age. His 37-year rule, which was completely focused on the consolidation of his power, marked the reign of a long series of Medici dukes. They ruled Florence for over two centuries but failed to halt the increasing political, economic, and cultural fall of the city in the 17th century, the time of the Thirty Years War and related crises. With the death of the last of the Medici princes – Gian Gastone – in 1737 the duchy fell to the Habsburg dynasty, under whose rule comprehensive reform was implemented to promote the modernization of the city's economy and trade, and its social and

Veduta of the city of Florence, ca. 1472, Museo di Firenze com' era, Florence

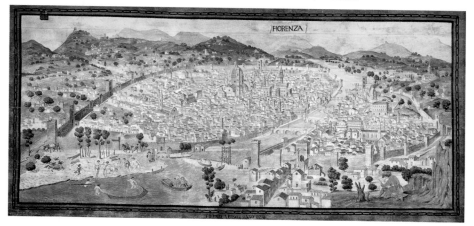

justice systems. The French occupation in 1799 forced the Austrian dukes to withdraw from Florence. Tuscany then became part of the Kingdom of Etruria for a few years, under the rule of Napoleon's sister, Elisa Bacciocchi. This French intermezzo lasted only until 1815 and ended after the Congress of Vienna with the much heralded return of Ferdinand III. The Habsburg Lotharingians soon found themselves under pressure from the 1848 rebellion and the Italian wars of independence. After the victory of the Piedmontese over Austria, Leopold II was forced to abdicate in 1859. The efforts to unite Italy culminated with unification (*Risorgimento*) in 1861.

Modern times

During the first half of the 20th century, Florence was strongly affected by the two world wars and the reign of fascism. In the city on the Arno, Benito Mussolini's fascist party met with both enthusiastic support as well as bitter opposition. The latter made the city into a center of Italian resistance. Fortunately, Florence was largely saved from the destruction of the Second World War, suffering only minor damage in 1943. The most serious destruction did not occur until 1944 when German occupying forces exploded all the bridges over the river – with the exception of the historic and picturesque Ponte Vecchio.

Giorgio Vasari: View of Florence during the Siege by the Emperor's Army in 1529, Palazzo Vecchio (Sala di Clemente VII), Florence

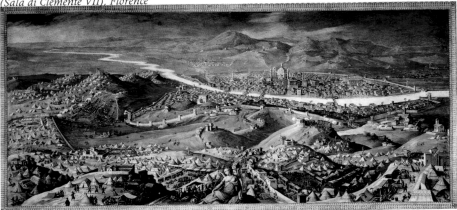

Stefano Buonsignori: Map of Florence, 1584, Gabinetto dei Disegni e delle Stampe, Uffizi Gallery, Florence

After the difficult postwar years, Florence developed into a modern service metropolis, which as the capital city of Tuscany not only houses numerous administrative authorities but also has made a name for itself as a university and congress city and a center of fashion and business. Its world renown, however, is mainly accounted for by its incomparable legacy of outstanding art works. The city has long been a major tourist center and visitors are attracted to the banks of the Arno throughout the year. However, this immense cultural legacy is not only a blessing, as it also involves a considerable commitment on the part of the city authorities to maintain and preserve the many fine buildings and memorials.

The Battle of Anghiari
Clemente Manenti

The battle of Anghiari (29 June 1440) is a typical example of the irony of history, as the scale of the actual event bears no relationship to its

Bonifacio Bembo: Portrait of Francesco Sforza, Pinacoteca di Brera, Milan

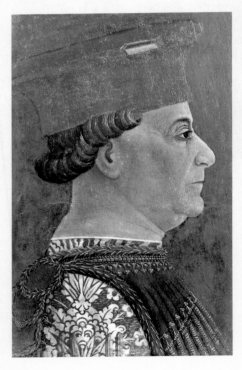

significance in terms of the political fate of Florence. As a result of this battle, the city acquired the eastern regions of Tuscany: Casentin and upper Valtiberina, a mountainous landscape with two extended valleys, through which the upper courses of the rivers Arno and Tiber flow. This expansion to the east transformed Florence into a central Italian territorial power. The fact that the sources of the two "fateful" rivers came into the possession of the Florentines was of high symbolic value for the city which declared itself the new Athens and aspired to become the new Rome. The territories won in this battle included flourishing towns, such as Borgo Sansepolcro, the birthplace of Piero della Francesca and Luca Pacioli. Important roads passed through these towns and guaranteed Florence control of the transport links between north and central Italy. Thirty years earlier, Florence had conquered Pisa, its enemy for many centuries, and hence obtained access to the sea and started upon the construction of a new fleet. With these new territories in the Apennines, the city-state moved closer to a more distant sea route. Originally a city of mountain dwellers who descended into the valley, Florence now became a maritime power.

The event which enabled the great city of Florence to realize its dream was a complete coincidence. In fact, Milan and Venice had been at war for years for dominion over the Po basin

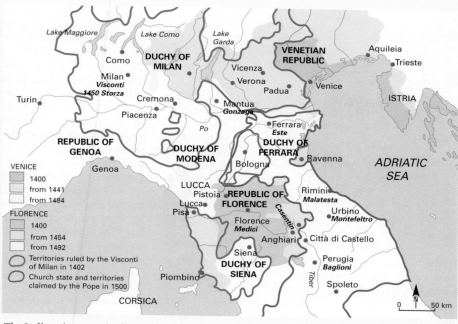

The Italian city-states in the 15th century

and wealthy towns like Brescia, Cremona, and Padua, which were all a long way away from Anghiari. However, Venice, *La Serenissima*, entered an alliance with the Pope and Florence, both of whom were interested in putting an end to the expansion policy of the Viscontis, Milan's ruling family. The enemy powers fought the armies led by the mercenary leaders (*condottieri*): Niccolò Piccinino fought on the side of Filippo Maria Visconti of Milan, and Francesco Sforza on that of the Alliance. Neither was interested in fighting in an open

field. It was more important to strengthen their individual positions in the eyes of their respective rulers. In 1439, Francesco Sforza finally decided to cross the Po and march in the direction of Brescia which had been under siege by the Milanese troops for three years. Instead of facing him, Piccinino brought the war over to Tuscany and united his men in the upper valley of the Tiber, in Borgo Sansepolcro and Città di Castello.

Piccinino's activities confused the Florentines and put them on their guard. Having

19

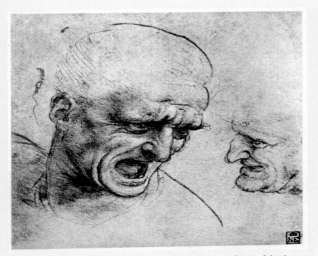

Leonardo da Vinci: Studies for the Battle of Anghiari, ca. 1503–05, silver point, 19.1 x 18.8 cm (reproduction), Gabinetto dei Disegni e delle Stampe, Uffizi Gallery, Florence

entire territory under Milanese rule. Piccinino followed his orders reluctantly. The Florentines, who had entrenched themselves in Anghiari, were informed of Milan's defeat in Brescia and Piccinino's order to withdraw. This marked the end of the war for them and on the evening of 28 June 1440 the soldiers of the Florentine and papal armies were given leave. The following morning, while taking his morning exercise on the sentry walk on the battlements of the city wall, the Florentine *condottiere* Micheletto Attendolo noticed "large clouds of dust" rising from the plain. "As soon as he realized it was the enemy, he gave the call to arms. There was great tumult and confusion in the Florentine camp. Already a disorganized camp, the turmoil was greater than ever as they believed the enemy to be far away and in retreat rather than on the offensive. Hence, they were all unarmed, one here, the other there ..." (Niccolò Machiavelli).

Piccinino had chanced his luck and gambled on surprising the Florentines. He wanted to teach the Florentines a lesson before leaving for the north. The latter had, however, succeeded in forming to defend the hill of Anghiari. The struggle for a small bridge which Piccinino's troops would have had to pass lasted a few hours "during which the Florentines soon emerged as masters of the bridge. And although

hitherto believed that they were engaged in a battle at the level of diplomacy and financial policy, they were surprised to discover that they were now embroiled in a war on their own territory. "We were and still are convinced that we can remain bystanders ... in this conflict" (Neri Capponi). In response to the unexpected military threat, Florence united its unimpressive defense forces with the papal troops 5 kilometers south of Sansepolcro. And that was the situation when Piccinino received a dispatch from Filippo Maria Visconti ordering him to leave Tuscany and return to Lombardy. Francesco Sforza had liberated Brescia from siege and was now threatening to capture the

both sets of troops maintained their balance during this fight, on both sides of the bridge the fighting went on to the disadvantage of Niccolò … When the Florentines were so sure of the bridge that their side could withdraw on the far side, Piccinino had no more time in the midst of the strong attack and awkward location to allow fresh groups to advance with the result that the front line and the back line mixed, one soldier pushed the next and all fled to Borgo without giving the matter any further consideration." Niccolò Machiavelli ended his account of the battle with the words: "In such a decisive defeat, in a struggle which lasted from the 20th to the 24th hour, just one single man died and not from his wounds but from injuries he received on falling under the horses' hoofs."

The Florentines knew how to exploit the situation to their best advantage and immediately occupied the towns abandoned by Piccinino which had previously belonged to the pope. The most important of these towns, Borgo Sansepolcro, was already their due as they had earned it as security for 25,000 florins which the Florentines had lent to the pope in 1439. After this they occupied the town of Casentin and Poppi castle and hence put an end to the feudal rule of the Guidi counts who had been careless enough to bring Piccinino to Tuscany. The siege of Anghiari resulted in a consolidation of the internal balance of power in Florence. After this battle, the camp of the Medici's opponent around Rinaldo degli Albizzi dispersed and Piccinino left on a pilgrimage to the Holy Land. The heroes of Anghiari received a warm and enthusiastic welcome on their return to Florence.

Peter Paul Rubens: Studies for a Battle on Horseback (copy after Leonardo da Vinci's Battle of Anghiari), Département des Arts Graphiques, Musée du Louvre, Paris

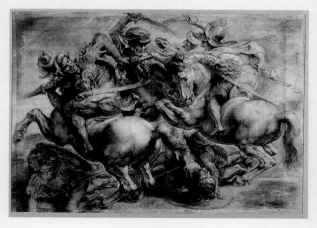

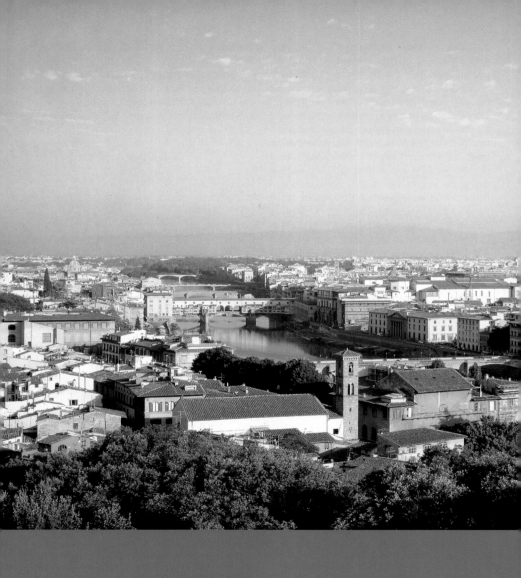

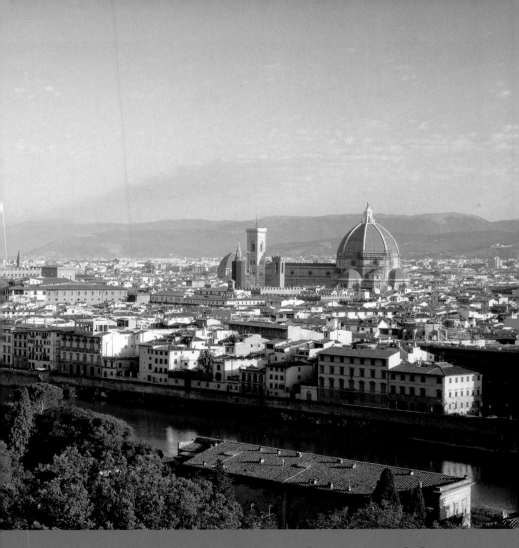

In the Heart of the City

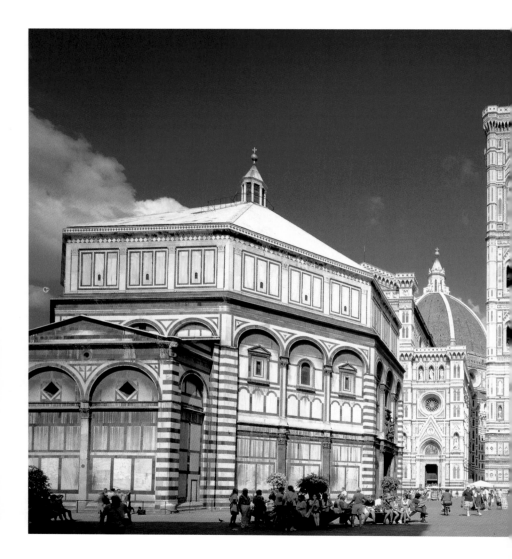

Battistero San Giovanni

Dante Alighieri (1265–1321), the famous author of the *Divina Commedia* (*Divine Comedy*), admired the beauty of the Baptistery in his native city of Florence. Like his contemporaries, however, he held the building to be an example of ancient Roman architecture, i.e. a temple originally devoted to the god Mars and built during the reign of the Emperor Augustus. Although the history of its predecessor building lay far back in the distant past, the construction of the Baptistery as it stands today probably started in the Romanesque era, around the year 1059. Work on the structure was already completed by 1128, following a comparatively brief construction period of approximately 70 years. The crowning lantern was added around 1150 and the rectangular choir chapel – because of its shape known as the *scarsella* (pilgrim's bag or money bag) – was added in the year 1202.

Dante's mistake is completely understandable given that the design of this building shows so many traits from ancient models that, as late as the 15th century, important Renaissance architects and architectural theorists still believed the Baptistery to be an exemplary work of classical antiquity. Filippo Brunelleschi (1377–1446), the ingenious architect of the cathedral dome, derived some important inspiration for his own designs from the forms and details found in the

In the heart of the city

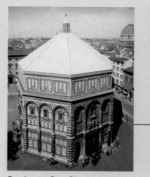

Battistero San Giovanni, Piazza San Giovanni, p. 30

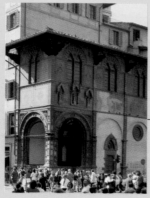

Loggia del Bigallo, Piazza San Giovanni 1, p. 84

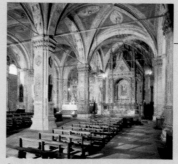

Orsanmichele, Via dell' Arte della Lana 1, p. 92

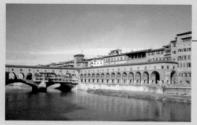

Corridoio Vasariano, p. 122

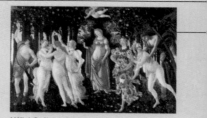

Uffizi Gallery, Loggiata degli Uffizi, p. 150

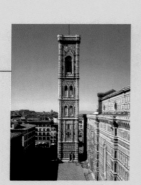

Campanile, Piazza del Duomo, p. 68

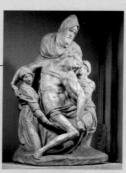

Museo dell' Opera del Duomo, Piazza del Duomo 9, p. 70

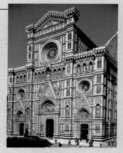

Duomo Santa Maria del Fiore, p. 52

Piazza della Signoria, p. 98

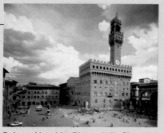

Palazzo Vecchio, Piazza della Signoria, p. 94

Loggia dei Lanzi, Piazza della Signoria, p. 99

View from the Campanile

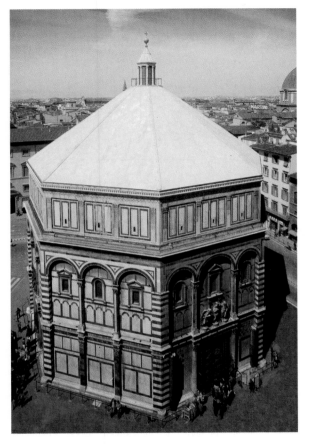

The Battistero San Giovanni or the St. John's Baptistery is built on a large octagonal plan. However, the building's original appearance has been much altered by various changes throughout the centuries. These alterations include the addition of the current pyramid roof, the raising of the surrounding street level, and the application of the striking zebra-stripe facing to the corner pilasters by Arnolfo di Cambio. The outstanding significance of the building in the religious life of the city for hundreds of years is demonstrated, not least, by the fact that Florentines were all baptized there up to the late 19th century. Moreover, the Baptistery enjoyed the status of a bishop's church for many centuries. St. John the Baptist, to whom it was dedicated in 1059, was honored shortly after as the patron saint of Florence.

Baptistery. Next to the church of San Miniato al Monte, this domed octagonal structure is considered to be one of the most exquisite works of the Florentine Proto-Renaissance.

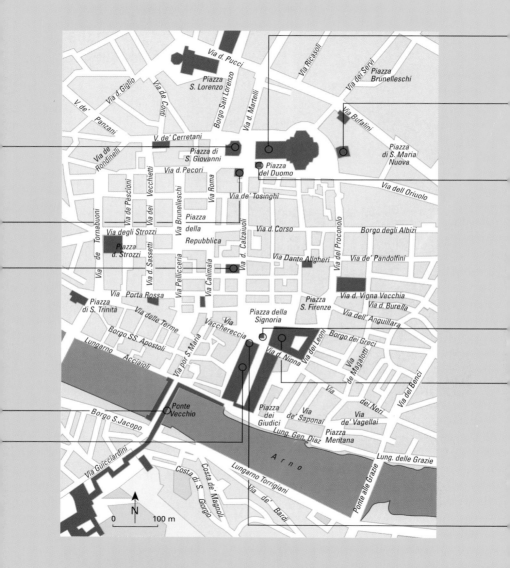

East façade with Gates of Paradise

It is impossible to tell from the outside of the Baptistery that its harmonious and well-proportioned wall articulation conceals a complex double-shell structure. In addition to numerous details – such as the capitals, grooved pilasters, and window surrounds – the entire structure shows the influence of models from Roman and Byzantine architecture. True to their time, the architects of St. John's appear to have had a strong interest in this ancient architecture. The overall appearance of the structure is completely dominated by the ornamental marble encrustation. The building is faced with alternating 5-centimeter-thick slabs of green and white marble. With its precise geometrical forms, the rhythm of the wall surface follows purely optical rules as well as those of proportion. This system of highly artistic façade and wall decoration can be found on numerous religious buildings in the city.

The most important elements in the sculptural decoration of the building are the three bronze doors

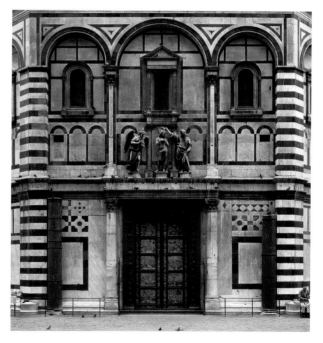

designed by Andrea Pisano and Lorenzo Ghiberti. The marble group depicting the baptism of Christ above the *Gates of Paradise* is mainly the work of Andrea Sansovino (1502–05); the figure of the angel was added by Innocenzo Spinazzi in 1792. The north door is crowned by a bronze sculpture of *St. John Preaching* by Francesco Rustici (1506–11), and the group above the south door shows the *Martyrdom of St. John* by Vincenzo Danti (ca. 1570).

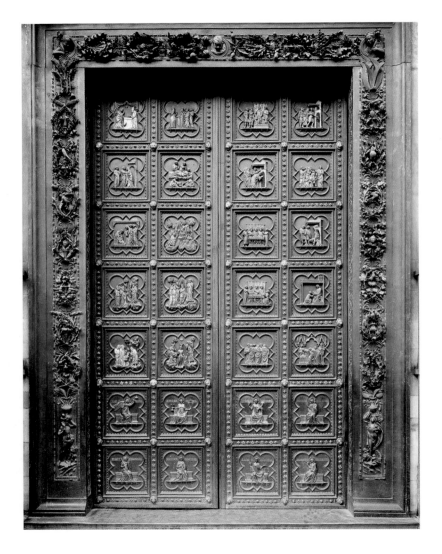

Andrea Pisano: south doors, 1330–36

Bronze (partly gilded), quatrefoils each 53 x 40 cm

Andrea Pisano was commissioned by the Florentine guild of refiners of woolen cloth (Arte di Calimala), which was responsible for the artistic design of the building, to execute the current south doors of the Baptistery. The wax models were completed in 1330 and were cast in bronze by expert craftsmen in Venice. The doors were fitted on the southern entrance in 1336.

The twenty upper relief squares depict several episodes from the life of St. John the Baptist whereas the eight lower squares show representations of Christian and worldly virtues. All of the relief scenes are framed by simple Gothic quatrefoil frames and reveal that Pisano's main influence was his teacher Giotto, who had completed the frescos in the Peruzzi chapel in Santa Croce only a short time earlier. Despite a certain Gothic

Annunciation of the Birth of St. John	Zacharias Leaves the Temple	St. John Accuses Herod	Incarceration
Visitation	Birth of the Baptist	The Apostles Visit the Dungeon	Jesus Preaches and Heals
Naming of the Baptist	St. John Entering the Wilderness	Dance of Salome	Decapitation of the Baptist
Preaching of St. John	Presentation of Jesus	The Head is Brought to Salome	Presentation of the Baptist's Head
St. John Baptizes	Baptism of Christ	Carrying of the Baptist's Body	Burial of the Baptist
Spes	Fides	Caritas	Humilitas
Fortitudo	Temperantia	Justitia	Prudentia

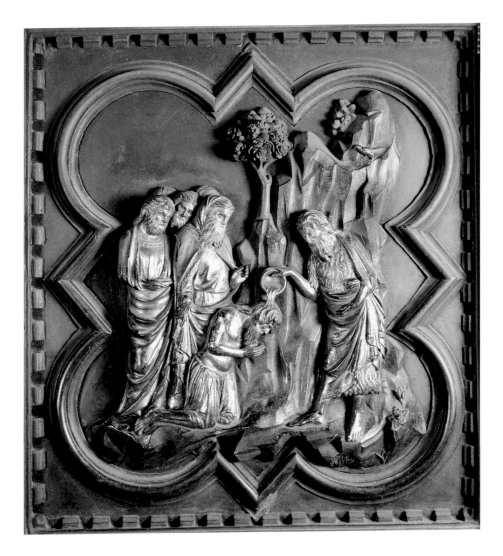

prettification of the figures and their garments, Andrea Pisano's narrative appears to concentrate completely on the esential nature of the scene without falling into pathos. The clear delineation of the picture area from the simple relief background, in front of which the figures are often assembled in groups, is a characteristic feature of his work. The richly decorated door frame contrasts starkly with the actual doors. This was created sometime around the mid-15th century by Vittorio, a son of Lorenzo Ghiberti.

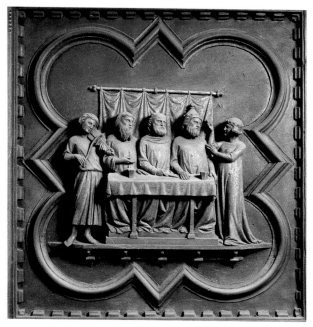

Andrea Pisano:
St. John Baptizes
(panel on the south doors)

As in the scene depicting the baptism of the people by St. John, the rendering of the activities in the individual reliefs on the south doors is entirely focused on a central moment in the narrative. The main emphasis lies in the visualization of the content and the artist ignores all superfluous ornament and anecdotal detail in order to achieve this focused expression. The landscape and architectural set pieces look like decorative staffage and could almost be described as mere props.

Andrea Pisano: Dance of Salome
(panel on the south doors)

At the request of her mother, Herodias, Salome persuaded Herod to execute John the Baptist during a bewitching dance. Pisano symbolizes this significant event without dramatization. While a musician plays on the left, a group of people seated behind the table direct their gaze at Salome whose dancing is merely suggested in her restrained gestures.

Jesus Carries the Cross	Crucifixion	Resurrection	Pentecost
Gethsemane	Jesus is Taken Prisoner	Flagellation	Pilate Washes His Hands
Transfiguration	Raising of Lazarus from the Dead	Jesus Enters Jerusalem	Last Supper
Baptism of Christ	Temptation	Expulsion from the Temple	Jesus Walks on Water
Annunciation	Birth	Adoration of the Magi	Jesus in the Temple
St. John Evangelist	St. Matthew	St. Luke	St. Mark
St. Ambrose	St. Jerome	St. Gregory	St. Augustine

Lorenzo Ghiberti: north doors, 1403–24

Bronze (partly gilded),
h. 450 cm (with frame),
quatrefoils 39 x 39 cm

The execution of the second set of doors for the Baptistery was preceded by a legendary competition held during the winter of 1401/02 which was won by the then barely 23-year-old Lorenzo Ghiberti. Like his reputable fellow competitors, Ghiberti had one year within which to produce a sample panel formally based on the model of the first set of doors created by Andrea Pisano. The prescribed theme for the relief plates on the new doors was the sacrifice of Isaac. Of the models submitted, unfortunately only those by Ghiberti and Filippo Brunelleschi have survived and these are now on view in the Bargello (see p. 414). The fact that the commission was awarded to Ghiberti is explained not least by the fact that, unlike Brunelleschi's proposal, his more economical method made it possible to create

the relief background and figures in a single casting, which represented an enormous saving in a project of this scale. Ghiberti's sample also betrayed the poignant lyrical elegance which is evident in the relief plates subsequently created for the north doors in his workshop. By the time the doors were erected almost 20 years later in 1424, Ghiberti had become the leading master in the specialized art form of the bronze relief which had not received much attention or advanced very much since the time of Andrea Pisano.

Like Andrea Pisano's doors, the north doors are composed of 28 individual relief squares, of which the eight lower squares contain portrayals of the evangelists and the church fathers. The life of Jesus is depicted above this, starting at the bottom left with the *Annunciation to the Virgin Mary* and ending at the top right with the *Miracle of Pentecost*. This rather unorthodox reading order has its basis in a north Italian tradition.

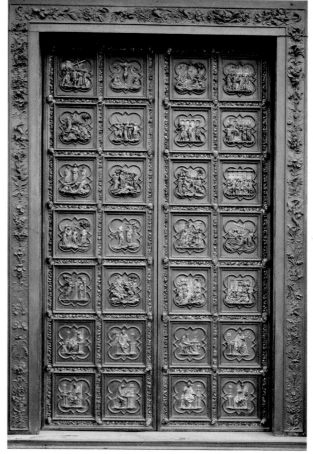

The impressive figures we meet in Ghiberti's reliefs betray both a Gothic feeling for the consummate flow of line

and an accuracy of body modeling, gestures, and expressions that is obviously schooled by close observation of nature. While the initial scenes are still developed along the width of the relief surface, as the work progresses the artist's increasing interest in the portrayal of depth becomes more evident.

The depiction of sections of buildings and landscapes also shows the beginning of Ghiberti's preoccupation with the rules of central perspective which were being discovered and developed in Florence at the same time.

The small heads on the north door, which appear between the reliefs at the intersections of the border strips, are particularly interesting. One of these heads has been identified as a self-portrait of Ghiberti himself (left door, center row, fifth head from the top).

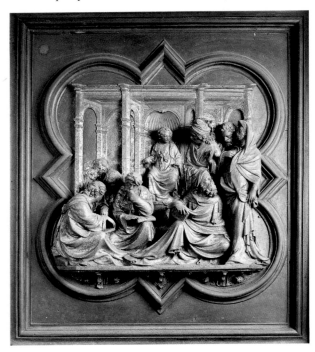

Lorenzo Ghiberti:
Jesus in the Temple
(panel on the north doors)

This relief shows the biblical episode of the 12-year-old boy Jesus speaking to a gathering of scribes in the temple on the feast of Passover. Ghiberti places the boy at the center of his image. The scribes gathered around him are both perplexed and impressed. The temple where the event takes place is depicted in an architectural background which already involves the use of central perspective in flat relief.

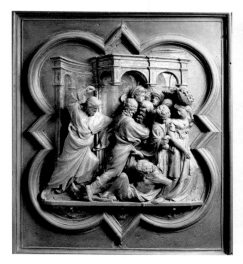

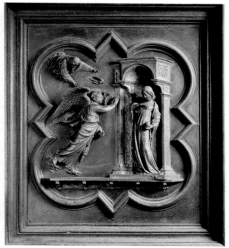

Lorenzo Ghiberti: Expulsion from the Temple
(panel on the north doors)

Lorenzo Ghiberti: Annunciation
(panel on the north doors)

Jesus of Nazareth drove money lenders, charlatans, and traders violently from the Temple in Jerusalem. In this plate, Ghiberti visualizes the most dramatic moment of this episode from the New Testament. We witness a tumultuous scene with fighting between the opposing parties. The complicated composition and exciting arrangement of the dense and intersecting figures is highly dynamic. This is further intensified by the formal contrast with the flat and static depiction of the architecture and the dynamic motion of the figures involved in the scene.

The feet of the suspended angel barely seem to touch the floor as he brings the news to Mary of her heavenly appointment. Mary's amazement is conveyed in her timid restraint. In this relief, which is reminiscent of the work of his predecessor Pisano, Ghiberti reveals that he is still a strong exponent of the Gothic style at this point. His subsequent virtuosity in accentuating contrasts using high and low relief does not appear to be fully developed here. He makes little attempt to create spatial depth and the relief background is not yet integrated into the event portrayed.

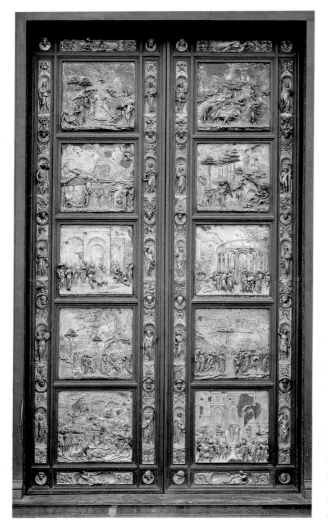

Lorenzo Ghiberti: Gates of Paradise, 1425–52
Bronze (partly gilded),
521 x 321 cm (total),
reliefs each 80 x 80 cm

Given the magnificence of the north doors, it is not surprising that Lorenzo Ghiberti's workshop was also commissioned to design the third outstanding pair of Baptistery doors. Based on a comment by Michelangelo, who deemed the work fully worthy of decorating the doors of Paradise, the name *Gates of Paradise* has survived to the present day. Ghiberti devoted 27 years of his life to the work on the doors, which he started in 1425. Giorgio Vasari described the doors in his posthumous biography of the artist as the most complete and beautiful work of art to be found on this earth. In his *Commentari* (memoir), a book written by Ghiberti in the last years of his life, the artist himself proudly discussed his much admired masterpiece in great detail and admitted that he was given a completely free hand in its design. This probably ex-

plains why, unlike the older doors by Pisano, the *Gates of Paradise* are subdivided into only ten square reliefs ordered from top left to bottom right. Several biblical episodes are presented simultaneously in each picture. The cycle is comprised of important events from the Old Testament, starting at the top left with the creation of Adam and Eve, their fall from grace, and the expulsion from the Garden of Eden and ends with King Solomon and the Queen of Sheba.

As the artist himself emphasized, the landscapes and architectural backgrounds are presented on the basis of the rules of perspective so that they appear exactly as they would in reality. The height and high projection of the figures gradually decreases as they diminish in size and recede further into the background. The expressive interacting groups are infused with vivacity and the execution of both forms and figures is often based to the last detail on classical models.

Paradise	Cain and Abel
Noah	Abraham and Isaac
Jacob and Esau	Joseph
Moses	Joshua
David	King Solomon and the Queen of Sheba

The life-like deciption of the figures and scenes had a significant influence on Florentine painting in later generations. Shortly after they were completed, the doors were deemed so beautiful that they were installed in the most prominent position of the Baptistery, opposite the façade of the cathedral, and the doors by Andrea Pisano, previously occupying this choice position, were moved to the south façade. The individual relief plates were recently replaced by copies to protect them from the effects of weathering and the originals are now kept in the Cathedral Museum.

Lorenzo Ghiberti: Story of Noah
(detail from the *Gates of Paradise*)

In the panel depicting Noah various aspects of the story are presented against the detailed landscape backdrop. An excerpt from the ark, which is presented not as a stranded boat but in the form of a pyramid, can be identified in the background. The presentation of the offering of thanks is depicted at the front on the right, opposite the biblical story of Noah's drunkenness. While Ham chides his inebriated father on account of his nakedness, the two other sons move toward Noah with their backs to him in order to cover up their naked father without facing him directly.

Lorenzo Ghiberti: Story of Joseph
(detail from the *Gates of Paradise*)

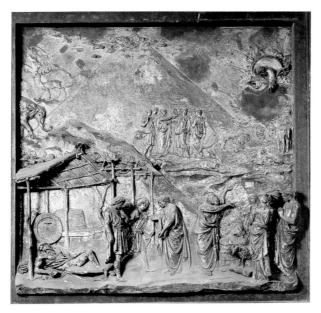

In the lively plate depicting the story of Joseph, a number of events from his life in Egypt appear. The favorite son of Jacob was driven into Egypt because of the jealousy of his brothers. Here Lorenzo Ghiberti once again demonstrates his remarkable narrative talent. Numerous figures populate this relief in a wide range of

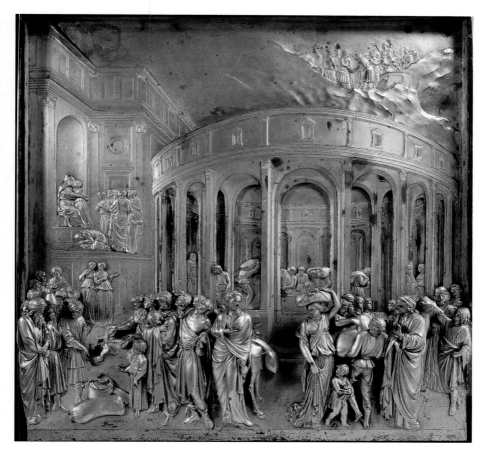

extremely lifelike poses. A most effective
sense of spatial depth is conveyed through
the virtuoso rendering of the landscape and
architectural backdrops, which are based on
detailed calculations of perspective.

The Baptistery interior

The street level around the Baptistery was raised as early as the 12th or 13th century. As this would have had a negative influence on the external proportions of the building, Leonardo da Vinci (1452–1519) designed a plan to raise the entire structure so that a plinth could be constructed beneath it. However, this clever proposal was never executed, with the result that visitors must still descend the steps to enter the interior, which is lit from above by a dome. Like the exterior, the interior walls are faced with ornamental marble inlay. In contrast to the exterior, the wall surface has a distinctly sculptural feel with its classical column pairs and double pilasters. This impression is even stronger on the third story where open rows of arches framed by pilasters provide a view of the galleries and also reveal the double-shell structure.

No effort or expense was spared in the decoration of the Baptistery interior which was carried out over centuries. Apart from the magnificent cupola mosaics, the floor with its splendid colored marble tiles arranged in a complex geometric pattern is particularly worthy of note. The outline of a large baptismal font which was removed in 1557 can still be traced in the middle of the floor.

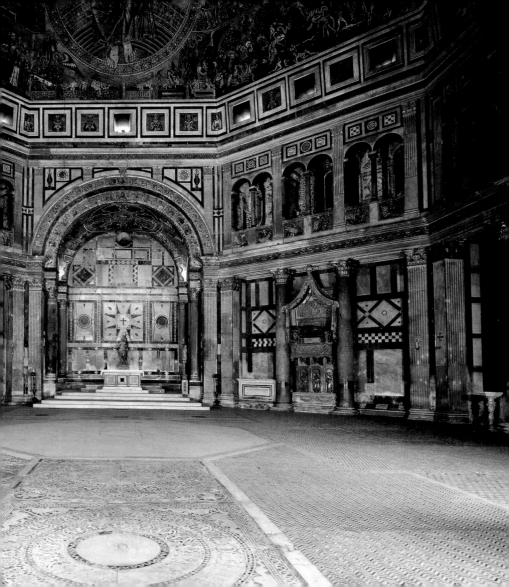

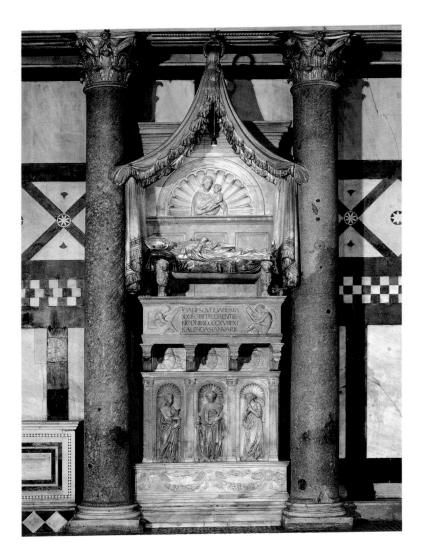

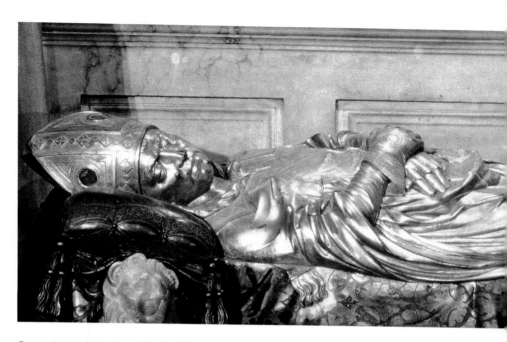

Donatello and Michelozzo: Tomb of the Antipope Baldassare Coscia, 1424–28
Marble and gilded bronze, 713 x 200 x 213 cm

Baldassare Coscia exercised the pontificate as antipope John XXIII until his removal from office by the Council of Constance. When he died in 1419, he bequeathed numerous relics and large sums of money for the decoration of the Baptistery. As a gesture of gratitude for his generosity, the executors of his will were allowed to commission a tomb for him in the Baptistery. Donatello and Michelozzo took an unusual approach to this task and designed the first baldachin tomb of the Renaissance, between two of the interior columns. The dead man's sarcophagus sits on four brackets above the allegorical figures of Faith, Hope, and Love. The dead man is rendered as a gilded figure lying on his death bed with his head turned to one side. Above this figure the work terminates with a raised curtain carved in stone.

The cupola mosaics

Work on the powerful cupola mosaics was started in the choir chapel around 1225, under the artistic direction of the Franciscan Jacopo da Torrita. This project, which involved the work of numerous artists and specialist artisans, took over a century to complete. It is, however, almost impossible to identify the individual hands behind the work today. Venetian mosaicists, who were particularly familiar with the Byzantine artistic tradition, appear to have made an important contribution. Reputable masters such as Cimabue, Coppo da Marcovaldo, and Giotto are named among the Florentine artists. This dome, which spans a diameter of over 85 feet (ca. 26 meters), has one of the most impressive mosaic cycles in Western art.

Arranged in eight concentric rings, the iconographical program includes images of the heavenly host of angels at the top, beneath which there are scenes from Genesis and episodes from the lives of Joseph, Jesus, and St. John the Baptist. The stripe-like succession is interrupted by the figure of Christ, over 26 feet (8 meters) high. Several of the details flanking the Christ figure refer to scenes from the Last Judgment (see detail).

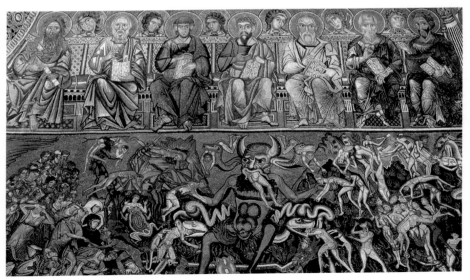

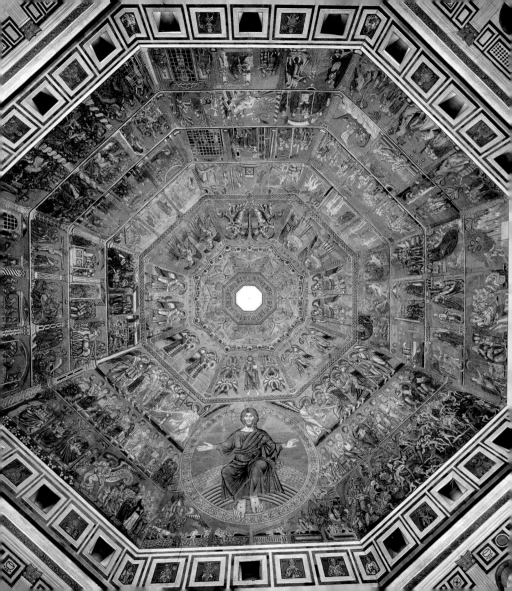

Duomo Santa Maria del Fiore

Florence Cathedral is the world's fourth largest Christian church after those of Rome, Milan, and London. Work on this building began in 1296 under the first cathedral architect Arnolfo di Cambio (ca. 1250–1302) on the site of an earlier and much smaller basilica dedicated to St. Reparata. The new church was dedicated to the Virgin Mary, however the name Santa Maria del Fiore also contains a reference to the city's former name of "Fiorenza." Work was already long under way on the construction of the great cathedrals in the nearby rival cities of Siena and Pisa, and, in Florence itself, work had already begun on the large Franciscan and Dominican churches of Santa Croce and Santa Maria Novella. From the city's perspective, the construction of an even larger cathedral was, no doubt, intended as a fitting reflection of the importance, wealth, and extraordinary power enjoyed by Florence at the turn of the 13th century. However, by the time of the death of Arnolfo di Cambio in the first decade of the 14th century, the great project was already flagging with the completion of just one story of the façade and a few bays of the side-aisle walls .

The original plans were changed by various architects – including Francesco Talenti, Giotto, and Giovanni di Lapo Ghini – at different stages in the project in the

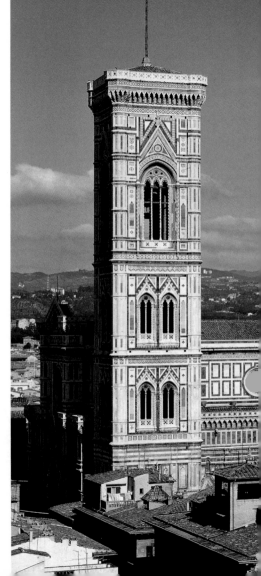

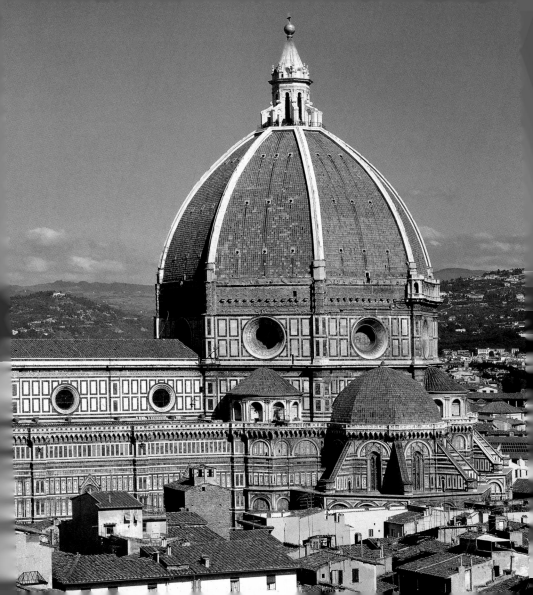

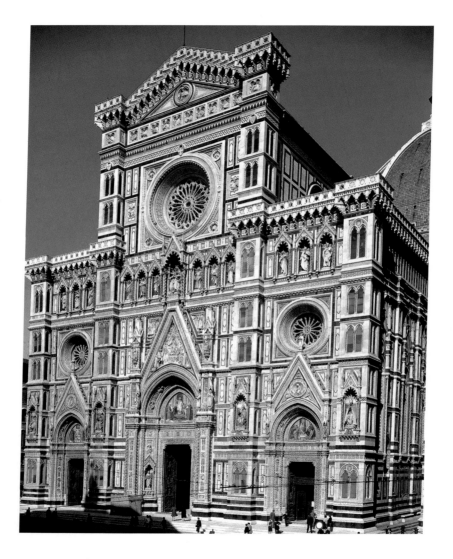

years following di Cambio's death. In 1368, a specially appointed commission finally agreed on a model which was deemed binding for the completion of the project. Work reached a preliminary culmination around the middle of the 15th century with the erection of Filippo Brunelleschi's majestic dome over the choir. The lantern was completed in 1472.

The cathedral façade

The history of the construction of Santa Maria del Fiore extends over several centuries. The façade we see today is a 19th-century structure. An older unfinished façade designed by Arnolfo di Cambio was demolished in 1588. The sculptures from this façade are now exhibited in the neighboring Cathedral Museum, Museo del Opera del Duomo (see p. 69 f.), which also contains drawings and models of Arnolfo's plans and those of his successors.

It was not until 1871 that agreement was reached on the construction of the neo-Gothic redesign of the façade based on the plans by architect Emilio de Fabris. It proved rather difficult to reflect the same architectural harmony and unity, which characterize other parts of the cathedral, in the discordant and excessively decorated façade.

Nanni di Banco: The Assumption of the Virgin (gable relief on the Porta della Mandorla), 1414–21
Marble, relief surface 407 x 387 cm

The Porta della Mandorla on the north nave and side-aisle part of the cathedral is named after the gable relief by Nanni di Banco, which is over 13 feet (4 meters) high. The Virgin Mary is enclosed in a *mandorla*, or almond-shaped aureole, which is being lifted up by four sturdy angels. The theme of the Ascension is linked with that of the Virgin lowering her belt to the doubting apostle Thomas. With its energetic and turbulent sense of movement, this work is viewed as a pioneering masterpiece of Early Florentine Renaissance relief art.

The cathedral dome

The size and shape of the dome to be built over the cathedral crossing were largely defined in the definitive model of 1368. The serious technical problems posed by the enormous dimensions remained unresolved for several centuries: the base of the dome was ca. 148 feet (45 meters) in diameter and it was almost 330 feet (100 meters) high. Among the solutions considered was a bizarre plan to pour an enormous pile of earth mixed with coins into the cathedral interior and, on completion of the construction work, allow the city's poor and children to remove the "enriched" material. This plan was soon dismissed for obvious reasons. In an effort to find a more realistic solution to the problem, the cathedral Opera (commission) published the brief in 1418 and, following extensive disputes, Filippo Brunelleschi surprisingly succeeded in winning the commission. The architect was able to start work on his audacious structure a few years later (about 1420).

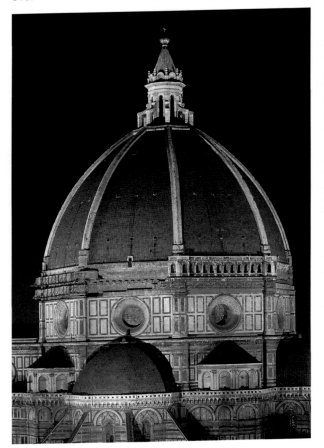

Axonometric projection of the dome of Santa Maria del Fiore (after Sanpaolesi), Istituto Germanico, Florence

The dome cupola is the city's most dominant architectural feature and an Early Renaissance masterpiece. As an engineering achievement, no other structure would exceed its dimensions until the dome of St. Peter's in Rome was built 150 years later. It crowns the city so majestically that as early as 1434, in a testimony to his admiration for his colleague's achievement, Leone Battista Alberti deemed it a suitable symbol to unite the peoples of Tuscany.

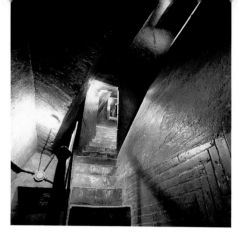

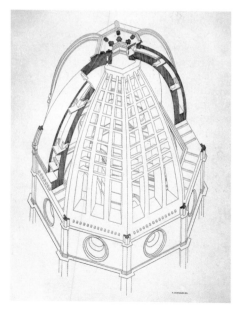

Interior staircase

The stability of the dome structure is provided by longitudinal ribs and a range of horizontal members between the two shells of the dome. Eight of these *sproni* or ribs have no static function but they are continued through to the outside of the structure in marble and divide the appearance of the dome in harmoniously proportioned segments. The climb up to the dome lantern is one of the most memorable impressions of a visit to Florence, not only because it gives a breathtaking view of the roofs of the city and its surroundings: the staircase leads up between the two wall shells and gives a direct view of the audacity of the structural principle as well as the outstanding nature of this architectural achievement.

Ludovico Cigoli: dome elevation

The idea behind Brunelleschi's ingenious design was to make it possible to construct the dome without a scaffold by building two shells of different strengths interconnected by carefully dimensioned stone ribs. The shells would then support a suspended scaffold which would grow ring by ring with the dome. Brunelleschi used a series of architectural tricks to guarantee the stability of the entire structure. He carefully selected building materials which as well as being light had good load-bearing properties. He supervised the precise execution of the masonry in the herringbone technique and designed new tools when needed. And, last but not least, Brunelleschi dealt with all of the day-to-day problems involved in the coordination and organization of his enormous studio and workshop.

The east choir

The overall impression of the cathedral is dominated by the rich white, red, and green marble inlay on all of the façades and the vast structure is impressively terminated by the east choir. Almost reminiscent of an independent central-plan building, three equal choir arms radiate from the domed octagonal crossing which, in turn, is circumscribed on five sides by the choirs. Thus, their plan is suggestive of a tambour while the small domes echo the main dome. Beneath the tambour, four exhedras designed by Brunelleschi deflect part of the powerful thrust, while their antique form is a typical Renaissance touch. Brunelleschi's plans contain a small arcade ambulatory which, however, was only executed on one side (1508–12). In a critical remark, Michelangelo mocked it as a "cricket cage" and it was deemed too delicate a detail for this powerful setting.

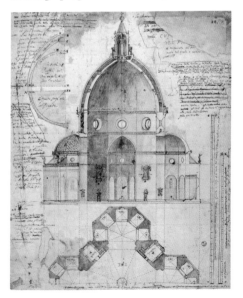

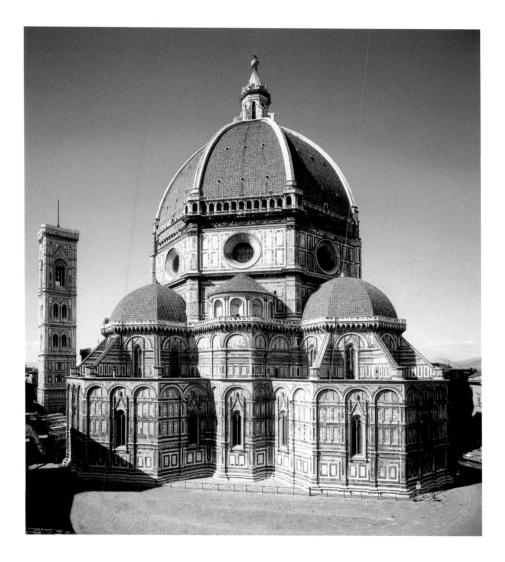

Duomo Santa Maria del Fiore

Paolo Uccello: painting of equestrian monument of Sir John Hawkwood (ca. 1436), p. 64

Domenico di Michelino: Dante and the Divine Comedy (1465), p. 63

Andrea del Castagno: Niccolò da Tolentino (1465), p. 65

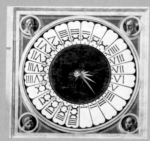

Paolo Uccello: Clock (1443), p. 62

Remains and crypt of the old cathedral of St. Reparata

Circular window with the Assumption of the Virgin (based on plans by Lorenzo Ghiberti, ca. 1410)

Entrance to remains and crypt of the old cathedral of St. Reparata

0 N 20 m

Campanile, p. 68

Porta del Campanile

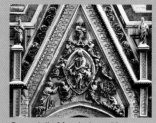

Porta della Mandorla, p. 53

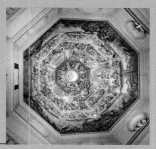

Dome fresco by Giorgio Vasari and
Federico Zuccari (1572–79), p. 61

Sagrestia Nuova – Luca della Robbia:
The Resurrection of Christ (1444)

East chapel – Lorenzo Ghiberti:
relic shrine of St. Zenobius
(1432–44), Luca della Robbia:
Candelabra Angel (ca. 1450)

Sagrestia Vecchia/Sagrestia dei Canonici
– Luca della Robbia: relief of the Ascension
(1442–45)

Access to Filippo Brunelleschi's dome

Porta dei Canonici

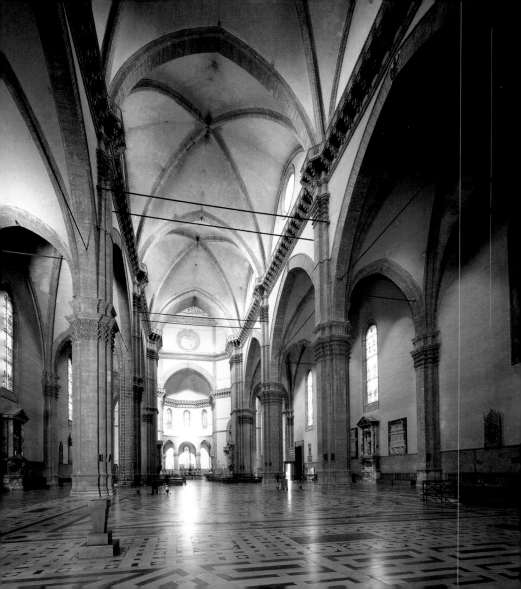

The cathedral interior

The cathedral is constructed as a three-aisle basilica on a Latin cross plan. Much of the extremely lavish interior decoration has been lost over the centuries or – like Luca della Robbia's and Donatello's choir galleries – is now on display in the Museo del Opera del Duomo (see p. 69 f.). Thus, the interior appears rather bare and almost "over-powering" in its enormous dimensions. The building is over 500 feet (153 meters) long and the arches of the side arcades climb to a height of 75 feet (23 meters).

Giorgio Vasari (and Federico Zuccari):
The Last Judgment (dome fresco), 1572–79
Fresco

Instead of the originally planned mosaic rendering of Giorgio Vasari's *The Last Judgement*, a powerful, impressive fresco of this same work can be seen above the dome tambour. The latter is lit by attractive stained-glass windows executed from designs by *inter alia* Donatello, Lorenzo Ghiberti, and Paolo Uccello. The painting was begun in 1572 and the work was completed by Federico Zuccari and his assistants after Vasari's death in 1574. Closer observation of these detailed paintings is most worthwhile.

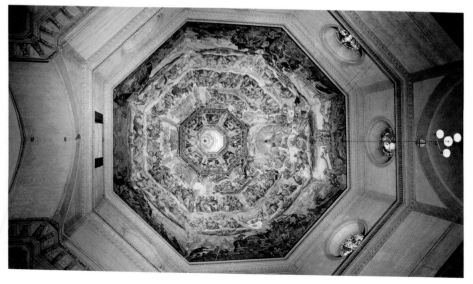

Paolo Uccello: clock, 1443
Fresco, 460 x 460 cm

An interesting piece from the original 14th-century decoration has been preserved on the inside of the cathedral façade. As was customary in clock design at the time, a single star-shaped hand covers the entire 24-hour cycle of a day. The hand moves in the opposite direction to that now described as "clockwise" and the 24-hour mark is at the bottom of the clock as opposed to the top. The heads of four unidentifiable holy men (prophets or evangelists) at the corners were painted *al fresco* by Uccello.

Domenico di Michelino: Dante and the Divine Comedy, 1465
Fresco

Dante Alighieri (1265–1321) was driven from Florence in the year 1302. The famous writer spent the rest of his life in exile, never to set foot again on his beloved home soil. Domenico di Michelino was commissioned to paint the fresco on the cathedral wall in 1465, at a time when Dante's native city had long wished to commemorate him, actively promoted research on his work, and held public readings of his works in the city. Thus, on the occasion of his 200th birthday, the famous poet was posthumously honored in a prominent place, the first of many such honors to be bestowed over the centuries.

With a laurel wreath adorning his legendary red poet's hat, in Domenico di Michelino's fresco Dante stands holding his famous work *The Divine Comedy* open in his left hand and draws our attention to the background scenes with a gesture of the right. The painter derives his motifs from Dante's descriptions of the hereafter in *The Divine Comedy*. On the left, the damned are being led to hell by horrendous demons.

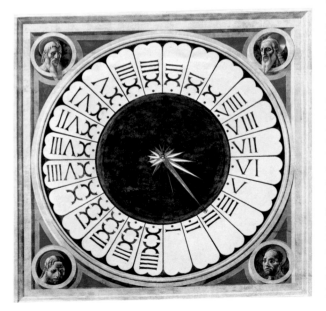

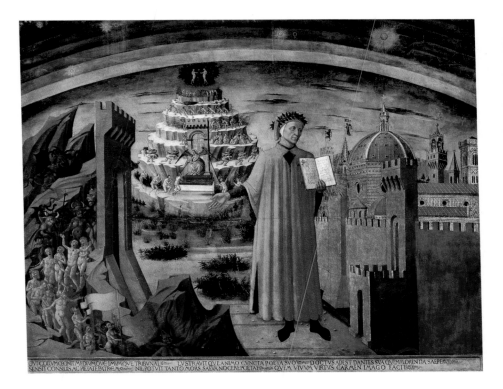

CVI CÆLVM CÆLONT MEDIVMQVE IAVMAQVE TRIBVNAL ⸱ LVSTRAVIT QVE ANIMO CVNCTA POETA SVO ⸱ DOCTVS ADEST DANTES SVA QVEM FLORENTIA SAEPE ⸱ SENSIT CONSILIIS AC PIETATE PATREM ⸱ NIL POTVIT TANTO MORS SÆVA NOCERE POETÆ ⸱ QVEM VIVVM VIRTVS CARMEN IMAGO FACIT ⸱

The mount of purgatory with Adam and Eve in the Garden of Paradise at the top is shown in the background. There is an interesting view of contemporary Florence, as never seen by Dante himself, on the right. The cathedral dome is already complete and crowned with Brunelleschi's lantern. The work on the green and white marble inlay has not, however, been completed.

Dante remains excluded and stands tellingly outside the city walls. However, beams of light radiate from the book he is holding and symbolically illuminate the city of Florence.

Paolo Uccello: Sir John Hawkwood (Giovanni Acuto), 1436

Fresco (transferred to canvas), 820 x 515 cm

In May 1436, Paolo Uccello was commissioned to paint an equestrian portrait of Sir John Hawkwood in the cathedral. The English mercenary soldier, who was known to the Italians as Giovanni Acuto, had served the city of Florence for many years and earned its goodwill. It was originally intended to erect a bronze monument as a gesture of gratitude in his honor. However, this project could not be realized for reasons of cost and it was finally decided to go for the less expensive alternative of a fresco. The brief expressly required that the fresco be executed as far as possible in monochrome *terra verde*, the greenish color which most closely resembles a bronze patina. This was undoubtedly a direct reference to preserved antique equestrian monuments and indicates that it was intended to honor Sir John

Hawkwood as the worthy successor of the famous Roman commander Fabius Maximus.

Uccello's first draft was not well received and deemed by the cathedral Opera as "not painted as it should be." The painter was requested to make some changes, the scope of which can now only be guessed. What is conspicuous about the painting is that the rider and horse are portrayed in strict profile with clear contours against the dark background, whereas the pedestal is projected in perspective to coincide with the eye level of an observer standing in the side-aisle.

Andrea del Castagno: Niccolò da Tolentino, 1456
Fresco (transferred to canvas), 833 x 512 cm

Andrea del Castagno painted the fresco of mercenary commander Niccolò da Tolentino as a direct pendant to Uccello's fresco of Sir John Hawkwood. Both portraits, which were originally painted in a higher position on the wall, were transferred to canvas in the 19th century. They also have similar dimensions and formal conception, and the obvious aim to imitate sculpture. At the same time, however, certain differences are clearly identifiable in the two works.

In the case of Castagno, there is far more emphasis on the sculptural modeling of the horse and rider and a much stronger sense of movement and action. In contrast with

Uccello's rather simple image, Castagno's is richly embellished with detail. Castagno also appears to have consciously modeled his fresco on the illusion of a marble monument, unlike Uccello who set out to convey the impression of an aged bronze statue.

Filippo Brunelleschi – The Early Renaissance
Uomo Universale

Pippo di Ser Brunellesco – now better known as Filippo Brunelleschi – was born in 1377. He was trained as a goldsmith in his native city during the last years of the 14th century and in 1398 he applied for membership of the more prestigious and highly regarded guild of silk weavers (Arta della Seta). As he came from an affluent background, Filippo was hardly concerned about earning a living from his trade. The only extant artistic works by Brunelleschi are his bronze pieces for the Jacobus altar in Pistoia (1399) and the *Sacrifice of Isaac*, the panel he created for the competition for the second set of Baptistery doors in 1402, which he lost to his life-long rival, Lorenzo Ghiberti, in 1402. In addition, his considerable talent as a sculptor is also demonstrated by the wooden crucifix in Santa Maria Novella, which, according to Vasari, was created for an artistic competition with Donatello.

Against the background of his solid education, Brunelleschi engaged in a wide range of studies in mathematics and architectural theory with unbounded enthusiasm. He made endless sketches of antique architectural monuments during a trip to Rome with Donatello. "He visited and surveyed all the places inside and outside Rome which were of interest and accessible" (Vasari).

Back in Florence, around 1415–20, he amazed his contemporaries by producing the first precise mathematical account of the rules of central-perspective representation. Using two, now unfortunately lost, plates from the Baptistery and the Piazza della Signoria, he

Florentine School: Five Famous Men (The Fathers of Perspective), ca. 1500–65, tempera on wood, 42 x 100 cm, Musée du Louvre, Paris

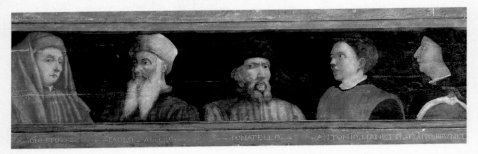

clearly demonstrated the way in which three-dimensional objects could be reproduced on a two-dimensional surface. This discovery based on the laws of optics and geometry was one of the most important and consequential innovations in the history of art.

Filippo Brunelleschi's main architectural achievement finally took shape in 1418. A commission specifically set up to resolve the problem of the construction of the cathedral dome finally selected him from a long list of competitors. His appointment to the office of cathedral architect initially attracted extensive criticism as many were skeptical of his ability. Although Brunelleschi was not exactly unknown in the circle of the cathedral Opera, his architectural ability had hitherto been demonstrated only in theoretical matters, and he had never been responsible for the construction of a single building. This attitude would change radically in the early 1420s when he designed the buildings whose conceptual clarity forms the basis of his reputation today as the most important architect of the Early Italian Renaissance. These projects were all designed in rapid succession. However, some of them were not completed until after Brunelleschi's death. The dome of Florence Cathedral, the Old Sacristy, the Foundlings' Hospital (started in 1419), and the basilicas of San Lorenzo (1421) and Santo Spirito (1434) are among the architectural masterpieces with which Filippo not only gave Florence a new face but also influenced the course of architectural history far beyond the borders of his native city.

Given the extraordinary course of his life and work, Filippo Brunelleschi was an exemplary

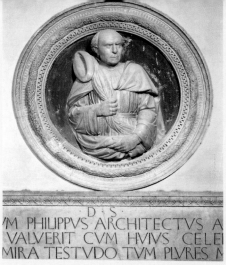

Andrea di Lazaro Cavalcanti (known as Buggiano): Filippo Brunelleschi's Portrait and Dedication, 1446, Santa Maria del Fiore, Florence

embodiment of the Renaissance ideal of the multi-faceted, educated man of universal interests, the *uomo universale*. When he died in Florence on 14 May 1446, the invaluable nature of his extraordinary achievements was undisputed. Brunelleschi was buried in the cathedral of Santa Maria del Fiore and honored with a tomb portrait. The inscription on his grave penned by Carlo Marsuppini declares him a *divino ingenio*, a divine genius.

Campanile

The construction of the Florentine Campanile, or bell tower, was carried out under the supervision of three successive cathedral architects. The first to be called to this office in 1334 was Giotto di Bondone. He appears to have been interested primarily in building the bell tower (*campanile* in Italian) as opposed to getting on with the construction of the cathedral itself. The structure as it stands today is

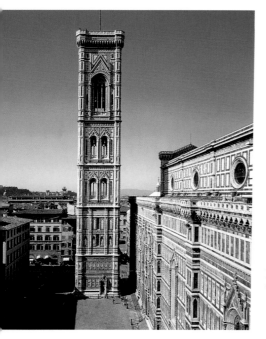

mainly based on Giotto's plans, despite the fact that only the lower story had actually been completed by his death in 1337. The square plan with its accentuated corner piers and the ubiquitous highly decorative Florentine marble inlay were already prescribed when Andrea Pisano took over the project in 1443. The three upper stories with windows were completed under Francesco Talenti. Talenti rejected Giotto's plan to crown the tower with a spire and he completed the tower at a height of about 278 feet (84.7 meters), as opposed to the originally planned 400 feet (122 meters). A viewing platform which Talenti added to the top story can still be accessed today by climbing the 416 steps. Thankfully, the various alterations to the original designs, which were introduced during different phases in the construction, do not impair the overall effect of the Campanile which is one of the most attractive in Italy.

The decoration of the lower part of the tower comprises a virtually encyclopedic relief cycle of human activities, virtues, sacraments, the planets, and the liberal arts. Important sculptors, including Donatello and Nanni di Bartolo, created marble statues of various saints, prophets, and sibyls for the niches in the upper stories. The original versions of these statues can now be seen in the Cathedral Museum (see p. 69 f.) and have been replaced by copies on the Campanile itself.

Museo dell' Opera del Duomo

The museum of the cathedral construction workshop, which was located on the east side of the cathedral square, was opened in 1891. The initial priority was to provide public access to the choir galleries or *Cantorie* by Luca della Robbia and Donatello which had been removed from the cathedral interior in 1688. In the course of the 20th century, the museum collection constantly increased as more and more originals, particularly paintings, were moved there from the cathedral, Campanile, and Baptistery. The museum now counts as one of the world's most important collections of sculpture and it also houses important documentation concerning the architectural history of the cathedral itself.

Arnolfo di Cambio: St. Reparata, ca. 1290
Marble, h. 142 cm

The sculptures which were originally located on the old cathedral façade - demolished in 1588 - are on display in the cathedral façade room. The marble sculpture of St. Reparata, the Early Christian martyr to whom the old city cathedral was dedicated, is the work of Arnolfo di Cambio, the cathedral's first architect.

The sitting figures of the four Evangelists, which were sculpted by Niccolò di Pietro Lamberti (St. Mark), Donatello (St. John), Nanni di Banco (St. Luke), and Bernardo Ciuffagni (St. Mathew) between 1408 and 1411 and are exhibited in the same room, also originate from the niches in the demolished façade.

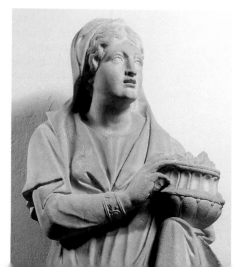

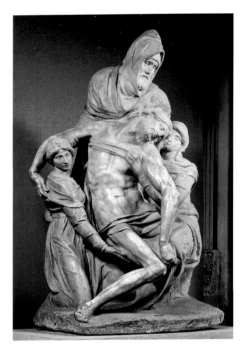

Michelangelo Buonarroti: Pietà, ca. 1550
Marble, h. 226 cm

Michelangelo started work on his re-
nowned *Pietà* in Rome and intended it to be
placed on his tomb. However, he destroyed
the incomplete work when problems
emerged with the material and the left leg
of the Christ figure broke off. Tiberio
Calcagni, a student of Michelangelo,
restored the work and his finishing touches
include the figure of St. Mary Magdelene

(left). The *Pietà* did not reach Florence until
the 18th century and it was exhibited in
the cathedral until 1981. This version of the
Pietà is unusual in that it links the theme of
the mourning over the death of Christ
with that of the removal of the body from
the Cross. The pyramidal composition
comprises three figures joined together in a
single block: the Virgin Mary, the dead
Christ, and St. Nicodemus, whose facial
features also reveal a sculpted self-portrait
of Michelangelo.

Donatello: Prophet with Scroll, 1415-18
Marble, h. 190 cm

Donatello's (1386-1466) early statue of the
prophet betrays the advent of a new artistic
sensibility trained in the observation of
reality. While reflecting the influence of
Roman portrait sculpture, the facial features
are also distinctly individual. The prophet's
searing glance is directed downward while
his right hand gestures to the scrolled
document he is holding in his left hand.

This work by Donatello is one of the five
sculptures the master created between
1415 and 1436 for the Florentine bell
tower. In view of its original position on
the third story of the tower, it would
appear that it was intended to convey an
urgent warning to the inhabitants of the
city looking up at it from below.

Donatello: Zuccone, 1413-26
Marble, h. 195 cm

Because of its prominent baldness, Florentines called Donatello's sculpture of the prophet Habakkuk *Zuccone* (= "big squash," i.e. "baldy"). Given the very life-like stance and expression of the figure, it is not surprising that Donatello is reputed to have cried out "Speak! Say something at last or be cursed!" while working on the statue.

Room of the Choir Galleries (Cantorie)
(illustration next page)

The 16 statues of the sibyls and prophets (the work of *inter alia* Andrea Pisano and Nanni di Bartolo), which were originally located in the niches of the Campanile, are exhibited in the Sala delle Cantorie below the magnificent choir galleries by Donatello and Luca della Robbia.

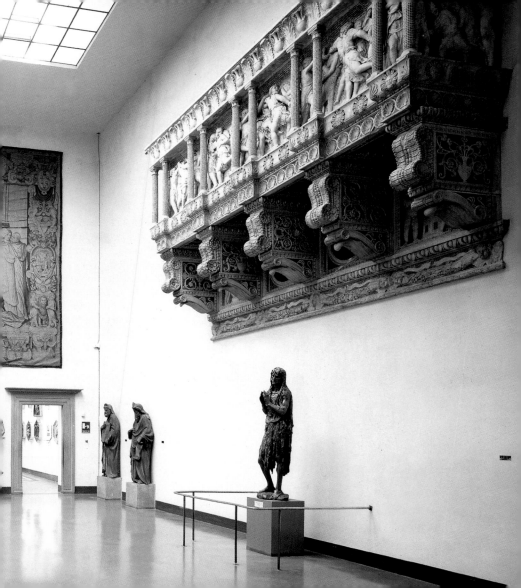

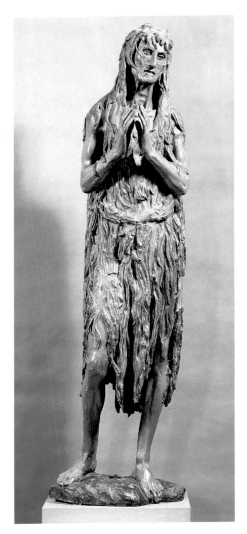

Donatello: The Penitent Mary Magdalene, ca. 1455

Wood (polychromy and gold), h. 188 cm

Donatello's sculpture of a penitent St. Mary Magdalene was originally intended for the Baptistery. With this polychromed and gilded figure, carved around 1445, the master created a harrowing and fascinating image of the biblical sinner which is far removed from standard portrayals of saints brandishing ointment jars, crucifixes, or skulls.

According to the New Testament, Jesus forgave her sinful life as a whore in the house of the Pharisee Simon. Mary Magdalene later spent decades as a recluse in the wilderness of southern France.

Gaunt and weak, in Donatello's vision, the woman once famed for her beauty seems closer to death than life. Marked by traces of ascetic denial, she is portrayed barefoot and clothed only in her own hair. Her hands are joined in prayer and her mouth slightly open as if releasing a sigh. It would be difficult to find a more poignant expression of the transitory nature of all earthly things in a sculpture. The intensity of the deep internal bitterness which informs this work is unequaled in Early Renaissance Florentine art. This representation of Mary Magdalene may well reflect the spiritual state of the ageing sculptor who was almost 70 when he completed this work.

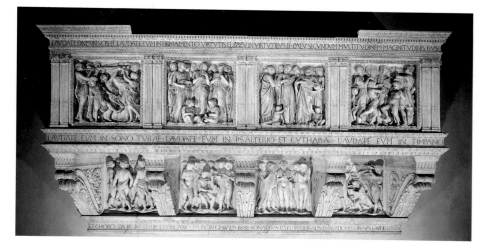

Luca della Robbia: Cantoria, ca. 1431-38
Marble, 328 x 560 cm

Donatello: Cantoria, 1433-38
(see double spread overleaf)
Marble, 348 x 570 cm

Donatello and Luca della Robbia created their *Cantorie* (choir galleries) for Florence Cathedral. Both works were dismantled on the occasion of the wedding of Ferdinando de' Medici with Violante of Bavaria and were not reassembled in their current form until 1895.

The structure of Luca della Robbia's *Cantoria* is dominated by its architectural articulation. The eight separate relief panels refer to Psalm 150, which calls on the children to praise the Lord with music and is also quoted in full on the *Cantoria*. All of the instruments that are mentioned in the biblical text are included in the sculpture.

The lively dance of the putti musicians is presented as a continuous frieze in Donatello's *Cantoria*. Free-standing pairs of columns which are decorated with the same mosaics as those adorning the relief background do not pose any obstacle to the boisterous dance of the young angels. Whereas Luca della Robbia's figures are spiritualized and dignified, Donatello's seem to be indulging in wild, almost bacchanalian, revelry. The precise elaboration of individual details is subordinated to the decorative effect of the piece as a whole and conventional composition is sacrificed in favor of intense and vigorous rhythm.

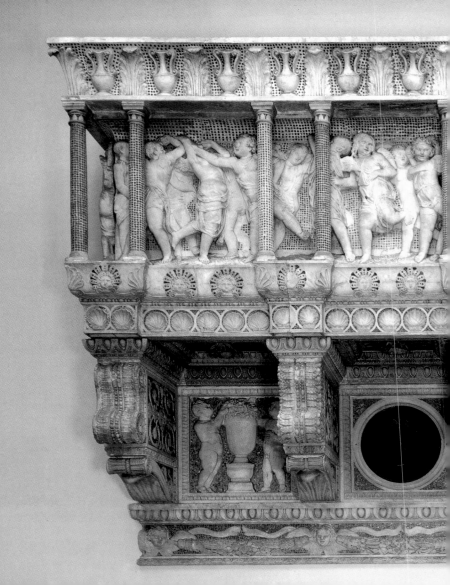

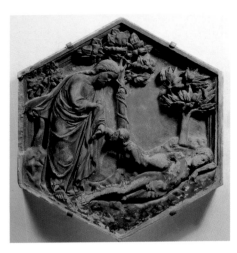

Andrea Pisano: The Creation of Eve, ca. 1335
Marble, 83 x 69 cm

A separate room is reserved in the Museo dell'Opera del Duomo for the relief cycle from the Campanile. The relief plates are hung in the order in which they originally appeared on the façade of the base of the bell tower where the originals have been replaced by copies. The works in the lower area are mainly by Andrea Pisano, with only five of them being later additions by Luca della Robbia.

The images are based on a complex iconographical program. The sum of all human being and doing is related to the basis of scholastic thought. The cycle starts with scenes from Genesis and the creation of the first human couple, Adam and Eve.

Andrea Pisano: Ploughman, ca. 1335
Marble, 83 x 69 cm

The cycle also contains striking portrayals of human inventions. This was the first time that the low artisanal trades (*artes mechanicae*) were included in this kind of artistic program along with the liberal arts (*artes liberales*). The individual topics are translated into a clear visual idiom. *Ploughman* shows two men tilling a field with the help of a yoke of oxen. An extremely realistic impression is conveyed of the hard work involved in this task. The clearly arduous movement of animals also successfully conveys the idea of the immense strength required to draw the heavy plough through the soil.

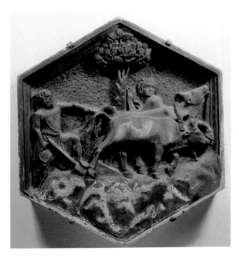

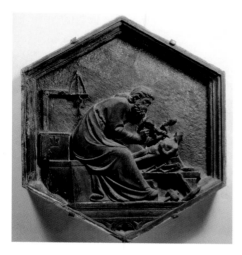

Andrea Pisano: Art of Sculpture, ca. 1335
Marble, 83 x 69 cm

In addition to architecture and painting, one of the Campanile relief plates is also devoted to the art of sculpture. Here, Pisano gives us an insight into the appearance of the sculptor's studio. The sculptor portrayed working in profile is probably Phidias, the legendary Attic forefather of this art form. The tools he needs to exercise his craft are spread within his reach. The way in which the artist uses the harmony of composition to give his representation a timeless universal quality is the outstanding feature of this impressive work.

Alberto Arnoldi: The Baptism, ca. 1375
Marble, 83 x 63 cm

The diamond-shaped relief panels in the upper zone of the Campanile socle show seven representations of the planets, the Christian virtues, and the liberal arts. These are enclosed by panels portraying the holy sacraments which are attributed to Alberto Arnoldi. The white figures are clearly delineated from the blue majolica background. The cycle starts with the sacrament of baptism which is followed by the six other sacraments of confession, marriage, ordination, confirmation, communion, and extreme unction.

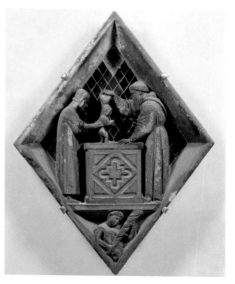

Plato in Florence – The Florentine Academy which Changed the History of European Culture Clemente Manenti

Raphael's famous fresco *The School of Athens*, in the Stanza della Segnatura in the Vatican Museum in Rome, shows Plato and Aristotle in conversation: one pointing upwards and the other pointing down. The here and elsewhere,

Francesco Furini: Lorenzo il Magnifico with the Poets and Philosophers of the Platonic Academy, Fresco, Museo degli Argenti, Florence

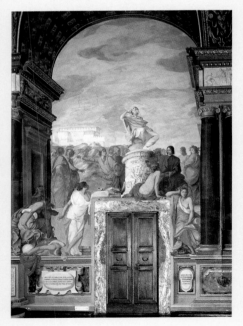

Heaven and Earth are the subject of their discussion. The fresco (1508–11) conveys an impressive synthesis of the world-view of the two great Greek philosophers that was formed in the course of the 15th century and would have been completely inconceivable just one century earlier. This was the result of the rediscovery of Plato which took place in Florence thanks to the efforts of the Platonic Academy and the activities of Marsilio Ficino and his circle. Restored to his master's side, Aristotle, who had never suffered the same neglect, could now speak, and his words took on a new significance.

Plato lived in Athens in the 5th century BC. He was a disciple of Pythagoras' school of philosophy which interpreted the universe as a mathematical system. Believing that a link existed between mathematics and music, Plato understood the heavenly bodies as entities separated by rhythmic intervals similar to those found in music. The heavenly spheres followed the same principles of harmony as those applied in music: they were heavenly music. According to Plato, the entire world of creation, which we perceive with our senses, is merely the shadow of the real world, the world of godly causality, the world of music. And only those minds which have been trained in the contemplative use of reason can know the world of pure harmony, the one true world.

Plato's teaching was as lost a cause in the Europe of the Middle Ages as the study and

knowledge of the Greek language. Apart from individual quotes used by Latin authors, all that was known of Plato's work was the Latin translation of the treatise on mathematics, the *Timaeus*.

Aristotle moved away from his teacher's ideas in that he believed it possible for man to understand the laws of the universe with his senses and study them with the help of logic. The Aristotelian mind is not contemplative but action-oriented, engaged in classification, and complete in itself. The main doctrine of the medieval church was based on established Aristotelian categories.

Logical mind games were something of an intellectual passion among the medieval schools of theology which, moreover, were completely comparable to the mind games of our times that have led to the invention of the computer. The fact that, having been engulfed by logic, the universe was ultimately disappearing left a degree of uncertainty with respect to the body of Aristotle's teaching. In its attempt to explain the world, Aristotelian reason lost itself in a room of mirrors.

Platonism began its slow spread in the city on the Arno when Manuel Chrysolaras

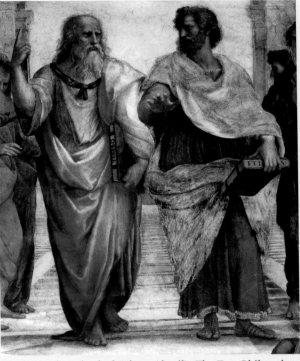

Raphael: The School of Athens (detail): The Two Philosophers, 1509, fresco, width of base 770 cm, Stanza della Segnatura, Vatican Museum, Rome

from Greece was invited to give a series of lectures at the University of Florence in the early 15th century. Chrysolaras' student circle included the young Cosimo de' Medici. Other persons who were interested in the study of philosophy gathered around Ambrogio Traversari in the monastery of Santa Maria degli

Angeli and the young Cosimo was also a member of this group. Traversari, the general prior of the Camaldoese monks was one of the few men of his time who spoke both Latin and Greek and he transformed the monastery of Camaldoli high up in the Casentin mountains into a workshop for the translation of classical authors.

Cosimo withdrew from his philosophical studies at the age of 40. Owing to the death of his father, Giovanni de' Medici, in 1429, he was obliged to take over the family business. However, he continued to buy books and spend part of his vast fortune on the support of humanists and their work. One such project carried out with Cosimo's help was a search by

Domenico Ghirlandaio: Annunciation to Zacharias (detail), 1486–90, fresco, Cappella Tornabuoni, Santa Maria Novella, Florence

Poggio Bracciolino and Niccolò Niccoli of Europe's monastery libraries for the ancient classical texts, which had been preserved for centuries thanks to the efforts of the Benedictines. In 1437, Cosimo de' Medici was present at the Council of Ferrara which brought representatives of the two Christian churches – Greek and Roman – together in a last attempt at unification. There he met the Greek scholars from the Byzantine delegation and the Emperor of Constantinople, John VIII Palaiologos.

When the town of Ferrara was no longer able to accommodate the Council, Cosimo offered to allow it to continue in Florence at the cost of the Medici. This gesture was enough to change the course of European intellectual history. The Greek scholars who moved to Florence with the Byzantine delegation included Georgis Gemisto Plethon, whose name roughly translates as "the new Plato." He held a series of memorable lectures at the University of Florence which was attended by all of the humanistic scholars living in the city at the time. The importance of the lectures given by Plethon, who was over 80 years old at the time, was connected with the fact that Plato's dialogs had already reached Italy a decade earlier thanks to the efforts of Giovanni Aurispa. Aurispa, a humanist, was a bibliophile antique dealer who was constantly on the road between Constantinople and Rome and had managed to save a considerable number of classical works.

The idea of rejuvenating Plato's Academy and making Florence into a new Athens came to Cosimo during the Council. However, the idea could not actually be implemented until the 1460s. Cosimo chose Marsilio Ficino, the son of

a medical doctor whose studies with Traversari he had funded, to manage his project.

Young Ficino was given the task of translating Plato and hence starting the Academy. Ficino translated the *Hymns of Orpheus* and the *Oracle of Chaldaea*, and in 1463 the works of Hermes Trismegistus into Latin. In 1464 he began translating Plato's dialogs. Cosimo had reached the end of his life when he was first able to read Plato's words in Ficino's translation. Cosimo wanted to die in the spirit of Socrates – open to that which would happen to him. He could not have wished for a better reward for his efforts: the Platonic Academy was well and truly established with the small group gathered around Cosimo's death bed listening to Ficino's translation. Europe's first modern academy was never associated with a particular building and met at different venues in the city and in the Medici villas in the Florentine foothills in summer.

The influence of the rediscovery of Plato in 15th-century Florence on the fine arts and their flowering during the golden age of the Tuscan city cannot be overemphasized. The works of Sandro Botticelli are now generally interpreted as a rendering of the Platonic mythology in

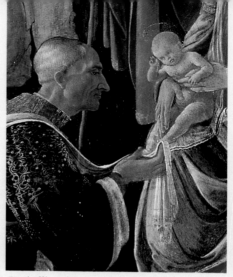

Botticelli: Adoration of the Magi (detail): Cosimo de' Medici – portrait, ca. 1475, wood 111 x 134 cm, Uffizi Gallery, Florence

painting. The art of Piero della Francesca, who reached the summit of his artistic career in Florence, also appears to be based on the philosophy of Plato. The sublime tranquillity of his figures and their imperturbable calm render them "ideal" figures in the Platonic sense.

Loggia del Bigallo

This delightful Late Gothic building was built by the cathedral architect Alberto Arnoldi in the 1350s. It was the premises

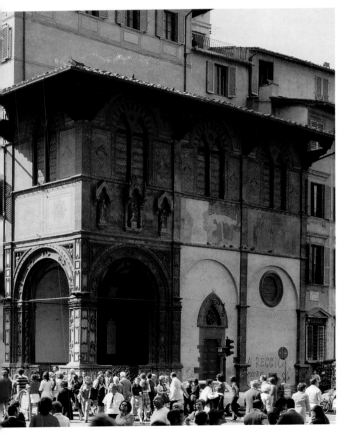

initially of the Asconfraternità della Misericordia, which still exists today, and later of the Compagnia del Bigallo. Both of these charitable orders, which were temporarily united between 1425 and 1489, were specifically dedicated to the care of the ill, orphaned, elderly, and needy. According to the story, in the 15th century the most pitiable of the orphans were "exhibited" below the arches of the loggia as a way of finding adoptive parents for them.

The attractive 14th-century sculptural decorations on the exterior walls are still intact and most of them are believed to be the work of Alberto Arnoldi. The building now houses the Museo del Bigallo, which exhibits mainly Florentine painting and sculpture from the late 13th, 14th, and 15th centuries. The exhibited works include Bernardo Daddi's fresco of the *Virgin of the Protective Coat* (ca. 1342) which shows one of the oldest extant views of the city of Florence.

Orsanmichele

The small oratory of Orsanmichele in orto was located in the middle of a vegetable garden (Italian = *in orto*) as early as the 9th century. Information about the original building, which was replaced by a covered grain market in the 13th century, is, therefore, preserved in the name Orsanmichele. The special devotion to a miraculous image of the Virgin, which was preserved at the original site, resulted in the market hall soon being used as a shrine and place of prayer. The multi-story building, which still stands today, was erected in 1337 following the destruction of the market halls by fire in 1304. The upper stories were used for grain storage while the hall on the first story continued to be used for religious purposes.

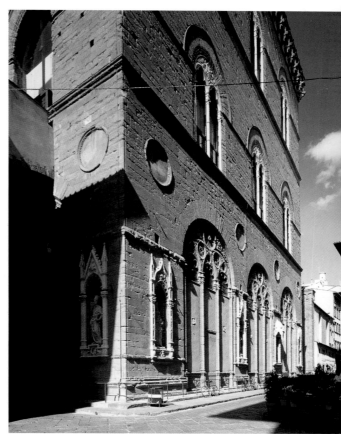

The 14 niches on the first-story exterior were assigned to the leading guilds of Florence which had the obligation of filling them with statues of their patron saints. Various prestigious masters were quickly commissioned in the early 14th century to provide these works. Hence, Orsanmichele became a showpiece for Early Renaissance Florentine sculpture.

Orsanmichele

Donatello: St. George; copy, original in the Bargello (ca. 1415)

Nanni di Banco: Four Crowned Martyrs (1410–15), p. 91

Lorenzo Ghiberti: St. Matthew (ca. 1419–22), p. 89

Lorenzo Ghiberti: St. Stephen (1425–29)

Nanni di Banco: St. Egidio (ca. 1415)

Donatello: St. Mark (ca. 1411–14), p. 89

Niccolò di Pietro Lamberti: St. Jacobus (ca. 1422)

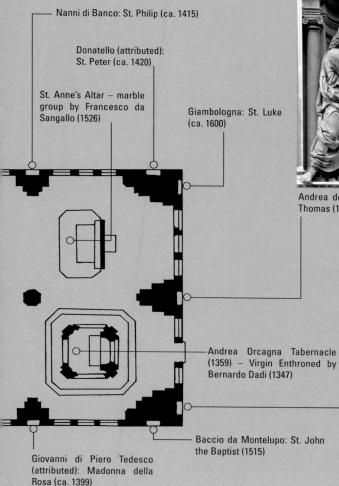

Nanni di Banco: St. Philip (ca. 1415)

Donatello (attributed):
St. Peter (ca. 1420)

St. Anne's Altar — marble
group by Francesco da
Sangallo (1526)

Giambologna: St. Luke
(ca. 1600)

Andrea Orcagna Tabernacle
(1359) — Virgin Enthroned by
Bernardo Dadi (1347)

Baccio da Montelupo: St. John
the Baptist (1515)

Giovanni di Piero Tedesco
(attributed): Madonna della
Rosa (ca. 1399)

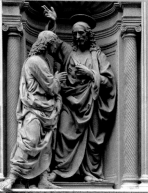

Andrea del Verrocchio: Doubting of
Thomas (1467–83), p. 90

Lorenzo Ghiberti: St. John the
Baptist (ca. 1414), p. 88

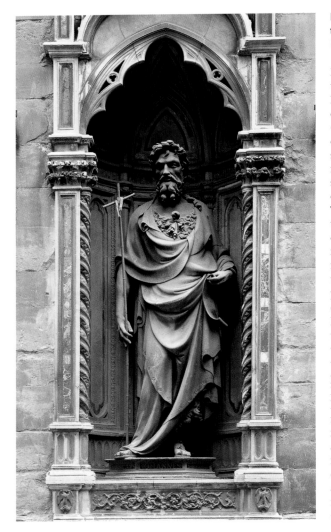

Lorenzo Ghiberti: St. John the Baptist, ca. 1414
Bronze, h. 255 cm

Lorenzo Ghiberti created the statue of St. John the Baptist for the major guild of wool refiners (Arte di Calimala). With a height of over 8 feet (2.5 meters), this sculpture is one of the first larger-than-life bronze sculptures to have been created since ancient times. The difficulties involved in the execution of a bronze casting of such monumental dimensions is reflected not least in the fact that the artist was forced to produce the statue at his own financial risk. As the leading master in this particular technique, Ghiberti was more than equal to the task. The saint's head is poignantly expressive while his cloak sweeps down in large, strong decorative folds. Despite the minimization of anatomic detail, a contrapposto is suggested in the contrast between the engaged and the free legs and emphasized by the folds in the fabric of the saint's cloak.

Lorenzo Ghiberti: St. Matthew, 1419–22
Bronze, h. 236 cm

Ghiberti completed his bronze *St. Matthew* after his *St. John the Baptist*. Here again he achieves a similarly convincing impression through the combined effects of the design of the saint's cloak and his physical presence. However, the *contrapposto* appears more natural in this instance and, in general, the figure is more convincing in the sum of its details than the earlier work. The block-like rigidity conveyed by the statue of St. John has been replaced here by a more uniform and muted animation which is conveyed in the subject's more relaxed gesture. It would appear that Ghiberti was inspired and influenced by the impetuous innovations that had since been introduced to the art of statue sculpture by his former student Donatello.

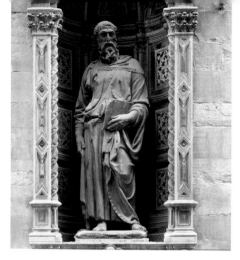

Donatello: St. Mark, 1411–14
Marble, h. 236 cm

The guild of linen weavers and peddlers (Arte dei Linaioli e Rigattieri) commissioned Donatello to create the statue of its patron saint, St. Mark, in 1411. A famous anecdote related by Vasari places Michelangelo among the admirers of this masterpiece by his predecessor and reports his comment to the effect that if St. Mark really looked like this, one could believe every word he wrote. This comment is a telling observation of the highly distinctive quality of Italian Early Renaissance sculpture. Donatello succeeded in creating a realistic and credible image of the man and in convincingly rooting the biblical Evangelist in this world.

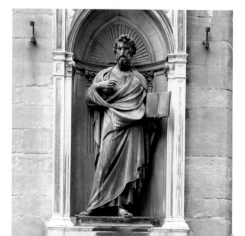

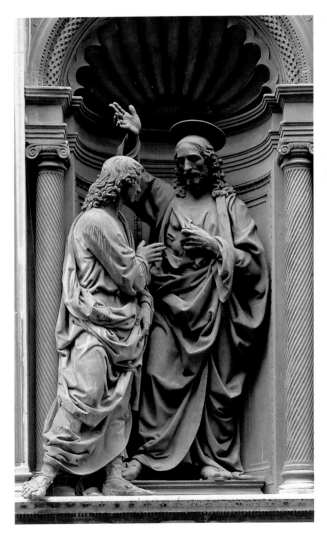

**Andrea del Verrocchio:
Doubting of Thomas, 1467–83**
Bronze, h. (of Christ figure)
230 cm

The Jesus-and-Thomas group tabernacle by Andrea del Verrocchio (1436–1488) may also have been designed by Donatello and Michelozzo. This was originally the position of Donatello's gilded bronze statue of *St. Ludwig of Toulouse* (now exhibited in the Santa Croce museum, see p. 385) commissioned by the Parte Guelfa. When the latter was eclipsed by the rise of the Medici, the niche was sold to the Università de' Mercatanti (merchants' guild) in the year 1460 and Andrea del Verrocchio was given the difficult task of accommodating a group of figures in the tabernacle which was originally built for just one figure. Verrocchio found a satisfactory solution for this spatial restriction by placing "doubting Thomas" in profile to the side of the dominating Christ figure.

Nanni di Banco: Four Crowned Martyrs, ca. 1410–15
Marble, h. 184 cm

The stone masons' and wood carvers' guild (Maestri di pietra e di Legname) commissioned Nanni di Banco to complete a group of figures of their four patron saints, the ancient sculptors and martyrs, Claudius, Castor, Symphrosian, and Nicostratus, who, according to tradition, were martyred during the persecution of the Christians under Emperor Diocletian in Rome. As a reflection of the thematic brief, Nanni di Banco clearly based his work on the model of ancient sculpture. The saints' heads are reminiscent of Roman portrait busts and their robes carved in the manner of Roman togas. The almost static block-like demeanor of the semicircular group lacks the vivacity of expression found in contemporaneous works by Donatello and Ghiberti.

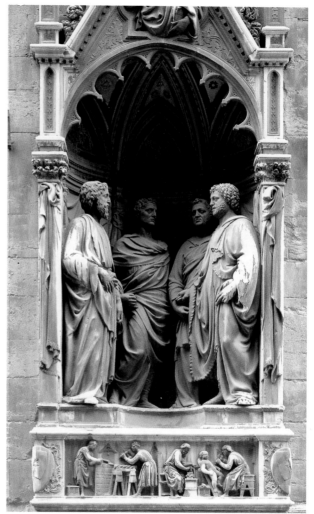

Interior

The interior of Orsanmichele is a two-aisle hall which is subdivided into six square bays, and is considered one of the finest extant examples of a late medieval plan in Florence. The shaft openings in the north pillars still act as a reminder of its original use as a grain store. In addition to the early 15th-century vault frescos, the contemporaneous and largely well-preserved window cycle with scenes from the life of the Virgin Mary is particularly interesting. The most significant part of the interior decoration is the monumental marble tabernacle by Andrea Orcagna (1359). Its magnificence is a reflection of the importance of the image of the Virgin painted by Bernardo Daddi in 1347 to replace the older painting destroyed in the fire of 1304.

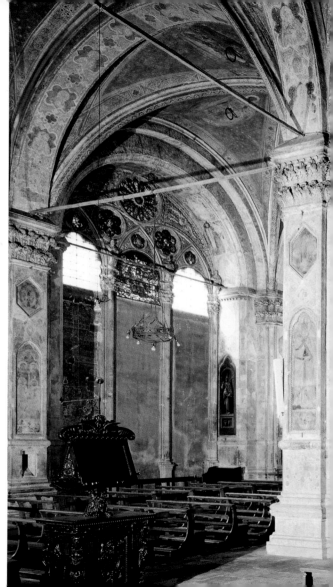

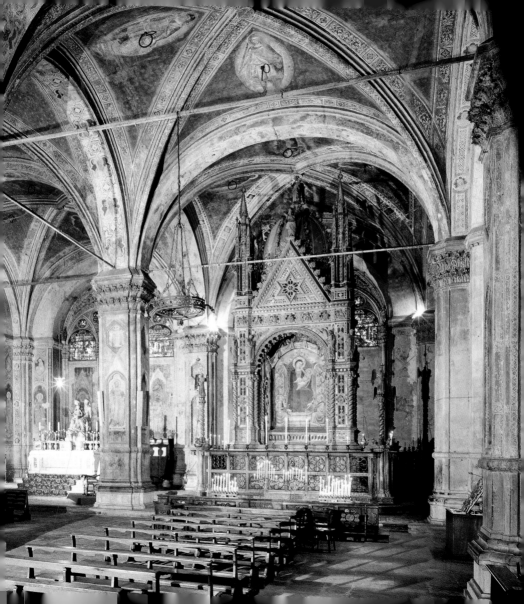

Piazza della Signoria

Since the 14th century, the Piazza della Signoria has served as an assembly point for the citizens of Florence for all aspects of day-to-day political life. During the 1980s, excavations under the square led to numerous archeological finds going back to medieval, Roman, and Etruscan times, and even all the way back to the Bronze Age. Today, the square is mainly dominated by the Palazzo Vecchio and the Loggia dei Lanzi. The tone is set by the sculptures placed here over the centuries, which have transformed the square into an open-air museum.

Giambologna: Grand Duke Cosimo I, 1594
Bronze, h. (minus socle) 450 cm

Ferdinando de' Medici commissioned the bronze equestrian statue to be erected as a memorial to his dead father, Cosimo I, in the Piazza della Signoria in 1494. In accordance with his patron's wishes, Giambologna succeeded in conveying the

Bartolommeo Ammanati: Neptune Fountain, 1560–75
Marble and bronze, h. 560 cm

To mark the occasion of the marriage of Francesco de' Medici to Johanna of Austria in 1565, the city's biggest fountain was built with the sea god Neptune rising from the water in a reference to the city's newly established maritime supremacy. Bartolommeo Ammanati's sculpture was not very popular among Florentines, however. They mockingly referred to the enormous sea god as the *biancone* ("great white one") and even coined the following short rhyme to express their disapproval: "Ammanato, che bell marmor ha rovinato!" (Ammanato, what a nice piece of marble you ruined!).

powerful foresight and dignity of the Grand Duke and hence also in reinforcing the ruling family's dynastic claims. Cosimo sits armed on the majestic striding horse, holding the command staff as a symbol of his power and rule. The socle relief illustrates significant events from Medici family history with images depicting the conferral of the title of Grand Duke on Cosimo, his crowning by Pius V, and the triumphant march into a defeated Siena.

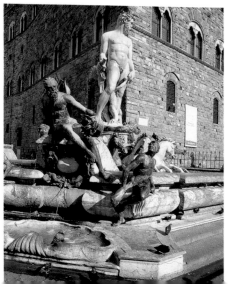

David – The Great Hero of Florence

Around 1500, Italy was divided into myriad small city-states and it would take almost four more centuries to achieve political unification. Florence was heavily populated and had achieved high levels of material and cultural wealth, demonstrated by the magnificent

Michelangelo Buonarroti: David (detail), 1501–04, marble, h. 434 cm, Galleria dell' Accademia, Florence

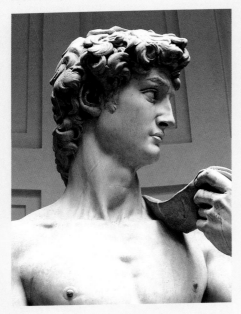

buildings and works of art which adorned the cityscape. At the same time, however, the city was constantly under threat of external attack. In terms of military strength and influence, the Duchy of Milan and the Republic of Venice were at least equal to Florence, while in southern Italy, the papal states and the Kingdom of Naples were the ruling centers of power. Like the mythological hero Hercules, whom the city adopted as its patron, Florence had always depended on its own strength and ability to defend itself as a strategy for dealing with the political intrigues and power struggles which repeatedly brought foreign armies to Italy – as well as relying on the far-sighted intelligence of its leaders. The city's inhabitants also appear to have adopted a piety that guaranteed them divine support in their hour of need, and not only in the aftermath of Savonarola. The two Old Testament heroes of David and Judith were traditionally deemed to be particularly exemplary embodiments of these virtues of strength and piety, as both had saved their people from the threat of annihilation by enemies perceived as more powerful than themselves.

It was probably for this reason that the city's ruling council, or Signoria, purchased Donatello's early marble statue of David in the year 1416 and placed it in the Palazzo della Signoria (city hall). An inscription added to the statue at this time leaves no room for doubt with respect

to the associated political symbolism. It stated that the gods would lend their support to those who fight bravely to protect the fatherland, even against the most terrible foes. Eight decades later in 1495 – exactly one year after the expulsion of the Medici – the Signoria again had two highly significant sculptures by Donatello transferred from the Palazzo Medici to the Palazzo della Signoria. The bronze statue of David was again erected inside the Palazzo della Signoria and the Judith-and-Holofernes group placed before the door. The city's leaders could hardly have expressed the self-image of the republic more clearly in those days of deep internal and external political crisis. Placed in this prominent position, Judith had become a symbol of the city, clearly visible to one and all.

Michelangelo was able to present his marble statue of David to his patrons in the year 1504 after working on it for three years. They quickly realized that, given its enormous dimensions, it would not be possible to erect the statue in the planned position above a pier buttress inside the cathedral of Santa Maria del Fiore. Neither would the antique nakedness of the figure be appropriate in this location. A very prestigious commission, whose members included the artists Filippino Lippi, Botticelli, Andrea della Robbia, and Leonardo da Vinci, was appointed to find a new place for the work. After much discussion, a highly symbolic position at the entrance to the Palazzo della Signoria in the political heart of the city was selected. This was the precise position where Donatello's *Judith and Holofernes* had been placed ten years earlier. Michelangelo's *David*, which is now one of the most prominent symbols of the city of

Donatello: Judith and Holofernes (detail), ca. 1455, bronze, h. (without socle) 236 cm, Palazzo Vecchio, Florence

Florence, was a more insistent and inescapable reminder to both Florentines and outsiders than the comparatively small work of his predecessor Donatello that "just as he defended and justly governed his people, they who rule the city must defend it courageously and govern it justly" (Vasari).

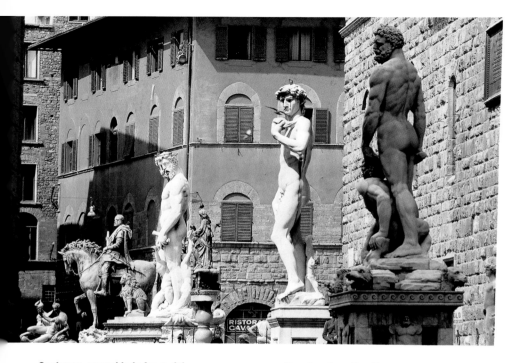

Sculpture ensemble in front of the Palazzo Vecchio

Over the centuries, various masterpieces of European sculpture have stood in the Piazza della Signoria, the famous square in front of the Palazzo Vecchio. Although many of the sculptures are now stored indoors for conservation, the copies that stand in front of the Palazzo Vecchio still convey the outstanding artistic quality and powerful effect of this unique ensemble.

Baccio Bandinelli's marble group of *Heracles and Cacus* (1525–34) stands on the right. This was created as a counterpart to Michelangelo's *David* which as the symbol of the Florentine Republic was proudly placed in front of the main door of the city hall. The original is the main attraction in the Accademia Gallery (see p. 311); another copy can be found overlooking the city in the Piazzale Michelangelo.

Although significantly smaller in size, Donatello's *Judith and Holofernes* and the

famous *Marzocco* (lion) are equally important in artistic terms (see p. 113). These statues are also copies and the originals can be viewed in the Bargello (see p. 406) and the Sala dei Gigli (Lily Room) in the Palazzo Vecchio (see p. 113).

Ammanati's powerful *Neptune Fountain* and Giambologna's equestrian statue of Grand Duke Cosimo I (1587–94) stand out in the background of this outstanding ensemble.

Loggia dei Lanzi

Benci di Cione and Simone Talenti started work on the Loggia dei Lanzi in 1376. In 1381, it was inaugurated as a prestigious venue for civic occasions. Its name originates from the 16th century the *lanzichenecci* (*Landesknechte*), German mercenaries who acted as bodyguards for Cosimo I, were lodged in this building.

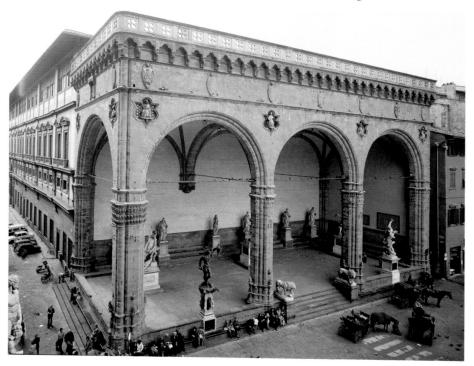

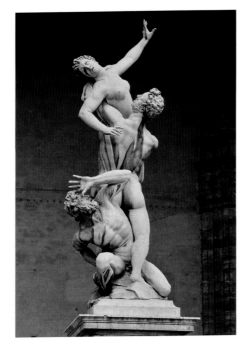

Giambologna: Rape of a Sabine, 1581–83
Marble, h. 410 cm

Giambologna's *Rape of a Sabine* is a perfect exposition of the Mannerist *figura serpentinata*, whereby three figures are linked in a twisted, spiral-like composition. Giambologna was a Flemish sculptor (originally Jean de Boulogne, 1529–1608), who studied numerous ancient works and the work of Michelangelo in Rome. He gradually developed his own approach and

solutions, which went far beyond the Renaissance context, and developed forms of expression which would latter become typical of the Baroque.

Benvenuto Cellini: Perseus and Medusa, 1545–54
Bronze, h. (with socle) 320 cm

Cellini's (1500–1571) reputation as an eccentric is confirmed by his *Autobiography*. Cosimo I commissioned the sculpture of *Perseus* in 1545. Cellini himself adopted Donatello's *Judith and Holofernes* and Michelangelo's *David* as his models and aimed to "thrice exceed" the excellence of both. Work on the sculpture was, however, dogged by dramatic events and setbacks. According to Cellini, the trials and tribulations of the nine years it took to complete the commission almost drove him to his grave. The result, however, is now considered one of the masterpieces of European sculpture. The exquisitely modeled muscular figure of Perseus is a triumphant figure holding high the decapitated head of Medusa, whose glance turned people to stone. Medusa's lifeless body lies at his feet. The figures and socle relief panels (originals in the Bargello) recall the applause the hero receives from the gods Minerva and Mercury for his courageous act.

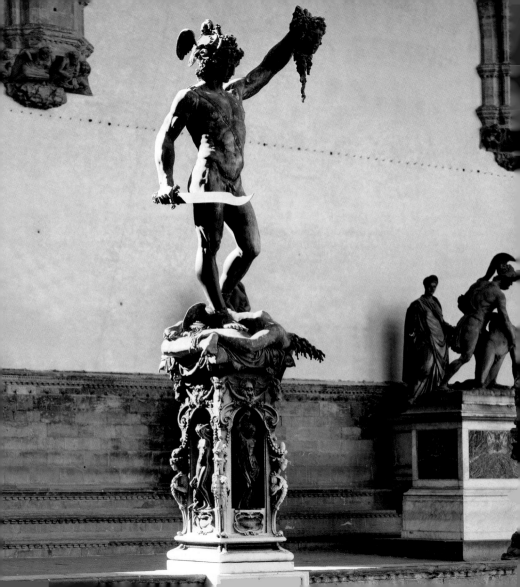

Giorgio Vasari and the Papier-mâché City

Clemente Manenti

At the time of Cosimo the Elder, a game was a game, a party a party, and a funeral a funeral. However, the return of the Medici to Florence in the 16th century marked the time of the great masquerades, the most important of which were held to mark the following occasions: the visit of Pope Leo X (1515); the entry of Emperor Charles V (1536); the arrival of Eleonora of Toledo, wife of Cosimo I (1539); as part of the funeral of Michelangelo Buonarroti (1564); and, finally, the wedding of Johanna of Austria and Francesco de' Medici (1565/66). The city was "masked" on all of these occasions and this process involved the construction of elaborate façades and backdrops, buildings, triumphal arches, monuments, statues of giants, and copies of ancient monuments. These works, which were executed in painted timber, plaster, and *papier-mâché*, were created by the city's most important artists. They were completed in record time and increased in size with each successive event.

The first occasion was a family celebration: Leo X was Pope but he was also the son of Lorenzo the Magnificent, the inventor of the modern carnival. Dozens of artists worked on the decoration of the city. Andrea del Sarto and Jacopo Sansovino covered the façade of Santa Maria del Fiore with painted timber; Antonio da Sangallo erected an octagonal temple in the Piazza della Signoria; Baccio Bandinelli built an imitation of Trajan's Column on the Mercato Nuovo; Rossi built a triumphal arch on the Canto de' Bischeri; and Baja set up a theater near the church of Santa Trinità. The papal procession made its way through arches, and past temples, statues, rivers, and gigantic images of the city. The Pope declared that the city had never looked so beautiful and the event was enjoyed by dignatories and citizens alike.

The formula developed for the first masquerade was repeated for the visit of Charles V on 29 April 1536. The emperor was not, however, a successful member of the de' Medici family but a dreaded foreign aggressor who had besieged Florence, plundered Rome, and humiliated the Medici family twice in different places. To receive Charles V, Florence hid behind a *papier-mâché* mask. The 25-year-old Giorgio Vasari was one of the participating artists on this occasion. In a letter written to Pietro Aretino on the following day, 30 April 1536, Vasari described the emperor's procession and the decorations that adorned the city to mark his visit. The repertoire of ancient mythology was not, of course, a sufficient treasure trove to honor the world conqueror, head of the first empire to reach America. Sea monsters attacked each other on Hercules' columns and replicas of the overthrow of the Incas, the conquest of Tunisia, the arrest of Barbarossa, and the flight of the Turks from the gates of Vienna were all created in the emperor's honor. In addition, the route was lined

with two-headed imperial eagles, seven-headed hydras, winged victory goddesses, gigantic grave inscriptions on false marble – "the letters of which could be read a third of a mile away" – hoards of African, Saracen, and Turkish prisoners, dead *papier-mâché* horses, allegories of the theological virtues (Faith, Hope, and Love), and of Happiness, Fate, Prudence, Justice, Peace, and Eternity. And all this effort was just for one single day.

For Giorgio Vasari, who was already a well-known artist, it marked the beginning of his new career as a director, choreographer, an impresario, historian, and technician of the Florentine masquerades (funded by Cosimo I) during the second half of the 16th century. Vasari was a very talented creator of fashions

Vincenzo de' Rossi (1528–1587): Twins with Cosimo I de' Medici and His Family, Museo degli Argenti, Florence

and trends, not least demonstrated by the fact that it was he who coined the term *Rinascimento*, i.e. Renaissance. He had the full support of Cosimo in this role and was on very close terms with the Grand Duke. With the consolidation of Cosimo's dictatorship, Vasari became the authorized representative of the Medici patronage and he surpassed himself on the occasion of the wedding of the young Duke Francesco to Johanna of Austria. The festivities

began on 16 December 1565 with the arrival of the bride in the city and ended with a large banquet on 23 March 1566. The city was disguised with hundreds of temporary new buildings. There were theater shows, religious ceremonies, fireworks, processions with carnival floats (the triumph of dreams, the genealogy of the gods), and an imitation battle for the conquest of a *papier-mâché* fortress in the Piazza Santa Maria Novella involving

Bernardino Gaffum: Piazza Signoria, Museo degli Argenti, Florence

precise detail. The coffin entered Florence on 9 March 1564 and was initially taken to the Palazzo Vecchio to facilitate completion of the necessary customs formalities. It was then taken to the monastery of the Confraternità dell'Assunta. On the evening of 12 March, the artists from the Accademia del Disegno (the Academy of Painting and Drawing) carried the coffin on their shoulders to the church of Santa Croce where Michelangelo's father had been laid to rest. The funeral bier was followed by a long procession of Florentine artists and other personalities, approximately one thousand people, each of whom carried a burning torch. The general public was excluded up to this point. Preparation for the extensive festivities in honor of the great man started in Santa Croce the day after the funeral. A committee had been set up to organize the event comprising two painters and two sculptors, namely Vasari, Cellini, Bronzio, and Ammanati, along with Borghini who had just set up the Accademia del Disegno. Benvenuto Cellini immediately fell out with Vasari and withdrew. The ceremony was postponed several times and was eventually held on 14 July 1564 in the church of San Lorenzo where the master's most important Florentine works and fully preserved remains were kept. Grand Duke Cosimo, who was now living in Pisa, did not participate in the

hundreds of horses and some two thousand people. This was the biggest performance ever staged by a ruling house in the city.

Michelangelo Buonarroti died in Rome on 18 February 1564. The removal of his remains and his funeral were state occasions in Florence. Cosimo had tried in vain to entice Michelangelo back to Florence to complete the work on the family mausoleum in the church of San Lorenzo. Shortly before Michelangelo's death, Cosimo had requested some of his confidants in Rome to watch the artist closely and in the event of his sudden demise to do all in their power to obtain possession of his artistic legacy. When news of his death reached Florence, the duke expressed the wish that the master finally be brought home with all of his papers. In the second edition of his *Lives of the Artists*, Vasari describes the transportation of the body and the funeral in

festivities. The decorations prepared by the committee with the help of some six other artists consisted of an elaborate catafalque, over which towered a large globe-crowned pyramid which culminated in the allegorical figure of Fame. The lower part of the catafalque contained a series of oil paintings and frescos depicting scenes from Michelangelo's life, each of which also included a patron from the house of Medici. The catafalque was over 54 feet (16.5 meters) high and comprised a total of 13 statues, 15 paintings, and some low relief panels with allegorical images. It was originally planned to exhibit the structure in the church for at least one year but owing to the funeral of Emperor Ferdinand, which was held in the church on 21 August 1564, it had to be dismantled earlier.

Giorgio Vasari: Monument to Michelangelo, Santa Croce, Florence

Palazzo Vecchio

The Palazzo Vecchio is one of the most important secular buildings in the city of Florence. The foundation stone was laid in 1299 on the basis of plans by Arnolfo di Cambio, and in 1314 the city's governing council, the guild leaders (*Priori*), and most senior justices (*Gonfaloniere della Giustizia*) were able to take office there. The different names by which this building came to be known at different times, i.e. Palazzo del Popolo, Palazzo della Signoria, Palazzo del Priori, and Palazzo Ducale, reflect the changes in its use and architectural history down through the following centuries. In addition to a museum, parts of the city administration are still accommodated here today. In architectural terms, the

cubic structure is characterized mainly by its fortress-like exterior. The external walls are of rusticated masonry crowned with a crenellated gallery resting on brackets. The asymmetric position of the 308-feet-high tower (94 meters) on the main façade was dictated by the integration of an existing medieval tower in this position.

The inner courtyard

The medieval inner courtyard was redesigned by Michelozzo around the mid-15th century. His harmoniously proportioned arcades were richly decorated on the occasion of the wedding of Francesco I

to Johanna of Austria. The walls are decorated with vedute of numerous cities from the bride's family's sphere of influence, the columns and pillars were adorned with gilded ornaments, and arches decorated with grotesque motifs. The putto with dolphin on the central fountain is the copy of an original by Andrea del Verrocchio which is now stored in the building.

The Sala dei Cinquecento

The Sala dei Cinquecento, which was added to the Palazzo Vecchio to accommodate the Council of Five Hundred, installed by Savonarola on the basis of the Venetian model as the city's most important political institution, is the most impressive interior space in the Palazzo Vecchio. Leonardo and Michelangelo originally produced their famous but unfinished draft paintings of the battles of Cascina and Anghiari for the walls of this room. The design of the room as we see it today is mainly the work of Giorgio Vasari and it is now considered to be one of the main works of Mannerism. The ceiling paintings depict important events from the history of Florence; the enormous battle paintings on the walls – also the work of Vasari – recall the military successes of Florence over Pisa and Siena. Of the sculptures, Michelangelo's allegorical figure of *Victory* (central south niche) is particularly worthy of note.

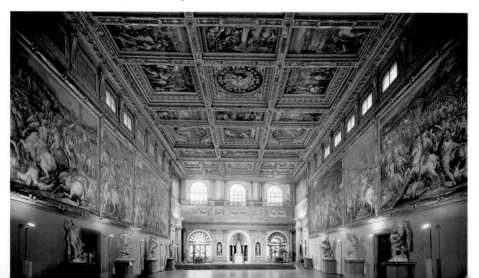

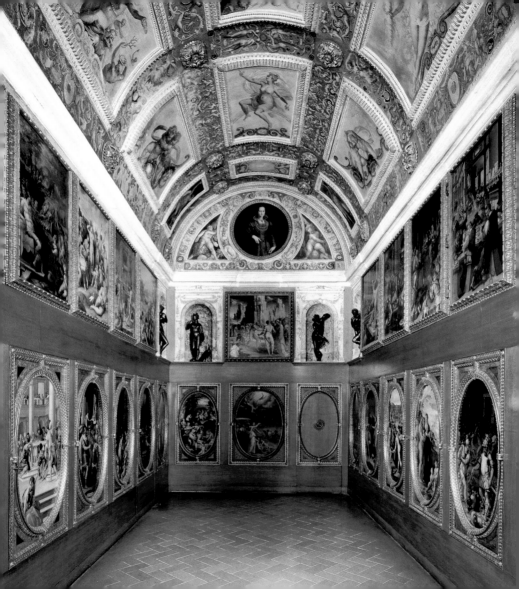

The Studiolo

The project for the decoration of this extraordinary study for Francesco I was once again carried out under the direction of Giorgio Vasari. The barrel-vaulted room, which has concealed doors and no windows, has the distinct feel of a treasure chamber or vault. The entire concept is clearly an embodiment of the *maniera* or Mannerist style. The interior reflects a particular interest in the sciences, alchemy, and art. The cycle of paintings on the walls (various artists), which is based on a highly intellectual iconographic program, includes representations of the four elements of water, earth, fire, and air. As the effective forces of nature, these elements are related here to the microcosm of human existence, reflecting a cosmological world-view. In addition to treasures and collections of various precious commodities such as diamonds, mineral stones, and outstanding works in gold, the wall cupboards also stored numerous devices which the master of the house used to pursue his passion for scientific experiments in candle-lit isolation.

The Sala degli Elementi

The Quartiere degli Elementi (Apartment of the Elements) occupies five rooms and two loggias on the third story of the palace. The rooms were commissioned by Cosimo I and the work was carried out by Battista del Tasso. After the latter's death, Vasari, who was making his debut for the Medici, took over the project. With their depiction of the "heavenly gods" the paintings make direct reference to the Sala Leo X on the floor directly below it. The latter was furnished with works celebrating the members of the Medici family, in other words the "earthly gods."

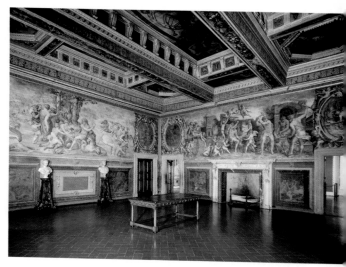

The Loggia del Saturno

The open Loggia del Saturno presents a breathtaking view of the Arno river valley and the landscape to the southeast. The terrace takes its name from the ceiling paintings executed by Giovanni Stradano on the basis of plans drawn up by Vasari, with a depiction of Saturn embracing his children at the center.

The Sala dell'Udienza

Court proceedings and meetings of the ruling council, the so-called *Priori*, were originally held in the Sala dell'Udienza (Audience Hall). Just as in the adjacent Sala dei Gigli – the two rooms were separated during the 1470s – the oldest elements of the building's interior decoration are preserved here.

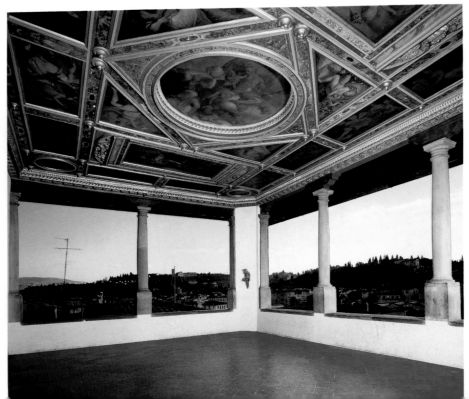

The richly decorated coffered ceiling (1470–76) is attributed to Giuliano da Maiano. Together with Benedetto da Maiano, he also designed the marble surround for the door. The wall frescos were finally completed around the middle of the 16th century by Francesco Salviati (1510–1563). The latter originally came from Florence but he was trained as an architect primarily in and around the Raphael school in Rome. Salviati soon made a name for himself as a specialist in large-format fresco decorations. Hence, the murals in the Sala dell'Udienza are predominantly based on Roman models and are not at all typical of the Florentine style. This hall also contains a depiction of scenes from the life of the Roman commander Furius Camillus, based on the text of the ancient philosopher and historian Plutarch.

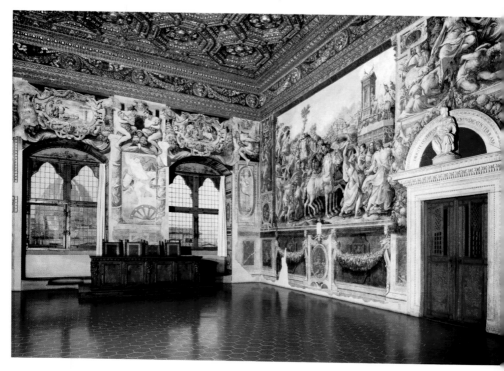

The Sala dei Gigli

The illusionist design of the fresco on the main wall of the Sala dei Gigli (The Lily Room) is the work of Domenico Ghirlandaio and his studio (1482–84). The fresco shows St. Zenobius, the first patron of the city of Florence, with important Roman thinkers and statesmen on each side.

The lily decoration, after which the room is named, is a reference to the traditional good relations between Florence, the French throne, and the house of Anjou whose coat of arms also features the lily.

Donatello: Judith and Holofernes, ca. 1455
Bronze, h. (without socle) 236 cm

Judith and Holofernes was transferred to the Sala dei Gigli in the Palazzo Vecchio after many years of restoration work. The ageing Donatello originally completed the life-size bronze sculpture around 1455 as a fountain figure for the inner courtyard of the Medici palace. After the second expulsion of the Medici from the city, the sculpture found its way into the Piazza della Signoria. As a result of an inscription added at this time, the *Giuditta* came to represent an exemplary embodiment of the free republican spirit to the Florentines.

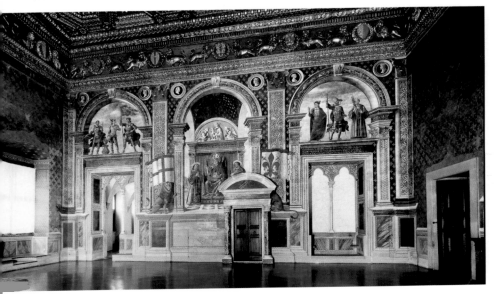

Like her masculine counterpart David in his fight against Goliath, Judith freed her home town Bethulia from the claws of a reputedly strong and powerful tyrant. She hid in the camp of the enemy commander Holofernes the night before the threatened overthrow by Nebuchadnezzar's army, which was camped just outside the town gates. When Holofernes fell asleep, overcome by drunkenness and lust, she beheaded him with his own sword. Deprived of their leader, the Assyrian troops immediately fled.

In Donatello's complex sculpture, the biblical heroine appears as the embodiment of Christian virtue which triumphs over the vices of *Superbia* (Pride, Arrogance). The muscular body of Holofernes is completely drained of its strength and would collapse in on itself if Judith were not holding up his head. The tender features of the slender female figure are clearly contrasted with the rawness of the tyrant. At once triumphant and pensive, Judith raises the sword to kill her adversary. The sculpture seems to capture this precise moment of contemplation and dialogue with God. The episode is described in the Bible as follows: "She approached the bed, grasped his hair and spoke 'Give me strength dear God of Israel on this day' and she struck the neck twice with all her might."

Niccolò Machiavelli

In his infamous treatise *Il Principe* (*The Prince*), Niccolò Machiavelli (1469–1527) gives a chilling account of the mechanisms and necessities of successful royal leadership. In order to promote his own interests, the prince must combine the characteristics of the fox and the lion and always allow for the possibility of deceit, hypocrisy, and fraud in his political calculations. Machiavelli also recommended that the prince should not shy away from a reputation for cruelty, as unyielding severity is the only guaranteed means of earning the respect of his subjects. Such cynical suggestions soon earned the author the reputation of a cold-hearted and plotting champion of unscrupulous power politics when his work was first published posthumously in 1532. The cliché of the almost diabolical cynic, devoid of all conscience who puts unconditional reasons of state before all moral-ethical principles, quickly became synonymous with the name Machiavelli. And beyond politics, the pejorative term "Machiavellian" is still used today to depict an utterly self-serving way of thinking and acting, the ultimate purpose of which is personal gain.

A less superficial consideration of his life, which takes into account the time and context of his work and his comprehensive literary legacy, shows just how far removed this notion really is from the historical achievements and character of Niccolò Machiavelli. The son of a notary, Machiavelli was born in 1469 and grew up in the Florence of Lorenzo the Magnificent. Reliable information about his career is not available until 1498 when the Medici had already been expelled from Florence for four years and Machiavelli was elected to the office of secretary to the *Consiglio dei Dieci* (Council of Ten) in his native city, a few weeks after the execution of Savonarola. He would hold this office for 14 eventful years and become the close confidant of Piero Soderini, the leader elected as a lifetime ruler of Florence. As council secretary, Machiavelli's tasks no longer simply involved military organisation and administration, for he also participated in numerous diplomatic missions which brought him to the courts of the most important leaders of his time. The notes and dispatches in which Machiavelli recorded his impressions during these journeys reveal not only the acute observational skills and analytical brilliance which would characterize his later writings, but also the passion with which he pursued his political tasks.

As a result of the turbulent events of the year 1512 which wittnessed the return of the Medici family to Florence after 18 years of banishment and the overthrow of Soderini's government, Machiavelli's active political career came to an

Tito di Santi: Portrait of Niccolò Machiavelli, Palazzo Vecchio, Florence

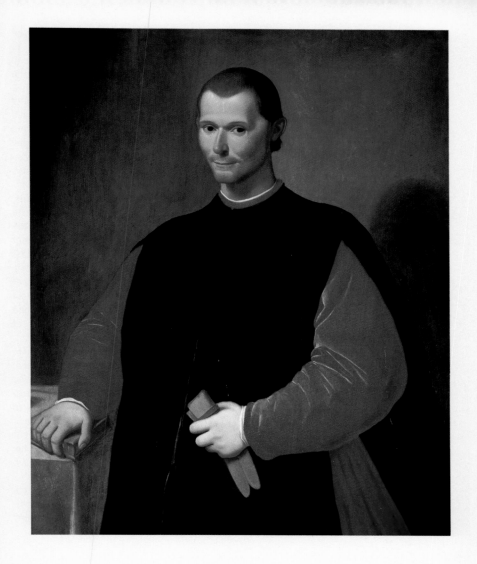

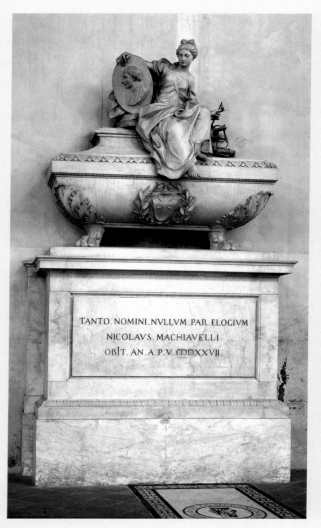

TANTO.NOMINI.NVLLVM.PAR.ELOGIVM
NICOLAVS.MACHIAVELLI
OBIT.AN.A.P.V.CIƆIƆXXVII.

abrupt end. In the company of "rats as big as cats and lice as big as butterflies" he found himself imprisoned under the charge of conspiracy against the Medici. The invalidation of the charge resulted in his quick release from prison but there would be no rehabilitation for the loyal servant of the former republican state.

Stripped of his offices, Machiavelli was forced to withdraw with his family to the estate he had inherited near San Casciano. Driven to despair by the threat of poverty and depressed by the futility of an existence far removed from all political life, he complained of his difficult existence at length in letters to friends.

His ongoing attempts to regain access to political office and tasks remained largely fruitless to the end of his days. However, thanks to this tragic caesura in the life of Niccolò Machiavelli brought about by the events of 1512, his successors can now enjoy the

Innocenzo Spinazzi: Tomb Monument of Niccolò Machiavelli, 1787, Santa Croce, Florence

literary legacy, to which he dedicated himself out of necessity in his involuntary exile, and on which his enduring fame is based.

He wrote his most famous work *The Prince* in just a few months. On finishing it in 1513, he immediately started work on *Discorsi*, his considerably broader considerations on politics and leadership. Working on the pessimistic premise that man is fundamentally bad, in both works – considered to be masterpieces of political writing – Machiavelli shows that he was a realist whose attention was completely focused on the necessities of this world. While he did not deny the canon of religious values handed down since the Middle Ages, he substituted it with passionate pragmatism in the area of political action. His main priority was always the preservation of the freedom of his native city and fatherland, the threat to which he had experienced directly. The eight-volume work recounting the history of the city of Florence, which Machiavelli handed over to Pope Clemens VII two years before his death in 1525, was to be informed by this principle. The work, which is excellent with respect to both its stylistic quality and the clarity with which this complex and comprehensive topic is approached, forms the basis of Machiavelli's reputation as a trailblazer of modern history writing.

Machiavelli also earned a particular reputation among the 16th-century Italian literati with his comedy *La Mandragola* (*The Mandrake Root*), considered one of the most original comedies of the Renaissance. In addition to a series of minor verse and novellas, this comedy bears witness to the extraordinary poetic talent of the *uomo politico* Niccolò Machiavelli.

Niccolò Machiavelli: Discorsi (c. 174, p. 88), ink on paper, Biblioteca Nazionale, Florence

The Uffizi Gallery

The Uffizi Gallery houses one of the most fascinating and famous art collections in the world. The name (*ufficio* = office) still refers to the fact that the building was originally commissioned by Cosimo I as a central office for the city administration. Giorgio Vasari took over as its chief architect in 1559. Because of the selected topographical position, right next to the prestigious Palazzo Vecchio, Vasari had to deal with a variety of problems. Proximity to the River Arno meant static problems owing to the poor load-bearing capacity of the soil, whilst the spatial restrictions of the site necessitated certain aesthetic compromises. In addition, a number of older buildings had to be demolished or, in some cases, integrated into the new structure. Hence, Vasari's plan gave rise to an elongated, street-like inner courtyard. After Vasari's death in 1574, the architects Bernardo Buontalenti and Alfonso Parigi took over the project. The design of the façades was dictated less by the architectural features of the interior spaces than by concerns of proportion and spatial design based on architectural theory. The tension between the strong horizontal emphasis of the building and its extreme height is a typical feature of Mannerist architecture.

The Arno side

The Uffizi Gallery has been converted and renovated many times, not just in the aftermath of the shocking bomb attack in 1993. Almost 40 million US dollars will have been invested in the "New Uffizi" by the year 2001. Much of the Gallery is now being redesigned and the exhibition area will be tripled to ca. 215,000 square feet (20,000 m²). Treasures which were previously in storage will be accessible to the public, making a visit to the Gallery even more worthwhile for the one and a half million annually.

The second and third corridors

The decision to accommodate the Medici family's extensive art collection in the upper story of the Uffizi dates back to Francesco I, son of Cosimo I. After the completion of the building he had the upper corridor, originally intended as an open loggia, roofed over. The light-flooded corridors were then used as gallery rooms for displaying the works of art. In addition to valuable tapestries, parts of the sculpture collection are now housed in this section of the Gallery.

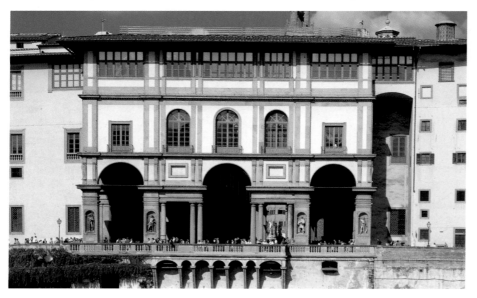

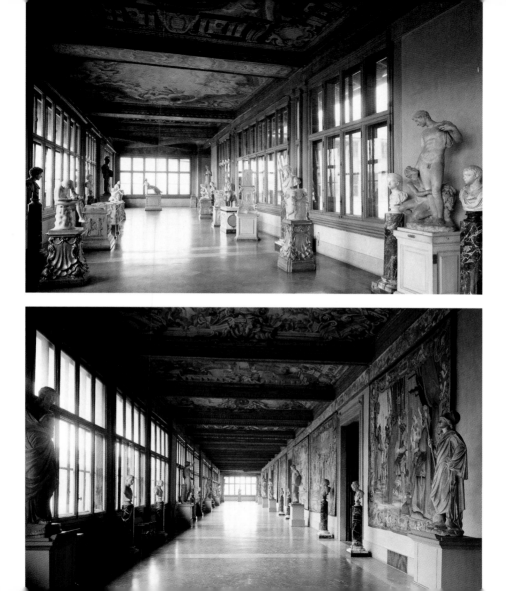

Corridoio Vasariano

The corridor that connects the Uffizi (and Palazzo Vecchio) via the Ponte Vecchio to the Palazzo Pitti on the opposite bank of the Arno is an outstanding feat of urban design. After a construction period of only five months, Giorgio Vasari completed the famous corridor as commissioned by Cosimo I. It was inaugurated as part of the celebrations to mark the wedding of Grand Duke Francesco de' Medici to Johanna of Austria in the autumn of 1565. Until 1866, use of the corridor was private and restricted to members of the ruling Medici and Lotharingian dynasties: they probably intended to use it as an escape route in the event of an attack.

Today, the Corridoio Vasariano, which is over 3280 feet (1000 meters) long, houses a collection of important paintings for which alternative accommodation could not be found in the actual Gallery. In addition to numerous 17th- and 18th-century masterpieces, most of the unique collection of artists' portraits started by Cardinal Leopoldo de' Medici are exhibited in the corridor. In addition to Italian masters, including Raphael, Andrea del Sarto, Guido Reni, and Salvatore Rosa, the collection includes portraits of numerous foreign painters from various eras.

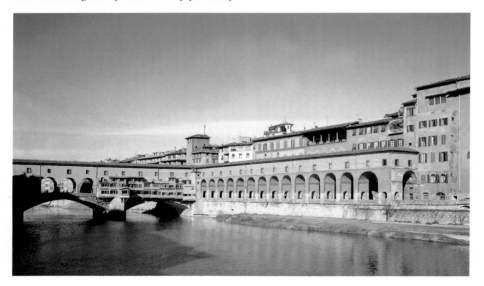

13th-Century Tuscan Art

Duccio di Buoninsegna:
The Rucellai Madonna, 1285
Tempera on wood, 450 x 290 cm

The three monumental panels of the Virgin in the second room of the Gallery give the visitor a unique opportunity to compare directly the work of three of the most

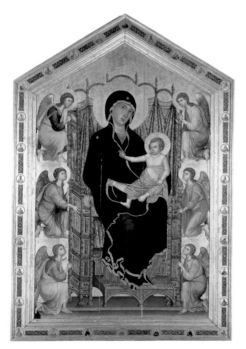

prominent masters of Sienese and Florentine painting from 1300. The fascination of Duccio's throned Madonna, which is named after its original location in the Capella Rucellai in Santa Maria Novella, lies in its almost melancholy beauty. A refined Gothic flow of line, as seen for example in the gold seam of the Virgin's cloak, takes precedence over spatial verisimilitude.

Cimabue: Santa Trinità Madonna, ca. 1280
Tempera on wood, 385 x 223 cm

As in the work of Duccio, the work of Giotto's teacher Cimabue shows clear points of contact with the Byzantine artistic tradition. However, there is a hint of a development in perspectivist reproduction in the throne architecture The stepping of the angels is a reflection of the heightened corporeality in the Virgin figure.

Giotto di Bondone: Ognissanti Madonna, ca. 1310
Tempera on wood, 325 x 204 cm

In Giotto (ca. 1266–1337) we find an outstanding master who introduced a whole new era in painting. The spatial organization of his *Ognissanti Madonna* betrays an interest in realistic three-dimensional representation. With her bent knees clearly visible under her robe, Mary sits credibly poised, a monumental figure on her baldachin throne. The previous application of two-dimensional linear composition is replaced by the presentation of clear solid volumes. The faces and materials of the robes are modeled in finely graduated color.

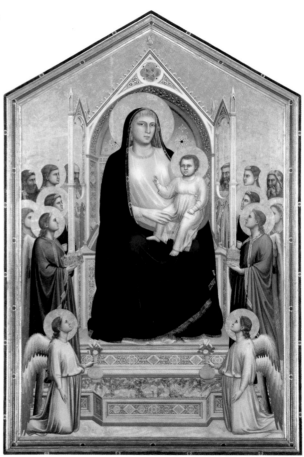

14th-Century Sienese Art

Simone Martini: Annunciation with Two Saints, ca. 1333
Tempera on wood, 184 x 210 cm

This painting of the Annunciation by Simone Martini (ca. 1290–1347) is one of the masterpieces of 14th-century Sienese painting. The sumptuous large-format altarpiece was painted for the Ansano altar in Siena Cathedral. Martini was assisted by his brother-in-law and pupil Lippo Memmi. The two saints flanking the central panel are attributed to the latter. In the depiction of the two main figures, the liberal use of gold is combined with a clear

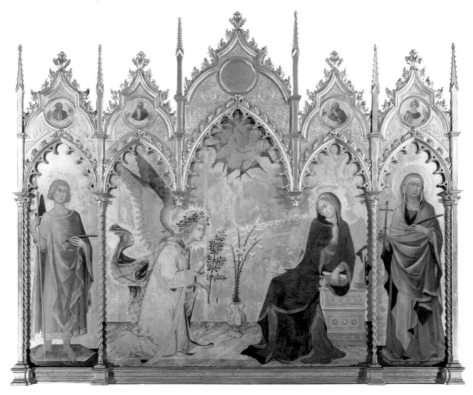

refined touch that fully reflects the Gothic sensibility. The clear outlines of the robes betray a sharp and subtle sense of line and the skillful balance in the figures' gestures and corresponding movements lends the scene its unique atmosphere. It would appear that Martini intended to make the transcendence of the event into the actual subject of the painting. Just as the birth of Christ would mark the transformation of God into man, in this outstanding depiction of the Annunciation, the bringing of the news to Mary by the archangel Gabriel is lifted up to a level of timeless metaphysical significance. The visibly shocked Virgin shrinks back from the prostrate angel who speaks the words "the Lord is with thee" (Luke, 1:26-38).

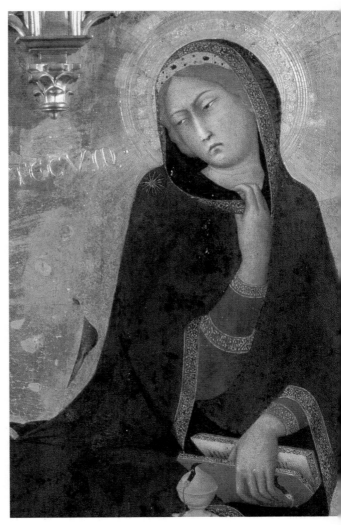

The Uffizi Gallery

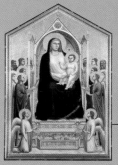

13th-Century Tuscan
Painting, p. 124

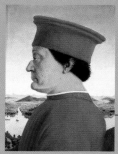

Early Renaissance, p. 137

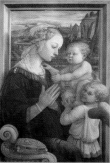

The Filippo Lippi Room,
p. 139

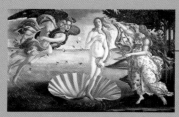

The Botticelli Room, p. 148

Other rooms

1 Archeological Room – Ancient Sculpture
2 14th-Century Sienese Painting
3 14th-Century Florentine Painting
4–5 The International Gothic Room
6 The Map Room
7 The Hermaphrodite Room
8 15th-Century Venetian Painting
9 Dutch and German Painting
10 The Emilian Painting Cabinet
11 The 16th-Century Corridor
12 The Niobe Room
13 The 18th-Century Painting Room

Loggia dei Lanzi

The Caravaggio Room, p. 187

Gentile da Fabriano: Adoration of the Magi, 1423

Tempera on wood, 303 × 282 cm

Gentile da Fabriano was one of the main masters of the International Gothic, the so-called "courtly style." His painting of the *Adoration of the Magi* was created for the Strozzi family chapel in the church of Santa Trinità in 1423. Palla Strozzi who commissioned the painting was one of Florence's most affluent citizens at the time and this is reflected in the extensive use of expensive materials and the expressly requested artistic variety in the depiction of the figures and landscape. The Adoration scene at the feet of the Holy Family is depicted to the front left of the painting while the train following the three wise men stretches far back into the landscape and almost disappears over the horizon.

The Leonardo da Vinci Room, p. 156

The A. Pollaiuolo Room

The Correggio Room

3 4 5

6

1 2

7 8 9 10

Piazzale degli Uffizi

13 12 11

The Rubens Room

The Tintoretto Room

0 20 m

The Veronese Room

Flemish and Dutch 17th-Century Painting, p. 190

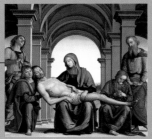
Perugino and L. Signorelli, p. 159

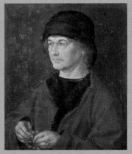
The German Room, p. 164

Michelangelo and Early 16th-Century Florentine Painting, p. 171

The Titian Room, p. 178

The Parmigiano Room, p. 181

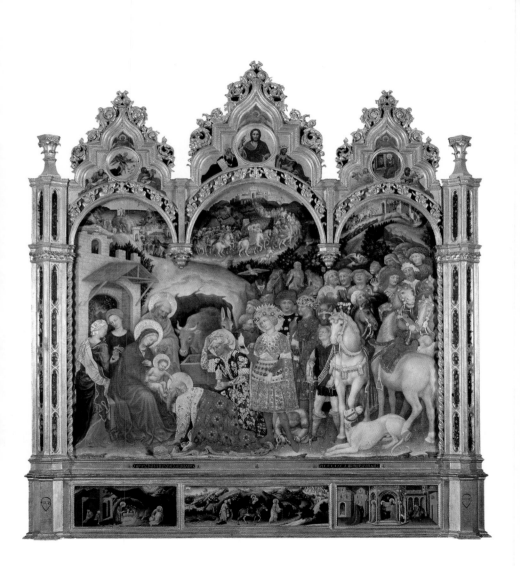

The Early Renaissance Room

Paolo Uccello: The Battle of San Romano, ca. 1456
Tempera on wood, 182 x 323 cm

The painting of the battle of San Romano was originally part of a three-part cycle whose right and left panels are now kept in the Louvre in Paris and the National Gallery in London.

Cosimo de' Medici (known as *il Vecchio*) commissioned Paolo Uccello, one of the most eccentric and individualistic Early Renaissance Florentine painters, to do this painting in 1456. The theme of the painting recalls the military victory of the Florentine army over the united forces of Milan and Siena near San Romano in 1432 under the command of Niccolò da Tolentino, in whose memory Cantagno's equestrian portrait in the cathedral was aslo painted.

In an inventory of the year 1598, the depicted event was identified merely as a "scene from an ancient tournament." This error is due not least to the fact that the credible portrayal of an actual battle is overshadowed in the painting by the extreme artificiality of the composition which lends a strong impression of sur-reality to the entire painting.

Paolo Uccello (1397–1475), whose "sole delight" according to Giorgio Vasari "lay in musing over some difficult and impossible problems of perspective," pushed every

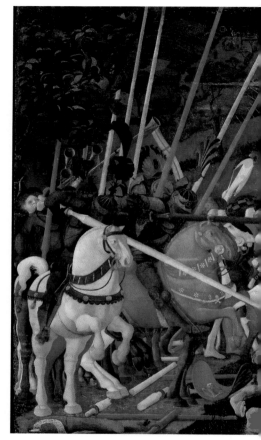

detail in the painting to a level of originality bordering on abstraction. The soldiers' broken lances are strewn on the ground to form a perspectivist linear network. The soldiers, who are rendered in

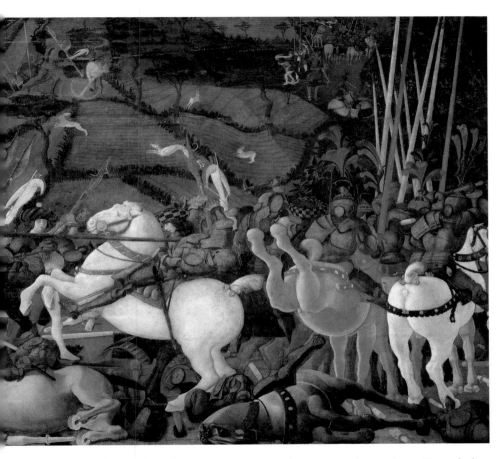

rather unrealistic colors, have a puppet-like quality. Similarly, the horses look more like rocking horses than real animals, giving the distinct impression that the artist may well have used such models to study new angles and positions before introducing them into his painting.

Piero della Francesca: Double Portrait of Federico da Montefeltro and His Wife Battista Sforza (backed with allegorical triumphs of the rulers), ca. 1465–72

Tempera on wood, each 47 x 33 cm

Piero della Francesca (ca. 1416/17–1492) was born in the small town of Borgo Sansepolcro near Urbino, but his artistic development led him to Florence at an early stage and his increasing reputation resulted in his being employed at some of the most important Italian courts of his day. His work is characterized by a deep intellectual preoccupation with general issues of art, mathematics, and geometry which he also explored in his theoretical treatises *De Prospectiva Pingendi* (*On Perspective in Painting*) and *Libellus de Cinque Corporibus Regularibus* (*Notebook on the Five Regular Bodies*).

The stark realism, use of color, and subtle landscape depicted in the background of this unusual portrait of the

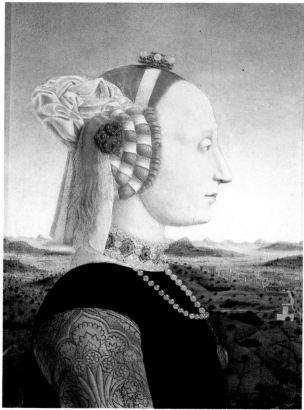

ruling couple of Urbino reveal that Piero della Francesca was familiar with contemporary Flemish painting. Federico is portrayed with facial warts and a characteristic aquiline nose. His portrait was probably completed as early as 1465, while that of his wife, who died in 1472, was painted posthumously. In accordance with the fashion of the time she is also presented in profile with a shaved forehead. The panorama-like landscape in the background with hills and plains, fading into the diffuse light on the horizon, corresponds to the area around Urbino which was ruled by the Montefeltro family. On the backs of both portraits there are miniature versions of allegories of a triumphant procession by the ruling couple in which Federico is depicted as the commander and Battista as the embodiment of marital virtue.

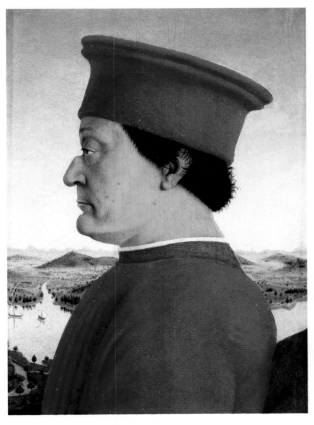

CLARVS INSIGNI VEHITVR TRIVMPHO ·
QVEM PAREM SVMMIS DVCIBVS PERHENNIS ·
FAMA VIRTVTVM CELEBRAT DECENTER ·
SCEPTRA TENENTEM ·

Domenico Veneziano: Madonna and Child with Sts. Francis, John the Baptist, Zenobius, and Lucy (St. Lucy altarpiece), ca. 1445
Tempera on wood, 209 x 213 cm

Domenico Veneziano's (ca. 1400–1461) panel painting is illuminated by the shimmering light which envelopes his native city of Venice. The falling daylight throws shadows, allows the distinction of fine variations of color, and surrounds the saints in an atmosphere of magical harmony. The Venetian features of the painting, e.g. the color, are combined here with a typical Florentine sobriety in the composition.

The Filippo Lippi Room

Filippo Lippi: Madonna with Child and Two Angels, ca. 1460
Tempera on wood, 92 x 63 cm

Fra Filippo Lippi (1406–1469) gives his painting of Mary with the baby Jesus and two angels an unusual atmosphere which lies somewhere between merriment and silent contemplation. The mother of God is depicted with distinctly attractive, girlish features in half-profile in front of an unusual window frame. The artist chooses to ignore the biblical context and dresses her in an elegant blue dress and an elaborate bejeweled headpiece based on the contemporary fashion. Her hands are folded in prayer while her son reaches out to touch her. The contemplative expression on her face probably refers to the future Crucifixion of Christ, indicated in the mountain in the background (Golgotha). In contrast, the mischievous smile of the angel at the front of the painting is probably associated with the joyous event of the arrival of the Savior.

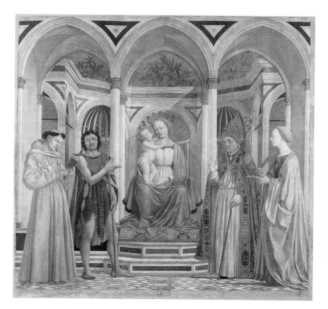

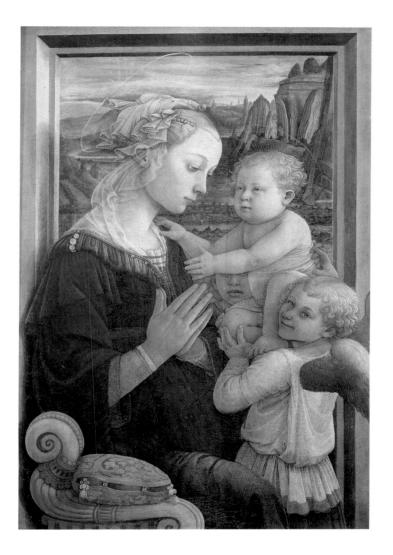

The Antonio del Pollaiuolo Room

Sandro Botticelli: Judith's Return from the Enemy Camp, ca. 1470
Tempera on wood, 31 x 24 cm

This small panel is an exquisite example of Botticelli's (1444/45–1510) outstanding ability as a draftsman. Indeed, in his early work, linear precision and grace often took precedence over thematic exploration. Judith strides ahead with her gown billowing while her servant skips behind her bearing the decapitated head of the enemy commander Holofernes.

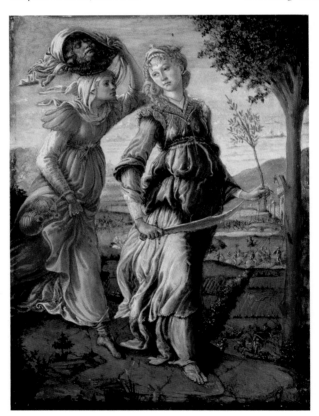

Piero Pollaiuolo: Moderation (La Temperantia), ca. 1469
Tempera on wood, 167 x 88 cm

The Florentine guild of traders and businessmen commissioned the brothers Piero and Antonio Pollaiuolo to complete six allegorical paintings of the virtues. The cycle was completed with Botticelli's depiction of Bravery (*Fortitudo*). These large panels were transferred to the Uffizi in 1717 from the council chambers of the commercial court for which they were commissioned. Piero Pollaiuolo provides a particularly apt symbol for the virtue of *Temperantia* (Moderation) in the mixing of water with wine.

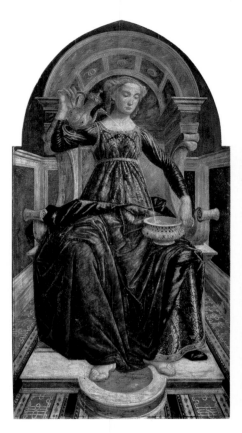

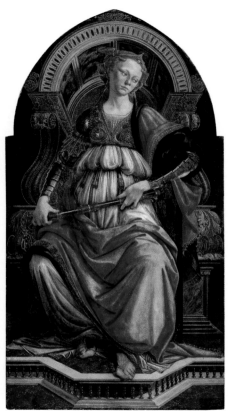

**Sandro Botticelli, Fortitude (La Fortezza),
ca. 1470**
Tempera on wood, 167 x 88 cm

The allegory of Fortitude is one of the earliest
assured works of Botticelli, who was 25 years
old when he painted it. The woman, who is
dressed in armor and wielding a staff, is the
embodiment of Fortitude. These martial
attributes contrast strikingly with the
melancholy evoked by her wistful expression
and slightly inclined head.

sculptor. The ninth room of the Uffizi Gallery is named after him and contains both of these remarkable Hercules panels which are, presumably, small replicas of far bigger canvases, now lost, which the painter completed for Piero de' Medici.

As the son of Gaia (mother earth), the giant Antaeus gained his incredible strength by merely touching the ground. Hercules managed in overwhelm him by lifting him into the air and squeezing him.

Antonio Pollaiuolo: Hercules and Hydra, ca. 1460
Tempera on wood, 16 x 9 cm

According to mythology, Hercules came into being by killing the nine-headed water serpent Hydra. Antonio Pollaiuolo's depiction of the fight betrays the anatomically tutored eye of the sculptor who was here trying to capture the ideal of a dramatically charged figurative representation in painting. "He succeeded in depicting the flexed muscle of the naked body, the wild eruption of physical and psychic life forces, in short the archetype of the human struggle against adverse forces by means of dynamic and tense outlines, periodically infused with passionate force and clarity" (L. Berti).

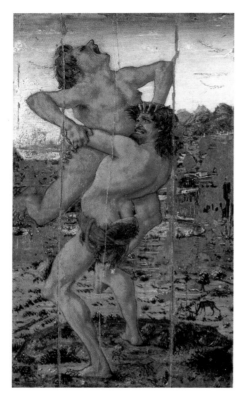

Antonio Pollaiuolo: Hercules and Antaeus, ca. 1460
Tempera on wood, 16 x 9 cm

Antonio Pollaiuolo (ca. 1430–1498), who outshone his younger brother Piero in terms of talent and expressive ability, was also a goldsmith, graphic artist, and

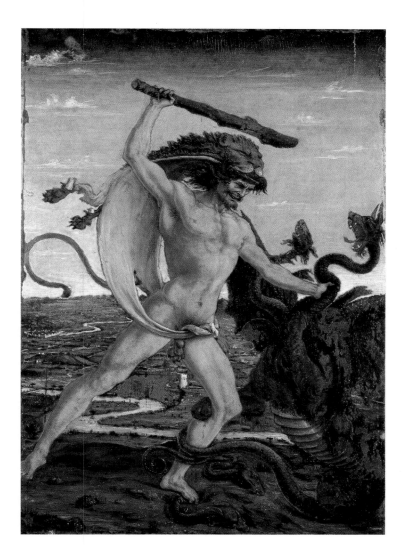

The Florentine Art of Drawing and the "Gabinetto dei Disegni e delle Stampe"

In the early 14th century, Cennino Cennini recommended that all aspiring artists first devote their efforts to perfecting the art of drawing. The art historian Giorgio Vasari referred to the genre of drawing as the "mother

Paolo Uccello: Study of a Goblet, pen and ink on white paper, 29 x 24 cm, Gabinetto dei Disegni e delle Stampe, Uffizi Gallery, Florence

Andrea del Verrocchio: Angel's Head, pen and charcoal on white paper, 21 x 18 cm, Gabinetto dei Disegni e delle Stampe, Uffizi Gallery, Florence

Among the distinctive characteristics traditionally associated with art in Renaissance Florence, the mastery and advancement of the art of drawing is one of the most important. Whereas Venetian artists gained a reputation in every aspect of *colorire* (coloring), the Florentine artists and sculptors can be described as the masters of *disegno* (drawing).

of painting" and deemed it the basis of all artistic activity, including sculpture and architecture.

The considerable number and incomparable quality of drawings by Florentine artists which have survived to the present day are among the most abundant and valuable of the many legacies of Renaissance art. For reasons of restoration and because these fragile masterpieces are very sensitive to light, they cannot be displayed openly for the public and must be carefully stored.

The Gabinetto dei Disegni e delle Stampe in the Uffizi Gallery in Florence holds one of the most important collections of drawings and prints from many centuries. The collection was initiated by Cardinal Leopoldo de' Medici (1616–1676) and now includes far in excess of 100,000 works by Italian and foreign artists.

Sandro Botticelli: Minerva, pen and bister over black chalk, heightened with white, on pink ground, perforated and squared off, 22 x 14 cm, Gabinetto dei Disegni e delle Stampe, Uffizi Gallery, Florence

The Botticelli Room

Sandro Botticelli: Adoration of the Magi, ca. 1475
Tempera on wood, 113 x 134 cm

In this painting, the biblical kings are replaced by members of the Florentine aristocracy gathered to pay homage to the child in front of a ruined timber and stone structure. The most famous members of the Medici family appear at the front. When this picture was painted, their prominence had reached its peak under Lorenzo the Magnificent and bestowed on Florence a golden age for art and society. Thus, the painting is almost a work of homage to the ruling house and the theme is secondary to this purpose.

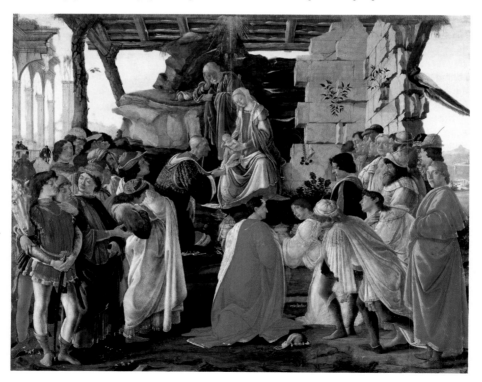

Sandro Botticelli: Pallas and the Centaur, ca. 1485
Tempera on canvas,
207 x 148 cm

This painting on canvas by Sandro Botticelli is also known as the *Medici Pallas* after the probable patrons, who are referred to by the artistic detail of the intricate interlocked ring pattern on the woman's tunic.

The identity of the young woman, however, is disputed. She has been identified variously as Athena (or Minerva), the goddess of wisdom, and Camilla, a virtuous heroine from Virgil's *Aeneid*. In his book *Of Famous Women*, Boccaccio recommended this mythological woman as a model for all brides.

In either case, the picture can be interpreted as an allegory of the triumph of Virtue over Vice. Although the Centaur has a pained, intimidated expression and appears to be begging for mercy, the figure of the beautiful young woman is clearly contrasted with what is actually a lascivious and avaricious creature, half man and half beast and requiring taming through Reason (Athena) or Chastity (Camilla).

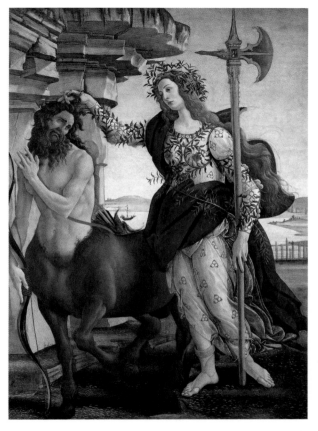

This essential contrast between the two figures is also reflected in the backdrop, which is sharply divided between the highly contrasting creviced cliffs on the left and a tranquil open landscape.

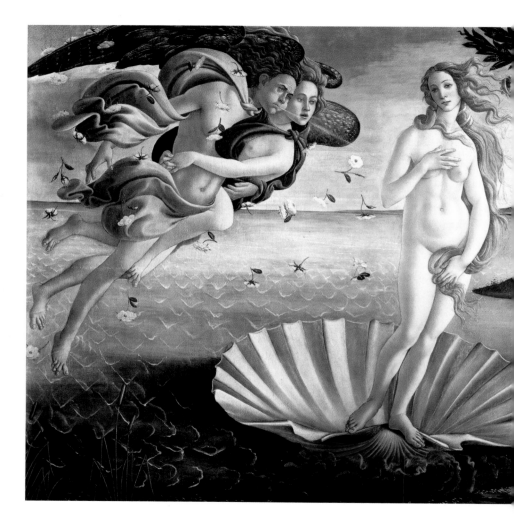

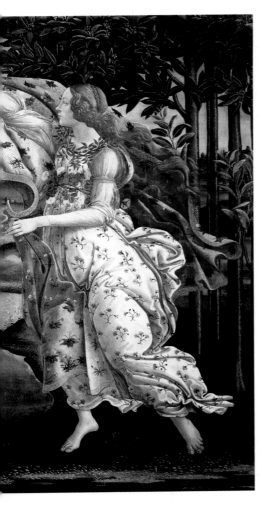

Sandro Botticelli: The Birth of Venus, ca. 1485
Tempera on canvas, 172 x 278 cm

Piero Francesco de' Medici is reputed to have commissioned this painting for his country villa in Castello. The theme of the work is taken from ancient myth and the title by which it is now known is slightly misleading. This painting does not portray the actual birth of Venus but the arrival of the goddess of love on the beach of the island Cythera, as described by the poet Angelo Poliziano (1454–1494) in one of his verses. Venus is presented as the embodiment of consummate beauty arising from the sea waves. Standing on a sea shell, she is driven by the wind gods Zephyrus and Aurora to the shore where a waiting Hour (or nymph) is ready to wrap her in a cloak decorated with flowers. While the wind foams the water, scatters the flowers, and blows through the hair and clothes of the wind and Spring goddesses, Venus herself is presented in statuesque tranquillity in accordance with the model of the ancient *Venus pudica* (modest Venus). While the composition is reminiscent of the traditional Christian image of baptism, the picture is based on an intellectual concept now difficult to understand. It relates to the literary-philosophical efforts of humanism but would ultimately appear to be trying to reconcile Christian and mythological concepts.

Sandro Botticelli:
Spring (Primavera), ca. 1478
Tempera on wood,
203 x 314 cm

Botticelli reveals a fully mature artistic personality in this early painting which takes us into the spring garden of the goddess Venus, who is depicted at the center of the group with one hand raised in a gesture of invitation.

The mysterious picture is probably an allegory of the arrival of Spring as described by the poets Angelo Poliziano and Ovid. The nymph Chloris is being attacked on the right by the wind god Zephyrus. Between them and Venus, dressed in a flower-embroidered garment, stands Flora, the goddess of Spring: Zephyrus will transform Chloris into Flora out of remorse for his violent approach. The three graces who are holding hands in a dancing pose celebrate the beginning of Spring while Mercury, the protector of the garden, drives away the last traces of cloud.

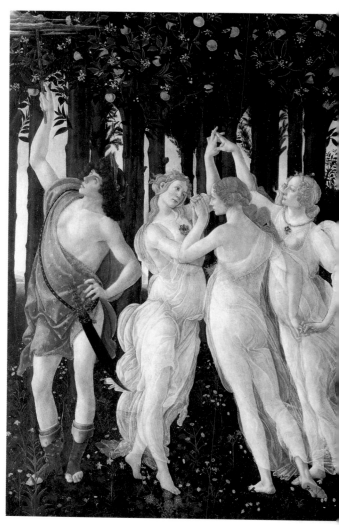

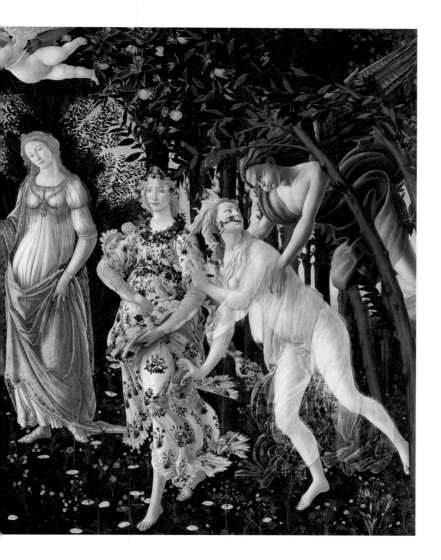

**Hugo van der Goes: Portinari Altarpiece
(central panel), ca. 1475**
Oil on wood, 253 x 304 cm

North of the Alps, 15th-century painting displayed an equally fascinating but completely diverse development. Rogier van der Weyden and Jan van Eyck were among the masters whose fame spread to Italy.

When the altarpiece by Flemish painter Hugo van der Goes (1435–1482) arrived in Florence in the year 1483, it caused quite a sensation among the local artists. Tommaso Portinari, a representative of the Medici bank in Bruges, commissioned Hugo van der Goes to create the monumental altarpiece and had it transported to Florence on completion.

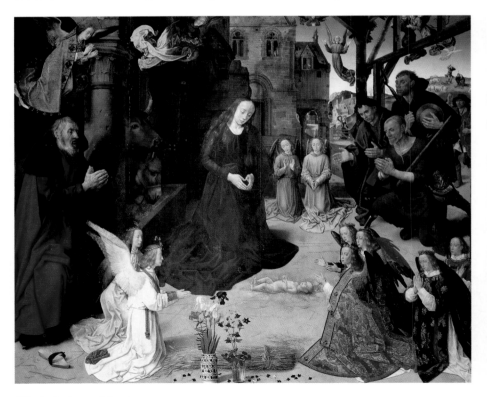

Although the Flemish painter neglected to apply the empirical rules of proportion in this work, favoring the ancient style of perspective whereby the size of the figures reflects their status in the work, van der Goes' Florentine contemporaries had never before seen such extreme and consistent attention to minute detail in the portrayal of natural objects and subjects.

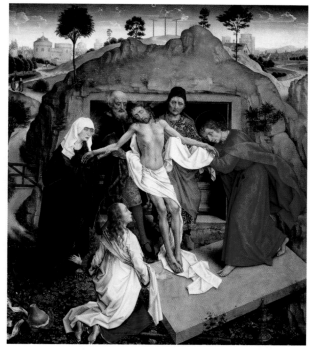

Rogier van der Weyden: Burial of Christ, ca. 1450
Oil on wood, 110 x 96 cm

This work by the Flemish painter Rogier van der Weyden (1400–1464) was originally on show in the Medici country villa in Carregi. Thus, it can be assumed that Cosimo de' Medici commissioned the work. Although the painting most likely originates from the artist's visit to Italy in 1450, and shows obvious similarities to an older predella panel (Alte Pinakothek, Munich) by Fra Angelico, this painting also clearly demonstrates the minutely detailed and uncompromising naturalism which distinguished 15th-century Italian painting from contemporary work north of the Alps.

Deep human emotion is expressed in the splendid portrayals of the faces of the saints who are seen "presenting" Christ's body.

**Andrea del Verrocchio and Leonardo da Vinci:
Baptism of Christ, ca. 1475–78**
Oil and tempera on wood, 180 x 152 cm

Leonardo da Vinci: Annunciation, ca. 1473–75
Oil and tempera on wood, 98 x 217 cm
(double spread next page)

The young Leonardo da Vinci (1452–1519) was trained as an artist in the studio of Andrea di Cione (known as Verrocchio, 1435–1488). This painting of Christ's baptism is widely considered the product of a collaboration by both artists. The master appears to have allowed his talented student to complete substantial parts of the picture. Parts of the background landscape show traits which betray the distinctive hand of Leonardo. The outer angel to the front of the picture, whose tender appearance contrasts sharply with the far more powerful modeling of the faces of Christ and St. John the Baptist, is also attributed to Leonardo.

According to Vasari, Verrocchio – of whom we know only a few works – was so overwhelmed by the superior artistic ability of the young boy that he decided to give up painting: if so young a child already knew more than he, he would no longer waste his time painting. Stylistic differences observed in the Christ figure also indicate the work of a third artist, probably Lorenzo di Credis.

The painting of the Annunciation to Mary was also originally located in the Chiostro San Bartolomeo in Monteoliveto near Florence. Its attribution to Leonardo da Vinci, who could have painted the work in the house of his master Andrea del Verrocchio, is disputed. Some art historians argue that it could not be the sole work of the barely 20-year-old artist who had only been a member of the Florentine artists' guild since 1452.

The angel Gabriel is portrayed kneeling on the left of Mary who is sitting at a lectern, whose elaborate design is accentuated by the architectural corner motif in the background. While the angel is presented as a classical profile figure gesturing to the Virgin, the latter is presented in an almost full frontal view. An interior room with a bed, possibly Mary's bedroom, can be glimpsed through the door on her left.

The simple arrangement of the figures, which follows a typical 15th-century composition plan, contrasts with a number of rather unusual details, by means of which the observer is almost casually offered a most plausible account of the event. The faces, clothing, angel's wings, and above all the magnificent atmospheric background landscape are executed in a most unusual and fascinating manner.

Leonardo da Vinci: Adoration of the Magi, 1481/82
Different materials on wood, 243 x 246 cm

The monks of San Donato a Scopeto commissioned this painting of the Adoration of the Magi. Extensive sections of this large panel still betray the character of a virtuoso drawing as Leonardo interrupted the work at an early stage when he left Florence in 1482 to go to Milan.

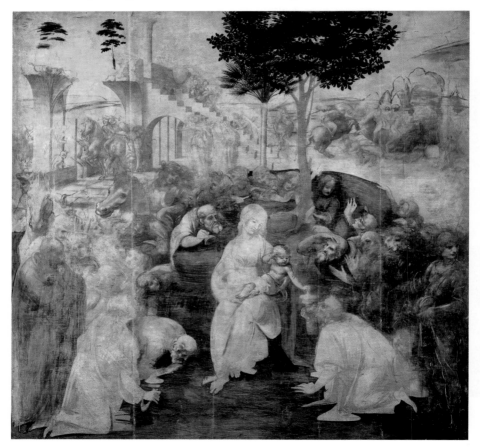

Irrespective of this, the "draft" already demonstrates the characteristics with which Leonardo would greatly enrich the practice of painting in his time and ultimately introduce the period of the High Renaissance. The front of the picture shows the earliest example of a pyramidal composition which is flanked by a number of other groups. There is an endless variety and activity in both the myriad gestures and animated facial expressions of the people gathered at a respectful distance around Mary and Jesus, and also in the design of the complex background. Although the fragmentary nature of the work provides a unique insight into the way in which the artist worked, it is regrettable that Leonardo did not complete this painting.

Perugino: Pietà, ca. 1493
Oil on wood, 168 x 176 cm

Perugino (real name Pietro Vannucci, ca. 1445–1523) was extraordinarily famous during the last decades of the 15th century and was one of Italy's most sought-after painters.

The Mourning of Christ (*Pietà*) in the Uffizi was painted around 1493 when the Umbrian painter was at the height of his creative powers.

The noble figures are characterized by a mystical rapture. The aim of the composition was to achieve a complete balance between the elements in the picture. The defining lines of the simple architectural forms are resumed in the poses and inclination of the heads of the figures. The Virgin stands in front of an arch at the center of the painting while the minimal impression of the background landscape is suggestive of infinity.

The Tribuna

Francesco I de' Medici commissioned Bernardo Buontalenti (1536–1608) to design an ideal gallery room for some special pieces from the Medici art collection. The design and decoration of the Tribuna were based on a cosmological program which honors the ruling house. Multiple references to the Medici coat-of-arms and symbols in the program firmly place the family in the context of a divinely ordained world order. Thus, the room can be interpreted as a symbolical representation of the four elements. A crowning weather vane symbolizes air while the element water is suggested in the mother-of-pearl inlay and blue of the tambour. The walls are covered with a fire-red fabric, while earth is represented by the green tones of the *pietra dura* floor. Buontalenti's idea of indirectly lighting the octagonal central space from above and completely filling the windowless walls with paintings would become a much copied model in museum architecture. Educated travelers would express their enthusiasm for the works of art exhibited here for centuries. The Medici *Venus* sculpture was singled out for particular fame. The figure is held to be a Hellenistic copy of an original by Praxiteles which, even during ancient times, was viewed as one of the most beautiful works of art in the world.

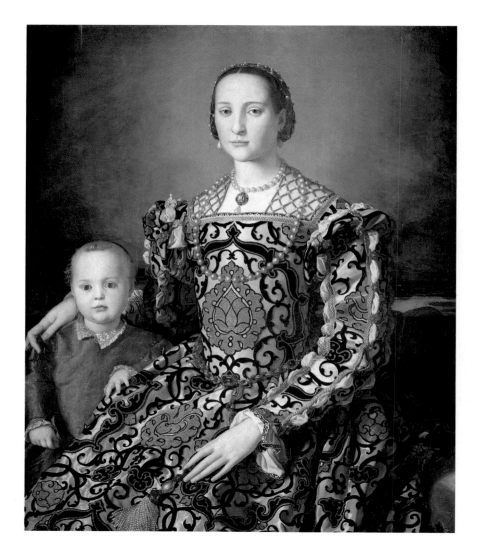

Agnolo Bronzino: Portrait of Eleonora da Toledo with Her Son Giovanni, ca. 1545
Oil on wood, 115 x 96 cm

Agnolo Bronzino (1503–1572) was promoted to court painter and portrait artist of the Medici family during the 1540s. The painting of Eleonora of Toledo and her son Giovanni is a masterpiece of Late Mannerist portraiture and powerfully conveys the typical mid-16th century aristocratic self-image. The stiff, rigid features of the subjects convey no inner emotion and the solemn expressions betray a strong sense of distance and superiority. The pose reflects the formality of courtly etiquette, despite the fact that Eleonora's hand is resting maternally on her son's shoulder. The reproduction of her elaborate dress is an impressive artistic achievement. When her grave was opened in the year 1857, it was revealed that the duchess was also buried in this dress following her early death in 1562.

Agnolo Bronzino: Portrait of Giovanni de' Medici as a Young Boy, 1545
Oil on wood, 58 x 45 cm

Eleonora, the first wife of Cosimo I and daughter of the Viceroy of Naples, bore her husband eight children. Bronzino (1503–1572) immortalized some of the youngest children in a series of touching child portraits.

The little boy in the scarlet jerkin is presumably Giovanni de' Medici who was just 2 years old when this picture was painted. He is holding a small bird in his right hand, close to his chest. His chubby cheeks and hands are still well padded with baby fat. His first two teeth can be glimpsed in his smiling open mouth. Bronzino impressively captures his spontaneous carefree expression of childish joy. The subject's life was, however, a short one: Giovanni de' Medici died at the age of 19 in 1562 of the fever which also killed his mother.

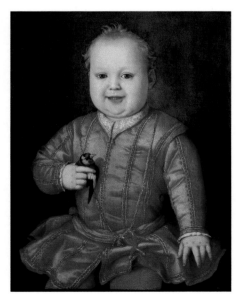

The German Room

Albrecht Dürer: Portrait of Father, ca. 1490
Oil on wood, 47 x 39 cm

Albrecht Dürer senior (1427–1502), the father of the famous painter, originally came from Hungary. Having toured the Low Countries, he reached Nuremberg, Germany, in 1455 and became established there as a goldsmith. This portrait is one of the earliest preserved paintings by his son of the same name, Albrecht Dürer junior (1471–1528). Close observation of this painting reveals the small shortcomings of an immature work. The upper torso appears rather too delicate and the head too big with respect to the narrow shoulders. The face, however, already

betrays an impressive artistic quality which leaves no doubt as to the talent of the young artist. This is an expressive yet sensitive and very detailed portrait of a serious, quiet, and contemplative man whose piety is indicated by the rosary in his hands. The picture conveys a distanced and respectful attitude on the part of the artist, who had probably just reached the age of 19. A portrait of the artist's mother was originally the pendant of this small painting. The family coats-of-arms on the backs of both panels confirm that the paintings were conceived as a pair.

Albrecht Dürer: Adoration of the Magi, ca. 1504
Oil on wood, 100 x 114 cm

This painting is proof of Dürer's interest in the Italian painting of his era, in particular the work of Andrea Mantegna which he had already studied from engravings. The ruins and landscape in the background are executed on the basis of precise perspectivist observations, while the figures in the foreground are rendered in bright colors and have a clearly sculptural quality. The accuracy and volume of detail are typical of works produced north of the Alps.

15th-Century Venetian Painting

Giovanni Bellini: Earthly Paradise, ca. 1485
Oil on wood, 73 x 119 cm

This painting by the Venetian artist Giovanni Bellini (ca. 1430–1516) has often been described as an allegory of purgatory. However, research has never ultimately succeeded in providing a conclusive interpretation of this painting, making it one of the most enigmatic works in the Uffizi collection. The unusually extensive view extends from the terrace at the front to a lake with cliffs and a cityscape in the background. Bellini shows his virtuosity as a colorist in the restrained use of muted color tones which surround the figures with a warm atmospheric light and which subordinate them to the omniscient presence of nature.

The Correggio Room

Andrea Mantegna: Triptych of the Adoration of the Magi, Circumcision, and Ascension, ca. 1466
Tempera on wood,
center panel: 77 x 75 cm;
side panels: each 86 x 43 cm

In 1506, Albrecht Dürer traveled specially from Venice to Mantua to meet Andrea Mantegna (1431–1506), the famous court painter of the Gonzaga royal family. On his arrival, he discovered to his dismay that the painter he greatly admired had recently died. Like Dürer, many other artists of the time were impressed by the extremely powerful work of Andrea Mantegna who translated the developments in 15th-century Florentine painting into a highly individual art form.

The three panels of the Uffizi triptych originate from Don Antonio de' Medici's collection and were probably painted around 1466 when Mantegna visited Florence for a few months. The central panel depicting the *Adoration of the Magi* is lavishly rich in imaginative detail and has an extremely sculptural quality. The brightly colored clothing of the figures distinguishes them clearly from the creviced cliff landscape.

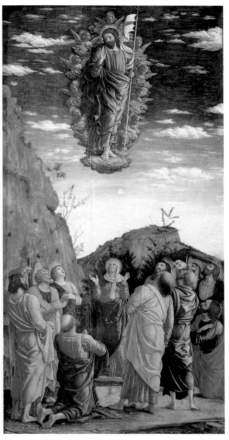

The three kings, Melchior, Caspar, and Balthasar, humbly approach the baby Jesus. They are about to kneel before the baby and pay their respects while their entourage in the background pauses. The

Adoration of the Magi is flanked by two other panels, the *Ascension of Jesus* (right) and the *Circumcision* (left).

Correggio: Rest on the Flight to Egypt, ca. 1515
Oil on canvas, 123 x 106 cm

Antonio Allegri (1489–1534) was nick-named after the name of his birthplace, Correggio. The Franciscan monk shown kneeling at the foot of the Holy Family is a reference to the location for which the painting was intended, a chapel in the church of S. Francesco. The scene takes place in a forest with the main figures painted in brightly lit colors against the background of a dark impenetrable thicket. The characteristic diagonal composition with which Correggio would pave the way for the dynamic movement of Baroque painting in his later work can already be observed in this early work.

Michelangelo and Early 16th-Century Florentine Painting

Michelangelo Buonarroti:
The Holy Family (Tondo Doni),
ca. 1504
Tempera on wood, diameter
120 cm

This painting (ca. 1504) – named after its patron Agnolo Doni who was known as Tondo – is the only extant easel painting by Michelangelo, and is still seen in its original frame.

The master clearly demonstrates a preference for a sculptural corporal ideal here. The arrangement of the main group is defined by the bright colors and complicated exaggerated poses, and this bestows on the painting a distinctly Mannerist touch.

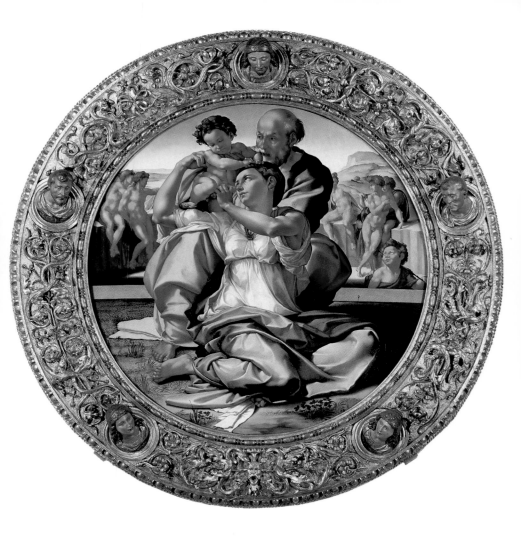

Giorgio Vasari – The "Father of Art History"

Giorgio Vasari (1511–1574) was born in Arezzo where his father and his grandfather worked as potters (Italian *vasario*). The young Giorgio trained as a glass painter and studied humanism in his home town. When he first went to Florence at the age of 13, he continued his artistic training with Andrea del Sarto and Baccio Bandinelli. The young man may also have had an opportunity to observe

Giorgio Vasari: Self-Portrait, 1566 – 68, oil on wood, 100 x 80 cm, Uffizi Gallery, Florence

Michelangelo at work in his studio, while he continued his education in the sciences of antiquity in the Medici circles. His first visit to Florence ended in 1527 when the Medici were temporarily expelled from Florence. This marked the beginning of a very insecure and varied period in Vasari's life. He stayed in Arezzo for two years and then returned to Florence. In 1531, at the instigation of Cardinal Ippolito de' Medici, he moved to Rome for a time. He moved around constantly in the following years, undertaking numerous journeys which took him to various towns and cities in Italy, including Venice and Bologna. During this time he worked as a painter and architect and even tried sculpture, concerned himself with scientific matters, and quickly became integrated into the educated humanistic circles wherever he went. He finally moved permanently back to Florence in 1545. Despite the wide variety of his artistic work – his innumerable Florentine commissions included the execution of the dome fresco in the cathedral and the construction of the Uffizi – Vasari's fame today rests mainly on his *Lives of the Most Eminent Painters, Sculptors, and Architects* (*Le vite de' più eccelenti architetti, pittori e scultori italiani*). In this work, first published in 1550 (with an expanded second edition in 1568), Vasari provided the first systematically organized account of artists' lives. It starts with Cimabue and ends with the masters of his own time. Vasari's account of

lives and works of the most reputable Italian Renaissance artists – including Giotto, Masaccio, Ghiberti, Brunelleschi, Donatello, Botticelli, Uccello, Mantegna, Leonardo, and Raphael – is both comprehensive and highly entertaining. Despite the fact that the historical information is not always the most reliable and the anecdotes are sometimes less than credible, the texts remain an almost inexhaustible source of information and are the basis for the author's reputation as the "father of art history." Vasari's work

Giorgio Vasari: Lives (biographies of the most famous painters, sculptors, and architects), 2nd edition, 1568

surpassed that of all previous biographical accounts – e.g. those by Brunelleschi's biographer Antonio Manetti (1423–1491) – not least on the basis of the virtually encyclopedic scope of the material which was probably collected over decades. "What is unique about this work is the way in which, in the mid-16th century, he succeeded in combining an account of history with an abundance of art historical facts to produce a work of monumental importance. He was the first to work on an area which was much later identified as the science of art" (U. Kultermann).

A distinctive feature of Vasari's account of the development of art is its division into three historical phases: the admirable flowering of the arts in ancient times is followed by centuries of neglect during the dark Middle Ages and rediscovery and rejuvenation from the 13th

century. The final section is in turn subdivided into three life phases: childhood (14th century), youth (15th century), and maturity. Vasari believed that with the work of Michelangelo Buonarotti, which he positively eulogizes, the ideals of antiquity had not just been achieved but actually exceeded, and art had ultimately reached a state of perfection.

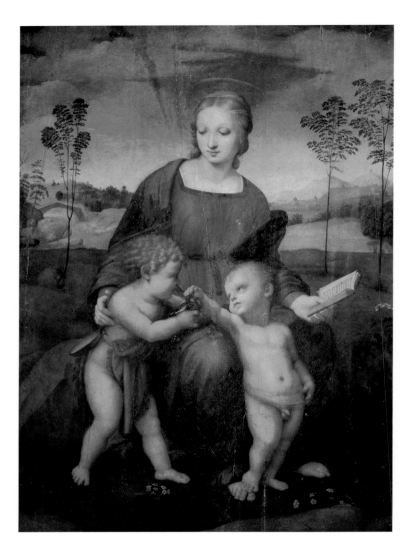

The Raphael and Andrea del Sarto Room

Raphael: The Madonna of the Goldfinch, ca. 1507
Oil on wood, 107 x 77 cm

The mysterious, shimmering landscape behind the Mary, Jesus, and John figures is executed in muted colors. Raphael painted this work around the end of his time in Florence and it shows that he was still influenced by Leonardo and Michelangelo. Mary's son is standing between her knees. He is leaning back, looking at his cousin John and stroking the bird, a goldfinch, which John is holding. The joyful companionship of the children is reflected in the tenderness and protective gestures of the mother. The landscape and figures are integrated here in a most successful atmospheric unity.

Raphael: Portrait of Pope Leo X with His Cardinals, ca. 1518
Oil on wood, 155 x 119 cm

The first member of the Medici family to become pope was Giovanni, the second son of Lorenzo the Magnificent. He remained in office as Pope Leo X until his death in 1521. This portrait shows him in the company of his nephews, the cardinals Luigi de' Rossi and Giulio de' Medici. Raphael makes no effort to prettify his subject's unattractive facial features and conveys an image of a self-assured and strong-willed man. The beautifully rendered book on the table is a reference to Leo's strong humanistic affinity with all aspects of the fine arts. The precise rendering of the different materials of the depicted objects is truly masterful. Numerous nuances bring the variety of dominating red tones to life while a network of interpenetrating diagonals contribute to the compositional unity of the work.

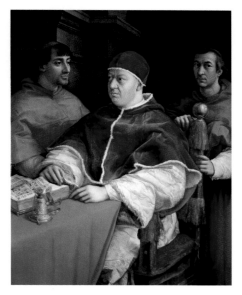

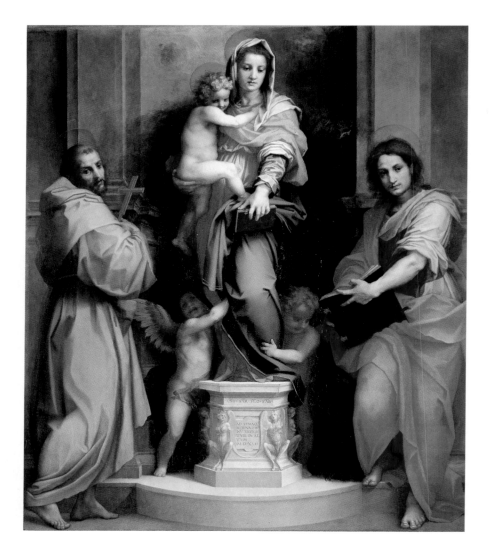

Andrea del Sarto: Madonna of the Harpies, ca. 1517
Oil on wood, 207 x 178 cm

Andrea del Sarto's famous masterpiece was transferred from the church of San Francesco to the Uffizi in 1865. Del Sarto's artistic endeavor is characterized by his relentless effort to assimilate figures and space in an intense atmosphere of harmonious unity. The softness of modeling in the *Madonna of the Harpies*, which takes its name from the harpy pedestal on which the figure of the Virgin stands, betrays the influence of Leonardo da Vinci, while the composition reflects the influence of Fra Bartolommeo and Raphael. The painting radiates a solemn monumentality, despite the fact that the dynamic poses and gestures of the figures are characterized by enormous vivacity.

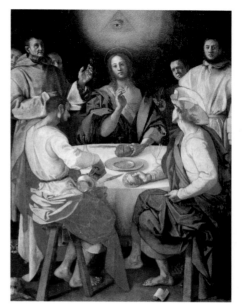

Pontormo: Supper at Emmaus, ca. 1525
Oil on canvas, 230 x 175 cm

There is an unreal and almost mystical atmosphere in the Emmaus scene by Jacopo Carrucci, who was known as Pontormo (1494–1556) and was one of the main masters of Early Florentine Mannerism.

The use of color has gradations from the dull semi-obscurity of the background to the very intense red, yellow, and green of the robes worn by the two seated disciples at the front of the painting. In terms of composition, they are linked with the dominating figure of Jesus as part of a triangle. An aureole of light with the eye of the Holy Trinity shines above Christ's head. The moment when the resurrected Christ reveals himself to the disciples by breaking the bread appears to be imminent. However, Christ appears to have raised his right hand in a gesture of blessing. Several Carthusian monks are gathered around, witnessing the scene. These are probably portraits of members of the Certosa di Galluzzo, for whom the painting was intended.

Titian: Venus of Urbino, ca. 1538
Oil on canvas, 119 x 165 cm

Tiziano Vecellio (ca. 1490–1576) was the outstanding Venetian painter of the 16th century. At the height of his fame, he was ennobled by Emperor Charles V and worked for kings, emperors, and ruling houses throughout Europe. His paintings were in great demand both in and beyond Italy. As one of the outstanding colorists of all time, Titian's achievements in color are on a par with those of the great Florentine masters in *disegno* (drawing).

Titian painted this famous canvas of the reclining *Venus of Urbino* for Guidobaldo della Rovere, the Duke of Urbino. The consummately beautiful female nude reclining on a white bed sheet looks straight at the observer with a coquettish and challenging expression, completely devoid of embarrassment. In contrast to Giorgione's *Sleeping Venus* (1505, Gemäldegalerie, Dresden), on which Titian modeled his painting, this image of the mythological goddess is completely profane. The idealized classical landscape is replaced by a magnificent Venetian interior, complete with two servants at work. The goddess herself – it may be a portrait of a courtesan – appears to be fully aware of the erotic effect of her seductive pose. This painting is an important example of Titian's mastery as a colorist.

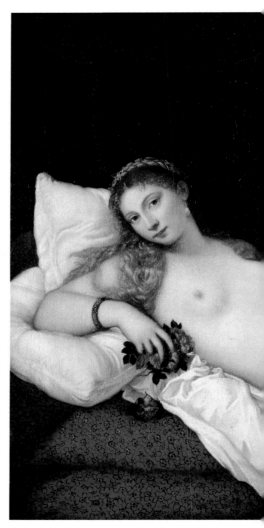

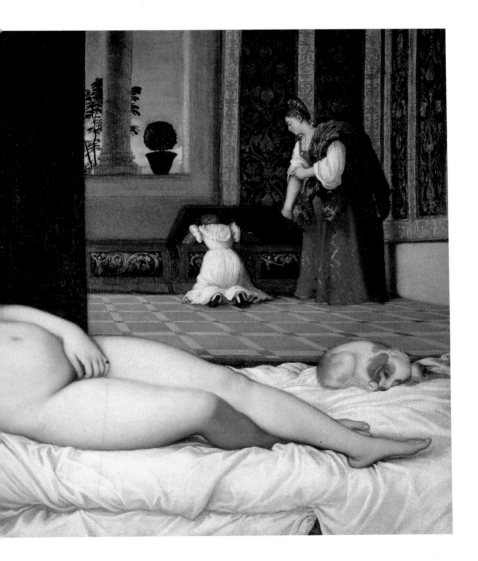

Titian: Flora, ca. 1515
Oil on canvas, 79 x 63 cm

Titian's mastery as a colorist is clearly evident in the richly contrasting and virtuoso color modeling of the widely varying surface properties – the skin tones, the fabrics, and flowers – in this early painting. Given the eroticism that radiates from this painting, it is not surprising that for a long time it was interpreted as the portrait of a contemporary Venetian courtesan. The curly hair falls back in tones of gold over the shoulders of the young woman. The flowers in her right hand identify her as the ancient goddess Flora. A mysterious melancholy emanates from the regular features of her head which is inclined to one side, while the light, thin fabric of the undergarment barely covers her bosom. The strong, clear facial features are reminiscent of ancient models.

Titian, who was at the start of his career as a painter and had only had his own studio for two years when this work was painted, is still clearly influenced here by the dreamy, enigmatic paintings of his teacher Giorgione. At the same time, however, he also shows his impressive talent in the execution of difficult details, such as the perspectivist shortening of the right lower arm of the goddess holding rose leaves and flowers in her hand.

Parmigianino: Madonna of the Long Neck, ca. 1534–40
Oil on wood, 219 x 135 cm

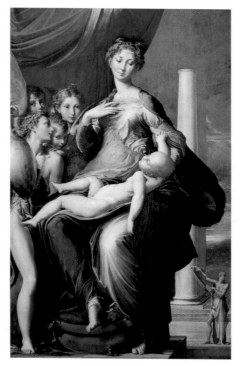

The *Madonna of the Long Neck* takes its name from the dramatically attenuated anatomical features of the main figure. Although it remained unfinished despite many years of work, this painting by the Emilian painter Girolamo Francesco Maria Mazzola (1503–1540), who was known as Parmigianino after the name of his birthplace Parma, is regarded as one of the earliest examples of Mannerist painting.

All of the logical laws of classical composition are ignored in this painting. The natural features of human physiology are also ignored in favor of an artificially heightened affected elegance. In accordance with the Mannerist ideal of the *figura serpentinata*, the extremely elongated limbs of the figures appear somewhat contorted. The unusual death-like sleeping pose of the Christ child appears to suggest the motif of the *pietà*, the mourning over Christ's body. Like that of his mother, who is frozen in a strange pose between sitting and standing, the gigantic body of the boy child is divorced from any links with a canon of binding proportions. Moreover, the diffuse spatial composition is truly surreal in its overall effect.

A heavy red-brown drape sweeps down over the heads of the child-like angel figures who are crowded together on the left while, with bizarre compositional asymmetry, the distant view to the right penetrates into the depth of the space. The towering column appears to be devoid of all tectonic function. Also there is no obvious thematic connection between the Virgin and the diminutive figure of the prophet (?) shown unrolling a document.

Paolo Veronese: The Holy Family with St. Barbara and St. John, ca. 1562
Oil on canvas, 86 x 122 cm

The rich artistic work of the Venetian painter Paolo Veronese (1528–1588) gives us an incomparable insight into the riches of the *Serenissima Repubblica Venezia*, the Mediterranean light of the Laguna city, and the extraordinary opulence of its golden age. This painting, which is executed with consummate elegance and impressive colorist brilliance, is a mature work. Mary and Joseph, St. Barbara (left), and the boy St. John are gathered around the Christ child with gentle gestures in an atmosphere of respectful serenity. The composition lines start in the multiple diagonals radiating from the figure of the sleeping baby Jesus.

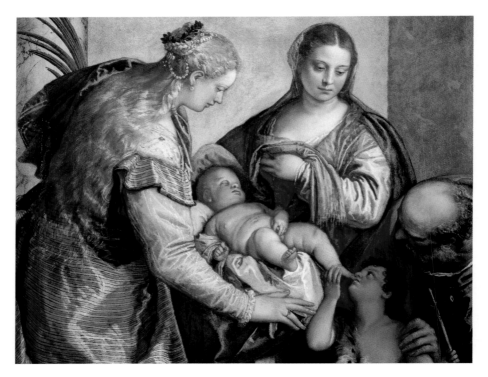

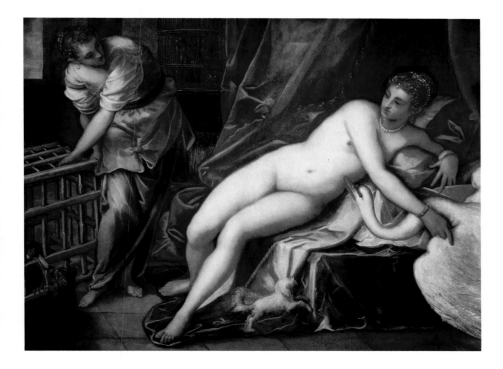

Tintoretto: Leda and the Swan, ca. 1570
Oil on canvas, 162 x 218 cm

In many respects, Jacopo Robusti (known as Tintoretto, 1518–1594) represented a kind of opposite pole to Titian and Veronese. Not only was he constantly trying to filch lucrative commissions from his reputable competitors but his restless artistic temperament repeatedly moved him to create extraordinarily dynamic compositions. This painting, which originates from his studio, is an example of this characteristic of his work: the compositional contrasts are among the key forces in this picture. Leda's glance is directed at a maid while her body is already facing the god Zeus disguised as a swan and approaching her from the right.

The Rubens Room

Peter Paul Rubens: Henry IV in the Battle of Ivry, ca. 1610
Oil on canvas, 367 x 693 cm

Along with the painting of Henry IV's triumphant entrance into Paris, which is exhibited in the same room of the Uffizi, this painting marks the beginning of an unfinished cycle portraying important events from the life of the French king. The series was commissioned by Maria de' Medici in 1610 in honor of her murdered husband. The theatrical staging is masterfully heightened to the most heroic dimensions while the dynamism of the composition which is built along diagonal lines is highly dramatic.

Peter Paul Rubens: Portrait of Isabella Brand, ca. 1620
Oil on canvas, 86 x 62 cm

Rubens painted this portrait of his first wife, Isabella Brand, just a few months before she died. The immediate effect of the painting primarily derives not from the beauty of the subject but from the tender affection which clearly guided the painter in this work. With her wide-open eyes and the hint of a smile on her lips, Isabella looks as though she has just been asked to stop reading the book she is holding in her hand. The special attraction of this portrait clearly lies in the great intimacy of its observation.

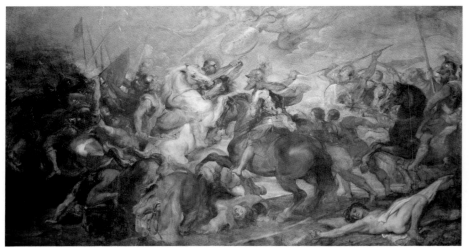

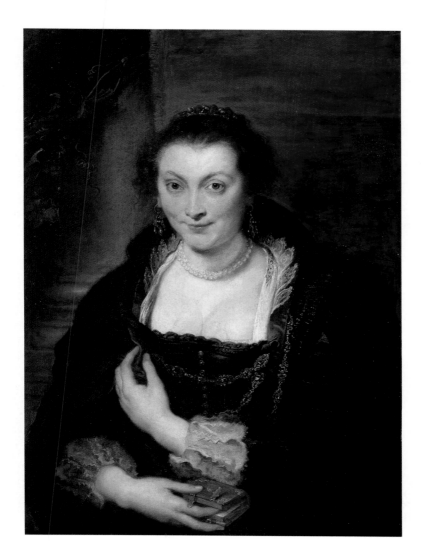

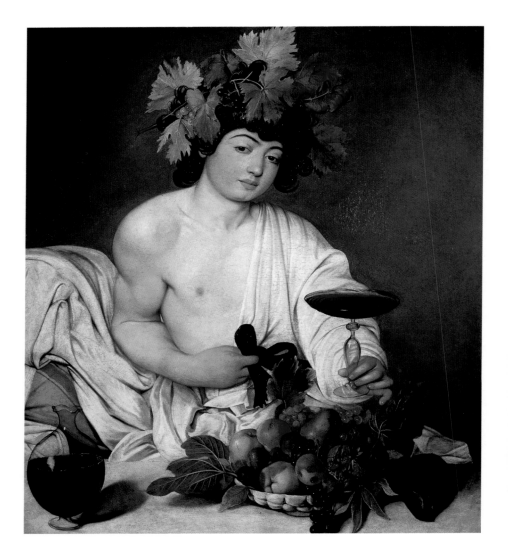

The Caravaggio Room

Caravaggio: Bacchus, ca. 1595
Oil on canvas, 95 x 85 cm

Michelangelo Merisi da Caravaggio (1571–1610), the artist who must be acknowledged as one of the most radical innovators in the history of European art, was born in Rome in the late 16th century. The effects of his brief but revolutionary creative life traveled far beyond the borders of his native country and time. The Uffizi *Bacchus* is one of the painter's early works. The ancient god meets us here in the form of a young boy with a rather feeble-minded expression who is wearing a crown of vine leaves and holding a goblet in his hand. The hands and slightly chubby cheeks seem reddened by the sunlight while the muscular right arm is indicative less of noble origins than of exposure to hard physical work: Caravaggio may have found his model in the streets of Rome. The young boy seems completely displaced in his costume, and his pose on the slightly graying, carelessly draped bed sheet seems rather awkward. There are no obvious signs of prettifying idealization. Instead, the painter's eye records a reality which could well mirror the actual scene in his studio. Caravaggio's great talent is evidenced in the magnificent fruit still life in the foreground of the painting.

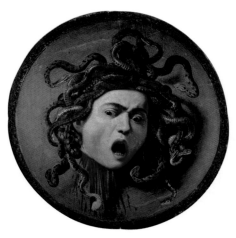

Caravaggio: Medusa, ca. 1595
Oil on a leather-covered wooden shield, 60 x 55 cm

Caravaggio painted this unusual version of Medusa's head on a convex curved shield for his early patron, Cardinal Francesco del Monte.

According to the Greek myth, Medusa's look transformed anyone who beheld her into stone. The hero Perseus succeeded in beheading the monster by means of a cunning plot. In Caravaggio's dynamic painting, the head has already been severed from the body but the grotesque face has not yet lost its terrifying power. Captured at the moment of death, the monster's eyes are wide open and the mouth gaping in a last cry.

Caravaggio: The Sacrifice of Isaac, ca. 1600
Oil on canvas, 104 x 135 cm

In this painting, Caravaggio drastically transforms the Old Testament episode of the sacrifice of Isaac into a barbarous act of violence which is infused with a raw, merciless brutality. The immediacy of the effect is heightened by the fact that the action in the painting is completely focused on a small excerpt from this biblical episode. Abraham decisively thrusts the knife to kill his own son and, unable to save himself, Isaac is gripped in panic. The angel who rushes to the scene has difficulty preventing the cruel act. The drama is intensified by the contrasting light and dark shadows which are typical of Caravaggio's work. In view of the strong naturalism, it is not surprising that those who commissioned work by Caravaggio often rejected the end product in shock.

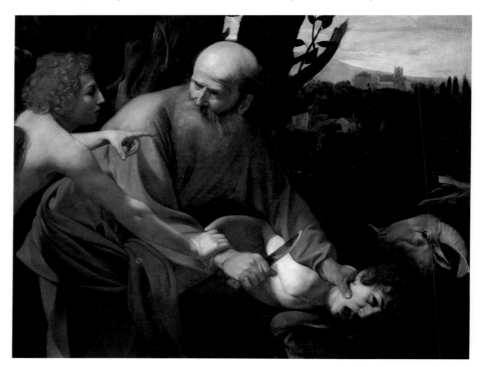

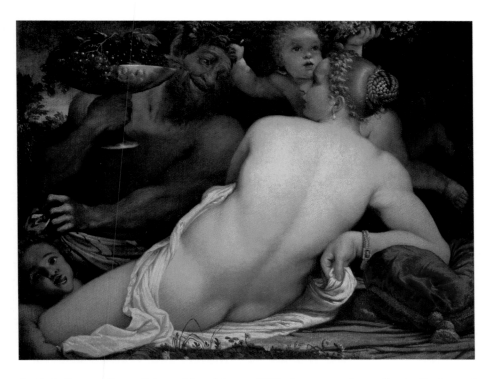

Annibale Carracci: Venus, Satyr, and Amorini, ca. 1588
Oil on canvas, 112 x 142 cm

The work of Annibale Carracci (1560–1609) contrasts sharply with the extreme verisimilitude of Caravaggio. Both painters adopted completely different strategies to overcome the stiff idiom of Late Mannerism. Annibale, who came from Bologna and eventually reached Rome in 1595 after years of traveling in Venice and Parma, is representative of a more classicist trend creating images which are pervaded by a sensual joy. His *Venus, Satyr, and Amorini* is filled with frivolous details and lewd references. A lusting satyr approaches the voluptuous female figure whose wonderful back dominates the painting and is not without erotic attraction.

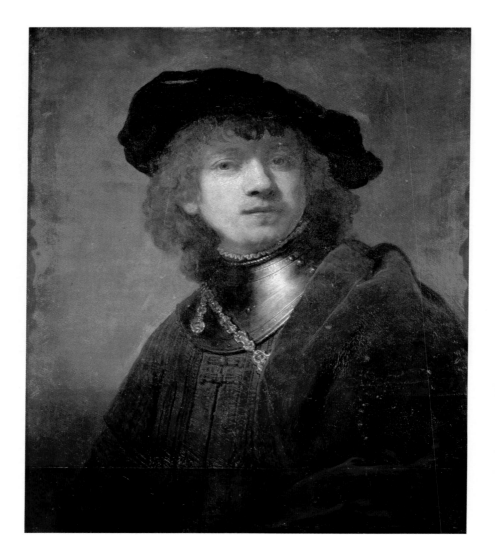

Rembrandt Harmenszoon van Rijn: Self-Portrait as a Young Man, ca. 1630
Oil on wood, 62 x 54 cm

Rembrandt Harmenszoon van Rijn painted an impressive series of self-portraits throughout his life as an artist. In this, the outstanding master of the golden age of Dutch painting not only left an important testimony to his development as an artist but also provided fascinating insight into the general subject of human existence.

In this early self-portrait (ca. 1630), Rembrandt presents himself as a confident young man wearing the typical painter's beret. The metallic shimmer of his collar is richly contrasted with the velvet fabric of his cloak and the young face is subtly modeled in the interaction of light and shadow. It seems as if the young artist setting out on his long and distinguished career is proudly demonstrating his ability to depict different surface properties in his work.

Rembrandt Harmenszoon van Rijn: Self-Portrait as an Old Man, ca. 1660
Oil on canvas, 74 x 55 cm

The early portrait hangs opposite this late portrait from the 1660s. As was often the case in his later work, the master does not include any non-essential elements or details here and does not provide any hints as to its hidden meaning.

The tests of a long life plagued by innumerable blows of fate have left their irrefutable traces in the ageing artist's facial features. Youthful confidence has been replaced by a melancholy expression which is not without bitterness and yet exudes the tranquillity and self-assurance that comes with age. In parts of this work the paint is thickly applied with the sureness of touch that distinguishes the late work of the great master.

Jean-Baptiste-Siméon Chardin: Girl with Badminton Game, ca. 1740
Oil on canvas, 82 x 66 cm

Jean-Baptiste-Siméon Chardin: Boy with House of Cards, ca. 1740
Oil on canvas, 82 x 66 cm

This magnificent study of a girl playing badminton was acquired for the Uffizi in 1951 together with its companion piece *Boy with House of Cards*.

Both paintings are high-quality copies which the French painter Jean-Baptiste-Siméon Chardin (1699–1779) made of his own paintings from the Rothschild collection. The originals are now kept on display in Paris and the National Gallery in Washington D.C.

The French painter Chardin is justifiably known as the great "poet of the everyday." Quietly concentrating on the card game, the elegantly dressed and neatly coifed boy seems to be completely cut off from the world around him. The restraint, subtlety, and overall technical brilliance of Chardin's work give the observer the impression of witnessing an everyday event touching in its carefree atmosphere and tone.

**Francisco de Goya: Portrait
of the Countess of Chinchón,
ca. 1800**
Oil on canvas, 220 x 140 cm

Around the turn of the 19th
century, Francisco de Goya y
Lucientes (1746–1828) was
the favorite painter of
the Spanish royal family. The
portraits of numerous
members of the aristocracy
around the Madrilene court
form an important part of
his wide and varied work.
In this portrait of Maria
Theresa de Bourbón y
Vallabriga, the Countess of
Chinchón and wife of the
influential minister Manuel
Godoy, the Uffizi has an
outstanding example of
this artist's subtle work. In
addition to the beauty
portrayed in the subject's
facial features, the carefully
selected color accents in the
headdress and artificial
treatment of the dress make
a significant contribution to
the elegant effect of this
impressive portrait.

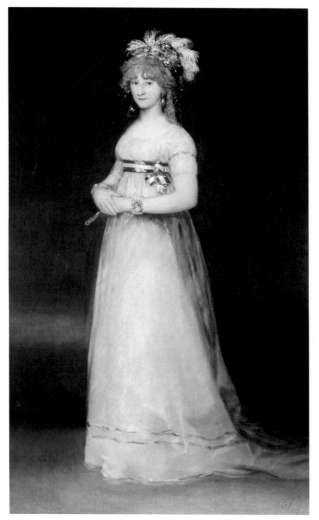

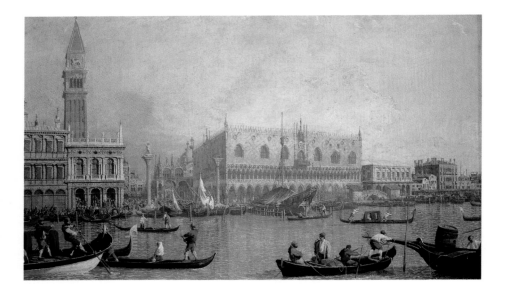

Canaletto: Veduta of the Palazzo Ducale in Venice, ca. 1750
Oil on canvas, 51 x 83 cm

The paintings of Giovanni Antonio Canal, known as Canaletto (1697–1768), were extremely popular during his lifetime, particularly among English travelers, and are still among the most famous and sought-after vedute of all times. Canaletto recorded numerous motifs from his native city on canvas with amazing precision and creativity. He not only documented scenes from everyday life in 18th-century Venice but also provided important insights into the topographical and historical develop-ment of the city on the Laguna. The magnificent and atmospheric view of the city which greeted travelers arriving in Venice by sea in the 18th century is conveyed in this painting at the Uffizi. The impressive south façade of the Palazzo Ducale is shown on the right, next to the columns crowned by St. Theodore and the lion of St. Mark's, the patron saint of Venice. Parts of the famous church of S. Marco can be glimpsed behind the Palazzo Ducale. The Campanile towers to the sky on the left while the gondoliers – still as popular as ever – go about their work in the foreground.

Francesco Guardi: Capriccio with Arch and Landing Stage, ca. 1750
Oil on canvas, 30 x 53 cm

Although Francesco Guardi (1712–1793) left behind a very varied repertoire of paintings, comprising portraits, still lives, and theater decoration as well as history paintings, his fame today tends to rest primarily on his Venetian city views. He is one of the most important veduta painters of the 18th century after Canaletto, who taught him from time to time.

However, Guardi moved away from the realistic depiction of existing motifs at a relatively early stage and soon became increasingly involved in free composition whose picturesque effect was facilitated by his very distinctive and loose brushwork and carefully emphasized color accentuation. Ultimately, the work of Francesco Guardi contrasts directly with the no less attractive but precise, accurate, and realistic work of his predecessor Canaletto. Not surprisingly, Guardi's atmospheric paintings enjoyed particular popularity during the Impressionist period. This painting from the Uffizi collection is one of the ideal vedute created from the painter's imagination. Such pictures were known as *capricci*, a term coined by Jacques Collot.

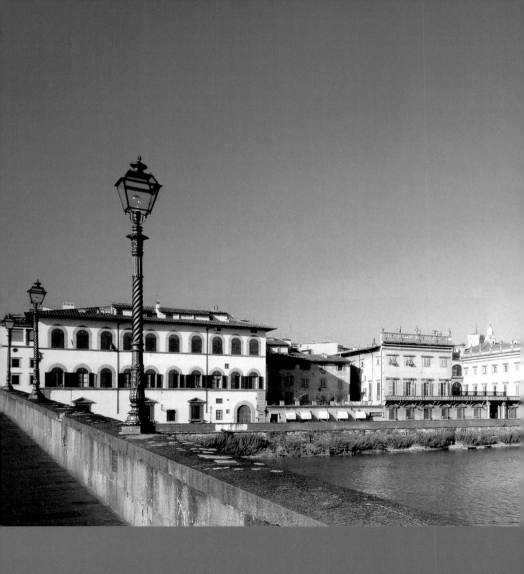

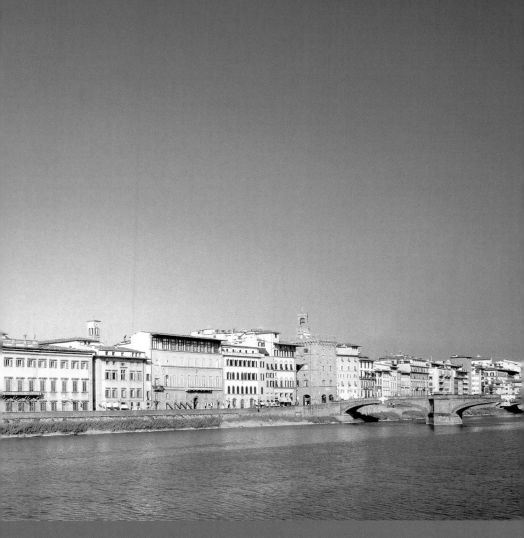

South of Santa Maria Novella

Piazza Santa Maria Novella

Just like the other main squares in Florence, the Piazza Santa Maria Novella was used as a venue for numerous great parties and festivities. Here, the Dominican friars from the nearby church of Santa Maria Novella preached their passionate sermons against heresy as well as staging regular open-air processions. The two obelisks in the square are decorated with bronze turtles by Giambologna and provided a turning point for the Palio dei Cocchi, a horse race that was held there each year until 1850.

Santa Maria Novella

The businessman Giovanni Rucellai commissioned architect and theorist Leone Battista Alberti (1404–1472) to redesign the façade of the Dominican church of Santa Maria Novella around 1456. The generous financing of the renovation work is acknowledged in an inscription under the gable area and by the billowing sail motif (on the main cornice above the lower story), which is a reference to the Rucellai family coat-of-arms. Alberti had to integrate the existing tombs of famous Florentine citizens, the two Gothic doors, and the central circular window into his new version of the façade, which was originally built and decorated with its first marble inlay in the 13th century. The architect framed the lower zone with side pilasters and introduced four engaged columns to set a vertical emphasis. He enclosed the large central main door with an arch and separated the lower part of the façade from the upper part by means of a wide horizontal strip decorated with square inlay. Although the central circular window weighs rather heavily on the attic zone below, it is successfully integrated into a conclusive series of circular motives by the framing volutes. The façade culminates majestically in an exquisite triangular pediment.

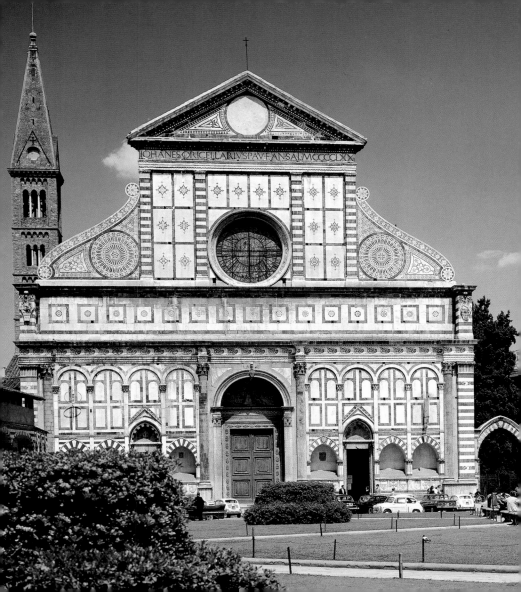

Santa Maria Novella

Strozzi Chapel – Frescos of Paradise, Hell, and the Last Judgment, p. 211

Spanish Chapel – Frescos by Andrea Buonaiuti (ca. 1365), p. 228

Chiostrino dei Morti (Strozzi family tomb)

Chiostro Grande

Refectory

Chiostro Verde, p. 224

0 N 20 m

Gondi Chapel – Filippo Brunelleschi: Wood Crucifix (ca. 1412)

Maggiore Chapel – Fresco Cycle by Domenico Ghirlandaio (1485–90), p. 221

Strozzi Chapel – Fresco Cycle by Filippino Lippi (1487–1502), p. 223

Sagristia – Giotto: Crucifix (before 1300)

Paolo Uccello: The Flood (ca. 1430–50)

Old cemetery

Entrance to the Museo di Santa Maria Novella

Masaccio: The Trinity (ca. 1427/28), p. 204

The interior

Two years after the first Dominicans became established in Florence, they were assigned a Marian church which was located outside the city walls and was built in the late 11th century on the site of a chapel mentioned in a charter from Ottonian times (ca. 983). With the rapid growth in the order's influence and followers, the desire – and probably also the necessity – soon emerged to get started on a project for a much larger church along with an extensive monastery.

The Dominicans recruited the architects Fra Ristoro da Campi and Fra Sisto Fiorentino from their own ranks to design the new church. Based on their plans, work started on the erection of the new church in 1246. The construction of Santa Maria Novella marked the beginning of a veritable building boom in Florence during the second half of the 13th century.

Santa Maria Novella was based on the model of the Burgundian Cistercian structures and was built as a three-aisle basilica with transept and five square chapels. Not only is the interior now regarded as the most beautiful to be found in the city, but it can also be described as one of the most important examples of a Late Gothic interior in Europe. The architects succeeded most admirably in bringing the upward-thrusting forms of the Gothic style into harmony with the horizontal dimensions of the length and width of the space.

The spatial boundaries between the center aisle and the two side-aisles are almost removed by the width of the arcades. Based on an optical calculation, the pillars become narrower as they lead up to the choir and hence emphasize the extended length of the nave and side-aisles which culminate in the north-oriented Maggiore Chapel. With its well-ordered proportions and harmonious details, the balanced formal language of the architecture unfolds to create a most remarkable atmosphere. It ultimately conveys a sense of space found only south of the Alps and differs markedly from the characteristic appearance of the north European version of Gothic architecture.

Giorgio Vasari, who despised the Gothic style as barbarian, made significant changes to the interior of the church between 1565 and 1572. The originally elevated monks' choir was demolished under his direction. Although Vasari had some of the 13th-century wall paintings covered, much of the extraordinary original artistic decoration has been preserved in Santa Maria Novella. In the Florentine context, the richness and outstanding quality of the 14th- and 15th-century masterpieces assembled here are comparable only with those in Santa Croce.

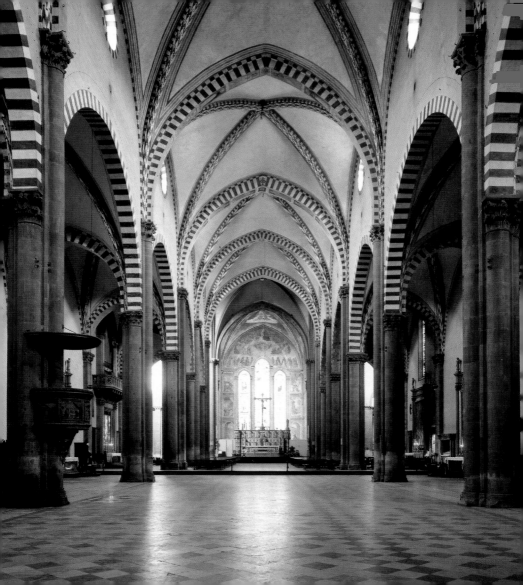

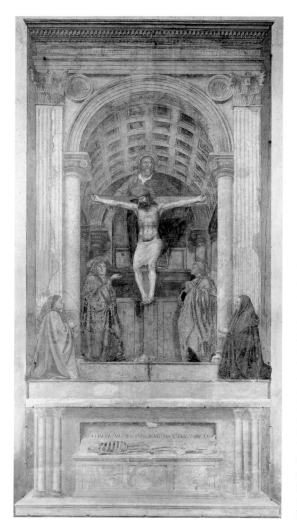

Masaccio: The Trinity, ca. 1427
Fresco, 667 x 317 cm

Masaccio's *Trinity* fresco represents a major turning point in modern European painting. This is the first work in which a painter consistently devoted his attention to the laws of linear perspective recently developed by Filippo Brunelleschi. The formal language of the architecture shown in the painting is also very reminiscent of the buildings designed by Brunelleschi in Florence. The suggestion that the architect acted as an artistic consultant in the execution of this art work is, therefore, plausible. The impression of a space extending back into the wall is created through the depiction of the coffered arched ceiling. God the Father dominates the crucifix with the Christ figure in the center. The Virgin and St. Joseph are shown kneeling at the sides of the crucifix. The illusion of three-dimensional spatial depth is reinforced by the two kneeling patrons

(heads of the Lenzi family) who are shown praying on a step below the chapel-like room in front of the side pilasters.

In the lower part of the fresco, also painted on the basis of a perspective scheme, is a tomb in a niche with a skeleton on top. The inscription with the words "I was what you are, you will be what I am" carries a clear warning on the transitory nature of all things worldly.

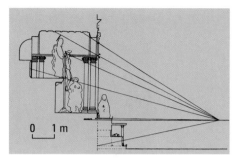

Hypothetical section (after Sanpaolesi)

This hypothetical reconstruction of the fresco composition demonstrates the precision with which Masaccio aimed to create the illusion of a real space opening into the wall surface on the two-dimensional surface. Using precise calculations, the painter was able to depict the figures in accordance with their three-dimensional positions.

Diagram of the perspectivist composition

A dense network of auxiliary lines provided a basis for the composition of the painting and can still be detected under the painted surface. The center of perspective, on the level of the lower step, forms the starting point of th eline of sight. This also marked the ideal position of the observer and allowed maximum identification with the depicted images.

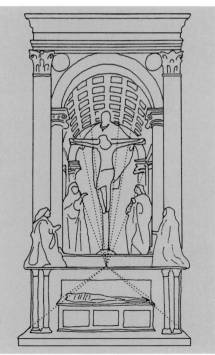

South of Santa Maria Novella

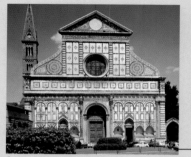

Santa Maria Novella/Museo di S. Maria Novella, Piazza S. Maria Novella, p. 199

Ognissanti, Borgo Ognissanti 42, p. 261

Palazzo Rucellai, Via della Vigna Nuova 18, p. 249

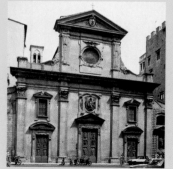

Santa Trinità, Piazza S. Trinità, p. 240

Palazzo Corsini, Lungarno Corsini 10, p. 265

Piazza della Repubblica, p. 232

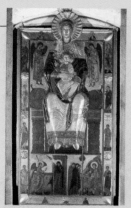
Santa Maria Maggiore, Via dei Cerretani, p. 231

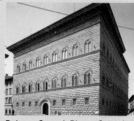
Palazzo Strozzi, Piazza Strozzi, p. 237

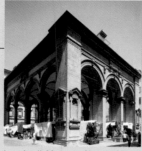
Loggia di Mercato Nuovo, Via di Porta Rossa, p. 235

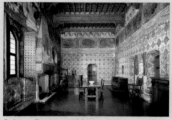
Palazzo Davanzati/Museo dell' Antica Casa Fiorentina, Via Porta Rossa 13, p. 239

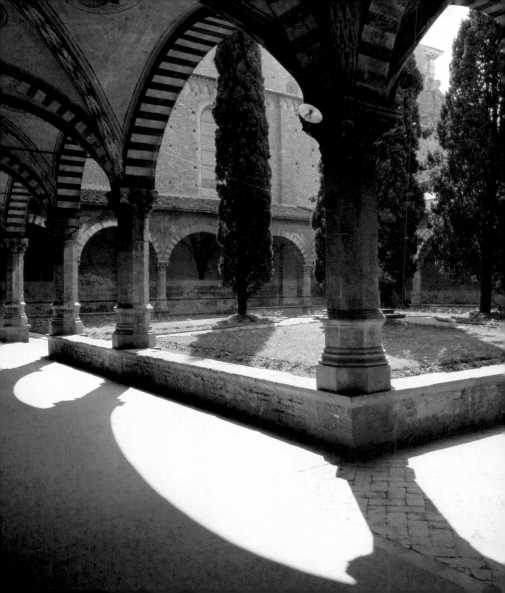

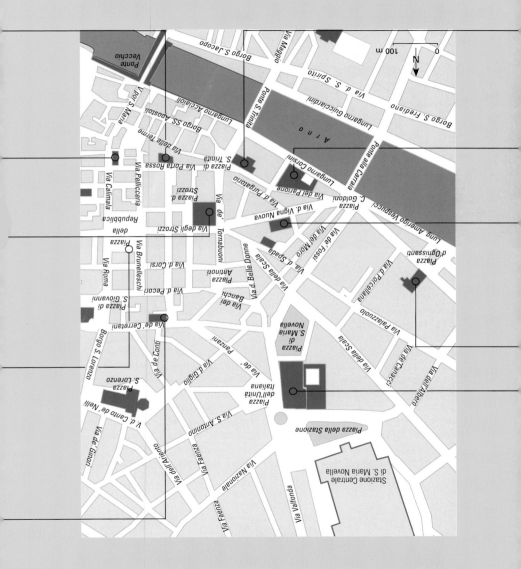

Ponte Vecchio

Via Por S. Maria

Borgo SS. Apostoli

Lungarno Acciaioli

Via delle Terme

Borgo S. Jacopo

Via Maggio

Ponte S. Trinita

Lungarno Guicciardini

Via d. S. Spirito

Borgo S. Frediano

Via Porta Rossa

Via Pellicceria

Via Calimala

Piazza d. Strozzi

Via de' Tornabuoni

Piazza di S. Trinita

Via di Purgatorio

Lungarno Corsini

Ponte alla Carraia

A r n o

Via degli Strozzi

Piazza della Repubblica

Via Roma

Via Brunelleschi

Piazza

Via de' Corsi

Piazza Antinori

Via de' Pecori

Via d. Belle Donne

Via del Parione

Via d. Vigna Nuova

Lung. Amerigo Vespucci

Piazza C. Goldoni

Via de' Rossi

Via del Moro

Via d. Spada

Via della Scala

Piazza d'Ognissanti

Via d. Porcellana

Via di S. Giovanni

Piazza di S. Giovanni

Via de' Cerretani

Via de' Conti

Via dei Banchi

Via de' Panzani

Piazza di S. Maria Novella

Via delle Scala

Via de' Canacci

Via Palazzuolo

Via dell'Albero

Borgo S. Lorenzo

Piazza S. Lorenzo

V. d. Canto de' Nelli

Via de' Ginori

Via d. Giglio

Via S. Antonino

Via dell'Ariento

Via Faenza

Via Nazionale

Piazza dell'Unità Italiana

Via Valfonda

Piazza della Stazione

Stazione Centrale di S. Maria Novella

N

0 100 m

The Invention of Central Perspective

European painting has the architect Filippo Brunelleschi to thank for one of the most momentous innovations in its entire history. In the second half of the 15th century, Brunelleschi succeeded in giving visual artists a practical method which, for the first time, would enable them to portray objects and figures on a two-dimensional picture surface in the way in which they appear to the eye in three-dimensional reality.

Brunelleschi first demonstrated his method of illusionist spatial representation of reality in

two often mentioned but lost panels in the Florentine Baptistery and the Palazzo della Signoria. With the help of a spanned thread cross, he probably transposed his object from an unchanging observer's standpoint to innumerable points and lines on a picture surface which was also marked with a grid. In accordance with the optical laws of the perception of reality, all of the orthogonal lines leading into the depth of the image converged on a fixed vanishing point or center of perspective, whose position in the image was

Piero della Francesca (?): Ideal City, ca. 1475, tempera on wood, 60 x 200 cm, Galleria Nazionale delle Marche, Urbino

image was defined by the observer's standpoint. As Brunelleschi's early biographer Antonio Manetti demonstrated, this practical process results in "a good and systematic foreshortening or enlarging of objects ... and of figures and other things to the size which they seem to have when viewed close up or from a distance as they appear to the human eye."

Masaccio's famous *Trinity* fresco in Santa Maria Novella (see p. 204) represents the first application of this innovation in painting. In relief art, Donatello and Ghiberti were among the first artists to exploit the new possibilities of perspective.

No previous artistic period, not even in classical antiquity, had been able to avail itself of such an important process. Now a replacement had finally been found for the medieval perspective, whereby the relationship between sizes and proportions within an image was governed by the ideal significance of the depicted object or figure.

The fact that painting continued to follow the laws defined on the basis of Brunelleschi's "invention" well into the 19th century is, not least, proof of their inestimable importance. It was not until the arrival of artists such as Van Gogh and Cézanne, Picasso and Braque in the modern period that art was finally liberated from the primacy of linear perspectivist representation as established in the Renaissance.

Schematic reconstruction of Brunelleschi's first Baptistery panel (after Parronchi)

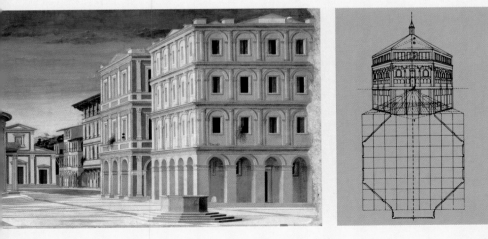

211

The Technique of Fresco Painting

The special technique of fresco painting, which reached its apotheosis with the work of 14th- and 15th-century Italian artists, was used as early as Roman antiquity. The term is derived from the Italian word *fresco* (fresh). In this type of wall painting, the paint was applied directly onto the freshly laid and hence wet lime mortar, which formed the final layer of plaster (*intonacco*). The chemical reactions that took place as part of the drying process resulted in the permanent mixing of the color pigments with the surface on which it was painted. In contrast to *secco* (dry) painting, which was carried out on dry plaster, fresco paintings are chiefly characterized by their extreme durability and the intensive quality of their color. Any such paintings which have managed to survive the ravages of major natural catastrophes, such as flooding and earthquakes, can be admired to the present day.

Benozzo Gozzoli: Annunciation, 1491, Museo delle Sinopie, Camposanto, Pisa

The specific requirements of the technique of fresco painting demanded a high level of technical ability and experience on the part of the artist (and his assistants). It was particularly important to ensure that the lime mortar and color pigments, which were applied without binding agents, had a specific consistency. The changes in the different color values which occurred over the drying process also had to be taken into account. As the *intonacco* (final layer of plaster upon which the fresco is painted) generally dried out quickly, the painting had to be executed extremely fast. Hence, detailed planning of the approach and a very clearly defined artistic plan were indispensable. The preliminary sketch was crucial to the success of the painting: it was either executed to scale directly on the plaster underlayer of the wall (*arriccio*), or transposed using small-format sketches drawn to scale by means of a grid. The

draft sketches produced in this way were known as "sinopie" and were named after the ochre-colored earth pigment that originated in Sinope in Syria and was widely used in these paintings. In many places, progress in painting restoration techniques have made it possible to remove (or transfer) the top paint and plaster layers to reveal the sinopie underneath. Comparison between the early draft stage and the actual finished fresco makes it possible to draw interesting conclusions with respect to

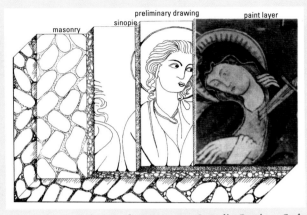

Structure of a fresco after Benozzo Gozzoli: Passion Cycle, ca. 1330/40, Evangelische Kirche, Waltensburg

artistic methods and approaches, particularly when deviations and variations exist between the two versions. The use of so-called "cartoons" became established in the 15th century as a further means of transposing preliminary drawings in 1:1 scale onto the wall surface. This technique involved drawing a preliminary sketch on strong heavy paper which would not tear. Holes were then punctured along the most important contours and outlines in the drawing. Next, the individual sheets were spread out on the wall and ashes rubbed along the punctuated lines. This would make the outlines of the preliminary drawing visible on the plaster when the cartoon was removed. Before applying the actual color, the artist defined the *giornate*, i.e. the sections which could be painted in one session or day (before the plaster dried), in as much detail as possible

on the basis of the preliminary drawing. The finish plaster was applied only to these sections, and any part of the sinopie that was accidentally covered as a result had to be drawn or traced again. A disadvantage of the fresco technique was that, once executed, the painting could be corrected only by removing the plaster and replacing it. Even if such retrospective corrections were avoided, it is still easy to identify the individual sections as fine cracks often form along the *giornate* in the course of time.

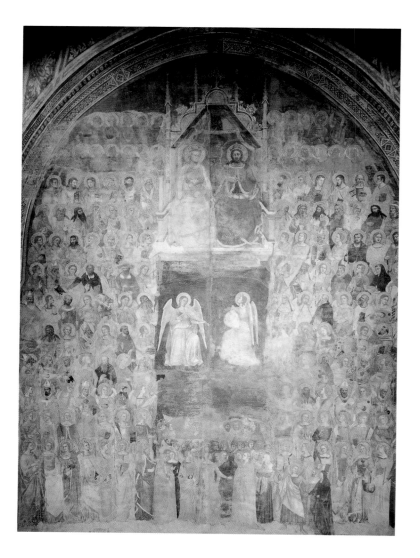

Cappella Strozzi di Mantova

Nardo di Cione: Paradise, ca. 1357
Fresco

Tommaso Strozzi commissioned the Cione brothers to paint the family chapel in Santa Maria Novella during the 1350s. While the Strozzi altar is acknowledged as an important work by Andrea di Cione (known as Orcagna), the murals were the work of his younger brother Nardo. The main wall bears a depiction of the *Last Judgment* while the two side walls are frescoed with motifs from Dante's *Divine Comedy* and include highly vivacious and dynamic portrayals of the *Inferno*, which according to the text was divided into nine circles. Hundreds of figures – including famous Florentine contemporaries – are assembled around Christ and Mary in *Paradise*. Today, it is still possible to gain an impression of the picturesque effect of the paintings, although the frescos have been badly damaged by widespread damp and have required the most extensive restoration work on several occasions over the 20th century.

Nardo di Cione: The Last Judgment, ca. 1357
Fresco

The variety of movements, gestures, and physiognomies of the individual figures, most of whom are portrayed in contemporary dress, betrays an inexhaustible imagination on the part of the artist. The many delightful details – for example, the three damned figures from the fresco of *The Last Judgment* – bear witness to the artist's special talent for the nuanced representation of human movement.

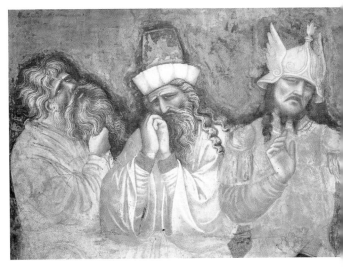

Cappella Tornabuoni

In 1485, Domenico Ghirlandaio was commissioned by the banker Giovanni Tornabuoni to paint the main choir chapel of Santa Maria Novella; the contract for this commission has survived to the present day. The walls were to be frescoed with events from the lives of Mary and St. John the Baptist in honor of the Tornabuoni family and to enhance the appearance of the church and the chapel. Ghirlandaio enlisted the help of his entire studio to complete this major commission and his assistants included his brother David, his brother-in-law Sebastiano Mainardi and, possibly, one 13-year-old apprentice named Michelangelo Buonarroti. To the patron's great satisfaction, the cycle was completed within four years. Although the master produced the drafts for the scenes, he was responsible for only some of the finished versions. Irrespective of their religious themes, the individual scenes transport the observer into the courtly aristocratic world of the late 14th century. In addition to portraits of his patron and his wife, Ghirlandaio also portrayed many famous Florentine contemporaries in the frescos.

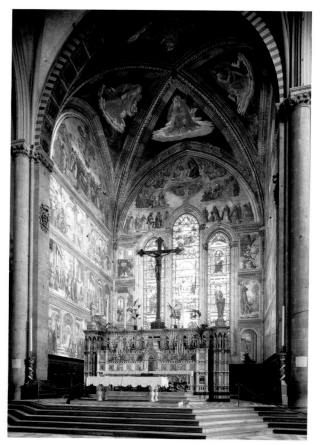

Death and Ascenscion of Mary

Crowning of Mary

Feast of Herod

Adoration of the Magi

Massacre of the Innocents

Burning of Books

Martyrdom of St. Peter

John the Baptist Preaches

Baptism of Christ

Presentation at the Temple

Betrothal of Mary

Annunciation

St. John in the Wilderness

Naming

Birth of St. John the Baptist

Joachim's Expulsion from the Temple

Birth of Mary

Patron Giovanni Tornabuoni

Francesca Pitti-Tornabuoni

Visitation

Annunciation to Zacharias

Domenico Ghirlandaio: Birth of the Virgin, 1485–90
Fresco

The *Birth of the Virgin* is without doubt one of the most atmospheric frescos in the chapel. Ghirlandaio places the event in a sumptuously decorated contemporary interior. The ingenious perspectivist portrayal of the room contrasts with the arrangement of the female figures in the foreground which is not graduated. Once again, portraits of the patron's family feature in this work. The group of women on the right includes Ludovica Tornabuoni, the patron's daughter. Her face, which is presented in profile, exudes refinement while her elaborate dress betrays her affluent and noble origins. The scene further to the right, where three women are busy looking after the newborn baby, is more emotional. The woman with the jug of water seems particularly dynamic in this static environment. Her gown appears to be billowing from the wind, although there is no indication where it could be coming from. Directly behind her, St. Anne – the wife of St. Joachim and mother of Mary – reclines in bed in a relaxed pose, gazing ahead and lost in reverie. She shows no signs of exhaustion from the birth. A parallel scene is played out on the stair landing at the top left of the fresco. This portrays the encounter of Anne and Joachim, Mary's parents, which is equated in the Bible with the immaculate conception of Mary.

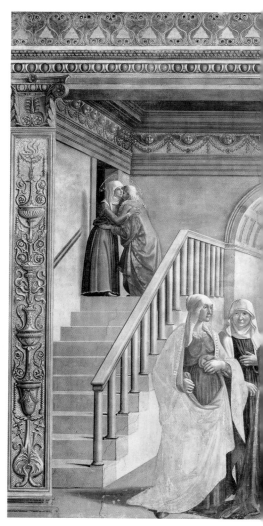

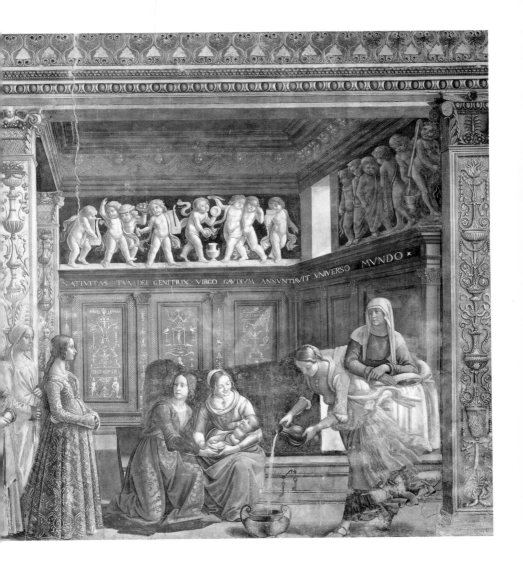

NATIVITAS TVA DEI GENITRIX VIRGO GAVDIVM ANNVNTIAVIT VNIVERSO MVNDO

Domenico Ghirlandaio: Birth of John the Baptist, 1485–90
Fresco

The *Birth of John the Baptist* is the counterpart of the *Birth of the Virgin* and is situated on the opposite wall of the chapel. Again, the event is placed in a sumptuous 15th-century Florentine interior, in which the Tornabuoni family would have felt completely at home. Female members of the patron's family are also portrayed in this fresco. The balanced tranquillity of the biblical event placed in a contemporary Florentine setting is disturbed only by the motion of the servant depicted with billowing garments rushing in to the scene from the right.

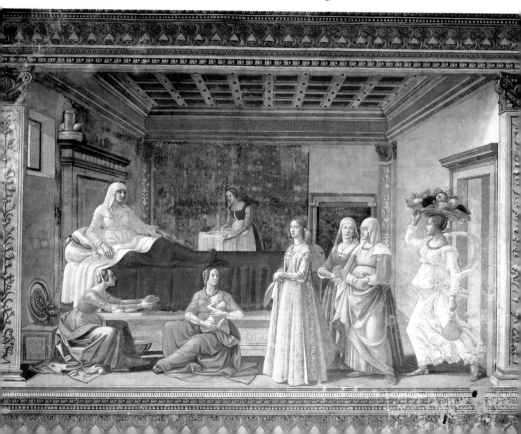

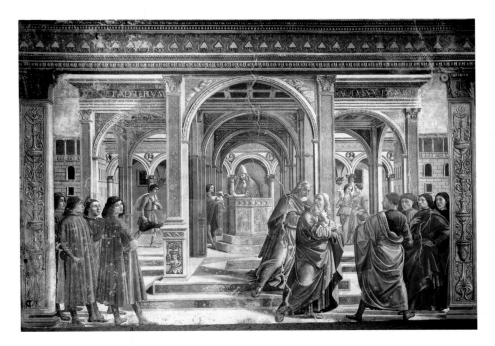

Domenico Ghirlandaio: The Expulsion of Joachim from the Temple, 1485–90
Fresco

According to tradition, Joachim – because he was childless – was not allowed to present the sacrificial lamb in the temple. The actual event is merely referred to in passing in Ghirlandaio's version. Joachim and the high priest who is driving him from the temple may be prominently depicted at the front of the fresco, but the work as a whole is largely dominated by the detailed portrayal of the architectural features. The row of arches in the temple give a view of a loggia at the back which is very reminiscent of Brunelleschi's Foundlings' Hospital. The observers on the left, dressed in contemporary 15th-century garb, are members of the Tornabuoni family. The group on the right includes a self-portrait of the artist, who confidently identifies himself as creator of the painting.

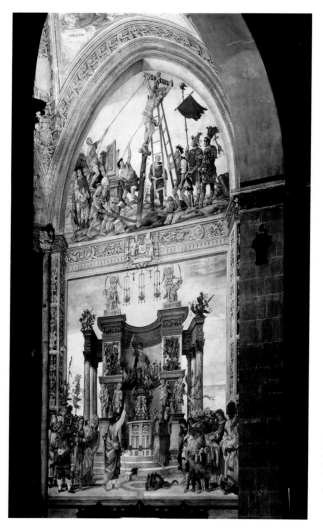

Cappella di Filippo Strozzi

Filippino Lippi: St. Philip Exorcising the Demon in the Temple of Mars (lower register) and Crucifixion (upper register), after 1487
Fresco

The banker Filippo Strozzi acquired the chapel in Santa Maria Novella in 1486 and soon after that commissioned Filippino Lippi to fresco the walls with episodes from the lives of St. Philip and St. John the Baptist. The patron himself was buried in the chapel on his death, while his tomb – executed by Benedetto da Maiano, 1491–93 – still stands at the back wall. In 1488, Filippino Lippi allowed himself the liberty of interrupting the work for a five-year interlude which he spent in Rome. In addition to the paintings, he also created the plans for the stained glass windows of the chapel.

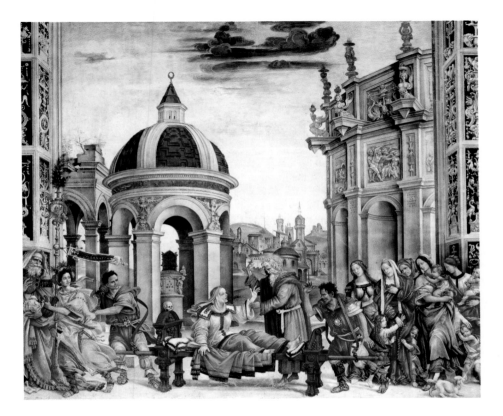

Filippino Lippi: Raising of Drusiana, after 1487
Fresco

In this fresco of the raising of Drusiana by St. John the Baptist, the main figures are executed in color and line drawings and have a distinctly sculptural quality. The main event unfolds like a stage drama while the background is formed by a very plausible architectural backdrop. The unusual and creative visual idiom of Filippino's frescos lends them an exceptional quality and they are considered as the painter's late masterpieces.

Chiostri Monumentali – Museo di S. Maria Novella

The entrance to the Chiostri Monumentali (cloisters), where the Museo di Santa Maria Novella is housed, is on the left side of the façade. It is possible to view the fascinating chapels and rooms which belonged to the former monastery. These are assembled around the "Green Cloister" (Chiostro Verde), which is like an oasis of quiet in the middle of the hustle and bustle of the city. The second, more extensive, cloister can be viewed from outside but is not accessible.

The Chiostro Verde takes its name from the green monochrome which dominates the wall paintings here. The roofed promenade was built between 1332 and 1357 by the lay brothers Giovanni da Campi and Jacopo Talenti. The genesis scenes on the external wall which borders the church originate from the first half of the 15th century: unfortunately, they are not well preserved. Among the various contributing artists, Paolo Uccello was one of the masters who left his mark on the fresco paintings. The portrayals in the first bay depicting the Creation of the Animals and Adam, the Fall from Grace, and the Creation of Eve as well as the story of Noah in the fourth bay are all attributed to Uccelo.

Paolo Uccello: The Deluge, ca. 1440
Fresco (transferred),
215 x 510 cm

Uccello divided the walls to be painted in the individual bays into two horizontal bands, within each of which two biblical episodes were depicted. The fourth bay contains a portrayal of Noah's drunkenness and sacrifice of thanks with the retreat of the flood in the lunette above.

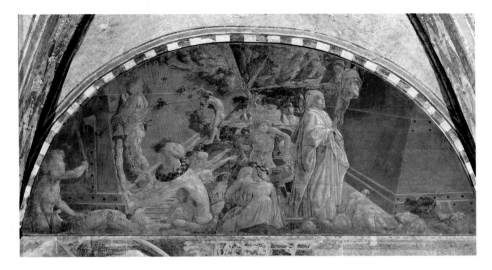

At an initial glance, Uccello's fresco may seem somewhat impenetrable and even quite chaotic. However, the turbulent composition is merely a reflection of the extreme drama of the biblical episode in question. The terror that sweeps over the people with the approach of the flood and the extent of the devastation that becomes apparent on its retreat can be visualized through the imaginative variety of anecdotal detail presented in the painting.

The borders of spatial and temporal logic are largely blurred. The contrasting use of color lends Paolo Uccello's images an almost surreal atmosphere. While the figures on the left are engaged in the desperate and hopeless struggle to escape from the approaching flood, on the right we see the bodies of the drowned (including a small child with a distended stomach) revealed by the retreating water. This unusual juxtaposition of successive scenes is logically counterparted in the double presentation of Noah's ark on the right and left extremes of the fresco. The ingenious use of perspective in the construction of the image achieves a deep maelstrom-like terror which reinforces the dramatic character of the depicted episode.

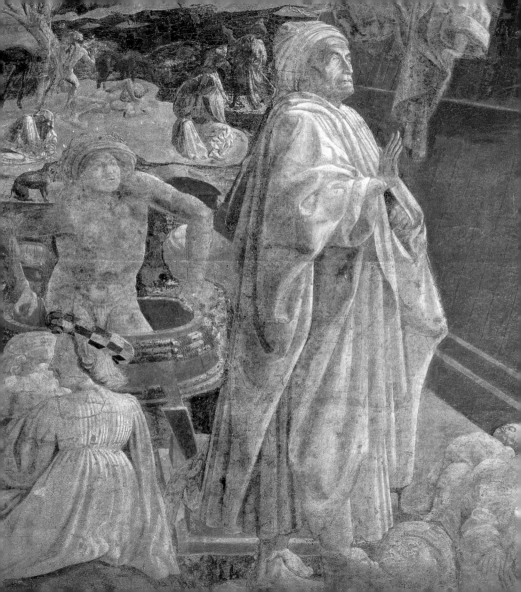

Paolo Uccello: The Deluge – detail (left)

Perhaps Cosimo de' Medici, who commissioned and financed this work, may have wanted to see himself portrayed as the city's savior and peacemaker. The conspicuous figure standing in the right half of the fresco bears an undeniable resemblance to surviving portraits of the head of the Medici family.

Paolo Uccello: The Deluge – detail (right)

The conspicuous black-and-white check headgear (which has slipped onto the figure's neck) appears in a number of Uccello's works. This is an indication of Uccello's predilection for very detailed perspective investigations. The precise execution of these *mazzocchi* was carefully prepared in numerous studies.

Cappellone degli Spagnoli

**Andrea Bonaiuti: Triumph of the Church,
before 1365**
Fresco

The former Dominican chapter-house was
built by Jacopo Talenti around the mid-
14th century. It became known as the
Cappellone degli Spagnoli (Spanish for
Chapel) when it was dedicated to the use of
the Spanish community in 1556 in honor
of the Duchess Eleonora of Toledo.

This vast fresco cycle – one of the biggest
projects of its time – was executed by
Andrea Bonaiuti (also known as Andrea da
Firenze) in the years coming up to 1356.
The richly detailed frescos are based on a
complex theological program which
reflects the philosophy of the Dominican
order and describes the path of man to
redemption and salvation. The allegory of
the *Triumph of the Church* shown here has
an enthroned Christ figure surrounded by
the heavenly throng at the top. In the
earthly sphere below, we see the church's
struggle – symbolized by a model-like
representation of Florence cathedral – to
save and redeem mankind. Members of the
Dominican order are given priority roles
among the numerous saints, church
dignitaries, and order members.

Santa Maria Maggiore

This church is first mentioned in the 10th century. The building as it stands today is based mainly on renovations carried out in the 13th and 14th centuries, although restoration work carried out since then has exposed some elements that are even older. The Virgin in the tympanum above the door is a copy of a 14th-century original housed in the interior.

Coppo da Marcovaldo: Virgin and Child, ca. 1250/60
Tempera on oil and plaster, 250 x 123 cm

The *Virgin and Child* painting by Coppo da Marcovaldo is the most important element in the interior design of Santa Maria Maggiore. The artist is the first of the masters known to us who worked in Florence (ca. 1250/60). His pupils included Cimabue who, in turn, taught Giotto di Bondone. The figure of the enthroned mother of God is executed in plaster and placed on the timber panel with the surrounding paintings. Hence, it represents a combination of the two genres of painting and low relief. The optical effect of the panel is similar to that of a work by a goldsmith. The frontal orientation of the Virgin and Christ child is based on a Byzantine model. The frame contains portrayals of the twelve apostles in the form of standing saints, while scenes from the Annunciation and the three Marys at Christ's grave are placed below the Virgin figure.

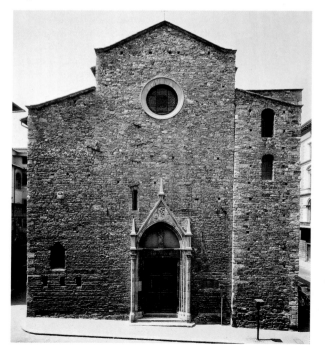

Piazza della Repubblica

This vast square is located at the historical center of the city of Florence. As early as Roman times, a granite column here marked the intersection point of the city's two main roads, the Cardo (north–south) and the Decumanus (west–east). Moreover, the significance of this location in Roman times is reflected in the fact that the Forum and Capitol Temple were situated at this point.

Today, however, the Piazza della Repubblica is like an alien object imposed on the cityscape. This is due to the large-scale redesign of the square carried out in the last decade of the 19th century, which involved the destruction of many elements of the medieval city. The Old Market (Mercato Vecchio) and the former Ghetto were demolished and only Vasari's old fish hall (Loggia del Pesce) was rebuilt on today's Piazza dei Ciompi. It formerly stood on the west side of the square where the enormous triumphal arch (*arcone*) was built in 1895. Like the latter, the other monumental structures and administrative buildings erected around the square seem excessive in their dimensions. Despite the loud vivacity of the numerous cafés and shops which keep the square alive late into the night, the atmosphere here could not be described as particularly pleasant.

The architectural innovations of the late 19th century, which from today's perspective could be deemed regrettable, can

be explained by an increased need for prestigious buildings arising from Florence's temporary status as the capital

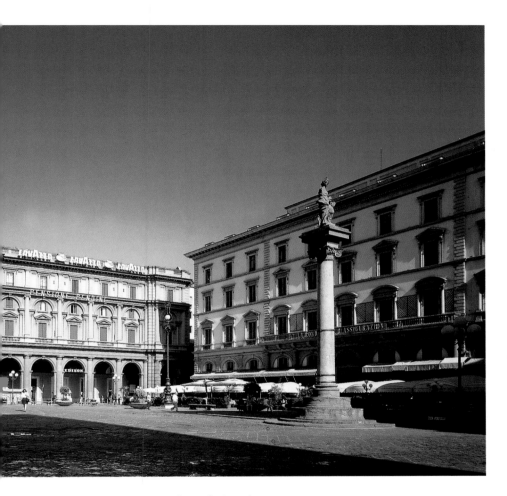

of Italy (1865–71). Hence, the redesigned
square was initially renamed in honor of
King Vittorio Emanuele II.

Loggia del Mercato Nuovo

The impressive new market loggia which is supported by 20 columns was commissioned by Cosimo I and built by Giovanni Battista del Tasso in 1547–51. Among the other activities pursued on this site, moneychangers had been going about their shady business here since the early 15th century, while silk traders dealt in their precious material, and precious stones and goldsmiths' wares were also offered for sale. Today, in addition to tourist souvenirs and trinkets, articles of clothing, jewelry, leather, and straw goods are sold in the market under the arcades which are open on all sides.

Pietro Tacca: Fontana del Porcellino, 1612
Bronze

The *Fontana del Porcellino* (literally "boar fountain") is located on the south side of the loggia. Like the *Trevi Fountain* in Rome, a special magical effect is attributed to the bronze figure of the crouching boar which Pietro Jacopo Tacca (1577–1640) created as a reproduction of an ancient Roman original in marble in the Uffizi. It is said that visitors who throw coins into the fountain and stroke the pig's nose will return to the city on the Arno.

Palazzo Strozzi

The foundation stone for the city dwelling of the affluent Strozzi business family was laid on 6 August 1489 on the basis of detailed astrological calculations. The building had a remarkable history behind it even before the work on its construction began. After a family dispute which had gone on for many years and resulted in the Strozzi family being expelled to Mantuan exile, they had to win back the good will of the Medici as, without their approval, it would not have been possible to undertake this ambitious project. Filippo Strozzi, the family head who wanted to build the palazzo, not only achieved a reconciliation but with great skill and diplomacy also managed to arouse Lorenzo de' Medici's interest by pretending to plan a very basic structure with a few shops on the first story. Lorenzo, nicknamed *il Magnifico* (the Magnificent), was particularly concerned with the improvement of the city. He was so vehemently opposed to this excessively

modest project that he became increasingly involved in promoting the construction of a far more magnificent and ambitious building. As a result, one of the most important secular edifices in Florence was built. It still stands today as a monument to the fame of the city of Florence and the Strozzi family. Fifteen houses in all had to be demolished to provide space for the enormous free-standing structure.

The architects Benedetto da Maiano, Simone del Pollaiuolo, and Giuliano da Sangallo were involved in the realization of this project. The three-story façades are crowned by a powerful cornice which is, however, partly unfinished. The rusticated masonry whose depth diminishes with the ascent from one story to the next is a major element behind the massive bulky impression conveyed by this building. The Palazzo Strozzi now houses various research institutes and is also used as a venue for special events.

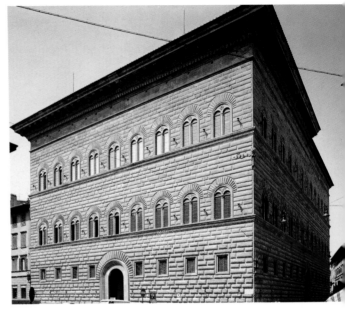

Inner courtyard

With its clear formal language and structure, the inner courtyard of the Palazzo Strozzi can only be described as classically beautiful. Its design is attributed to Simone del Pollaiuolo (known as *il Cronaca*) who succeeded in harmoniously combining the influences of the Early Florentine Renaissance (in the arcades surrounding the first story) with certain elements from Roman architecture (in the upper stories).

Palazzo Davanzati/ Museo dell' Antica Casa Fiorentina

The Palazzo Davanzati is one of Florence's most important medieval family palazzis. The house was originally built in the 14th century for the Davizzi family. In 1578, it then came into the ownership of the Davanzati business family whose coat-of-arms still adorns the exterior.

On the first story, the façade is broken up by three entrances which originally provided access to a hall. Soon, however, they led the way to workshops in which wool products were made and sold. The three upper stories are each divided by five windows of the same shape which, however, vary in height and design of masonry. An open-arched loggia resting on columns has crowned the building since the 16th century.

Sala dei Pappagalli

Thanks to the commitment of the art dealer Elia Volpi, who acquired the building in 1906 and had it restored, most of the original medieval architectural features of this building have been preserved. The Museo dell' Antica Casa Fiorentina (Museum of the Ancient Florentine House) has been located in its interior since 1956. With its numerous fittings and objects from the Middle Ages, Renaissance and Baroque periods, the museum provides a comprehensive impression of the everyday life of the well-to-do in past times. The walls are covered with illusionist paintings which are imitations of tapestries. This room is named after the parrot images used in its decoration.

Santa Trinità

In 1092, the Benedictine order of Vallombrosa came into possession of the predecessor church of today's Santa Trinità, which is first mentioned in a document of 1077 and was then located outside the city boundary. It is presumed that the new Gothic church was erected on the site in the course of the 14th century. Important elements of the rich interior decoration originate from the following century. The façade as we see it today was not actually built until 1593 by Bernardo Buontalenti, a student of Vasari. A distinctive and powerful cornice delineates the upper and lower stories and hence prevents the more organic continuation of the individual forms along the entire wall surface. In this, Buontalenti's design deviates clearly from the Baroque façade models which were popular in subsequent years, particularly in Rome.

Interior

The church is built as a three-aisle basilica based on a Latin cruciform plan. Unlike comparable church buildings in Florence, the relative proximity of the arcade columns gives rise to a clear differentiation of the central aisle from the side-aisles. Moreover, the slightly elevated side chapels are located along the walls of the nave – a feature which is also unprecedented in the city's church architecture. Parts of the interior façade of an earlier Roman structure were revealed during the 19th century.

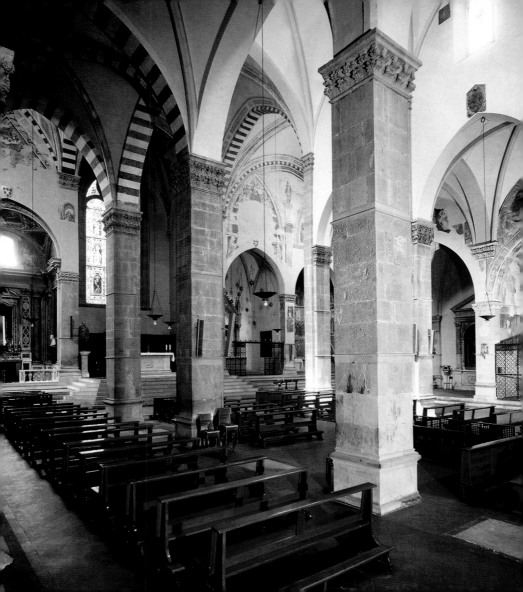

Santa Trinità

Cappella Sassetti – Domenico Ghirlandaio: Altarpiece Nativity and Adoration of the Shepherds (1485) j245and the fresco cycle dedicated to the life of St. Francis (1482–86), p. 244

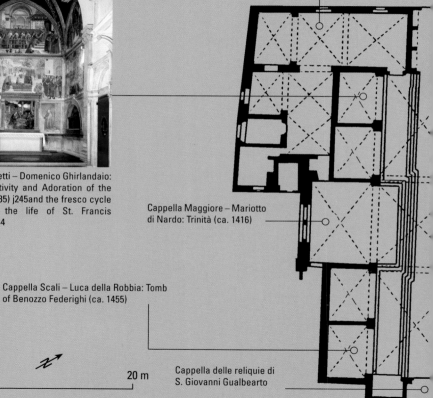

Sagrestia, family and burial chapel of the Strozzi family (1418–23)

Cappella Maggiore – Mariotto di Nardo: Trinità (ca. 1416)

Cappella Scali – Luca della Robbia: Tomb of Benozzo Federighi (ca. 1455)

Cappella delle reliquie di S. Giovanni Gualbearto

0 20 m

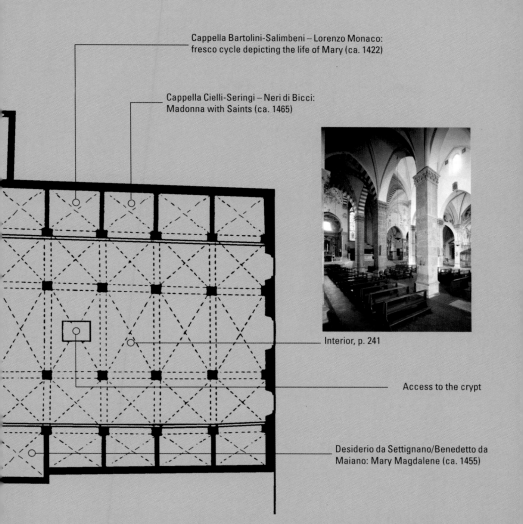

Cappella Bartolini-Salimbeni – Lorenzo Monaco:
fresco cycle depicting the life of Mary (ca. 1422)

Cappella Cielli-Seringi – Neri di Bicci:
Madonna with Saints (ca. 1465)

Interior, p. 241

Access to the crypt

Desiderio da Settignano/Benedetto da
Maiano: Mary Magdalene (ca. 1455)

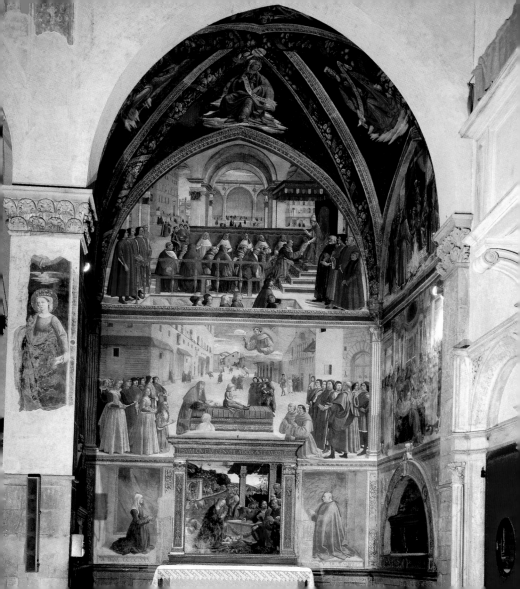

Cappella Sassetti

Francesco Sassetti originally planned to decorate a chapel in the church of Santa Maria Novella with scenes from the lives of his patron saint, St. Francis of Assisi. However, the Dominicans, who were in residence there, were not enthusiastic about the idea of the founder of the Franciscan order being honored in their church. They opposed the plan so vehemently that Sassetti, who was a very influential banker, had to abandon his project.

After very many years of quarrels and disputes, the proposed Francis-cycle was finally executed in a side chapel of the neighboring church of Santa Trinità.

Domenico Ghirlandaio was commissioned to produce the decorative fresco. After their deaths, Francesco Sassetti and his wife Nera Corsi were buried in the chapel. Their tombs, which are still in the chapel, were most likely produced in Giuliano da Sangallo's studio. The two patrons also had themselves portrayed in the fresco in a kneeling position at the side of the altarpiece in the lower part of the main wall.

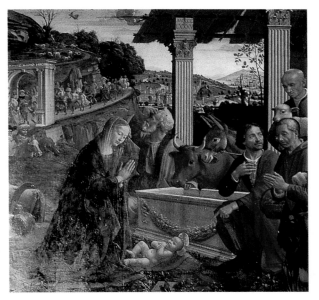

Domenico Ghirlandaio: Nativity and Adoration of the Shepherds, ca. 1485
Oil on wood, 167 x 167 cm

Ghirlandaio's altarpiece is inspired by the Portinari Altarpiece in the Uffizi (see p. 152). It also includes motifs from Roman antiquity which refer to a prophesy by the augur Fluvius. According to the inscription, a god will rise to the world from his tomb. This is an oblique reference to the concept behind the chapel decoration which tries to link Roman antiquity with Christian salvation.

Domenico Ghirlandaio: Stigmatization of St. Francis, ca. 1485

Fresco

The figures in the Sassetti Chapel frescos reveal that Ghirlandaio carefully studied Giotto's St. Francis cycle in the church of S. Croce (see p. 381) before he started working here. In contrast to his famous predecessor, however, he executed the backgrounds of his frescos as images of contemporary Florentine locations or elaborate landscapes which are as rich in detail as they are attractive.

This fresco, which is dominated by green color tones, portrays the miracle of the stigmatization of St. Francis of Assisi (1182 –1226). At the foot of the La Verna mountain, the reputed site of the event in 1224, the saint went down on his knees before the apparition of the crucified Jesus. The beams of golden light on his body symbolize the apparition of Christ's wounds. The witnesses to the event include the persons shown in the background of the picture as well as a second Franciscan monk, who is presented in the foreground shading his eyes with his hand.

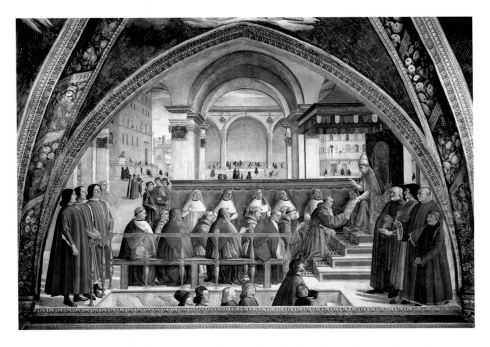

Domenico Ghirlandaio: The Confirmation of the Rules of the Franciscan Order, ca. 1485
Fresco

In this fresco, Ghirlandaio ignores the fact that the rules of the Franciscan order were actually confirmed by Pope Honorius III in Rome and he transposes the historical event to contemporary Florence. The Piazza della Signoria is clearly recognizable in the background. A variety of attractive scenes from everyday life can be observed under the arcades of the Loggia dei Lanzi, while the façade of the Palazzo Vecchio can be observed further left. The Uffizi had not yet been built at the time of this painting, and Michelangelo's *David* would not be erected in front of the Palazzo until two years later. However, Donatello's lion (*Marzocco*) can already be seen on the subsequently demolished platform in front of the façade.

The fresco also provides visual proof of the Sassetti family's loyalty to the Medici. On the far right, Francesco Sassetti is portrayed wearing a red cloak and standing beside Lorenzo de' Medici.

Palazzo Rucellai

Around the mid-15th century, the affluent wool trader Giovanni Rucellai entrusted Leone Battista Alberti with the planning and design of his family's city palace. The latter's plans, which were executed by Bernardo Rosselino's studio around 1450, provided Florence with what is probably its most outstanding secular building. Alberti confidently drew on his knowledge of ancient Roman architecture in the design of the façade and combined this consistently and successfully with forms of expression which were specific to Florentine palazzo architecture. The building is horizontally articulated in three stories which are vertically linked by a grid of pilasters with no structural function. As in the Coliseum in Rome, the column order is Doric on the first story, Ionic on the second, and Corinthian on the third. As was standard in Florence, the wall surfaces are clad in rusticated masonry, but the individual stones are smooth as opposed to rough-hewn. The strict series of rectangular forms is interrupted only by the arched window surrounds.

Loggia dei Rucellai

Bernardo Rosselino (1409–1464) was commissioned around 1460 by the banker Giovanni Rucellai to build the Loggia dei Rucellai on the basis of plans designed by his teacher Alberti. This building stands opposite the Palazzo Rucellai and was originally used by the family for receptions and prestigious events.

The Museo di Storia della Fotografia Fratelli Alinari is housed in this building.

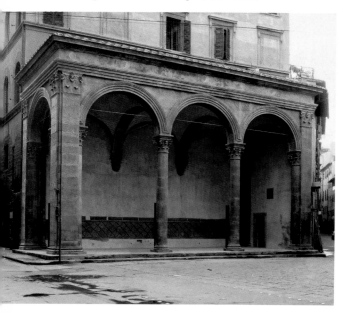

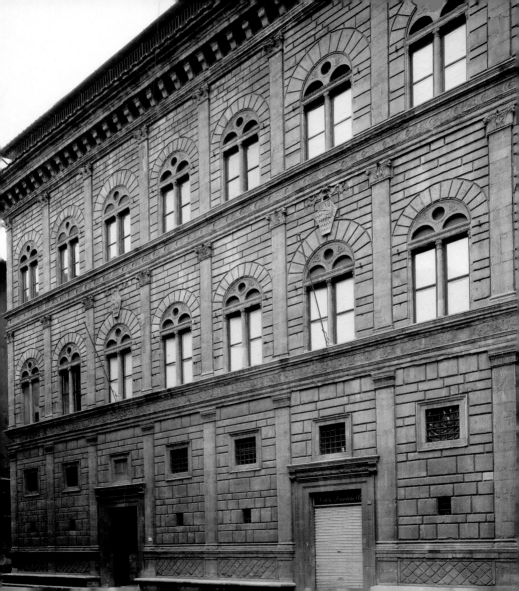

The Florentine Renaissance Palazzo

Historically and architecturally, the great era of the Renaissance palazzo begins in the middle of the 15th century. With the considerable rise in their fortunes, the city's wealthy bankers and traders seem to have felt the need to build stately residences, often of considerable size. The architects enlisted for these buildings were among the outstanding talents of their time and not only changed the appearance of Florence but also extended their work far outside the borders of the city. The new building craze reached its peak around the middle of the century. In the years between 1450 and 1478 alone, 30 palazzi were built. Alberti summarized the tremendous changes in the center of the city: "How many houses had only boards in our childhood, where now marble lies." Around 1450 he himself had designed the new residence of the Rucellai family after Michelozzo had erected the much admired prototype of the classical Renaissance palace with his Palazzo Medici (built from 1444 onwards). Brunelleschi is credited with the first plans for the Palazzo Pitti on the other side of the Arno, for which construction work began in 1457. Benedetto da Maiano designed the Palazzo Strozzi (after 1489), and his brother Giuliano the palaces of the Antinori (1461–69), Pazzi (1462–72) and Gondi (around 1490) families. As Luca Landucci remarked in his Florentine diary, "the people of that time built to such an extent that there was a lack of craftsmen and material." In order to make the

Palazzo Davanzati: Detailed view of the inner courtyard with frescos and columns

Palazzo Antinori, façade

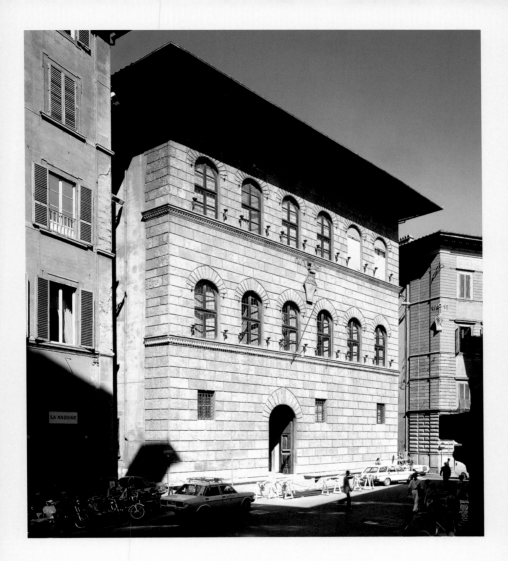

tremendous costs more bearable, all those who had houses built on undeveloped plots of land were even granted a 40-year tax exemption at the instigation of Lorenzo de' Medici in 1489. Nevertheless, in many cases older buildings still had to be pulled down to make more space for the huge new constructions.

Despite deviations in the details, the palazzi of that time resemble each other in some essential characteristics. Following the model of the Palazzo Medici the architects, when designing the basic cubes of buildings, were often inspired by the large town palazzi such as that of the Signoria in order to illustrate the links of the clients' families with the community. The outer façades usually have a defensive character, with rusticated masonry contributing substantially to the impression. The stories – usually three in all – are clearly divided from one another, the shapes of the ashlars often varying

Palazzo Gondi, facade

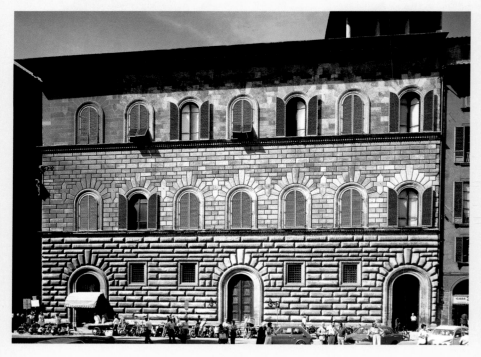

The gardens of the Palazzo Medici-Riccardi

from one story to the next. The buildings are closed off at the top by cornices and the broad overhang of the roof, whilst a stone bench running around the base of the exterior may have served those waiting to be admitted.

Harmoniously arranged courtyards lay at the centers of the palaces. There would often be a fountain in the middle, and the surrounding colonnades were directly reminiscent of the city's monastic cloisters.

Museo Marino Marini – San Pancrazio

The former church of San Pancrazio had already been secularized in the 19th century. Over the years it was in use as a tobacco factory and a military depot until the Museo Marino Marini was opened here in 1988. The rooms of the museum are hidden behind the late 14th-century façade which has been preserved as far as possible – the portal originates from Alberti's neighboring Rucellai chapel and was added in the 19th century. The interior was designed in a surprisingly modern way by Lorenzo Papi and Bruno Sacchi using concrete and iron.

Inside, almost 200 works of the painter, graphic designer and sculptor Marino Marini (1901–1980) are on show. The artist, one of the most important Italian sculptors of the 20th century, is most famous for his sculptures of horsemen. He made these large works, usually reduced to only a few striking characteristics, as monumental and partly free-standing forms of great size.

Ognissanti

The church of All Saints (Chiesa di Ognissanti) was founded by the Humiliati order of monks in the mid-13th century. Here, near the Arno, an economically important center of the wool industry was established. In 1561 the Franciscans took the church into their care and it was altered several times, until well into the late 17th century, and largely rebuilt. Today's Baroque façade (around 1637) dates back to Matteo Nigetti. Above the main portal the majolica of the Coronation of the Virgin (around 1515) has been preserved.

Members of the famous Vespucci navigator family found their last resting place in Ognissanti. Domenico Ghirlandaio had decorated their family chapel around 1472 with frescos of the *Virgin of Mercy* and the *Lamentation of Christ*, which have been preserved to this day. Ghirlandaio also painted the fresco of *St. Jerome* on behalf of the Vespucci family. Sandro Botticelli, who was also buried in Ognissanti, had already painted its counterpart of *St. Augustine*. Formerly both pictures were located at the entrance of the monks' choir, but then in 1970 the paintings were removed and they are now situated opposite one another in the nave.

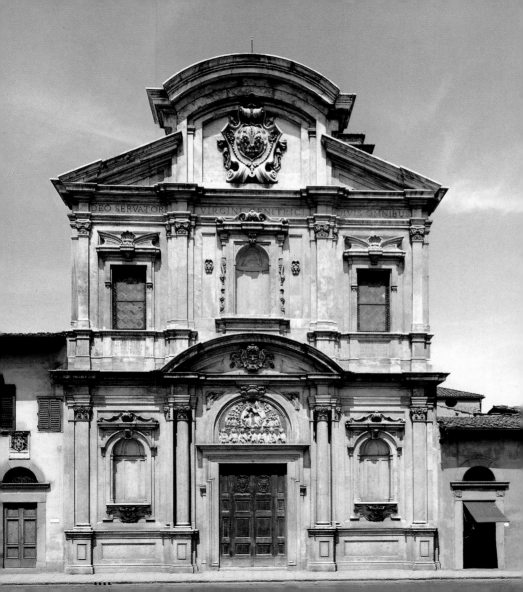

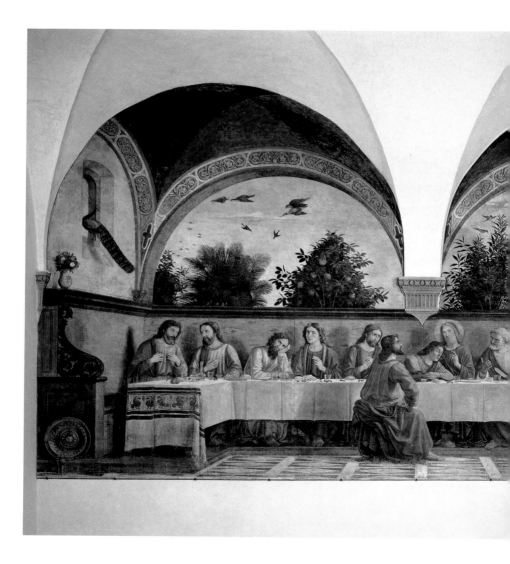

Domenico Ghirlandaio: The Last Supper, ca. 1480

Fresco, 400 x 800 cm

Ghirlandaio's fresco in the refectory of Ognissanti owes essential ideas to an earlier version by Andrea del Castagno in the Cenacolo di Sant' Apollonia. Judas is placed in isolation from those at the table in both paintings. In contrast to the more monumental and dramatically charged style of the figures by Castagno, Ghirlandaio's apostles appear more spiritual. They seem more life-like in their spiritual expressions and their gestures; the mood is marked by an almost melancholy gentleness.

Ghirlandaio extended the actual architecture of the refectory in an illusionistic manner in the painted room. The painter seems to have aimed at the greatest possible identification with the events shown, the design of the perspective being adapted to the viewer in precise calculation. The exposed sinopia, which can be seen on the left side-wall of the room, bears witness to Ghirlandaio's artistic practices.

Only a few years later Ghirlandaio was entrusted with a similar painting of the Last Supper in San Marco. The frescos found an admirer in Leonardo da Vinci, who was inspired by the subject to create one of the masterpieces of art history in his famous *Last Supper* (1495–98), in Santa Maria delle Grazie in Milan.

Domenico Ghirlandaio:
St. Jerome, ca. 1480
Fresco (transferred),
184 x 119 cm

Ghirlandaio's fresco of St. Jerome was the result of a competition with Sandro Botticelli, who had just painted the fresco of St. Augustine by the choir of Ognissanti. The picture shows Jerome, the Father of the Church, "in his study," a room furnished with Greek, Latin and Hebrew manuscripts as well as numerous writing materials. The saint has interrupted his writing down of the Bible translation for a moment and is looking in the direction of the viewer. This early work clearly shows Ghirlandaio's orientation toward Flemish models. A small-format panel painting made by Jan van Eyck (to be found today in Detroit), which at that time belonged to the Medici, seems to have been particularly inspiring.

Sandro Botticelli:
St. Augustine, ca. 1480
Fresco (transferred),
152 x 112 cm

Botticelli's fresco provided the formal dimensions of space for Ghirlandaio's – both paintings had been on a wall of the monks' choir. However, they differ distinctly in mood. St. Augustine, a voluminous figure, is also depicted in a well-equipped study, whose arrangement again betrays Botticelli's knowledge of Flemish models. However, he is positioned at a greater distance. In this picture the saint is not looking at the viewer but is lost in thought. Augustine seems moved by prophetic visions which cause him to make the touching gesture of his right hand in a moment of religious emotion.

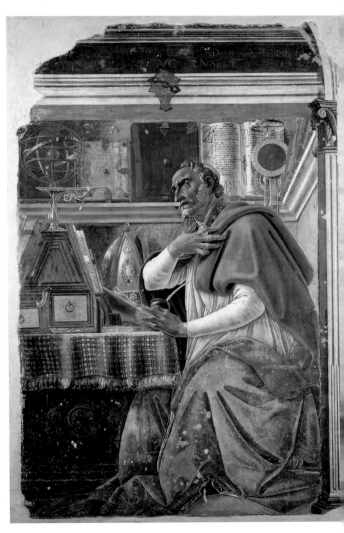

Domenico Ghirlandaio: Virgin of Mercy, ca. 1472
Fresco (transferred)

In the early Middle Ages the legal practice, especially north of the Alps, of giving asylum and thus protection to important persons, people seeking help and the persecuted, was referred to as the "Cloak of Protection." During the 13th century, the type of picture known as the "Virgin of Mercy" developed from this old legal tradition, especially within the Dominican and Cistercian orders. Mary appears as "the Madonna of Mercy" with her cloak spread wide, protecting the faithful. Domenico Ghirlandaio's lunette fresco in the chapel of the Vespucci family corresponds to the tradition of the subject of these pictures. The Virgin is positioned like a statue on a pedestal with her head slightly bowed. The inscription on the pedestal says that the world is filled with the compassion of God. With open arms Mary has raised her hands to give the members of the founder family protection. Men and women, strictly separated, are kneeling to the right and left of her. Two assisting angels are holding her cloak at either side. Behind the Virgin on the left we may recognize the famous discoverer Amerigo Vespucci (1451–1512), to whom America owes its name.

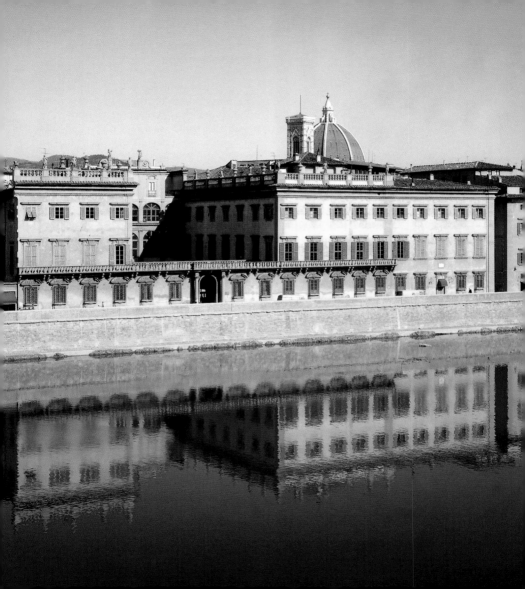

Palazzo Corsini

The main parts of the Palazzo Corsini were built between 1648 and 1656 according to the plans of the architect Pierfrancesco Silvani. In the subsequent period it was added to by Antonio Maria Ferri among others. The side of the extensive building facing the Arno is decorated with allegorical statues and the most unusual examples of Baroque architecture on Florentine soil. The imposing interior, which was, however, never occupied by the Corsini family, is also decorated in the taste typical of Florence at the end of the 17th century.

In the first story an artificial grotto was constructed, while monumental steps lead up to the luxuriously decorated halls on the second story. The Galleria Corsini today still houses one of the most impressive private collections of Italian painting (from the 15th to the 17th century). Unfortunately entrance to the rooms of the gallery must be booked in advance.

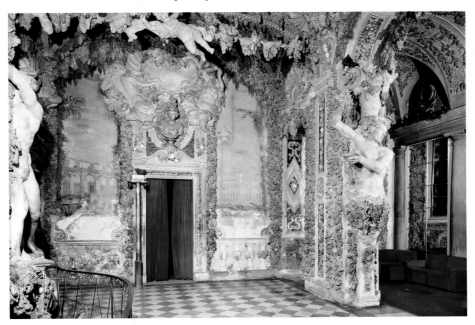

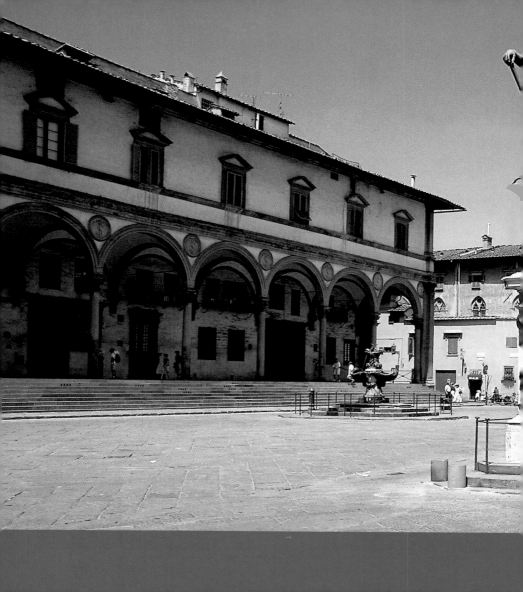

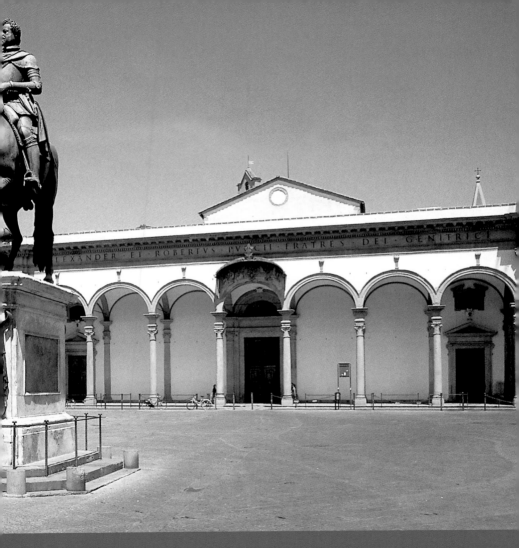

From San Lorenzo to the Piazza Santissima Annunziata

San Lorenzo

The San Lorenzo complex dates back to one of the oldest church foundations in the city (around 380). Today only a vague impression of the previous buildings remains, because before the present basilica could be built a whole district had to be pulled down in 1418. Filippo Brunelleschi was put in charge after building the adjacent Old Sacristy. The work soon came to a standstill, though, because the money from the sponsors involved threatened to dry up. Finally, only the Medici family continued to provide the enormous sums needed to complete the basilica. In this way San Lorenzo became their family church. Long after Brunelleschi's death (1446) the construction was completed by Antonio Manetti but the exterior remained unfaced, so the outer walls still look austere. The monument of Giovanni delle Bande Nere, the father of Cosimo I, was set up in front of the church. The seated figure of the former head of the Medici is by Baccio Bandinelli and had initially been erected in the Palazzo Vecchio after it was completed in 1544.

The Interior

Brunelleschi planned an impressive interior, harmoniously worked out down to the last detail. A three-nave basilica with a cupola-vaulted transept is based on a traditional ground plan. The arcades of the flat-roofed long nave are carried in even succession by monolithic columns with richly decorated capitals. The side naves are vaulted; however, they continue the rhythm of the middle nave in the fluted pilaster frames of the flanking chapels and the arches above these. The individual shapes, which are in Classical vein, remind one of early Christian models, but were also used in buildings of the Florentine Proto-Renaissance. Even today, the evenly lit room still appears clearly adjusted to the human scale in its conception and its canon of proportions.

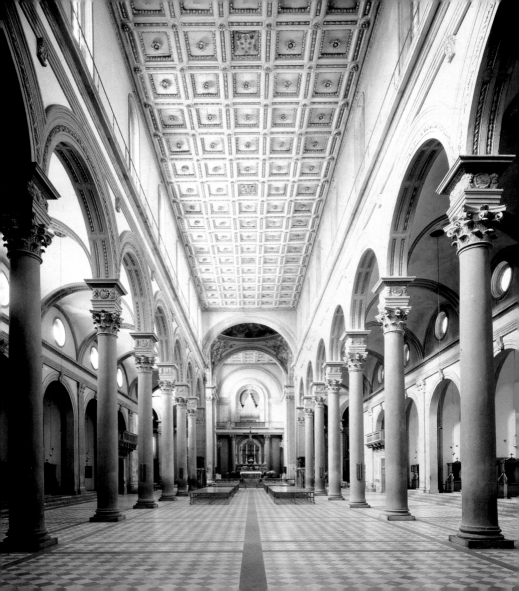

Donatello: Passion Pulpit, after 1460
Bronze, 137 x 280 cm

In accordance with the subjects depicted, Donatello's famous San Lorenzo pulpits are respectively known as the Resurrection and Passion pulpits (shown here). The master died while still working on the reliefs; assistants completed the work, but the two pulpits were not joined up to form their present shapes until long after Donatello's death. Nonetheless they provide a late brilliant example of his pioneering relief art.

At the age of almost 80, he seems to have surpassed all contemporary conventions of artistic interpretation. Even today his unusual, indeed unique, reliefs are evidence of an artistic disposition which did not shrink from continuing the narrative flow beyond the limits of the reliefs and which, in its richness of imagination, makes closer observation very worthwhile.

Filippo Lippi: The Annunciation, ca. 1440
Oil on wood, 175 x 183 cm

The altarpiece of the *Annunciation* is one of Filippo Lippi's most important works. The combination of diverse stylistic features has seldom been brought to a more effective synthesis. A precise flow of the lines in late Gothic style does not interfere with the plasticity of the physical figures. The clear compositional structure is enriched by a fullness of architectural details. Strong accents are set in the coloring, while at the same time bright daylight adds to the modeling and conjures up an atmosphere of fantasy. The figures of the archangel and the Virgin Mary reveal the influence of Donatello's magnificent Annunciation in Santa Croce. They also remind us that none other than Sandro Botticelli was Filippo Lippi's most famous pupil.

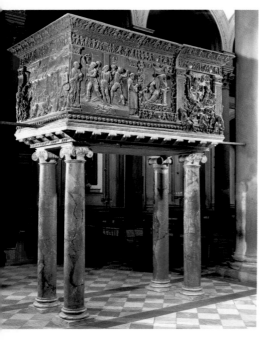

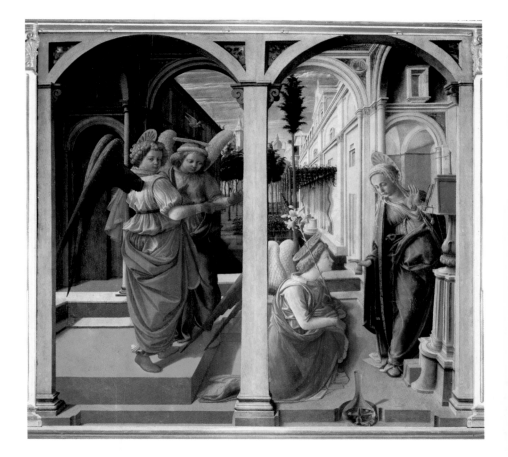

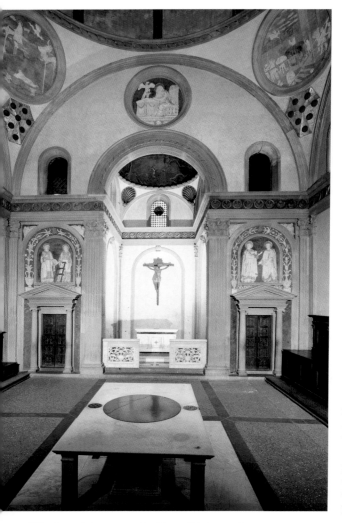

Sagrestia Vecchia

Together with the Ospedale degli Innocenti, the Old Sacristy (Sagrestia Vecchia, built between 1422 and 1428) is one of the earliest and most important examples of the architectural theory of Filippo Brunelleschi. Two simple geometrical figures, the square (cube) and the circle (sphere), are the basis of the whole architectural conception. In elevation the building is divided into three parts of equal size. The side walls are separated by clearly accentuated entablatures. The rectangular shape of the walls dominates. Above that, arches and pendentives lead into the dome.

The dome's radius again corresponds exactly to the measurements of the sections of the wall. Each detail is designed in a precisely calculated proportion to the whole. With the Old Sacristy, the first central-plan space of the Renaissance, Brunelleschi set the standards for later European architecture.

The "purist" Brunelleschi is not supposed to have been very taken with his friend Donatello's later, sculptural adornment of the room, especially since he had probably not been consulted. Commissioned by Cosimo the Elder, between 1434 and 1443 Donatello created four circular reliefs with scenes taken from the life of St. John in the pendentives and pictures of the four Evangelists in the lunettes. With a diameter of more than six and a half feet (2 meters) the impressive stuccoed tondi are of monumental size, which until then might only have been found in a comparable context in glass windows. In addition, Donatello's decoration comprises the two sopraporte and the only preserved bronze portal made by him with pictures of martyrs and apostles.

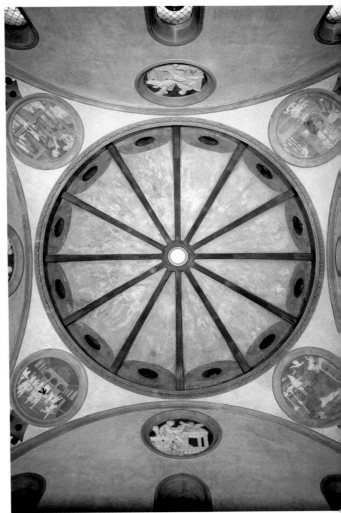

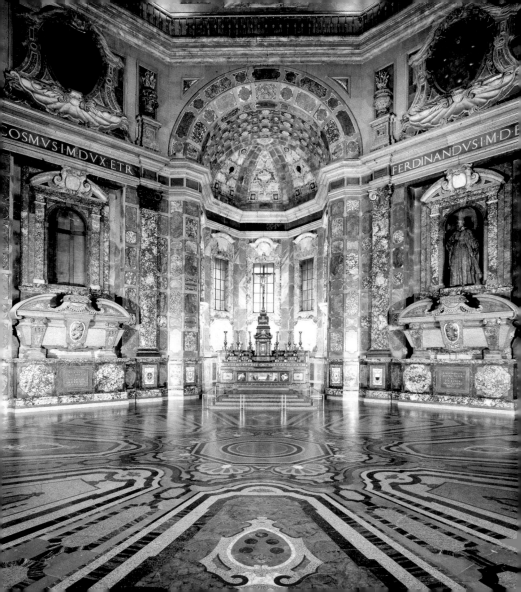

Cappella dei Principi

Vasari had already presented Cosimo I with plans for a mausoleum of the Medici grand dukes in 1568. It was, however, not until 1605 that the implementation of the plans began, following a model by Don Giovanni de' Medici under the supervision of Matteo Nigetti. In the meantime the earliest plans had already been extended considerably, to create the gigantic structure which can still be seen in the royal chapel. The building, an independent, central-plan room, whose cupola can be seen from afar in the panorama of the city, is built on an octagonal ground plan. The extensive work could only be completed over several centuries. The cupola was closed in 1826, and additional decorative work is still being carried out in our times. For the costly *pietra dura* decorations no expense and no pain was spared. The most precious materials were gathered from all over Europe and were processed with an admirably skilled meticulousness. The monumental sarcophagi of the grand dukes (Ferdinando

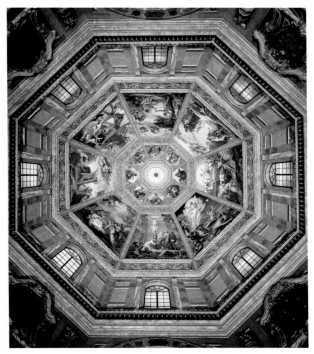

I, Cosimo II, Ferdinando II, Cosimo III, Francesco and Cosimo I) are built into the side walls. Only two of the planned bronze statues of the deceased have been made.

Between 1828 and 1836 Pietro Benvenuti created frescos with biblical scenes and saints to decorate the cupola.

San Lorenzo

Sagrestia Vecchia, p. 272

Filippo Lippi: The Annunciation
(ca. 1440), p. 271

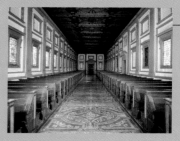

Biblioteca Laurenziana (second story),
p. 293

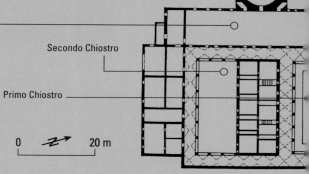

Secondo Chiostro

Primo Chiostro

0 20 m

"Balconata" (gallery of
relics according to plans by
Michelangelo, ca. 1530)

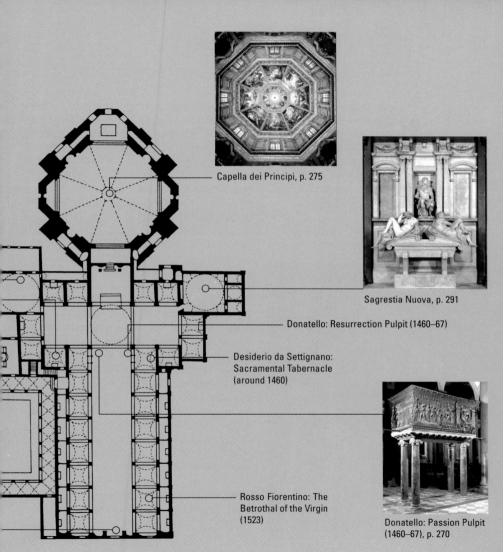

Capella dei Principi, p. 275

Sagrestia Nuova, p. 291

Donatello: Resurrection Pulpit (1460–67)

Desiderio da Settignano:
Sacramental Tabernacle
(around 1460)

Rosso Fiorentino: The
Betrothal of the Virgin
(1523)

Donatello: Passion Pulpit
(1460–67), p. 270

Florence and the Medici

No other name is as closely connected with the history of Florence as that of the Medici family. Members of the family belonged to the "first citizens" of the city for over three centuries, and, with some minor interruptions, they unofficially ruled the metropolis on the Arno. Although we do not know of any doctors in the Medici family, it can be assumed, based on the origins of the

The Medici coat of arms, intarsia, Capella dei Principi, San Lorenzo, Florence

family name (medico = Italian for doctor), that some members must originally have carried out this profession. Giovanni di Averardo di Bicci (1360–1428), the first ancestor of the Medici known to us, was a banker. He was one of the richest citizens of Florence when he died. Not only did he leave behind a thriving banking house but he had also established his family in the highest social circles of the city. He was the initiator of the long-standing family tradition of charitable support for the community and generous patronage of the arts. His son Cosimo, known as *il Vecchio* (the old man, 1389–1464), one of the most outstanding personalities of the Quattrocento (15th century), became head of the Medici family.

Cosimo combined foresight in business with an astonishing talent for diplomacy. Modesty and intelligence, generosity and a high degree of culture were features of his character. He was able to increase the Medici's prosperity and influence continually without encroaching on the sensitive democratic and republican identity of the city's inhabitants. Cosimo's list of successes was only interrupted for a short time in 1434 when he was imprisoned and exiled. He returned with new strength from his Venetian exile after only one year, however. The Albizzi family, his chief opponents, were now exiled from Florence. Cosimo finally moved to the top of the small group of influential personalities who held the actual power in Florence. For over 30

years, until his death in 1464, he was *pater patriae* to the Florentines, the father of the fatherland.

Without doubt, the name Medici owes its special fame to the fact that they supported the intellectual, cultural and scholarly life of their time to an unusual extent. Cosimo not only found enormous sums for the renewal and decoration of the monastery complex of San Marco, but asked Brunelleschi to work on San Lorenzo and commisioned Michelozzo to begin building the Medici family palazzo on the present Via Cavour in 1444. In addition to the outstanding architects, the most talented painters and sculptors of the time profited by Cosimo's patronage. Paolo Uccello, Filippo Lippi and probably also his friend Donatello were among those who were inspired by Cosimo to great Renaissance works of art. However, this generous support given to art was never completely without ulterior motive, as the farsighted banker always seemed to be aware of the propaganda value of his donations. The splendor of the paintings and sculptures was intended to increase respect for the Medici family.

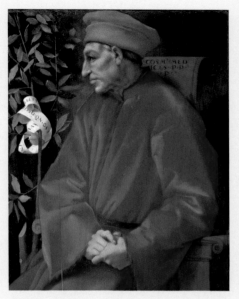

Pontormo: Cosimo il Vecchio (posthumous), ca. 1518, oil on wood, 86 x 65 cm, Galleria degli Uffizi, Florence

Moreover, Cosimo devoted himself, with great interest, to the intellectual life of the time. He acquired many manuscripts which were the basis of famous libraries. His house was frequented by the most progressive scholars. Cosimo encouraged Marsalio Ficino, to whom he left a house in Florence and a villa near Carreggi, to translate Plato's texts. Cosimo also founded the legendary "Platonic Academy" following the Classical model. Within a short time the most important humanists of the time were meeting in association with the academy.

Like Cosimo de' Medici, his son and successor Piero de' Medici (1416–1469) was an enthusiastic collector of books and precious stones, coins and exquisite objects of all kinds. The young Botticelli and Benozzo Gozzoli were among the artists supported by Piero. However, he was only to rule for five years, thanks to his ailments, which caused the Florentines to give him the name *il Gottoso* (the Gouty). Although biographers describe him as having a compassionate nature as well as a definite talent for politics, he is seen as one of the more

unfortunate descendants of the Medici. At the age of 20 Lorenzo (1449–1492), one of Piero's five children, became perhaps the most colorful figure in the upper ranks of the family's hierarchy. His nickname is also revealing of his personality: the Florentines referred to him as *il Magnifico*, the Magnificent. His physical appearance, which was often described as ugly, stands in contrast to the passion with which he devoted himself to aesthetic objects during his life. He also continued the tradition of patronizing the arts, as well as philological and philosophical circles. The modest reserve

Giorgio Vasari: Lorenzo il Magnifico (posthumous), 1534, oil on wood, 90 x 72 cm, Galleria degli Uffizi, Florence

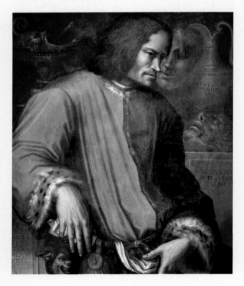

which distinguished Cosimo il Vecchio, however, found its opposite in Lorenzo. He cultivated a liking for splendor and luxurious display. It was at his instigation that carnival was introduced in Florence, among many other festivities, and Lorenzo himself was in the habit of writing secular songs for these occasions.

Lorenzo's rule doubtless stands as one of the highlights in the history of the Medici dynasty, although the signs of its future decline could not be overlooked. On 14 April 1478 Lorenzo only narrowly escaped an attempt on his life in the cathedral by the hostile Pazzi family while his younger brother Giuliano was killed in this assassination attempt. Lorenzo managed to strengthen his position of power again, and the conspirators were hanged at the windows of the Palazzo Vecchio in the full sight of everyone. The years before Lorenzo died were ultimately clouded by the growing conflicts with the ascetic preacher Girolamo Savonarola. The differences between the worldly potentate and the fanatical Dominican friar were insurmountable.

Lorenzo died on 8 April 1492 at the age of only 43. His son Piero (1472–1503) soon turned out to be incompetent and not very fortunate in his handling of all public and family issues. He has thus correctly gone down in history as *lo Sfortunato* (the Unhappy one). He could not do anything to counteract the growing number of Savonarola's supporters. He and his family were forced to leave Florence in 1494 and the glorious history of the Medici dynasty had reached its temporary end, although the family was to provide the popes Leo X, Clement VIII and Pius IV in the 16th century and even win back their dominance in Florence.

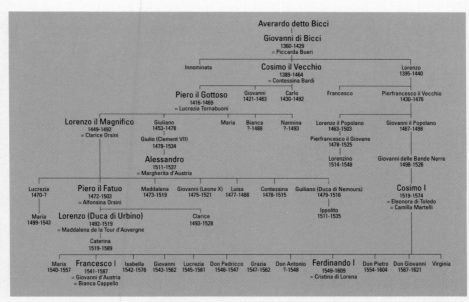

Family tree of the Medici family (from the beginning to the 16th century)

The rule of the first Medici grand duke Cosimo I (1519–1574) already showed the clear features of an absolutist reign. His successors could not continue the glory of past times. After the last male successor Gian Castone (1671–1737) died, the Grand Duchy fell to the Lorraine dynasty. The family finally died out completely in 1743 with the death of Anna Maria Lodovica de' Medici, the last descendant.

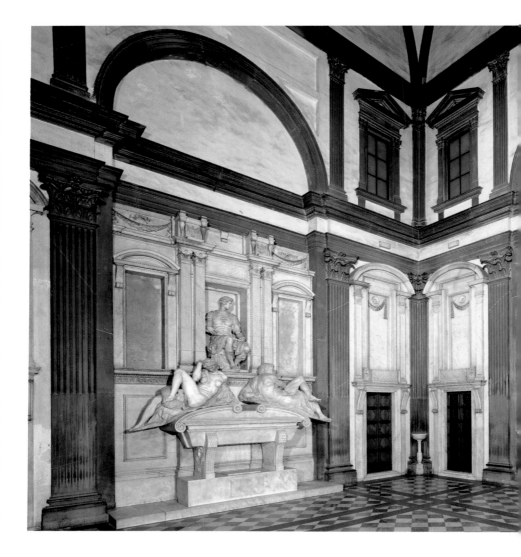

Sagrestia Nuova

Michelangelo's New Sacristy is a mausoleum for members of the Medici family. The Medici pope Leo X had commissioned the building of the chapel in 1519. Together with Lorenzo il Magnifico (the Magnificent, 1449–1492) and his brother Giuliano (1453–1478), the two identically named Medici dukes Giuliano (1479–1516, son of Lorenzo the Magnificent), and Lorenzo (the Duke of Urbino 1492–1519) were supposed to be buried here. The main dynastic line of the Medici had died out with the early deaths of the latter two as neither had a legitimate heir. In view of the tragic circumstance Leo X is supposed to have proclaimed: "From now on we no longer belong to the house of Medici, but to the house of God." The construction of the funeral chapel was intended "to keep, apart from the Magnifici, the young dukes also in honorable remembrance and praise the glory of the dynasty – at a point when their fate was uncertain" (V. Guazzoni).

The unusual feature in the commissioning of Michelangelo was that he was entrusted not only with the architecture but also with the adornment with sculptures and frescos. Being architect, painter and sculptor at the same time, he was to make the building into a harmonious whole; in a sense, a total work of art.

Unfortunately he never managed to complete his plan. When Michelangelo

From San Lorenzo to the Piazza Santissima Annunziata

Chiostro dello Scalzo,
Via Cavour 69, p. 336

Cenacolo di S. Apollonia/
Museo Andrea del Castagno,
Via XXVII Aprile 1, p. 334

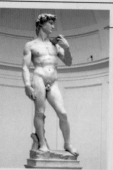

Galleria dell' Accademia,
Via Ricasoli 60, p. 311

San Lorenzo,
Piazza San Lorenzo p. 9, 269

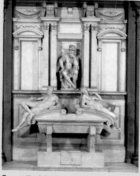

Cappella Medici, Piazza Madonna
degli Aldobrandini, p. 290

Palazzo Medici-Riccardi,
Via Cavour 1, p. 294

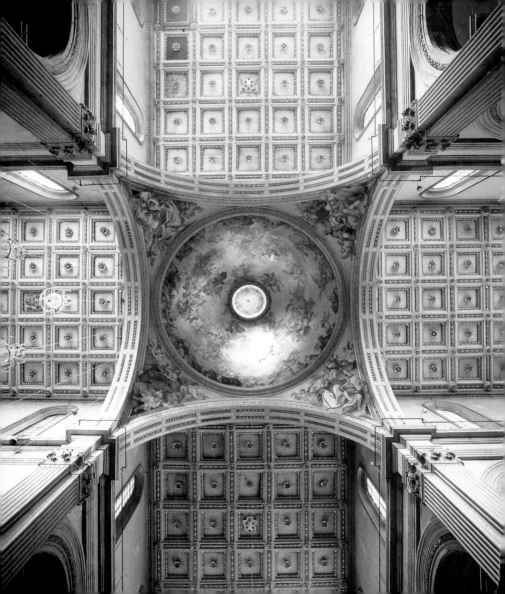

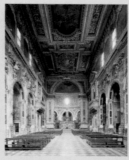

Chiesa di San Marco/
Museo di San Marco,
Piazza San Marco, p. 319

SS. Annunziata, Piazza della
SS. Annunziata, p. 346

Piazza della SS. Annunziata,
p. 341

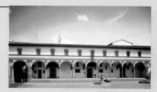

Ospedale degli Innocenti,
Piazza della SS. Annunziata, p. 352

Museo Nazionale
Archeologico, Via della
Colonna 36, p. 359

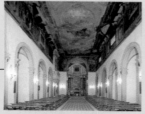

Santa Maria Maddalena dei Pazzi,
Borgo Pinti 58, p. 360

Tempio Israelitico
(synagogue), Via Farini 6,
p. 362

Piazza della Indipendenza

Via XXVII Aprile

Via Nazionale

Via S. Zanobi

Via S. Reparata

Via S. Gallo

Via Guelfa

Via Camillo Cavour

Via G. La Pira

Via Pier Antonio Micheli

Giardino dei Semplici

Viale Giacomo Matteotti

Giardino della Gherardesca

Piazza San Marco

Via Gino Capponi

Piazza del Mercato Centrale

Via Taddea

Via S. Antonino

Piazza della SS. Annunziata

Via Laura

Via Giuseppe Giusti

V. d. Giglio

Via d. Pucci

Via degli Alfani

Via d. Colonna

Borgo Pinti

Piazza M. D'Azeglio

Via Ricasoli

Via d. Servi

Piazza Brunelleschi

Piazza S. Lorenzo

Via d. Martelli

Via della Pergola

Via L. C. Farini

Via de' Cerretani

Via Bufalini

Piazza di S. Maria

Via Fiesolana

Via de' Pilastri

Via G. Carducci

Piazza di S. Giovanni

Via d. Pecori

Piazza del Duomo

Via del Proconsole

Borgo Pinti

Via de' Pepi

Via di Mezzo

Via dell' Oriuolo

N

0 100 m

moved to Rome for good in 1534 after 14 years of work, which had been interrupted several times, he left only a torso. In 1546 Vasari and Ammanati arranged the incomplete sculptures as they are to be found today.

When he was planning the room Michelangelo was clearly influenced by Brunelleschi's Old Sacristy, which was built exactly 100 years earlier. The square ground plan covered by a half-cupola is copied from Brunelleschi. The Old Sacristy was also the model for the motifs of the decorative mural structure. In contrast to Brunelleschi, however, Michelangelo added a mezzanine below the coffered cupola, so that this room appeared considerably more dynamic. This is not least because of the extreme emphasis on the height.

Michelangelo had great difficulties in finding a satisfactory solution for the Medici tombs, as many preserved sketches show. In his first plans he intended to erect a detached monument in the middle of the chapel; instead, the dukes were finally entombed in the side walls facing each other. The monumental seated figures of the deceased face the entrance where the double tomb of the two brothers Lorenzo and Giuliano was originally to stand. They were in fact buried here, but the planned monument was never built.

Today the New Sacristy gives only a vague and very fragmentary impression of the original plan. There are records testifying that the sculptural plan was intended to include, among others, four figures of the River Gods and allegorical statues (of the Earth and Sky) in the tabernacles

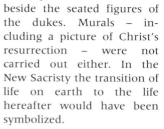

beside the seated figures of the dukes. Murals – including a picture of Christ's resurrection – were not carried out either. In the New Sacristy the transition of life on earth to the life hereafter would have been symbolized.

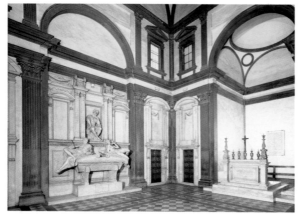

**Michelangelo Buonarroti:
Medici Madonna (detail)**
Marble

Of all the sculptures that stand today by the entrance wall instead of the originally planned tomb of the Magnifici, the only figure sculpted by Michelangelo himself is the remarkable Medici Madonna. Although the work is unfinished it shows the master's touch, not least in the wonderful features of Mary.

The sculptures of the Medici patron saints Cosmas and Damian on either side were, however, made at a later date by Michelangelo's pupils Angelo Montorsoli and Raffaele da Montelupo.

Michelangelo Buonarroti: Tomb of Lorenzo de' Medici, ca. 1525
Marble

In 1519 Lorenzo, Duke of Urbino, died at the age of only 27. His contemporaries had already given him the name *Pensieroso* (the Thoughtful). Portraying him in a classic pensive pose, Michelangelo seems to be paying tribute to this characteristic feature. Any similarity to the actual physiognomy of the deceased has, however, been neglected in favor of an idealized portrait. Lorenzo appears as a Roman general. He is shown lost in thought, his features contemplative and almost melancholy. The two figures at his feet presumably symbolize Dusk and Dawn.

Michelangelo Buonarroti: Tomb of Giuliano de' Medici, 1526–31
Marble

Giuliano de' Medici (1479–1516), Duke of Nemours and the youngest son of Lorenzo de' Medici, is pictured in Michelangelo's sculpture sitting upright with all the characteristics of proud self-confidence. The principle of a contemplative way of life as depicted in the figure of Lorenzo on the opposite side of the sacristy is almost antithetically countered here by the ideal of the *vita activa*. The seated figure resembles a portrait of a Classical general with his baton and style of clothing, but it also alludes to Giuliano's position as commander of the papal troops in Rome. Above the sarcophagus are allegorical reclining figures symbolizing Day and Night.

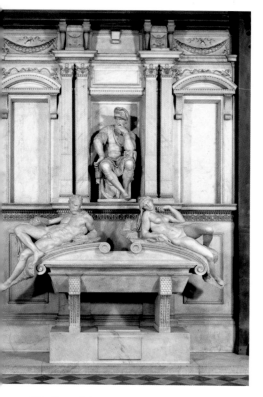

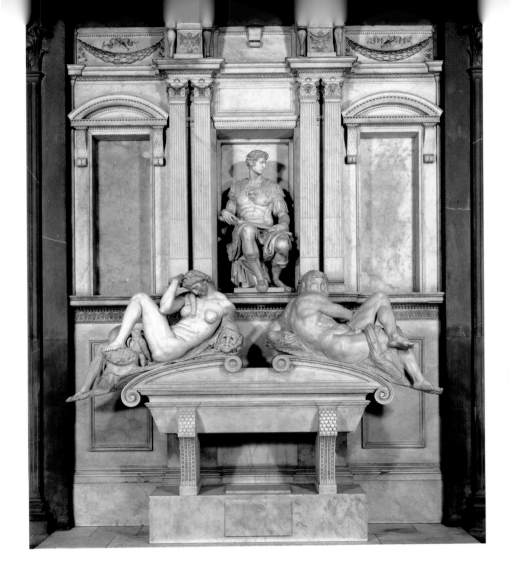

Biblioteca Laurenziana

The Vestibule

The Biblioteca Laurenziana, which can be reached via a staircase in the cloisters of San Lorenzo, is one of Michelangelo's most important architectural legacies. In 1524 he was instructed by Pope Clement VII to plan rooms for the Medici's collection of exceptionally valuable manuscripts. Because of lack of money the library could not be opened until 1571.

For the vestibule Michelangelo designed a masterpiece of illusionistic architecture whose individual components are not purely functional. Rather, their purpose is

the imaginative impression they make. The ground plan is restricted in its 33 square feet (9 square meters), but Michelangelo designed the interior as an open courtyard with the surfaces of the walls resembling façades in the extreme emphasis of the vertical lines. The freestanding staircase leading up to the library rooms sets a dominant architectural accent.

The Reading Room

The upper library and reading room is astonishingly large compared with the narrow vestibule. The architectural structure of the walls resembles façades in the same way as that of the library's vestibule. Yet here the emphasis is on the length of the room, which extends over 150 feet (46 meters).

Palazzo Medici-Riccardi

Michelozzo began building the Palazzo Medici in 1444. Cosimo de' Medici had rejected Brunelleschi's much more flamboyant plans, an action which in its own way bears witness to his talent for diplomacy. Being modest he had wisely always avoided too provocative a display of his wealth. Despite its relative modesty, compared for example to the Pitti Palace on the other side of the Arno, Michelozzo succeeded in presenting an impressive building which pointed the way to the future for secular architecture of the time. On his visit to Florence in 1459 even Pope Pius II thought the building to be worthy of accommodating a king. 00The three-story façade shows Classical elements in many individual forms. The stories are separated from one another by plinths, as can be seen on comparable buildings in the city. The height of each story diminishes regularly from the first story upwards, while the façade of rusticated masonry becomes less pronounced from story to story. In 1659 the palace was acquired by the Riccardi family, who had many alterations made. Among these was the extension of the palazzo's front by seven bays. Sadly the original proportions of the building have been confused by this alteration.

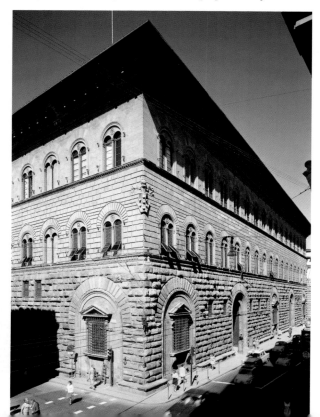

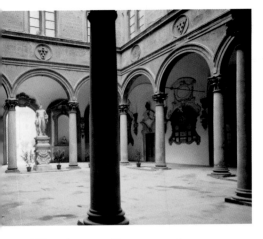

Cappella dei Magi

A comparatively small room in the palazzo served the Medici as a private chapel. The altarpiece depicting the *Adoration of the Child*, painted by Filippo Lippi, can here only be seen in a poor copy of the original (now in Berlin-Dahlem). The richly decorated coffered ceiling and the wooden choir stalls by Michelangelo still remain. The exceptional fame of the room is primarily due to the splendid frescos painted by Benozzo Gozzoli (1420–1497) around 1460.

The Inner Courtyard

The courtyard of the palace, which the Medici used as a residence and as an imposing headquarters for the administration of their bank, looks almost like a narrow cloister with its arcades which evenly surround the courtyard on all four sides. Above the arches the tondi of the family coat of arms are flanked by reliefs with mythological scenes. Of the many statues once erected here, only Baccio Bandinelli's statue of Orpheus (around 1529) remains. A small museum on the history of the Medici which has been set up in the basement can be reached from the courtyard. A staircase leads up to the famous Cappella dei Magi above.

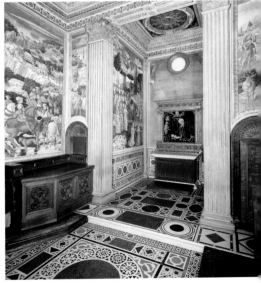

Benozzo Gozzoli: The Procession of King Balthazar (eastern chapel wall), 1459–61
Fresco

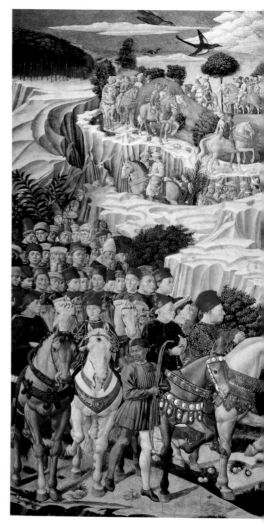

The paintings extend across all the side walls of the chapel and are focused on the altarpiece depicting the *Adoration of the Child*. The murals have imaginatively laid out backgrounds in which the virtually never-ending winding procession follows the Three Wise Men. Gozzoli arranged his frescos with magical splendor and an incredible amount of detail. In their luxurious decoration, these frescos reflect Gentile de Fabriano's *Adoration of the Kings* in the Uffizi.

The private palace chapel was not open to the public; the envoys of foreign merchant families and dynasties, however, were received. The head of the household's high rank and his proud self-image were presented in an impressive manner in the frescos: important members of the Medici family are depicted in the painting of the Procession of the Magi, although the exact identification remains disputed. It was thought one could recognize an idealized portrait of Lorenzo de' Medici because of the balls on the Medici coat of arms on the bridle of the horse on which the youngest king is sitting. Although only 11 when the picture was painted, he was already considered to be the promising future head of the family.

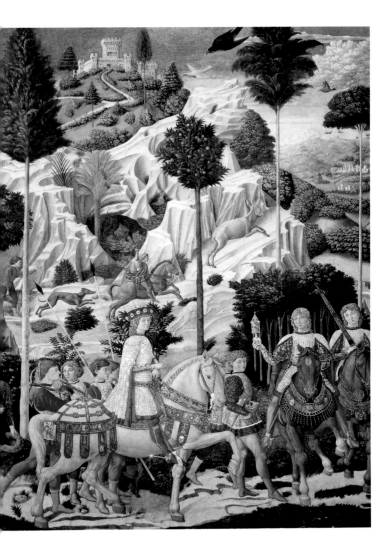

Benozzo Gozzoli: The Procession of King Balthazar (detail)
Fresco

Benozzo Gozzoli: The Procession of King Caspar (on the west wall of the chapel), 1459–61
Fresco

Benozzo Gozzoli added an impressive and striking self-portrait among the densely-packed crowd of figures following the oriental King Balthazar who is leading the way to Bethlehem. His eyes are focused on the viewer while the golden signature *opus Benotii* on the red cap reveals him to be the creator of the painting.

The procession of the oldest king, Caspar, and that of the youngest king, Balthazar, are on opposite walls. The fresco of Caspar was divided when the Riccardi family made the alterations in 1689 and suffered greatly thereby. In spite of this, Gozzoli's imagery is very impressive in its abundance of detail. Many charming representations of animals liven up the scene. At the top right-hand side the procession is winding its way up a hill. The old king – with a striking white beard and magnificent garments – is following it sitting on a white mule. We may be able to recognize in him a portrait of the patriarch Joseph of Constantinople who in 1439 took part in the council which was moved from Ferrara to Florence at the instigation of the Medici. Presumably Gozzoli's frescos were supposed to recall this important event. Apart from the members of the Medici dynasty other important participants in the council are portrayed.

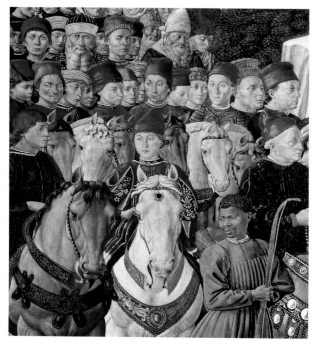

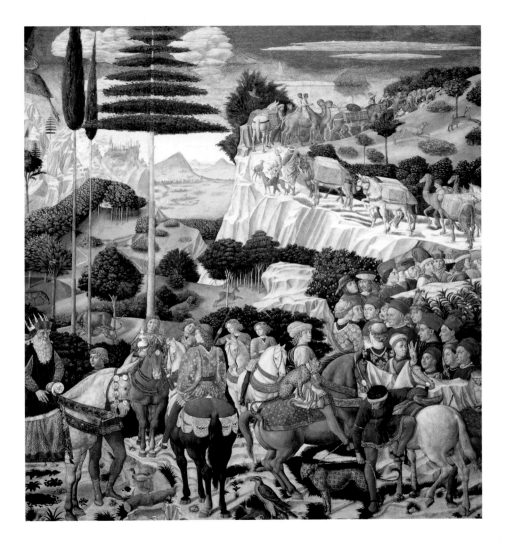

The Council of Florence – Between Two Worlds

Clemente Manenti

In 1439, on Wednesday, 11 February, the patriarch arrived in Florence "on a normal weekday on which people were busy with their daily chores. Because of this the festivities for his welcome were relatively modest. He was, nevertheless, accompanied by two cardinals, around 30 bishops and the whole papal

The tomb of Joseph (Giuseppe) II, patriarch of Constantinople, Santa Maria Novella, Florence

household with more than 500 horses. The wealthy citizens stood in front of the doors of their palazzi and waited for him. When he arrived Chancellor Leonardo Aretino gave a speech in Greek in which he conveyed the city's best wishes. Thereafter the patriarch continued his journey to the Palazzo Ferrantini, which had been prepared for his stay ..."

The emperor, however, arrived a few days later on a holiday: carnival Sunday. "All the streets, balconies and roofs along the street were full of men and women, splendidly dressed, excitedly awaiting the arrival of the emperor. Five cardinals, the papal household, most of the Greeks who had already arrived and a large crowd accompanied him from the monastery outside the city walls, where he had spent the night, to the city gates. Here the councilors, the guilds, and the leaders of the two political camps, the Guelphs and the Ghibellines, together with the representatives of all the guilds, and many cardinals as well as Roman Catholic and Greek Orthodox clergymen were waiting for him. The emperor was wearing a white tunic and a red cloak as well as white headgear on the top of which, among many other gems, there was a sparkling ruby bigger than a pigeon's egg. Leonardo Aretino made another speech in Greek, a canopy was held over the emperor and the entourage was lining up when it suddenly began to rain heavily. The crowd and all those on the balconies and roofs

tried to find shelter and within a short time only the royal entourage was left on the mud-covered street … The cardinals, the train of attendants and the representatives of the guilds were completely drenched." Later the emperor was given presents: "large candles, sixteen boxes of candied fruit, marzipan, wine, oats for the horses but not meat as he did not eat any" (Pero Tafur).

In the first months of 1439, Florence welcomed the most important religious and political event of the century with such magnificent receptions: the ecumenical council for the reunification of the Christian churches, the Roman Catholic and the Greek Orthodox church of Constantinople, which had split up four centuries before. When reading the reports today, it is almost impossible to imagine how strenuous, difficult and worrying the situation must have been for the Greek prelates on their arrival.

Although the council had been opened in Ferrara on 9 April 1438 and was thus in its second year, it had not come up with any results in all these months. The Greeks had already set off with 700 people in November 1437, the leading figures being the old patriarch Joseph II and Emperor John VIII Palaiologos. Apart from the most important representatives of the

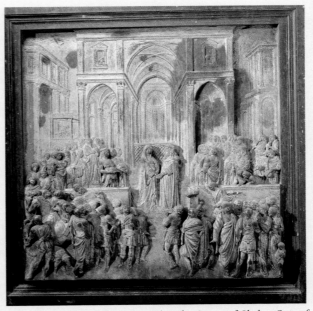

Lorenzo Ghiberti: Solomon Meeting the Queen of Sheba, Gate of Paradise, Baptistery of St. John, Florence

Orthodox church, important secular intellectuals, such as the famous Gemistos Plethon, were part of the Greek delegation. For the Greek people the reunification with the Roman church was a question of life and death.

It was the end of the 1000-year-old Byzantine Empire which had ruled over the Mediterranean for so many years. The lands it had possessed in Asia and the Balkans were now in the hands of the Turks. In order to keep the remaining areas, which were in Greece alone, and to ensure the supply of food, the emperor had to pay tribute to

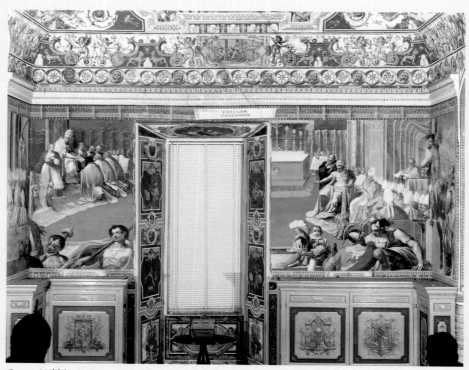

Cesare Nebbia (1534 –1614): The Council of Florence, Vatican Library

the Turkish sultan. There was hardly anyone left in Constantinople, once the wealthiest city in the world; palaces and churches were in ruins, hens were kept and fruit and vegetables grown in the former flower gardens. The emperor himself, with his family and staff, lived in only one wing of the once magnificent palace. John Palaiologos now hoped that the Christian princes of Europe would take part in the council of unification, thus resulting in an alliance which would save the empire from the Turks.

With his sights on the longed-for arrival of the European rulers, he had tried to delay the work of the council in Ferrara for as long as possible. The powerful men in Europe were, however, involved in internal disputes, and then the western emperor Sigismund, one of the most enthusiastic supporters of the council, died a

few months before it began. On the other side Pope Eugene IV was also interested in reaching a successful outcome for a number of reasons. He especially wanted to stabilize the papal supremacy in the western church which had been shaken by the movement for the council. The beginning of the work was also delayed by a number of occurrences concerning the "rules of protocol"; for instance the pope expected the patriarch to kiss his feet at their first meeting, which Joseph absolutely refused to do. The emperor, on the other hand, expected to cross the rooms of the palace, where the meeting was being prepared, on horseback, in order to reach his throne, according to eastern tradition, without dismounting. This meant that the passageways had to be enlarged.

All this had taken place in Ferrara, while the discussions about purgatory were beginning, as to whether the souls of the repentant sinners roasted in fire as the Roman church claimed, or if they merely suffered by not seeing God as the Greek church believed. In the meantime worrying news was received from Constantinople, where there were increasing signs of the Turks' preparations for war, and from Ferrara, where a plague had broken out which claimed many victims among the delegation of Isidor, the metropolitan of Kiev and all Russia. In addition, the town had been threatened by the troops of the mercenary leader Niccolò Piccinino since the beginning of summer. Piccinino was working for the Milanese ruler Visconti, one of the pope's most bitter enemies. Finally, the pope was not paying the 700 members of the Greek delegation, so that they were virtually on the breadline. At this point Cosimo de' Medici generously invited the council to move to Florence, where the city would take over the complete costs. It was Ambrogio Traversari, the all-important director of the council, who was responsible for Cosimo making this decision.

The meetings in Florence took place in the rooms of the Dominican monastery Santa Maria Novella and made relatively good progress. The discussion about purgatory, which was in fact unimportant to the Greeks, was ignored and the actual core of the theological dispute between the churches was tackled: the question of the origin of the Holy Ghost. The Greek Orthodox believe the Holy Ghost comes from God, and God alone, whereas Roman Catholics believe that it originates from the Father and the Son to the same extent, in the same way and with the same quality. The Roman Catholic creed thus contains the wording *filioque* ("... and from the Son"), which is missing in the Greek Orthodox creed. The Orthodox believed that this was an inadmissible addition bordering on heresy. Both sides bombarded each other with a barrage of quotations, which had been taken from the sources of the early church fathers, and the resolution of the seven councils from the time before the schism. After lengthy discussions the Orthodox accepted the Holy Ghost as also originating from the Son. It was agreed that each church could continue with its own wording without looking upon the other as heretical. They could thus move on to the other big controversy, the discussion about the pope's primacy. By this time the Greeks were completely exhausted and had only one desire: to return home. Besides, many of them agreed

with the arguments of the Roman Catholic church and were convinced that the reunification was right. At this point the patriarch Joseph II died, on 10 June 1439. He had been ill for a long time and had not had enough strength to take part in the meetings of the council. A letter was found on his desk, dated 9 June; it recommended the reunification and closed with the words: "For the safety of all I acknowledge the pope of ancient Rome the Holy Father of Fathers and the Pontifex Maximus and the representative of our Lord Jesus Christ."

The patriarch Joseph had succeeded in gaining the respect and affection of the Roman Catholics as well as that of the Greek Orthodox. He was buried in the church of Santa Maria Novella with a service in which the whole of Florence took part. His death helped bring the council to a close, and Ambrogio Traversari drew up the decree of the reunification together with the Greek metropolitan Bessarion. On 5 July 1439 all Greek Orthodox representatives of the church signed it, with the exception of Mark of Ephesos. On 6 July Florence had the biggest celebration in its entire history. The Greeks left thereafter.

In Florence Mark of Ephesos had been the only person not to sign the decree of reunification, but back in Greece he got others to agree with him. The eastern church refused to accept the decree signed by its representatives and many of those who had been in favor in Florence now dissociated themselves from it. The patriarch Joseph, whose death had helped to end the council, could now no longer bring his influence to bear. His seat was vacant for a long time. After the emperor's return to his country he seemed paralyzed. Mark of Ephesos did not keep only to questions of doctrine. He now argued in a way that convinced clergy and the faithful alike: If we join the Roman Catholic church, he said, they will force us in the end "to shave the beards off our chins." A prelate of the Greek Orthodox church was – and still is – unthinkable without a beard.

And could God be imagined without a beard? The popes of Rome, the cardinals and the priests all shaved. This proved their heresy. "It is better to live under the turban of the sultan than the miter of the pope," said one prelate who had signed the decree of reunification in Florence. The turban of the sultan arrived on 8 April 1453. It was on this day that the church of St. Sophia was turned into a mosque, and from that point on the world was divided into two parts: East and West.

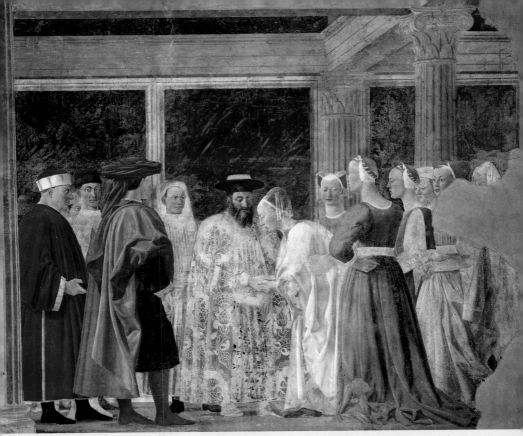

Piero della Francesca: The Adoration of the Holy Wood and the Meeting of Solomon and the Queen of Sheba, 1452–66, fresco, 336 x 747 cm, San Francesco, Arezzo

Galleria dell' Accademia

The Florentine Academy of Fine Arts (Accademia delle Arti e Disegno) grew from the St. Luke's Guild of the early 14th century and was founded by Cosimo I in 1562. Not only were drawing, painting, sculpture and architecture taught here, but in time an extensive collection of art was accumulated. In 1784 this collection was made public at the instigation of the Grand Duke Pietro Leopoldo. Important works of Tuscan painting and sculpture from the 13th to the 16th century by Giambologna, Bronzino, Pontormo, Filippo Lippi and Sandro Botticelli are on display here.

Without a doubt, however, the main attractions of the Accademia are the sculptures by Michelangelo; the original of *David*, which has been kept here since 1880, naturally dominates the collection.

Michelangelo Buonarroti:
St. Matthew, 1503–05
Marble, h 271 cm

We can be especially thankful for the fact that Michelangelo never finished his marble statue of St. Matthew, as it reveals the exceptionally gifted sculptor's ways of working. Originally the sculpture was supposed to be the first of 12 apostles commissioned by the Florentine cathedral stonemasons' lodge in 1503. When the agreement was canceled two years later Michelangelo had only begun the sculpture of St. Matthew. It becomes very clear how the artist is almost wresting the figure from the marble, how he is peeling it out of the solid material looking from the main angle. Vasari made a good comparison: the body's outlines slowly become apparent, as when water is gradually drained from a bath.

**Michelangelo Buonarroti:
Bearded Slave, ca. 1530–34**
Marble, h 265 cm

Apart from the famous statue of David, the four unfinished marble sculptures of the so-called slaves (or captives) can be seen in the Galleria dell' Accademia. Together with two other statues in the Louvre in Paris, they were originally intended for the tomb of Pope Julian II in Rome but were never taken there. After having been placed for some time in the Buontalenti grotto of the Boboli gardens, the sculptures found their way to the Accademia in 1909. The interpretation of the figures is disputed, and their function within the planned tomb can scarcely be clarified today. The execution at this early stage is based on Michelangelo's designs and can probably be ascribed to his helpers. However, it is thought to be quite clearly the master's hand that can be seen in the head of the *Bearded Slave*.

Michelangelo Buonarroti:
Waking Slave, ca. 1530–34
Marble, h 275 cm

Later generations of art lovers have found the unfinished slaves particularly appealing. Ignoring interpretations made over the centuries, the "actual subject" – the "struggle with the subject" which runs all the way through the master's work – seems to be inherent in the fragments in two ways: on the one hand, in the difficulty of making progress in the sculptural work, and on the other, as the tragic and fateful disposition which is the basis of the human condition. The figures' laborious struggle to free themselves seems to arise amidst deep torture of the soul and, in the end, their efforts seem hopeless. In these works Michelangelo's admiration for the great masterpieces of the Classical age becomes apparent – especially the famous Belvedere Torso.

Michelangelo Buonarroti: David, 1501–04
Marble, h 434 cm (including socle)

In 1501 Michelangelo Buonarroti was commissioned to carve the figure of David for one of the cathedral's buttresses. The conditions for the work were not very good because the material provided was merely an allegedly useless piece of marble which had been "hacked about" years earlier. Despite these adversities the sculpture was completed in 1504 as the first over life-sized, free-standing statue since the Classical age and it was positioned in front of the Palazzo Vecchio instead of on its intended spot. In this way the figure of David, who had killed the giant tyrant Goliath, was given a political significance. The sculpture became the ultimate symbol of the liberal republican attitude of the city.

Michelangelo dispensed with the usual attributes – the sword and the cut-off head of the defeated giant. It is therefore assumed that the scene a moment before the deadly stone was slung is depicted. The future king of Israel is looking firmly and self-confidently at his opponent. He has placed the sling on his shoulder with his left hand. Compared to Donatello's and Verrocchio's earlier statues, which are boyish, David has become a giant himself in Michelangelo's version. His physique is presented in an athletic counterbalance. Details such as the over-sized right hand display enormous strength and determination.

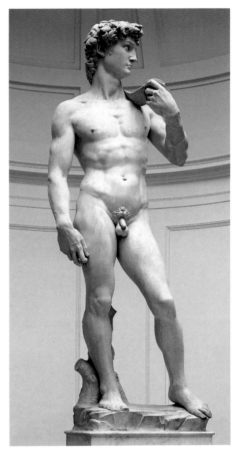

San Marco

In 1434 Pope Eugene IV left the old, decaying Silvanian monastery of San Marco to the Dominicans of Fiesole. Cosimo de' Medici, who had done his utmost for the Dominicans in this matter, also to a large extent financed the rebuilding of the monastery by Michelozzo (1437–52). Rumor had it that the banker wanted to ease his conscience with large donations after doing dubious business. Considerable alterations were made by Giambologna toward the end of the 16th century in and finally during the Baroque period. In 1678 the interior was renewed by Piero Francesco Silvani. Gioacchino Pronti erected today's façade in 1780.

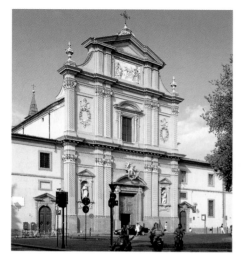

Museo di San Marco

The monastery of San Marco was built between 1437 and 1452 by Michelozzo. While large parts of it are still inhabited by monks, the Museo di San Marco can be visited in the older part of the complex – around the first, so-called cloister of St. Anthony. Frescos by Fra Angelico can still be seen in the cloister. The adjoining museum rooms contain other noteworthy frescos and panel paintings by Fra Bartolomeo. Ghirlandaio made a fresco of the Last Supper, directly based on the one in Ognissanti, in the small refectory.

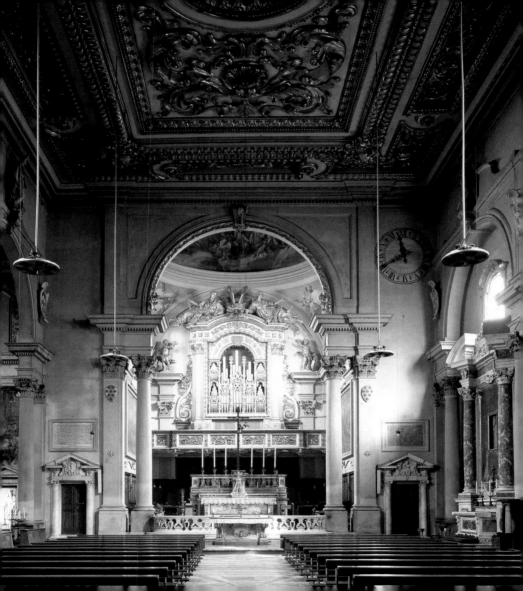

Museo di San Marco/Chiesa di San Marco

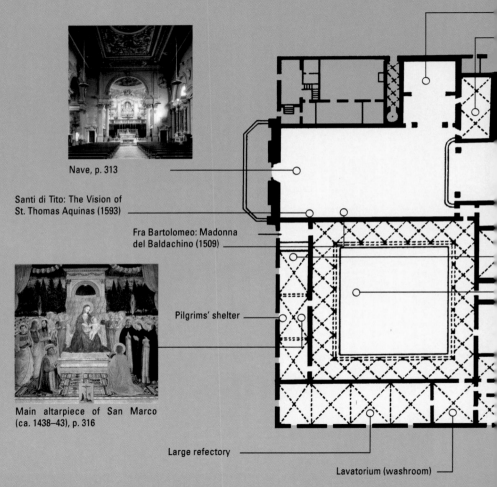

Nave, p. 313

Santi di Tito: The Vision of
St. Thomas Aquinas (1593)

Fra Bartolomeo: Madonna
del Baldachino (1509)

Pilgrims' shelter

Main altarpiece of San Marco
(ca. 1438–43), p. 316

Large refectory

Lavatorium (washroom)

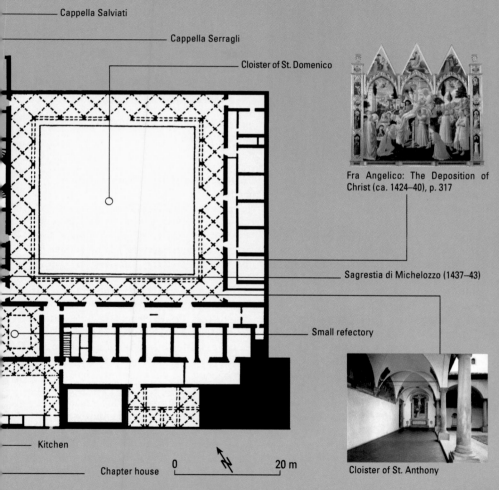

Cappella Salviati

Cappella Serragli

Cloister of St. Domenico

Museo di San Marco

Fra Angelico: The Deposition of Christ (ca. 1424–40), p. 317

Sagrestia di Michelozzo (1437–43)

Small refectory

Kitchen

Chapter house

0 20 m

Cloister of St. Anthony

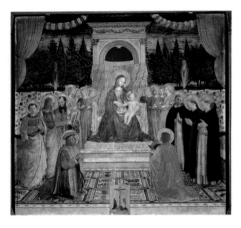

Fra Angelico: Main altarpiece, ca. 1438–43
Tempera on wood, 220 x 227 cm

day before the altar. The law of poverty of the preaching order is referred to on the left, in a passage in the opened gospel of St. Mark.

The special quality of the painting is due not least to the clarity of the composition. The viewer's gaze is led into the depth of the room, to the central group of the Virgin and Child; this is all done in a plausible arrangement. Behind the throne a curtain, slightly raised to the side, gives us a view of a garden scene with cypresses and cedars, here taking the place of the traditional gold background.

Fra Angelico: The Deposition of Christ, ca. 1425–40
Tempera on wood, 176 x 185 cm

Unfortunately the colors of Fra Angelico's main work were considerably affected in the 19th century by overzealous cleaning. Cosimo de' Medici had commissioned the painting for the high altar of San Marco around 1438. The red dots surrounding the carpet, which have been depicted according to the rules of perspective, remind us of the balls in the coat of arms of the founder family. We can also recognize the patron saints of the Medici family in the eight saints who are portrayed. Fra Angelico linked this reference to the patron of the monastery to statements concerning rules, principles and liturgical traditions of the Dominican order. The small scene of the Crucifixion of Christ in the foreground reminds us of the reading of the Mass each

Palla Strozzi originally gave Lorenzo Monaco the commission for the altar retable for his family's chapel in Santa Trinità. Monaco had presumably only painted the arched panels and the pictures of the saints at the side when he died in 1425. The Dominican friar Fra Angelico finally completed the work during the 1430s.

In the center of the picture the body of Christ is being removed from the Cross. Tension in the composition is created by the diagonal lines of the body and the outspread arms. All the faces are highly individual. The skin tones and the gestures are very varied, and the coloring of the light garments is extremely vivid. This does not affect the strange atmosphere of stillness. A deep spiritual intensity is

shown by the group of mourning women on the left. The instruments of torture are depicted on the opposite side, contemplated in silence by the bystanders. The background is a Tuscan landscape with trees towering into a brilliant blue sky.

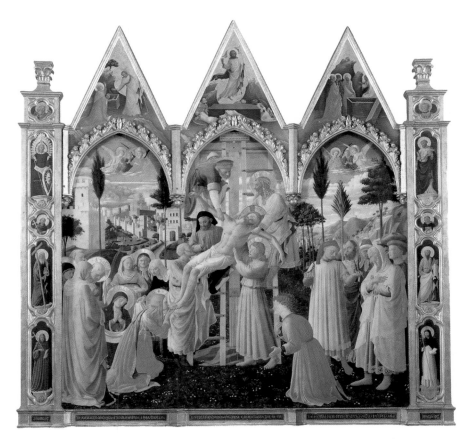

Girolamo Savonarola and the Bonfire of the Vanities

One of the most exciting chapters of the history of Florence is linked with the life and work of Girolamo Savonarola, the Dominican preacher of repentance. Born in September 1452 in Ferrara, Girolamo began by studying medicine. He secretly left Ferrara, his home town, on the eve of the festival of St. George in 1475. He traveled on foot to Bologna in order to join there the Dominican mendicant order of preachers. Savonarola gave the reasons for this in a letter to his father; the words he used almost seem to predict the preoccupations of his later life. He

Savonarola's double cell in the dormitory of the convent of San Marco

not only complained about people's malice and the world's misery, shameful acts and adulteries, he was also appalled by the dreadful blasphemy in a world which had reached a point where no one was to be found who behaved justly.

Savonarola received his basic monastic education in the monastery school of San Domenico in Bologna. It was a *studium generale* with scholars of the highest caliber. At that time the Dominican monastery of San Marco was in its prime as Michelozzo had completed the first library in Europe to be opened to the public. Many codices, collected from all over the world, could be seen here. The frescos which Fra Angelico had recently painted were emblazoned on the walls of the monastery.

However, since the middle of the Quattrocento there had been some indications that the Dominican order was falling apart. A debate on the basic principle of monks being forbidden to have possessions had flared up, especially since the growth of the order meant an increase in the number of friends and supporters – and in donations. In addition, Pope Sixtus IV had already enacted a decree allowing the owner-

ship of real estate and the administration of fixed incomes. Even the Chiostro di San Marco "was not free of an inclination toward luxuries owing to gifts from the Medici" (H. Hermann). Cosimo il Vecchio had, after all, financed the reconstruction of the monastery and had otherwise also proved to be a generous patron. However, when he was ordered back to Ferrara for three years in 1487, there was little indication of the vehemence with which Savonarola would fight against the decay of morals in later years. "The manners of the strange preacher and his way of talking seemed coarse and uneducated to the Florentines, his Lombard accent harsh, his expressions coarse and unrefined, his gestures hasty and violent" (Pastor). This was to change completely when Savonarola was ordered back to Florence in 1490. As early as February 1491 he was preaching from the most reputable pulpit of the city in the cathedral of Santa Maria del Fiore. The same month he was made prior of San Marco. The monk pilloried the decay of morals in ever harsher words; he complained about the extravagance of the rich and the tyranny of the powerful. He predicted the breakdown of the church and the clergy in prophetic sermons and, at the same time, justified himself because his stories came directly from God. He threatened the Florentines with the chastisement of God that awaited them and described the dangers of a second flood in eschatological accounts. Soon the speeches of the radical monk took on a much more social and political character. Apart from his visions of a purified church, he described his idea of a renewed society; a theocratic form of government. The gulf

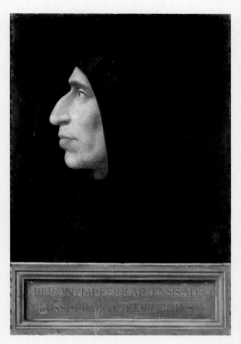

Fra Bartolomeo: Girolamo Savonarola, ca. 1498, oil on wood, 53 x 47 cm, Museo di San Marco, Florence

between Savonarola and Lorenzo the Magnificent, who governed the city, inevitably became greater. Even at Lorenzo's deathbed the monk, who had been called to his bedside, refused to give the extravagant Medici the last rites.

After Lorenzo's death in 1492 Piero de' Medici became head of the family. Soon the Florentines were saying of him that he had only one talent, namely that of always making the most

unfortunate decision in all difficult questions and conflicts. The city fell into one of its worst crises under his rule. It had been Piero's misinterpretation of the political issues of the day that had contributed to the dangerous situation when the troops of Charles VIII were outside the city gates in 1494 and threatened to conquer Florence. The angry mob was not even appeased by the large quantity of wine Piero provided, and evicted the Medici from the city. Since there was no one in power now, Savonarola took over and led a delegation of five people to negotiate with Charles VIII, and must have been so successful that the largest army the Florentines had ever seen left the city after only a few days, without causing any great damage. Savonarola's popularity reached its climax during the turbulences and his scope and volatility increased. The monk condemned the evils of the time, which seemed in every way to contradict the ideal of life determined by God. He was quite unscrupulous in his means, since he openly demanded the burning of those who indulged in sexual excesses or gambling. Mothers were told not to put their children out to nurse, so they would only receive the milk of their natural mother and thus not be provided with a lower moral attitude. Within the sphere of art he requested the beauty of ideas instead of perfection in form, meaning, not least, the complete renunciation of nude figures in the world of art. "

According to Savonarola there were even dangers to be found in science, or at least in excessive interest in it.... After some more thinking he came to the conclusion that it would be best to confine the knowledge of the sciences to only a few aspects. This special knowledge should only be used for disputes with hostile scholars. For the average person the knowledge of grammar, morals and religion would be sufficient" (Kristeller).

Considering these demands, it is rather surprising that Botticelli, the painter of *The Birth of Venus*, supposedly supported Savonarola. Even the educated humanists of the time supported the brother. In retrospect even Marsilio Ficino admitted: "Even I was a slave to Savonarola at the beginning. When Florence was enraged by the French because of the many changes in the republic even I, along with intimidated citizens, was – God knows by what demon – intimidated and misguided for a short time."

The activities of the radical Dominican finally reached their preliminary climax during the days of carnival in 1497 with the first so-called bonfire of the vanities. Savonarola ordered a ceremonious procession for the night of 7 February and had an enormous funeral pyre put up in the Piazza della Signoria. Apart from the symbols of mundane vanities and vices (such as wigs, musical instruments, playing cards, mirrors, perfumes and portraits of beautiful women), books by vernacular authors "full of indecency" – among them Boccaccio, Morganti and Petrarch – were burnt.

The children of the town had become very helpful in Savonarola's almost dictatorial intrigues. One could almost describe them as the child police, who went through the streets of Florence on the lookout for any kind of offensive occurrences they could report about. There were even formal hierarchical structures for the

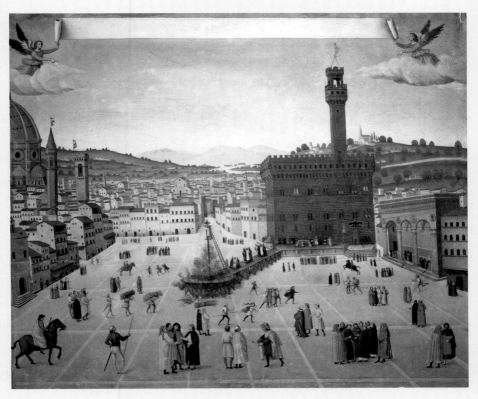

Unknown artist: Execution of Girolamo Savonarola in the Piazza della Signoria, ca. 1498, tempera on wood, Museo di San Marco, Florence

PREDICHE DEL REVERENDO PADRE
Fra Girolamo Sauonarola da Ferrara , sopra il Salmo
Q V A M B O N V S Israel Deus , Predicate in
Firenze, in santa Maria del Fiore invno aduens
to , nel . M . CCCCXCIII . dal medesi
mo poi in Latina lingua raccolte . Et
da FraGirolamo Giannoti da Pistoia
in lingua volgare tradotte . Et da
molti eccellentissimi huomini
diligentemente reuiste &
emendate , & in lingua
Toscha impresse.

M D X X X I X .

Unknown artist: Savonarola Preaching, taken from: Prediche del Reverendo Padre Fra Girolamo Savonarola, sopra il Salmo Quam Bonus Israel Deus [...], woodcut, no indication of place, 1539, Biblioteca Nazionale, Florence

different parts of town, which helped organize these "guardians of morals."

Savonarola had long angered the pope in Rome by his actions. Already in 1495 he had been cited before the Holy See. Alexander VI at first praised the monk in a quite friendly letter for his efforts to encourage Christian behavior in Florence, but at the same time he demanded to hear him because of his claim that he preached according to divine inspiration. In fact, as far as the dogmas of the church were concerned, it looked as if the pope's claim to be the sole representative of the official church was being questioned. Savonarola answered the pope that he was too weak to come to Rome. In view of his stubbornness Savonarola was soon forbidden to preach. The monk, however, only kept to this for a few weeks and then soon began preaching his messages even more vehemently than before. With the spectacular bonfire of the vanities in 1497 Savonarola had finally gone much too far. When news of the events reached Rome Alexander VI excommunicated the Dominican prior. Seemingly immune to the now undisguised threats Savonarola again mounted the pulpit. He then provoked the final confrontation when he staged a second, more stupendous bonfire of the vanities in February 1498.

It was here that he was to encounter the flames himself only two months later. His supporters could no longer protect him against the pressure coming from Rome. At the last minute a trial by fire was prevented since accusations of heresy could not be proved. When he tried to preach again the following day there was a great tumult. Angry enemies

stormed the Chiostro di San Marco, ending in Savonarola's arrest. The mood in the city had changed completely and Savonarola's attempts to reinstate the old values had failed. The very next day the first interrogations took place in the presence of commissioners sent from Rome. These interrogations went on for seven weeks accompanied by constant torture. On 22 May 1498 the monk was condemned to death. This was to take place the following day. Just before his execution Savonarola supposedly expressed his explicit thanks for the mercy shown to him. Considering the methods of torture available at the time, they had been very mild in their choice. In addition the „Pope" granted him indulgence, and thus saved Savonarola from the worst torture by having him hanged before he was burned. The funeral pyre was ignited under strict guard and the ashes were scattered in the Arno for fear of people hunting for relics.

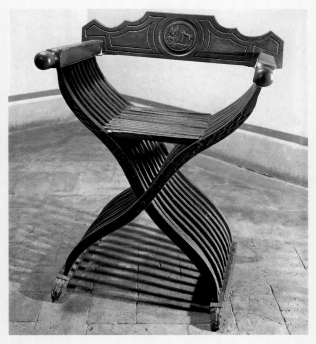

Savonarola's chair in San Marco, Museo di San Marco, Florence

Today a commemorative plaque on the Piazza della Signoria reminds the florentines of the radical reforming monk, who was despised by some as a religious fanatic, whereas others revered him as a visionary of a new way of life determined by God.

Dormitorio di San Marco

A visit to the monastery of San Marco will undoubtedly establish one of the most unforgettable impressions of Florence. The Dominicans of San Marco entrusted their brother Fra Giovanni da Fiesole (1387–1455) – later known as Fra Angelico or Beato Angelico (the Angelic) – with the decoration of the monks' cells and the corridors in the dormitory (second story). Many helpers and pupils participated in the extensive work. It is not always easy to distinguish between the paintings done by Fra Angelico himself and those done by his assistants.

Fra Angelico: The Annunciation, ca. 1442
Fresco 230 x 297 cm

According to legend St. Dominic received the habit from the Virgin Mary, and Fra Angelico's marvelous fresco of the Annunciation shows the special reverence the Dominicans had for the Mother of God; this fresco can be seen on the wall opposite the dormitory entrance. In spite of Mary's absorbed rapture, the open loggia, under whose arcades she accepts the angel's annunciation, reminds us directly of the actual architecture of Michelozzo's cloisters in the monastery.

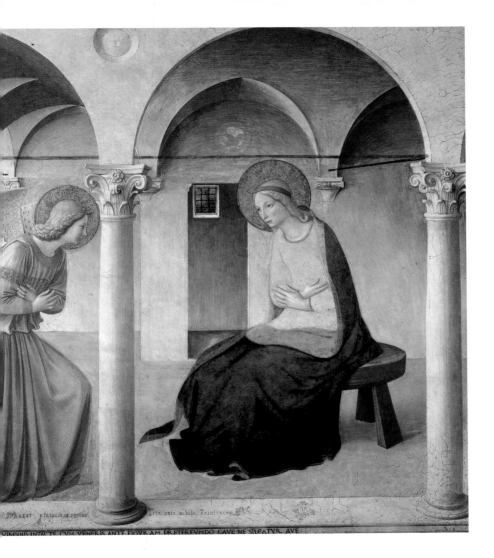

SALVE VIRGINIS INTACTE CVM VENERIS ANTE FIGVRAM PRETEREVNDO CAVE NE SILEATVR AVE

Dormitorio di San Marco

The Adoration of the Magi, p. 330

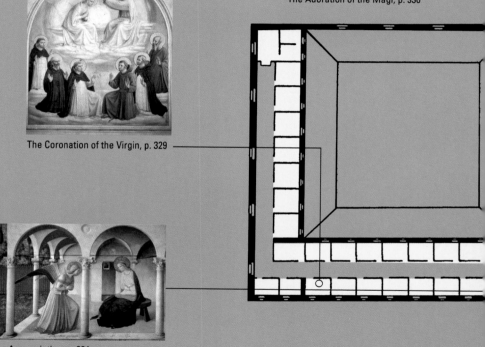

The Coronation of the Virgin, p. 329

The Annunciation, p. 324

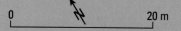

0 20 m

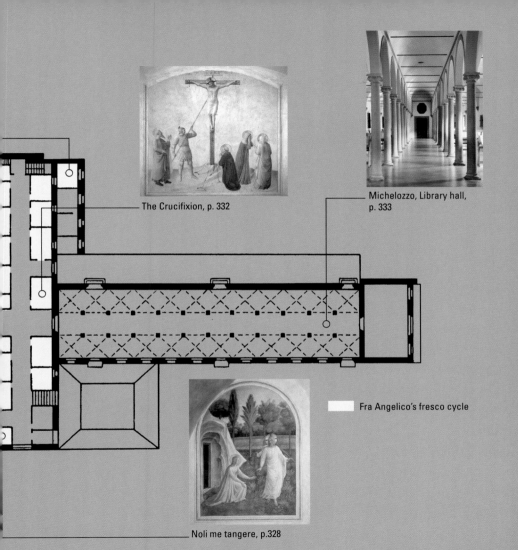

The Crucifixion, p. 332

Michelozzo, Library hall, p. 333

Fra Angelico's fresco cycle

Noli me tangere, p.328

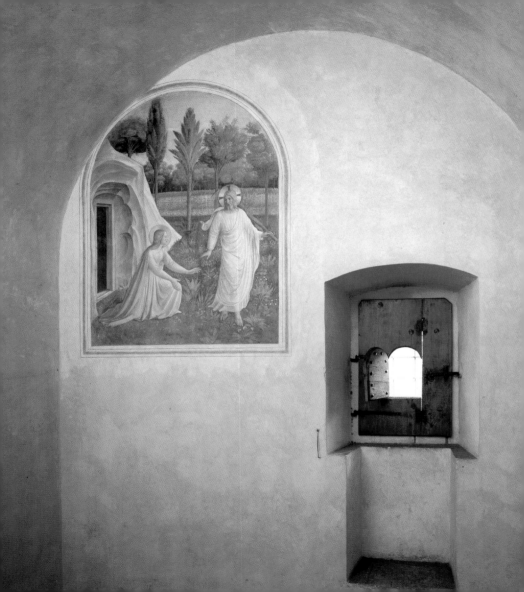

Fra Angelico: Noli me tangere, cell 1, ca. 1442
Fresco, 166 x 125 cm

Fra Angelico: The Coronation of the Virgin, cell 9, ca. 1441
Fresco, 171 x 151 cm

The main characteristics of the frescos Fra Angelico painted in the dormitory cells of San Marco are the urgency of the restrained imagery, the clear structure of the composition and the extensive renunciation of too secular a decor. In the bare rooms the paintings were intended solely for the monks' quiet devotions and contemplation. Even today, this particular quality of Fra Angelico's painting has not lost any of its magical effect.

In the dormitory's first cell an event is depicted which is described in the Gospel of St. John (20.14 – 18). On Easter morning Christ meets Mary Magdalene in front of the open tomb. She at first assumes he is a gardener but when she recognizes the resurrected Christ, he says to her *noli me tangere* (do not touch me). This moment is visualized impressively in the restrained, subtle gestures.

Mary's coronation is surrounded by a circular aureole of light. The founders of the Dominican order are placed below the scene. The extraordinary thing about this picture is its composition: the painter closes the upper arch at the edge of the picture with the monks in a semicircle below.

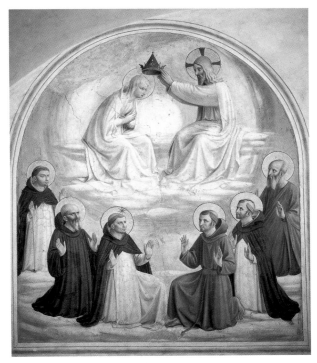

Fra Angelico/Benozzo Gozzoli: The Adoration of the Magi, cell 39, ca. 1440
Fresco, 175 x 357 cm

There was always a double cell reserved in the dormitory for Cosimo de' Medici, the great patron of the monastery of S. Marco. It is reported that the powerful potentate often retreated here to reflect and meditate in the quiet seclusion of these rooms. Significantly, his cell was decorated with the fresco of the *Adoration of the Magi* (ca. 1440). The mural is far bigger than those in the monks' cells and is more extensive in its representation of the Orientals in the entourage of the Magi, but it does not show much of either secular luxury or splendor. As is fitting for a devotional picture, its imagery is comparatively plain and reserved to match the place and its purpose. On the left side the epiphany takes place in front of a background of bare rocky scenery with neither trees nor plants. The fresco seems rather plain compared to later pictures of the same subject. It is hard to imagine that large parts of this fresco were probably done by the young Benozzo Gozzoli, who painted the almost overwhelming frescos of the *Procession of the Magi* in the Palazzo Medici chapel a few years later.

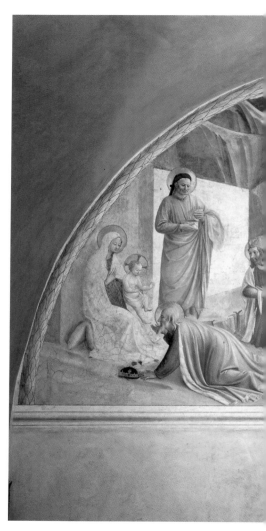

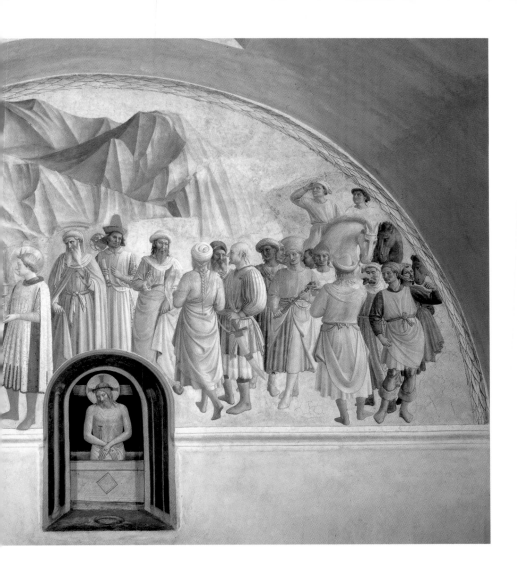

Fra Angelico: The Crucifixion, cell 42, ca. 1450
Fresco, 196 x 199 cm

The Library Hall of San Marco

No other subject was painted as often in dormitory cells as the Crucifixion of Christ. In these types of works, St. Dominic is almost always shown at the bottom of the cross with other saints. This Crucifixion with the wound inflicted by a lance must certainly belong to the most sensitive pictures of this kind. St. Martha, with only her back shown, appears on the far right comforting Mary. The latter has turned away from the cross, her hands raised to her face in desperation and pain.

Commissioned by Cosimo de' Medici in 1444, Michelozzo di Bartolomeo Michelozzi created the library hall of San Marco on the second story of the monastery. The library is considered one of the city's most harmonious and beautiful Renaissance interiors. The even series of arcades are supported by simple, narrow pillars with Ionic capitals. The arcades divide the barrel-vaulted aisles and provide the long hall with a rhythmic, recurrent pattern. The remarkable atmosphere, especially on sunny days when the light shining in seems to imitate the forms of the architecture, is a direct reminder of the original use of the room, which had been Europe's first public library and had served as a scriptorium for the monks. Some of the valuable manuscripts, which the Dominicans studied and illuminated in the 15th century, are still on display here today.

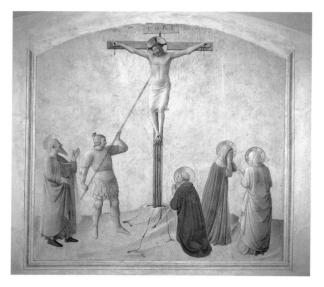

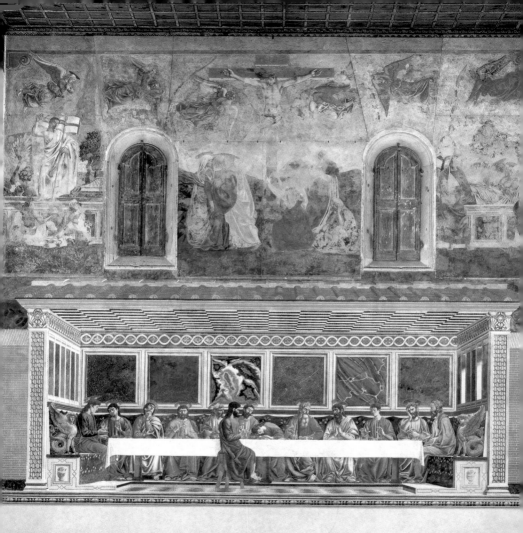

Cenacolo di Sant' Apollonia – Museo Andrea del Castagno

Andrea del Castagno: The Last Supper, 1447–50
Fresco, 920 x 980 cm (whole wall), 470 x 975 cm
(Last supper)

**Andrea del Castagno: The Resurrection of Christ
(detail)**

Today there is a museum in honor of the painter Andrea del Castagno in the refectory of the former Benedictine monastery of Sant' Apollonia (secularized in 1808). The main work is the great fresco of *The Last Supper* which the individualistic artist painted here.

The table, covered with a white cloth, is standing parallel to the surface of the picture and seated at this table are the apostles who have gathered for the Last Supper. The symmetrical seating arrangement with Christ in the middle is broken by Judas. He is sitting on a stool in front of the table and is thus clearly marked as the traitor among Christ's followers.

Castagno differs greatly from his contemporary artists in his portrayal of people. There is no charm and lyrical elegance to be found here as is usual in Early Renaissance paintings. The apostles are depicted with rough, almost peasant features and there is a rigidity about them. The architecture surrounding them is arranged soberly and deliberately. The box-like room opens up to the viewer while the strictly symmetrical structure of the perspective is focused on a central viewpoint, thus drawing the viewer into the spell of the important events.

The main wall of the refectory is divided into two horizontal pictures. The lower part shows the Last Supper, above that – unfortunately damaged quite considerably by water – is the Crucifixion of Christ flanked by scenes of the Entombment and the Resurrection.

Chiostro dello Scalzo

Andrea del Sarto: Herod's Feast, 1510–26
Fresco, 194 x 308 cm

The brotherhood of John the Baptist used to have a barefooted person carrying the Cross leading the processions. This custom soon resulted in them being called the *Confraternità dello Scalzo* (Brotherhood of the Barefooted) in common parlance. This association commissioned Andrea del Sarto to decorate the cloister of their headquarters. The fresco cycle about the life of John the Baptist is still preserved today. The work, with which the painter Franciabigio assisted, was interrupted several times because the patrons nearly ran out of money or Andrea del Sarto was working somewhere else (at the court of King François I of France). All in all it took from 1510 to 1526 for the fresco finally to be completed.

The cycle's obvious special feature is that the paintings were completely carried out

in grisaille (a technique only using tones of gray). Although del Sarto used no colors whatsoever he achieved an impressive plasticity and depth by sensitively varying the different shades of gray. In the scene of Herod's feast a servant is just coming in carrying John the Baptist's head. Starting from this point the group of figures forms a semicircle, curving from the main characters sitting at a small table to the thoughtful figure on the far right. The walls of the narrow but very long room have been left undecorated.

The style of Andrea del Sarto's figures is of a massive monumentality; voluminous garments support the powerful modeling of the bodies. Del Sarto was already admired by his contemporaries at an early stage for his abundance of scenes, his masterly use of shades and his extreme perfection in drawing. His contemporaries used to call him *Andrea senza errore* (Andrea without mistakes).

Andrea del Sarto: Caritas, ca. 1513
Fresco, 194 x 110 cm

Andrea del Sarto's fresco cycle of John the Baptist in the so-called Cloister of the Bare-footed is complemented by four pictures of the Christian virtues *Fides, Caritas, Justitia,* and *Spes* (Faith, Love, Justice, and Hope). *Caritas* appears in the figure of a beautiful young woman whose smooth facial features could not be more charming. The fineness of these features is almost in contrast to the plump physical presence of the figures, particularly of the three boys surrounding her. With its special grisaille technique the painting has the effect of a complete marble sculpture.

The Great Catastrophes of the Middle Ages – Famine and Plague

In the early 14th century, Florence was one of the largest and richest cities of the western world. The population had grown to an impressive 100,000 and the florin had become the dominant currency throughout Europe. During the Trecento there was a great expansion of building and blossoming of culture, but it was also a time of many difficult and traumatic crises. The social, economic and political stability was endangered by various military defeats, continuing battles for power and class struggles within the city as well as the collapse of the important Peruzzi and Bardi family banking houses. In the first decades of the 14th century, at intervals of only a few years, Florence was additionally hit by the terrible disasters which also continued to cause disruption in the later history of the city.

It all began with the famines which occurred periodically (in 1315–17 and 1328–30) and which were a great affliction for the inhabitants of the city and the surrounding countryside for much longer than the Middle Ages. Variation in climate, too much or too little rain as well as unexpected sudden frosts, quickly led to a shortage of food. Huge losses in the crops were caused by sudden attacks of pests or the depredations of marauding troops of mercenaries. Contemporaries such as the chronicler Giovanni Villani were already reporting the wide-ranging consequences. Although an attempt was made to feed the hungry at Orsanmichele and outside the city gates, the supplies only met a third of the required amount. The number of those who died of hunger increased daily. There were often riots which led to armed guards having to be provided in order to control

Codex Biadaiolo: The Feeding of the Hungry Outside the City Gates. (14th century), Biblioteca Laurenziana, Florence

the restless population demanding more food.

For Florence, its position on the Arno was not always an advantage, as it was also a continual threat. The river provided vital water and over the centuries it served as a means of transportation for trade, but it could turn into a torrent in a short space of time. Florence was just recovering from the worst years of famine when in 1333 the high waters of the Arno caused a great deal of damage and swept the Ponte Vecchio away with them the flood.

Only a few years later the whole city found itself almost at the mercy of a completely different kind of threat. The plague was raging in large parts of Europe and – after a short interlude in 1340 – approximately 25 million people fell victim to it within a few months in 1348/49. In Florence alone 60 percent of the 100,000 inhabitants died. We owe the most forceful contemporary account of this horrific event to the poet Giovanni Boccaccio (1313–75), to whom the plague served as a narrative basis for his famous collection of stories, the *Decameron*. He complained that neither pious prayers nor wisdom nor precautions of any kind could avert the catastrophe. Social coexistence was determined by fear and mistrust, and friendships and family bonds were broken.

Codex of Giovanni Sercambi: Allegorical Depiction of the Plague (14th century), Archivio di Stato, Lucca

Priests refused to give the sacraments out of fear and parents cast out their own children. The social structure of the city was shaken by the strange and unpredictable illness. And the beginning of the century had been so promising.

Piazza Santissima Annunziata

The Piazza Santissima Annunziata is one of the city's most beautiful squares; it is extremely popular, and not only with the students of the adjoining university faculties. Although the adjacent buildings all date from different times the atmosphere of a well-organized arrangement of buildings in the style of the Renaissance can still be felt here. The harmonious appearance is mainly due to the fact that on each side of the square the fronts of the buildings all have open arcades. Filippo Brunelleschi's Foundling Hospital served as a model to all architects working here in later times. Antonio Sangallo and Baccio d'Agnolo (1516–25) imitated the row of arches of the Foundling Hospital when they built the headquarters of the Servite order on the opposite side.

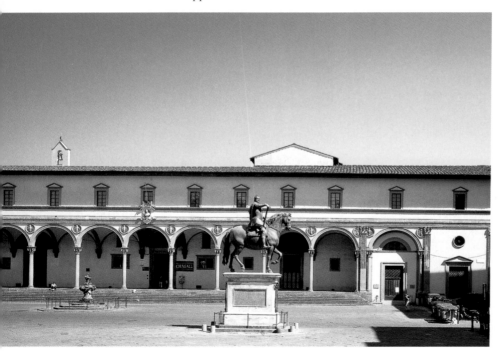

Giambologna: Equestrian Statue of Ferdinando I, ca. 1608
Bronze

In 1594 Ferdinando de' Medici had commissioned Giovanni da Bologna (called Giambologna) to create a bronze equestrian statue in honor of his deceased father Cosimo, which today stands in the Piazza della Signoria. More than ten years later, he commissioned him with a similar task. This time Ferdinando I wanted to perpetuate himself on a horse. Unfortunately the artist died in 1608 while still working on the statue; however, his pupil Pietro Tacca completed it following the master's sketches. Tacca also designed the two fountains to be found on the Piazza Santissima Annunziata. According to records, the material needed for casting was obtained by melting some guns originating from the booty taken from the Turks – this fact can be read on the inscription carved on the horse's girths.

Santissima Annunziata

Santissima Annunziata was founded by the Servite order in 1250. Miracles supposedly soon occurred here, making the church popular then and now as a place for the adoration of Mary. It also brought in many donations from the faithful. The chapel, which used to be quite small, thus grew in time to a complex of buildings which was extended several times.

Today's church is mostly the work of Michelozzo. He started the new building in 1444 after being commissioned to do so by Cosimo the Elder. The architect built an atrium, which was formerly open at the top, in front of the church. In order not to clash with the fronts of the other buildings, the arches of the portico were added to the front of the church around 1559–61.

Santissima Annunziata

Alessio Baldovinetti: The Birth of Christ (ca. 1460)

Cosimo Rosselli: The Vocation and Robing of St. Filippo Benizzi (1476)

Andrea del Castagno: St. Filippo Benizzi Clothing a Leper (ca. 1510)

Andrea del Castagno: St. Filippo Benizzi Admonishing the Mockers (ca. 1510)

Andrea del Castagno: The Curing of One Possessed by St. Filippo Benizzi (ca. 1510)

Andrea del Castagno: The Raising of a Child by St. Filippo Benizzi (ca. 1510)

Andrea del Castagno: The Curing of a Child by St. Filippo Benizzi (ca. 1510)

Michelozzo: Tempietto (ca. 1450)

Rosso Fiorentino: The Assumption of the Blessed Virgin (1517)

Chiostro dei Voti

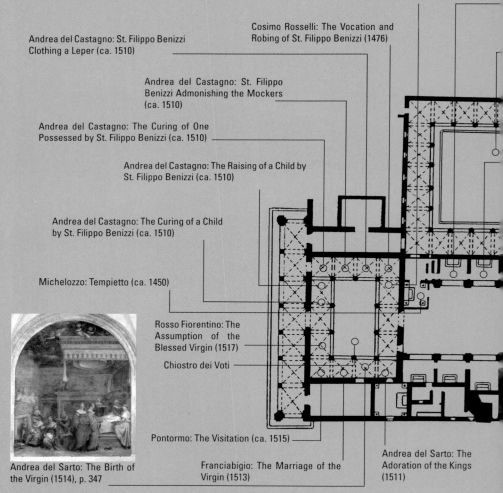

Andrea del Sarto: The Birth of the Virgin (1514), p. 347

Pontormo: The Visitation (ca. 1515)

Franciabigio: The Marriage of the Virgin (1513)

Andrea del Sarto: The Adoration of the Kings (1511)

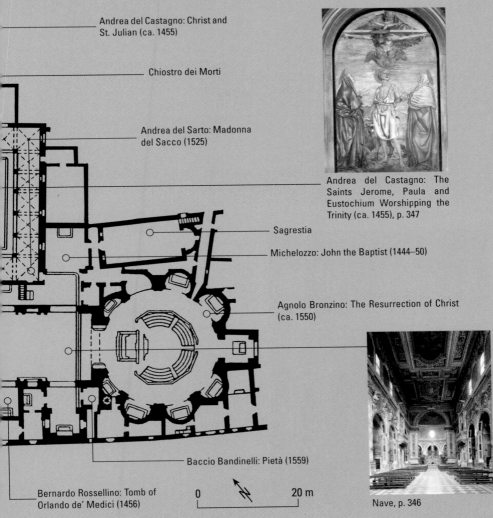

Andrea del Castagno: Christ and
St. Julian (ca. 1455)

Chiostro dei Morti

Andrea del Sarto: Madonna
del Sacco (1525)

Andrea del Castagno: The
Saints Jerome, Paula and
Eustochium Worshipping the
Trinity (ca. 1455), p. 347

Sagrestia

Michelozzo: John the Baptist (1444–50)

Agnolo Bronzino: The Resurrection of Christ
(ca. 1550)

Baccio Bandinelli: Pietà (1559)

Bernardo Rossellino: Tomb of
Orlando de' Medici (1456)

0 20 m

Nave, p. 346

The Interior

In 1252 an unfinished fresco of the Annunciation in the interior of Santissima Annunziata was said to have been completed overnight by an angel. The news of this miracle made the church such a frequented place of pilgrimage that an extension soon became inevitable in order to accommodate the faithful. A lack of space of a different kind was due to the custom, which slowly took on enormous proportions, of setting up votive and consecrational offerings. Wealthy citizens (and strangers) had the right to express their piety here in images of wax or papier maché, often life-sized and equipped with real clothing of the donors. There are even supposed to have been knights in full armor among them. As the available space inside the church was quickly exhausted, people started to tie the votive offerings to the timbers of the church roof. This soon proved to be an unfortunate solution because, as the report goes, some worshippers were killed by parts falling down.

Finally the Chiostro dei Voti was erected specially for consecrational gifts. In the 18th century the last remainder of this peculiar collection was completely removed so that today one can hardly imagine what the rooms must have looked like centuries ago.

Today the interior of Santissima Annunziata is almost completely overlaid by Baroque decorations. The rearrangement of the choir requires a special mention as it is an architectural innovation of the 15th century which pointed the way to the future. It was presumably Michelozzo's idea to design it as a cupola-vaulted rotunda. This was finally completed in 1477 under the supervision of Leon Battista Alberti, the architect in charge of the project at the time.

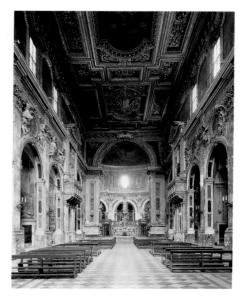

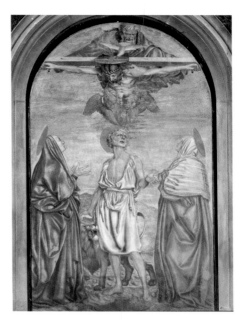

Andrea del Sarto: The Birth of the Virgin, 1514
Fresco

The scene with its many figures is well thought out and takes place before our eyes in a contemporary interior as if it were the most natural thing in the world. In their movements and postures, the figures are rhythmically adapted to the clarity of the architectural structure of the picture. Everything is interlinked to form a whole by using a range of matching shades of colors. "Andrea without mistakes" – as the Florentines were already calling him in his lifetime – here comes close to his artistic ideal of harmony.

Andrea del Castagno: The Saints Jerome, Paula and Eustochium Worshipping the Trinity, ca. 1455
Fresco, 300 x 179 cm

Andrea del Castagno (1421–1457) was one of the pioneering Florentine artists of his generation. The artistic development in Florence, which was already initiated by Masaccio and Donatello, is clearly evident in Castagno's works, including the figural style of the late Trinity fresco in Santissima Annunziata.

Santa Maria degli Angeli and Ambrogio Traversari
Clemente Manenti

The Florence of the year 1295, the city of the 30-year-old Dante Alighieri, was full of large building sites. Construction had been going on at Santa Maria Novella and the adjoining buildings of the Dominican monastery for years and work had been started on the church of Santa Croce. The Ponte Vecchio was being restored and

Jacobo Magliabechio: Portrait, engraving, Biblioteca Nazionale Centrale, Florence

ILLVSTRISSIMO D.D. IACOBO MAGLIABECHIO
Nuntiaturæ Apostolicæ in Regno Poloniæ Auditori generali
effigiem hanc B. Ambrosÿ A.66. general. Camaldulensis
è picturis ad coiuum expressis à Petro Dandino Pictore celeberi
depromptam. Adrianus Haelwegh D.D.D.

altered, and the grounds intended for the Palazzo della Signoria were already being dug out.

Owing to the enthusiasm for those large projects no one noticed the arrival of six monks, dressed in white, on 31 May of that year. They were hermits from Camaldoli who had come from the Casentino hills where their fellow monks had prayed and worked and suffered boredom in their cells for more than 150 years. They intended to found a new retreat in the middle of the city, which was a center of international trade.

A year earlier, when the snow had melted, the monks of Camaldoli had sent one of their brothers to Florence with 200 Pisan lire to see how he would invest the sum. Don Orlando had purchased a house with a garden in Cafaggiola. It was not in the center of town but in an area where there was a lot of building work – the area where the Via degli Alfani is today. The six monks took up quarters here. "They built a small chapel … where it was possible to talk to women if necessary," their first chronicler reported. The house, the garden and the chapel were known as the monastery of Santa Maria degli Angeli.

A century later, toward the end of the 14th century, Santa Maria degli Angeli had become one of the busiest and most thriving producers of handicrafts in the city. The monastery had acquired the entire area surrounding the first building. The best embroidery, tapestries and

illuminated manuscripts of their time were manufactured here by the Angioli (angels), as the Florentines called the monks.

The monastery's other main concern was the upkeep of orphanages and the orphans' education. In the early 15th century the Angioli managed to convince the powerful Guild of Silk Weavers to finance Europe's first big orphanage, the Ospedale degli Innocenti, which Filippo Brunelleschi had begun building in 1419. By educating the orphans the Angioli also had a fine opportunity to win new scholars for the monastery. At the same time Santa Maria degli Angeli established itself as the center of a new discipline: the study of Greek. People in Florence who wanted to learn classical Latin or Greek went to the Angioli, for instance Giovanni Bicci de' Medici's two sons Cosimo and Lorenzo. Monks of the Camaldolite order made the first Greek–Latin translations of the early church fathers as well as translations of secular works such as Diogenes Laertios' *The Life and Opinions of the Famous Philosophers*, a large compendium of Greek philosophy in ten volumes. The parchments were decorated with miniatures and hundreds were copied and reproduced.

The young monk Ambrogio Traversari was an important translator and the development of the arts and science also owe a debt to him. Born into an influential noble family from Ravenna he had entered the order of Santa Maria degli Angeli in 1400 at the age of 14. In the order he studied eastern patristics as well as Greek and Hebrew, music, singing and embroidery. His first biographer Fortunion reports that in spite of his seclusion he was widely renowned for his

Leonardo da Vinci: Studies of central-plan buildings, pen and ink on paper, 23 x 16 cm, Institut de France, Ms.B, f17v, Paris

academic knowledge and piety so that no person of importance who came to Florence failed to visit him. He was in close contact with the important artists and scholars of his time. For example, he advised Lorenzo Ghiberti on biblical matters when he was designing the scenes for the door of Santa Maria Maggiore. He was especially friendly with Giovanni Aurispa, the Sicilian merchant and scholar who brought him valuable manuscripts from Constantinople. Two later popes, Gabriele Condulmer (Eugene IV) and

Filippo Brunelleschi: Santa Maria degli Angeli, ground plan, Istituto Germanico, Florence

Tommaso Parentuccelli (Nicholas V), were among his most enthusiastic visitors.

In 1433, after the construction of Santa Maria del Fiore's cupola had begun, Traversari entrusted Brunelleschi with a relatively small project, namely the construction of the new church of the Florentine monastery. Brunelleschi designed an octagonal church, each side of which has one chapel with a double apse; there is a large cupola, also octagonal, which is placed over them as a vault. In 1434 the rotunda was begun by erecting the outer walls. The work was stopped in 1437, however, because of an outbreak of plague and the war with Lucca and it was never resumed. The Signoria commissioned Brunelleschi with more urgent tasks, namely a technical project to flood the city of Lucca with the water of the River Serchio.

Traversari was voted prior general of the Camaldolite order in 1431. At the age of 45 he left the monastery and now he was the one to visit others: he visited all the houses of the order to inspect them and while doing so he kept a diary. At the Council of Basle he was the emissary of the pope and he visited Emperor Sigismund in Hungary. He suggested the Council of Ferrara-Florence, which was to deal with the re-unification of the Roman Catholic and Greek Orthodox churches, and played a key role there by drawing up the closing bull in both languages. A relief dedicated to the council can be seen on the door of the middle portal of St. Peter's Church in Rome, designed by Filanete. It depicts Traversari suggesting to one of the bishops of the council how an article should be phrased. It is an impressive synopsis of this historical event.

For Traversari the Council of Florence was both providence and accomplishment: the Camaldolite order had been founded around 1020 just before the schism, hence at a time when the conflict between the two churches had come to a head. The founder of the order, the Benedictine Romualdo, also came from Ravenna, the capital of the old Byzantine exarches, which had been influenced by Greek culture and its imagery. The church there suffered directly from the dispute between Rome and Constantinople. Romualdo left the town for Spain at a very young age. After his return he founded a hermitage and a hospital in

the Apennines between Romagna and Tuscany. It was located near a pilgrim trail which led from the northwest of Italy to Rome. In establishing this Romualdo adopted the traditional life of a hermit based on eastern monastic life and made it an element of the Benedictine order. The Camaldoli community had always kept itself distant from the events in Rome. The Camaldoli coat of arms, two doves drinking from one chalice, shows what had been the congregation's aim from the beginning: over coming the schism of the two churches. Approximately three centuries later Traversari thought it was the right time to achieve this unification. Three months after the Council of Florence ended, Traversani died unexpectedly at the age of 51 on 21 October 1439 in the monastery of Santa Maria degli Angeli. The church neither beatified nor canonized the monk. The monastery Santa Maria degli Angeli fell into ruin and is no longer one of the attractions of Florence.

Unknown artist of the 16th century: Portrait of Ambrogio Traversari, Monastery of Camaldoli

Ospedale degli Innocenti

In 1419 the wealthy Silk Merchants' Guild donated the financial means to erect Europe's first orphanage. The name Ospedale degli Innocenti is a reminder of Herod's Massacre of the Innocents in Bethlehem. In 1445 the rooms were completed and in 1451 the adjoining church was consecrated. The number of children being looked after there grew rapidly and was evidence of the extreme need for such a charitable organization. In difficult times more than 1000 orphans lived there. Up to 1875 it was possible, by making use of a *rota* – a rotating stone cylinder – at the side of the loggia, for desperate mothers to remain anonymous when leaving their children at the Ospedale. Large parts of the complex are still used as an orphanage today while a small but thoroughly worthwhile collection of pictures (with works of important Florentine artists such as Ghirlandaio, Botticelli, L. Monaco, Fra Bartolomeo and also Luca della Robbia) can be seen on the upper stories of the Galleria dell' Ospedale.

The Silk Merchants' Guild commissioned Filippo Brunelleschi as the architect in 1419. With his plans for the whole site, but even more so with his design of the open arcade front, he left an early example of his pioneering creativity. Although Brunelleschi himself withdrew as early as 1427 and others took over the enormous project, the Ospedale still shows

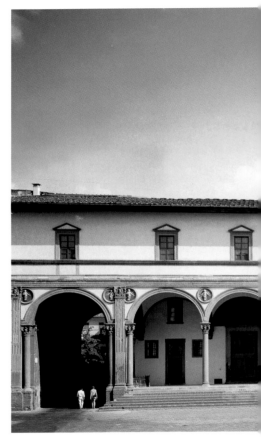

the "mark" of the outstanding Renaissance architect. The original plan suffered, however, because Francesco della Luna left out, among other things, the pilasters on the upper story. In addition, the front was

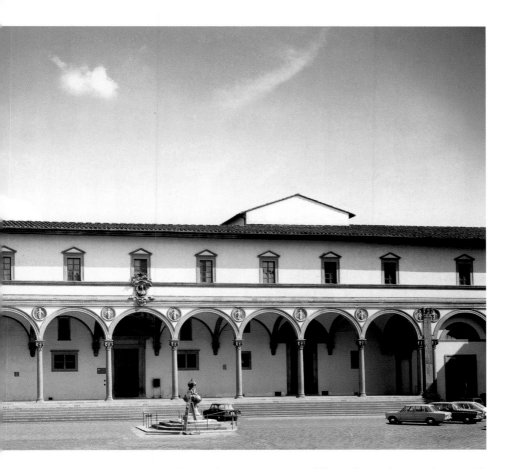

widened in 1430 (on the right) and again in 1843 (on the left).

The front is notable for its clearly delinated structure. In Brunelleschi's sketch this façade merely comprised the nine middle arches. The windows with simple pediments on the second story above the continuous architrave are situated directly above the center of the arches forming the loggia below. The clear

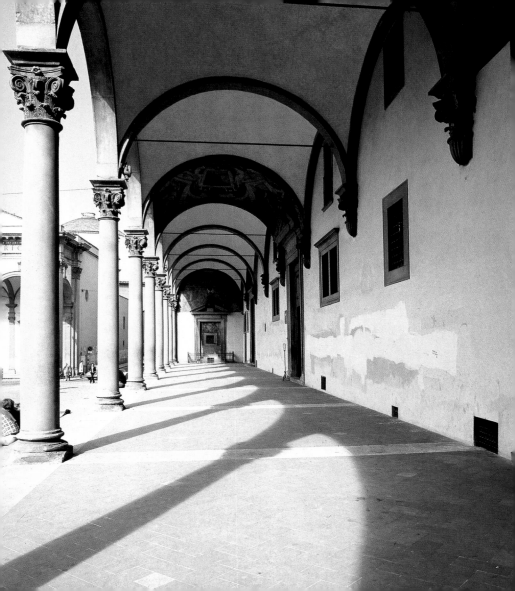

proportions determine the structure of the entire façade according to the architectural-theoretical proportions presented in the treatises of Vitruvius. The narrow pillars also correspond to the width of the arches not only in height, but also in the distance between the architrave and the beginning of the roof. The height of the windows (including the triangular pediments) corresponds to a ratio of 1:2 to the half-circles of the arcade arches. The distance between the cornice below the window and the top of the steps is double the height of the pillars.

Brunelleschi's plans were not only intended for the comparatively mundane function of an orphanage. They also demonstrate the mentality of the Renaissance, which transformed the simple useful building into an independent masterpiece of architecture influenced by the principles of proportion.

Andrea della Robbia: Foundling Tondo, ca. 1463
Terracotta (glazed), diameter 146 cm

The architecture of the Ospedale is enlivened by ten terracotta tondi which Andrea della Robbia added to the spandrels of the arches around 1463. The lovingly made and colorfully glazed reliefs contain depictions of foundling babies in swaddling clothes on a blue background. This not only alludes to the function of the building as an orphanage but also appeals to the sympathy of the passers-by and thus increases their willingness to give donations.

Colorful Terracotta – A Specialty from the della Robbia Workshop

The brothers Giovanni (1469–1529) and Girolamo (1488–1566) della Robbia ran a very successful workshop well into the 16th century in Florence. Their specialty was the manufacture of fired, colorfully glazed clay pictures. The special

Andrea della Robbia: Madonna of the Stonemasons' Guild, 1475–80, terracotta, glazed, 134 x 96 cm, Museo Nazionale del Bargello, Florence

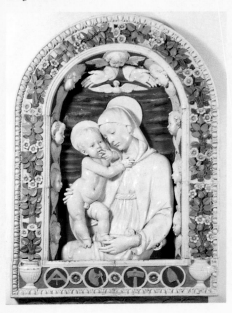

technique of making this terracotta (from Ital. *terra* = earth and *cotta* = cooked) had remained a secret of the workshop for three generations. Their father Andrea (1435–1525) had already taken it over from his uncle, the "founder of the company," Luca della Robbia (1339–1482).

Although no early work of his is preserved, one can assume that Luca, who had been trained by Ghiberti and Nanni di Banco from an early age, had made a name for himself as a sculptor of marble when he was commissioned to produce the cantoria for the cathedral. Luca della Robbia had thus worked as an artist for many years before, in the 1430s, experimenting with a new form of sculpting using techniques from the production of faience and majolica. Florentine sculpture was thus enriched by another form of expression which soon became very popular and made the inventor famous for it even after his death.

Luca cannot be called "the inventor" of the glazing of clay in the narrowest sense, but he was the first sculptor to use this technique in a modified way to produce large sculptures. It can be assumed that he demonstrated the impressive possibilities of this new method in 1442–45 with the *Resurrection of Christ* for the Florentine cathedral. Such works were comparatively cheap, owing to the reasonable price of the clay material, whilst glazing made it long lasting and even made later cleaning easier. In the beginning Luca mostly used blue for

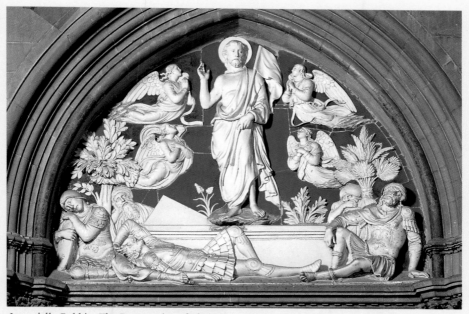

Luca della Robbia: The Resurrection of Christ, 1441–1445, terracotta, glazed, 200 x 265 cm, Duomo Santa Maria del Fiore, Florence

the background of the relief and white for the figures. Even from a distance the clear contrast made a tremendous impression, as the white parts even looked like the popular but much more expensive marble.

Luca della Robbia thereafter worked almost solely with this technique, which he was constantly perfecting. His most remarkable works include, among others, the reliefs of the Virgin, which were extremely popular in the Quattrocento and were delivered in large numbers by the della Robbia workshops, and the apostles tondi, which Luca made for Brunelleschi's Pazzi chapel. Four decades later his nephew Andrea designed the moving tondi of the foundlings and babies for the façade of Brunelleschi's Foundling Hospital.

Museo Archeologico

In the year 1818 the Archeological Museum was opened in a 17th-century palace near the Piazza Santissima Annunziata. The numerous objects reflect the passion for collecting centuries-old artifacts. There are still individual exhibits from Cosimo de' Medici's personal belongings. Especially during the period of Historicism (in the 19th century) valuable pieces were added. Today the Etruscan and Egyptian departments of the museum, in particular, are among the most important of their kind.

Chimera of Arezzo, 4th century B.C.
Bronze

One of the most famous exhibits of the Archeological Museum is the chimera found in Arezzo in 1553. This mythological creature is a mixture of lion, goat, and snake and – according to the inscription – it was a consecrational gift.

This splendid bronze statue dates back to the 4th century B.C. and presumably belonged to a group of sculptures. We have to imagine the hero Bellerophon opposite it, who – according to myth – killed the mythological creature from his winged horse Pegasus in a fight.

Santa Maria Maddalena dei Pazzi

The Interior

From its founding in 1257, this convent, now belonging to the Augustinians, was the home of many different orders. The convent takes its name from the Carmelite nun Maria Maddalena Pazzi who was canonized in 1669.

The interior was originally a simple single nave, to whose walls Giuliano da Sangollo added six side chapels during alterations in 1480–92. The decoration with Baroque frescos mostly dates from the second half of the 17th century. The uncontested masterpiece of the Santa Maria Maddalena dei Pazzi is Perugino's fresco of the Crucifixion displayed in the chapter house.

Perugino: The Crucifixion, after 1493
Fresco, 480 x 812 cm

Raphael's master Pietro Perugino (ca. 1445-1523) painted this unusual fresco in the years following 1493. An illusionistically painted row of arches divides the wall's surface into three equal parts. In the center is Christ on the Cross and before Him Mary Magdalene kneels in prayer.

With the Virgin Mary and St. Bernard of Clairvaux on the left and St. Benedict and John the Evangelist on the other side, the position of the figures forms a triangle, the tip of which is above Christ's head.

Perugino's power of artistic expression had almost reached its peak when he painted this fresco. The fresco of the Crucifixion indeed displays a powerful sense of poetry. The three arches distance the viewer from the sphere of the religious events; they serve as a spatial barrier. The few figures are depicted in front of a background whose atmosphere urges the viewer to pause in silence.

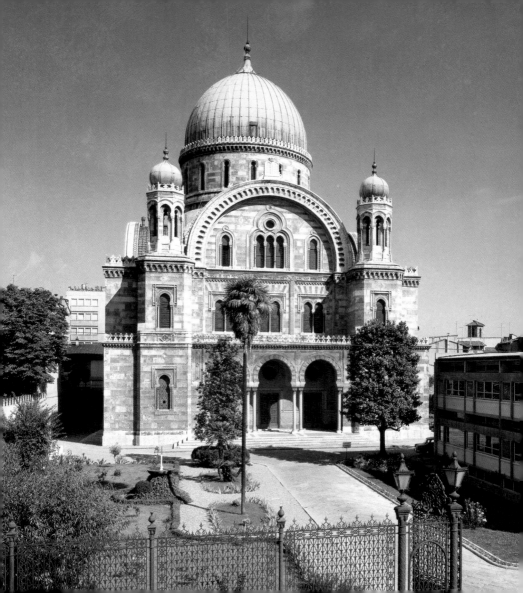

Tempio Israelitico

The construction of this spacious synagogue was made possible by the bequest of the Cavaliere David Levi, who had been president of the Jewish community in Florence between 1860 and 1870. The building was erected as a vaulted centrally planned building by the architects Marco Treves, Vincenzo Micheli and Mariano Falcini. It's design reflected the academic taste of the late 19th century. In this regard the architects were influenced by various features of the Byzantine (Hagia Sophia), Romanesque (windows) and specifically Florentine architectural tradition as seen in the two-colored marble facade.

The Interior

The synagogue was consecrated in 1874, only eight years after the laying of the foundation stone, and the interior of the building was equipped with the most valuable hand-crafted work in wood and bronze, with splendid mosaics and marquetry. In accordance with Jewish beliefs, there were no pictorial representations of biblical scenes. Arabesques dominate the decoration.

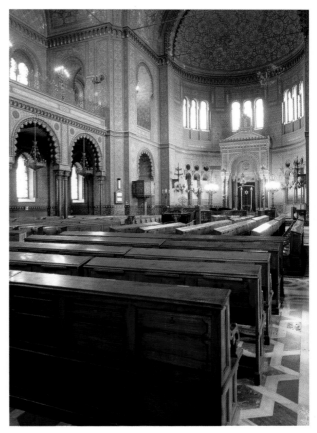

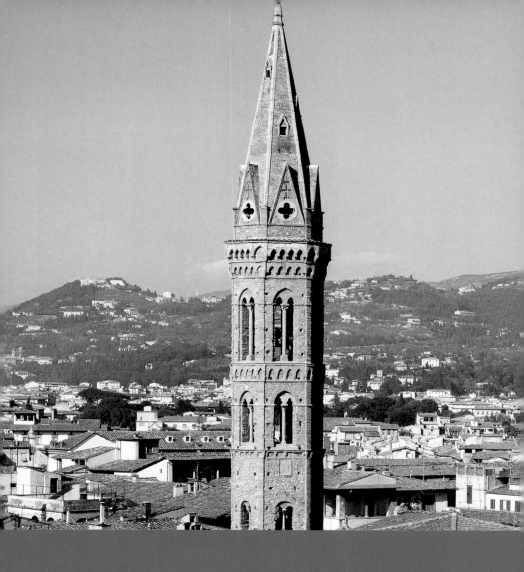

Around Santa Croce

Santa Croce

The foundation stone of the Franciscan church of Santa Croce was laid in the year 1294. The architect of the cathedral, Arnolfo di Cambio, was not only supposed to replace the previous smaller church, which had been erected around 1222 during the lifetime of the founder of the order Francis of Assisi, but was also supposed to surpass the enormous dimensions of Santa Maria Novella, construction of which had been started by the rival mendicant order of the Benedictines around 50 years earlier in the north of the city. After a brisk start, the transept and choir must have already been completed about the turn of the century. However, the remaining work took until 1385 and the façade of the church remained unfaced, in fact, for almost five centuries. It was not until the 1850s that the architect Niccolò Matas started working on this and presumably fell back on the sketches of previous centuries. The front thus dominates the eastern side of the extensive Piazza Santa Croce. Many events and ceremonies still take place in the Piazza today, such as the annual *Calcio Storico* (historical soccer game).

Because of this Enrico Pazzi's Dante memorial (1865), which was formerly in the middle of the Piazza, was removed and placed to the side of the façade in more recent times.

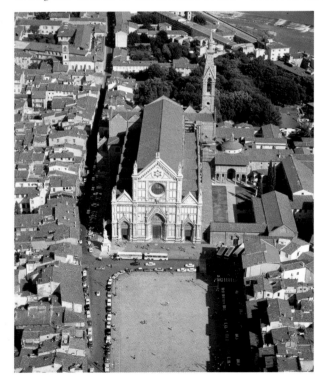

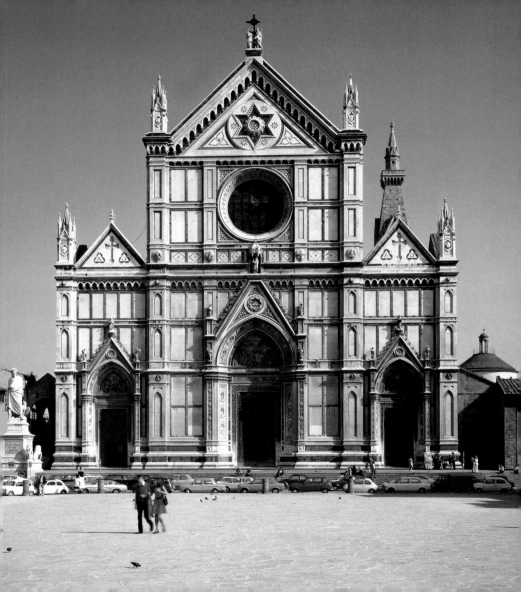

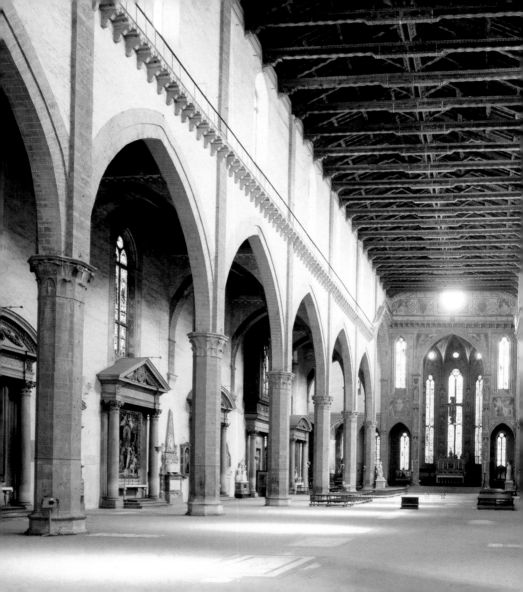

The Interior

The interior of Santa Croce is a highlight of the specifically Italian architecture of the Gothic style and is impressive owing not only to its spaciousness but especially to the formal clarity of its architecture, which is so characteristic of Florence. The extremely wide nave opens into the flanking aisles with wide arches as is the case in Santa Maria Novella. As in nearly all Franciscan churches the timbers are open and not covered by a vault. The view into the depth of the church ends with the rectangular enclosure of the choir.

According to their ideal, the Franciscan mendicant order was under the obligation to lead an ascetic life without personal belongings. Hence the order was dependent on generous donations of wealthy families in order to finance Santa Croce. These families also contributed to the extensive artistic decoration and because of this had the right to bury their relatives here. In this way, the basilica finally became a kind of pantheon for the important figures of the fine arts, music, the sciences and the city's intellectual life. The tombs (and cenotaphs) of Michelangelo, Galileo, Machiavelli, Dante, Ghiberti and even Gioacchino Rossini, for instance, made Santa Croce into a regular place of pilgrimage for 19th-century travelers eager to acquire culture.

Cappella Maggiore

The nave of Santa Croce stretches in an unusual manner up to the rectangular enclosure of the impressive main choir chapel. The outer wall of this chapel is decorated with many paintings, corresponding with the actual architecture of the church. Tabernacles painted here depict saints, and the lunettes above contain prophets. In the last decade of the 14th century Agnolo Gaddi decorated the interior of the Cappella Maggiore with frescos whose theme is the legend of the Holy Cross. It was the first time that such an extensive cycle had been dedicated to this theme in Santa Croce. The *Legenda Aurea*, the famous collection of the lives of the saints which the Dominican Jacobus de Voragine had compiled in the first half of the 14th century, served as the literary basis.

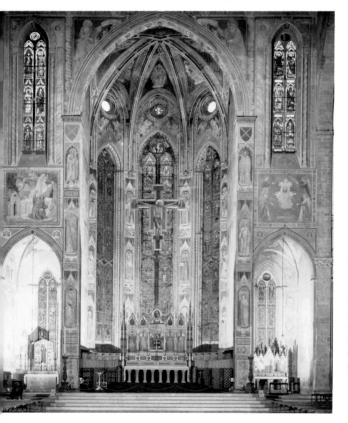

The light coming in through the high Gothic glass windows, which in part were probably also made around 1380 according to designs by Angelo Gaddi, increases the magnificent impression of the decoration. The creator of the crucifix above the altar cannot be identified for sure. It was presumably made in the first half of the 14th century.

Agnolo Gaddi: The Finding and Proof of the True Cross, ca. 1385
Fresco

Some see Gaddi (around 1350–1396) as a disciple of Giotto, who sacrificed his master's quality of portrayal for cluttered sensationalism. Others praise him for his effective imagery, with which he gave his frescos great clarity.

The scene of the finding of the True Cross combines two episodes shown here as parallel scenes. On the right Empress Helena finds the Cross of Christ. In her presence the authenticity of the Cross is proven by the miracle of raising of a deceased woman. Many figures surround the two main scenes while in the sparse background charming side scenes have been inserted. "People, animals, objects, nature, the sky and villages, everything can be found in this great scene full of busy people. The wonderful event, the occurrence of which is so far away in history, is projected in a direct way into the present of the viewer of the Trecento just as it is for today's observer" (R. Salvini).

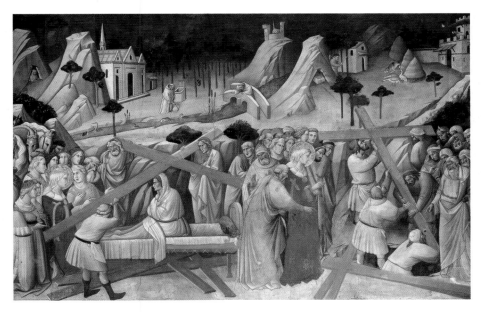

Santa Croce

Donatello: The Annunciation
(ca. 1435), p. 376

Bernardo Rosselino: Tomb of
Leonardo Bruni (1446–1447), p. 375

Tomb of Galileo Galilei (1737,
according to sketches by
Giulio Foggini)

Benedetto da Maiario:
Pulpit (1472-1476)

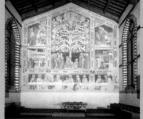

Cappella dei Pazzi by Filippo
Brunelleschi (after 1429), p. 382

Primo Chiostro

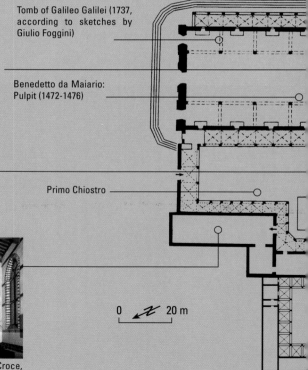

Museo dell' Opera di Santa Croce,
p. 388

0 20 m

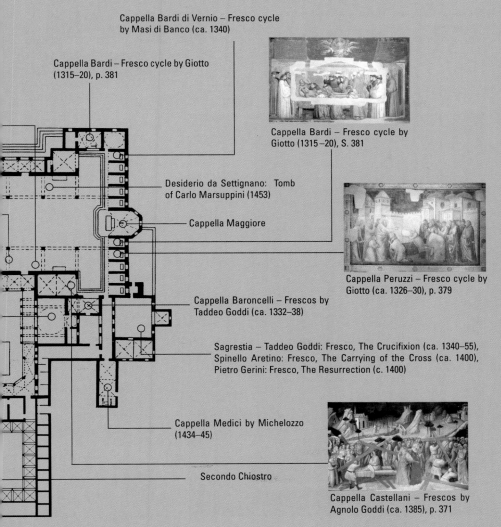

Cappella Bardi di Vernio – Fresco cycle
by Masi di Banco (ca. 1340)

Cappella Bardi – Fresco cycle by Giotto
(1315–20), p. 381

Cappella Bardi – Fresco cycle by
Giotto (1315–20), S. 381

Desiderio da Settignano: Tomb
of Carlo Marsuppini (1453)

Cappella Maggiore

Cappella Peruzzi – Fresco cycle by
Giotto (ca. 1326–30), p. 379

Cappella Baroncelli – Frescos by
Taddeo Goddi (ca. 1332–38)

Sagrestia – Taddeo Goddi: Fresco, The Crucifixion (ca. 1340–55),
Spinello Aretino: Fresco, The Carrying of the Cross (ca. 1400),
Pietro Gerini: Fresco, The Resurrection (c. 1400)

Cappella Medici by Michelozzo
(1434–45)

Secondo Chiostro

Cappella Castellani – Frescos by
Agnolo Goddi (ca. 1385), p. 371

Bernardo Rosselino: Tomb of Leonardo Bruni, ca. 1445–50
Marble, 610 x 328 cm

Among the many tombs in Santa Croce that of the humanist Leonardo Bruni (1369– 1444) has a special status. Bruni worked for many years as a teacher at the court of the Medici, served as secretary to several popes and was State Chancellor of Florence during his last years (1427–44).

Bernardo Rosselino's monument was a leading prototype of the humanist Renaissance tomb with its classic and dignified structure. Fluted Corinthian pilasters placed on a plinth support a richly decorated round arch. In the lunette above it there is a Madonna tondo flanked by angels; below that the deceased lies on a bier which is being lifted to Olympus by eagles.

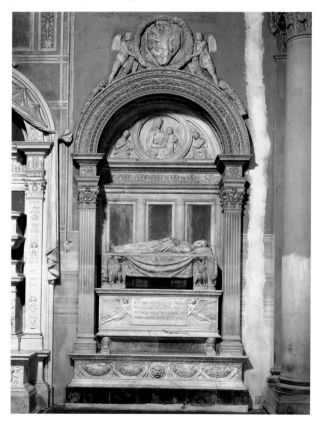

Bernardo Rosselino: Tomb of Leonardo Bruni (detail)

The tomb pays special tribute to Leonardo Bruni as the learned author of many important works. The main work *Storia Fiorentina* (The History of Florence) is shown placed in his hands and a laurel wreath crowns his head. The sculptor also attempted to give the impression of the silk garments which clothed the deceased at his funeral. On the front of the sarcophagus two angels bear the

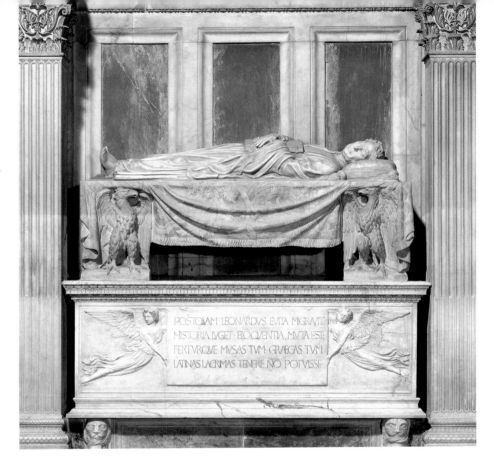

inscription: "Since Leonardo has passed away history is mourning, eloquence has fallen silent and it is said that the muses, the Greek as well as the Latin ones, have not been able to hold back their tears."

Donatello: Cavalcanti Annunciation, ca. 1435
Sandstone (partly gilded), 218 x 168 cm

Donatello produced his much admired *Annunciation* in 1435 for the Cavalcanti family. The two figures of St. Gabriel and the Virgin Mary are worked into an elevated, almost completely sculptured relief within the richly decorated tabernacle, which also contains gold ornamentation. Donatello dispenses with illustrative trimmings, with impressive results. The contents of the delivered message are expressed only in reserved gestures and the corresponding posture. The angel is on bent knees with his wings still spread while announcing the forthcoming birth of her son to the Virgin Mary. His posture is humble, while the restrained movements of her delicate figure show not only astonishment but also quiet concentration on the angel's words.

Examples of Classical sculptures, which Donatello had studied in particular detail in Rome, have had an unmistakable effect in the design of the garments. At the same time there is a sensitive spiritualization of expression, of a poetic intensity seldom found in Classical sculpture.

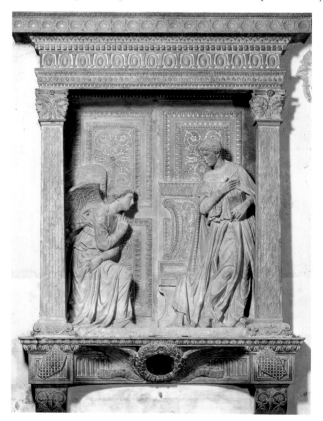

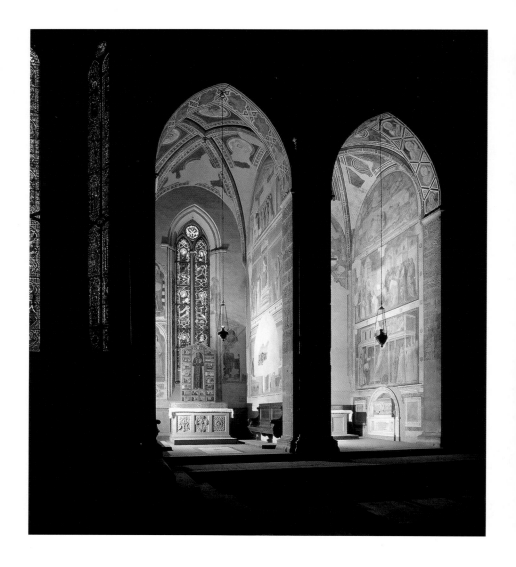

Cappella Bardi (on the left)
Cappella Peruzzi (on the right)

Giotto di Bondone: The Resurrection of Drusiana, ca. 1320 (Cappela Peruzzi)
Fresco, 280 x 450 cm

A new era began for European painting with Giotto di Bondone (1266–1337). According to Vasari he had been born among "incompetent masters"; however, enabled by the blessing of heaven, he was to reawaken art which had almost died out and to take it to a new excellence. For many years S. Croce was the master's main place of work in Florence. Unfortunately his murals, which belong to the most important artistic bequests of the early Trecento, are only preserved in part. All in all he decorated four chapels of the church with frescos, of which only the scenes from the lives of John the Evangelist and John the Baptist in the Bardi chapel as well as those of the legend of St. Francis in the Cappella Peruzzi are still preserved. The paintings were covered with whitewash until the middle of the 19th century and unfortunately the substance of the frescos was strongly affected when it was removed. During the extensive restoration from 1958–1961 an attempt was made to restore the original condition as far as possible.

The resurrection of Drusiana was one of the most important miracles ascribed to John the Evangelist. Despite the damage, the fresco still shows the narrative intensity of Giotto's powerful imagery. Similar to a stage in structure, the event unfolds over the whole width of the surface of the picture. It is remarkable how the architecture of the background, reminiscent of a fortress, emphasizes and serves as a background to the two crowded groups of the cortège on the right and the saint's followers on the left. The bier in the middle of the composition connects the two. On this bier lies Drusiana, who has just awakened from the dead. The people - surrounding her are characterized by a heavy physical presence.

Giotto di Bondone: The Ascension of St. John, ca. 1320 (Cappella Peruzzi)
Fresco, 280 x 450 cm

The frescos of the Peruzzi chapel are evidence of Giotto's mature style in his later work. This style is also characterized by the freer arrangement of figures in the space. The architectural elements are no longer parts of the background but are included in the depiction of the events as an indispensable frame for them.

In the picture of the ascension of St. John, an architectural prospect which has been arranged in perspective makes up the background. It is striking that, in his angled view, Giotto obviously took into consideration the observer's point of view from the side at the entrance of the chapel. Figures of monumental size are witnessing the ascension of St. John. However, the miraculous event is not an abstract spiritual weightless rising; instead it seems as if the saint, who still shows plenty of signs of heavy build, is having to be laboriously pulled up toward heaven.

Giotto di Bondone: The Death of St. Francis, ca. 1320–25 (Cappella Bardi)
Fresco, 280 x 450 cm

Giotto di Bondone had already painted a fresco cycle – in the Upper Basilica in Assisi – with events from the life of St. Francis at the end of the 13th century. He and his workshop were asked to perform the same task once more in S Croce more than two decades later.

One of the most famous pictures of the cycle shows the body of the saint lying on a bier surrounded by Franciscan monks. Some are seen kneeling at the sides of his deathbed lost in prayer; yet another is lifting his hands in lamentation. The other groups of figures to the left and right of the scene seem much more restrained, though not without noticeable involvement. Here Giotto succeeds without excessive pathos and obvious dramatics. Sympathy and grief are expressed without a word in an atmosphere of dignified tranquillity. In the meantime, angels are already lifting the soul of the deceased up to heaven in a nimbus at the top margin of the picture. Death, as the end of all life on earth, is thus opposed to the comforting certainty of eternal life in the hereafter.

Cappella dei Pazzi

The Cappella dei Pazzi, on the east side of Santa Croce's first cloister, was built as a funeral chapel for the founder family as well as a chapter house for the Franciscans.

It was one of Filippo Brunelleschi's main architectural works although here, too, his successors completed what he had begun. The building was completed two decades after the architect's death.

An open, barrel-vaulted and coffered vestibule with an extremely high entrance arch is incorporated into the front. Here six delicate pillars support the beams, whose continuity is broken by the high middle arch, and the attic is provided with Corinthian double pilasters. A richly adorned cornice closes it. This type of portico façade, which was much admired for its delicacy and grace, was an innovation for the architecture of that period.

The Interior

The interior of the rectangular main room seems at first sight reminiscent of the Old Sacristy of San Lorenzo, built approximately ten years earlier. Compared to its predecessor, the Pazzi chapel presents another enhancement of the pure rational complexity with which all the elements of

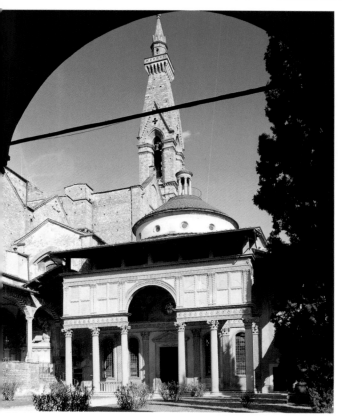

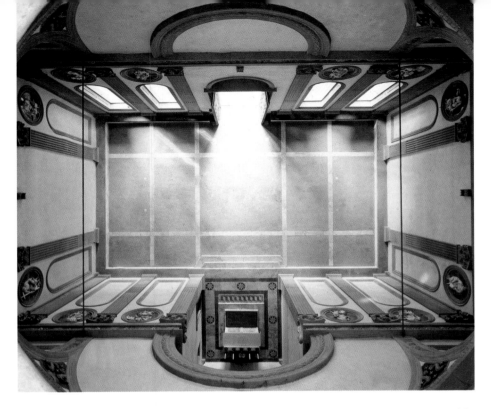

the architectural structure relate to one another. Regular geometrical shapes and the well-arranged proportions determine the harmonious appearance. Flooded in a wonderful light by the windows of the cupola, the basic shapes of the room can be seen in the pattern of the floor.

Luca della Robbia's (ca. 1399–1482) terracotta tondi of the 12 apostles on the side walls deserve attention. They harmonize with the architecture just like the four colored medallions of the evangelists in the pendentives of the cupola.

Museo dell' Opera di Santa Croce

Taddeo Gaddi: The Last Supper and the Family Tree of Christ, ca. 1340
Fresco (transferred to canvas)

Taddeo Gaddi's (ca. 1300–1366) beautiful frescos adorn the front wall of the former refectory of Santa Croce. The family tree of Christ is shown above the earliest monumental painting of the Last Supper in Florence.

The unusual subject of the family tree is based on the *Lignum vitae* of St. Bonaventura, and assigns depictions of prophets of the Old Testament to the Cross of Christ which is here symbolized as the family tree.

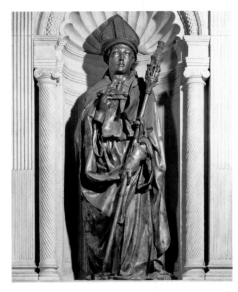

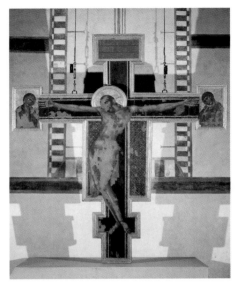

Donatello: St. Louis of Toulouse,
ca. 1421-25
Bronze (gilded), h 226 cm

Cimabue: Crucifix, ca. 1290
Oil on wood, 448 x 390 cm

In 1421 the *Parte Guelfa*, or Guelph party, which supported the Pope, commissioned Donatello to produce the gilded bronze statue of St. Louis of Toulouse. To adorn their tabernacle at Or S. Michele they chose a historic figure whose life exemplifies obedience to papacy. Donatello clad the saint in episcopal robes. However, the slight, youthful-looking Louis almost looks lost in his oversized garment.

Cimabue's enormous crucifix is tragically famous not only for its extraordinary quality but also for the fact that it suffered irreparable damage during the disastrous floods of 1966 when the Arno overflowed its banks. Nevertheless, even today it is still possible to recognize that Cimabue's depiction of the crucified Christ bore the seed of a new, more realistic way of painting, despite the dominance of the Byzantine tradition.

Around Santa Croce

Bargello/Museo Nazionale del Bargello, Via del Proconsolo 4, p. 409

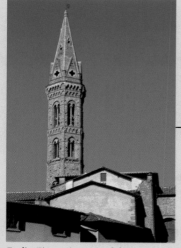

Badia Fiorentina, Via del Proconsolo (Via Dante Alighieri), p. 404

Museo Horne, Via dei Banci 6, p. 339

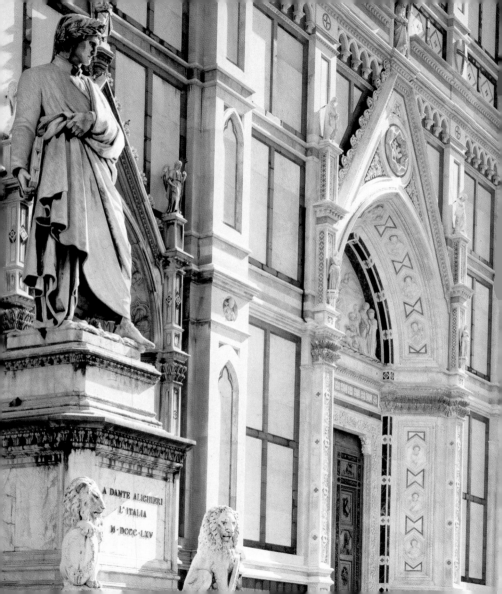

San Salvi, Via S. Salvi 16, p. 396

Casa Buonarroti, Via Ghibellina 70, p. 394

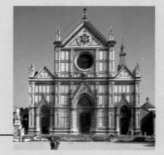

Santa Croce/Museo dell' Opera di Santa Croce, Piazza S. Croce, p. 367

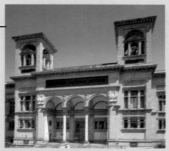

Biblioteca Nazionale Centrale, Piazza die Cavalleggeri 1, p. 398

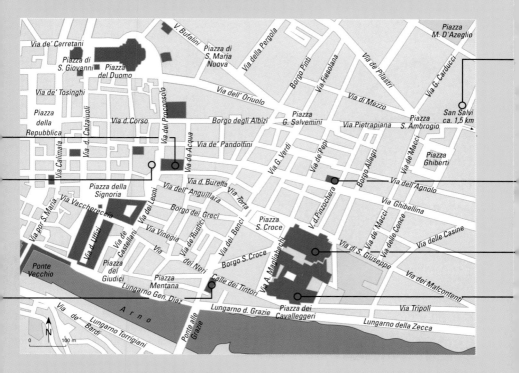

Dante Aligheri – An Exiled Genius

Casa di Dante

In his birth place, Florence, fate was kind to Dante Alighieri, probably the most important poet and writer of the European Middle Ages, only for about 37 years. Born in 1265 as the offspring of a noble but impoverished family he grew up in the part of the city, later named after him, to the southeast of the cathedral. He had an excellent education at a very young age, which soon made him fall under the spell of poetry and permitted him at the same time to study law at the renowned University of Bologna (1285-87). Having socialized with highly gifted artists and writers for a long time, and having kept in contact with men of Giotto's renown, his earliest – autobiographically inspired – poetry *La vita nova* (The New Life, 1292–95) finally appeared in the last decade of the Trecento. There his love for Beatrice is made the subject of his work for the first time. Dante had first caught a glimpse of her in Santa Maria Novella when she was only 9 and – according to his own

own words – was immediately entranced by her. His yearning for Beatrice, which was to remain unfulfilled throughout his life, thereby becoming, according to medieval ideas of courtly love, the highest, most divine form of love, was to reappear continually as a major motif in Dante's later poetry.

However, on completing his first literary works Dante was turning his attention increasingly to a political career in Florence. By 1295 at the latest he had taken on his first public functions and in the following years was a member of different councils and committees. Renewed disputes between the parties in Florence reached their climax at the end of the century and ended in a temporary triumph in 1302 for the Guelphs, the loyal supporters of the pope. Dante's involvement as a supporter of the Ghibellines ended in his being exiled from Florence. Shortly afterwards he was sentenced to death. Luckily Dante was able to escape his sentence by staying away from Florence until he died. During his unsettled vagrant life he found refuge in, among other places, Verona and Treviso, possibly also in Lucca and even in Paris, until he finally reached Ravenna where he died in 1321 following a bout of fever. With the exception of his earliest works Dante Alighieri's most important works of literature were thus written during his sad years of exile. Apart from his lyric poetry (collected in the so-called *Rime*) his most important works are the constitutional treatise *De Monarchia* (On Monarchy, 1310-15) and the encyclopedic thesis *Il Convivio* (The Feast, 1306-08), which was written in vernacular prose. Before that Dante had already earned praise for his uncompleted treatise *De volgare eloquentia* (On Eloquence,

1305) with which he pioneered the use of Italian. This treatise was also designed for non-Italian specialists and was thus written in the common language of scholars, namely Latin. In this fragment Dante discusses if it would be possible to derive a vernacular (*volgare illustre*) from one of the many Italian dialects and if it would meet the requirements of distinguished poetry, thus making it suitable as the literary language of his native country.

Unknown artist: Portrait of Dante Alighieri, ca. 1495, tempera on canvas, 55 x 48 cm, private collection, Geneva

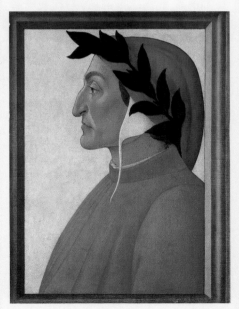

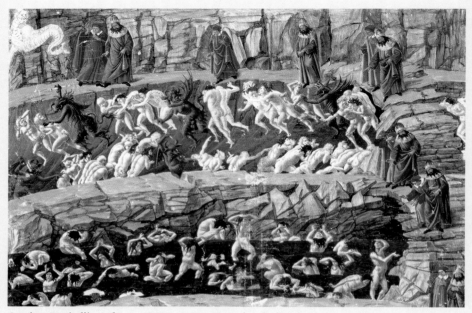

Sandro Botticelli: Inferno XVIII, 1482–90, colored drawing on parchment, 32 x 47 cm, Kupferstichkabinett, Staatliche Museen Preussischer Kulturbesitz, Berlin

During the last ten years of his life Dante finally wrote his world-famous masterpiece *La Divina Commedia* (The Divine Comedy) in the Tuscan dialect. In 100 cantos and more than 14,000 lines the poet describes his visionary journey through the hereafter, *Inferno* (Hell), *Purgatoria* (Purgatory) and *Paradiso* (Heaven). Virgil, representing earthly erudition, at first guides him through the nine crater-shaped circles of Hell and the fields of Purgatory. In the sphere of Heaven the Roman poet is replaced by Beatrice, who is made the symbol of divine salvation and mercy. The poetic strength of the linguistic style to be found in the *Divina Commedia* makes it not only an outstanding book of Italian literature but also an extensive compendium of the knowledge of that time. In a synthesis of western theological and secular medieval images, the work describes the human path to redemption and salvation in an allegorical sense. Dante's later irreconcilable attitude regarding his home town Florence, with which he seems to have had a love-hate relationship, found its way directly into the

book, not least by having many contemporaries and enemies from the Florentine years appear among those condemned, whom he meets in Hell during his journeys to the hereafter.

It was only after his death that Dante Alighieri was acknowledged and held in esteem in Florence as he should have been during his life. Today his portrait hangs in the Cathedral of Santa Maria del Fiore, and on many buildings one can see engraved plaques quoting the poet's famous verses. A museum was dedicated to him in the so-called "Casa di Dante," in which he himself, however, never lived, and an enormous monument was erected in his honor in the Piazza Santa Croce. In the church itself a huge cenotaph in his memory was erected in 1829. Today Dante's remains are buried in Ravenna, far away from his home town.

Stefano Ricci: Cenotaph for Dante Alighieri, 1829, Santa Croce

Casa Buonarroti

In 1508 Michelangelo Buonarroti acquired a plot of land on the Via Ghibellina and gave it to his nephew and heir Leonardo, who had the present building erected in 1508. Here, from the early 17th century onwards, another descendant of the family, the talented poet Michelangelo the Younger, collected mementos, documents and scattered works of his famous ancestor.

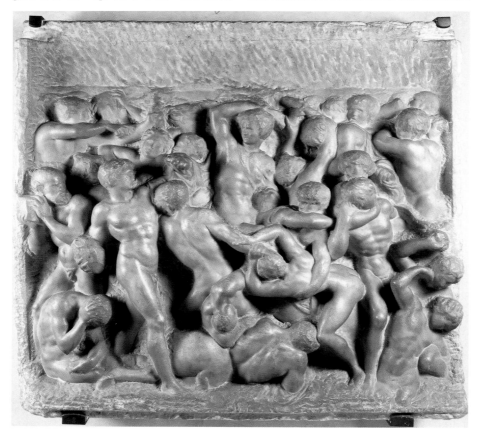

Moreover, he had the rooms decorated with paintings by contemporary artists in honor of the *Divino* Michelangelo (the Divine). In 1859 Cosimo Buonarroti, the last descendant of the family, finally left the house to the city of Florence, which opened it to the public as a museum.

Apart from the many objects from Michelangelo's personal belongings, there are also models, drawings, originals and copies of the master's works on display. The early works which are preserved here are of particular importance, to scholars and art-lovers alike.

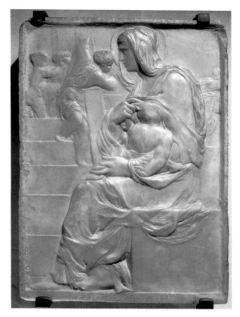

Michelangelo Buonarroti: The Battle of the Centaurs, ca. 1491/92
Marble, 84 x 90 cm

The relief of the *Battle of the Centaurs* is one of the earliest works of the sculptor Michelangelo, who here let himself be inspired by Classical Roman sarcophagi. The whole area is dramatically filled by moving, intertwining bodies.

Michelangelo Buonarroti: Madonna della Scala, ca. 1491
Marble, 55 x 40 cm

The so-called "Virgin of the Stairs" is worked in a completely different manner from the *Battle of the Centaurs*, although it was probably made at the same time. Dating from around 1491, it still clearly shows the influence of Donatello, whose reliefs the 17-year-old Buonarroti had studied extensively in Florence.

Mary is seated and gazing serenely into the distance. The marble relief is carved in the "relievo schiacciato," a method introduced by Donatello in which the leveled surface is specially treated. The baby Jesus is presented in an unusual way with his back to the viewer and his right arm is twisted behind his back.

San Michele a San Salvi – Museo di Andrea del Sarto

A little outside the center, in the east of the city, lies the monastery of Vallombrosa San Salvi (founded in 1048). After extensive destruction in 1529 only a few parts of the original building are still intact. It houses, among other facilities, a psychiatric clinic. The former refectory houses a museum which is worth visiting because of its fresco of *The Last Supper* by Andrea del Sarto (1486–1531).

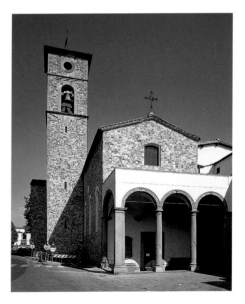

Andrea del Sarto: The Last Supper, 1521-1529
Fresco, 525 x 871 cm

Andrea del Sarto's *Last Supper* is the last monumental fresco on this topic on Florentine ground. On the one hand the painting is clearly in the tradition of its predecessors by Domenico Ghirlandaio (Ognissanti and San Marco) or Andrea del Castagno (Sant' Apollonia). On the other hand the influence of Leonardo da Vinci can already be seen in the composition of the painting. His famous fresco of *The Last Supper*, which unfortunately is in very poor condition, in the refectory of Santa Maria della Grazie in Milan pointed the way to new artistic ground for this subject. As in Leonardo da Vinci's painting, Judas Iscariot cannot be identified in Andrea's painting at first sight. On the right of Jesus he equally has his place along with the other apostles and protests his innocence with a gesture of hypocritical indignation. The rest of the apostles are in great uproar about Christ's revelation that there is one amongst them who will betray Him and deliver Him to the Cross. Different feelings are portrayed. Some apostles have leapt to their feet full of shock and resentment, others look at each other questioningly. Even the two servants looking on from the balcony seem to respond by looking at each other in distrust.

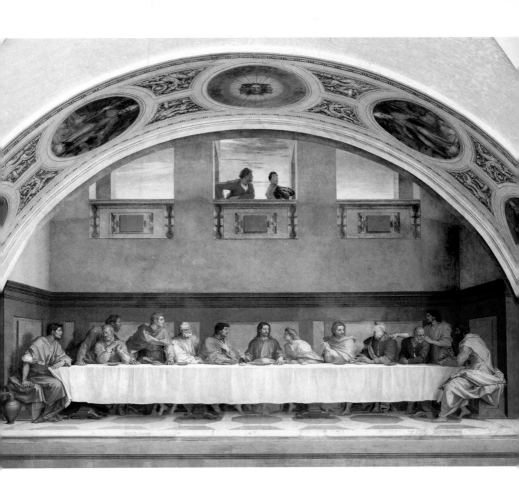

Biblioteca Nazionale

The foundation of the Biblioteca Nazionale was made possible by Antonio Magliabecchi's bequest. In 1747 he left, for the benefit of the town and especially for the poor, about 30,000 volumes and valuable manuscripts. His example was followed up to the present day by numerous other famous families, whose private libraries were added. A royal decree in 1870 stated that from then on one copy of every book printed in Italy had to be sent to the National Library. The shelves inside stretch over 53 miles (85 kilometers) and at present contain not only five million volumes but also a million letters and documents, plus thousands of handwritten and original manuscripts of famous Italian authors.

There are also numerous sheets of music, maps and views of towns. After the library had been housed in the Uffizi for some time, Cesare Bazzani constructed a new building from 1911 to 1935 on the banks of the Arno. Owing to lack of space the rooms had to be extended in 1962. Building so near the river caused irreplaceable losses and damage during the disastrous flood of 1966, as it was not possible to save everything from the waters in time.

Museo della Fondazione Horne

The English art critic Henry Percy Horne (1864–1916) left the building he had acquired in 1891 to the state of Italy. The family palace of the late 15th century also contains a collection of historic everyday articles, goldsmiths' work, furniture and works of art. Among the valuable pieces on display there are paintings by famous masters, sketches by Michelangelo, and by Raphael and Tiepolo, and small sculptures by Ghiberti and Giambologna.

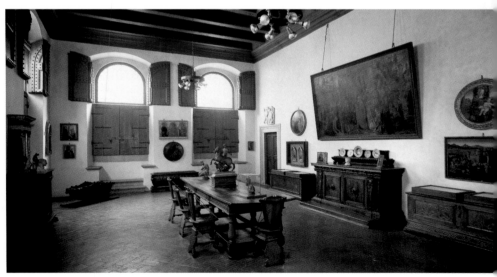

The Case of Galileo Galilei

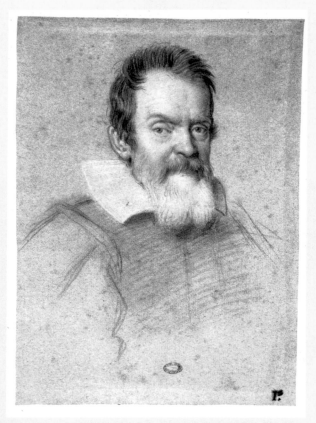

Ottavio Leoni (1587–1630): Portrait of Galileo Galilei, Biblioteca Marocelliana, Florence

The astronomer and mathematician Galileo Galilei (1564–1642) was already one of the foremost European scholars of his day when Pope Urban VIII summoned him to the Holy City in 1632. The purpose of his visit was so that he could be examined by a court of the Inquisition, thus putting an end to a dispute about the theories of Nicholas Copernicus (1473–1543) which had dragged on for decades.

In his *De revolutionibus orbium coelestium libri VI* ("Six books on the orbits of the heavenly bodies"), Copernicus had claimed that the sun was at the center of the universe and was orbited by the Earth and other planets. A specially convened commission of theological experts in 1616 had already adjudged this thesis to be not only foolish and stupid, but incompatible with the truths of the Christian faith.

Some 73 years after *De revolutionibus* first appeared in 1543 – the year its author died – the work was put on the

Index, meaning that its distribution as well as its possession was strictly forbidden. Galileo had for some years had a reputation as a defender of Copernican ideas and had publicly supported them on a number of occasions. On 26 February 1616 in Rome, he was explicitly warned by Cardinal Bellarmine – at the behest of the Pope – to refrain forthwith from any such expressions of false doctrine in line with the commission's verdict. Galileo had long since been completely incapable of doubting the correctness of the Copernican model, even though he was now required to exercise the greatest caution and restraint: all the evidence and proofs he had collected so assiduously in the course of his astronomical observations seemed to him to confirm the irrefutable truth of Copernicus' astronomical predictions.

The most important instrument which Galileo used to carry out his observations of the heavenly bodies was the telescope. It was originally invented in the Netherlands, but Galileo continued to develop and perfect the design himself. In 1609 he had been able to demonstrate its awesome effect to a group of astonished Venetian senators from the top floor of the campanile. Indeed, this demonstration was so impressive that he was immediately offered a professorship in mathematics for life at twice his current salary. The news of his extraordinary success spread Galileo's fame far and wide and his optical instruments were soon in demand throughout Europe. Overwhelmed by the potential and the unexpected insights his telescope gave him, particularly in terms of astronomical observations, Galileo quickly began to write up his spectacular discoveries.

As early as 1610 he was able to present his sensational *Siderius nuncius* ("Messenger of the Stars") which even today is considered a seminal work in modern astronomy. This text marked the first time anyone had described the Milky Way as consisting of a multitude of individual stars, or provided an account of the craters, mountains and valleys of the surface of the moon.

In addition, Galileo reported the sensational discovery of Jupiter's four moons. As Medicean

Galileo Galilei: Compass drawing, Biblioteca Nazionale, Florence

stars (*Medicea Sidera*) he dedicated them to his patron Cosimo II, at whose court he was soon appointed official mathematician and philosopher to the Grand Duke of Tuscany with a yearly salary of 1000 scudi. His successes however soon raised the hackles of his enemies and others jealous of his achievements. After Galileo had gathered clear proof for the correctness of Copernicus' predictions with his observations of the phases of Venus, he published further work such as his *Discourses*

Galileo Galilei: Phases of the moon–drawing, Biblioteca Nazionale, Florence

on Floating Bodies (1611) and his findings on the movement of sunspots. The hostility of those who would not (or could not) follow his explanations began to spread. He increasingly came under fire from critics who had long since begun to accuse him of godlessness and behavior damaging to the church. The ban on advocating Copernican thought placed on Galileo in 1616 brought only a temporary halt to the debate which raged around him, and was followed by a further escalation of the controversy in 1632. Once again Galileo had roused the ire of his opponents with his *Dialogo sopra i due massimi sistemi del mondo* (Dialogue on the two world systems). It seemed all too apparent to his opponents that this unorthodox professor had continued to assert the plausibility of the Copernican hypothesis while belittling the geocentric model of the Greek astronomer, Ptolemy, which had been valid for 2000 years. Pope Urban VIII, who had issued the publishing rights to Galileo under the condition that he made amendments, was furious. The Pope was led to believe that he had been cruelly caricatured in the figure of the dullard Simplicio, the defender of the Ptolemaic system in Galileo's dialogue against Salviati, the articulate proponent of the Copernican model. Even Galileo's supporters were unable to prevent a charge of heresy being laid against the astronomer.

In January 1633 Galileo, already ailing, set out yet again on the arduous journey to Rome. He arrived at the Dominican monastery of Santa Maria sopra Minerva in June of the same year. Threatened with a possible death sentence, Galileo knelt before the assembled Inquisitors in

a white penitent's robe and read out a declaration recanting the teachings of Nicholas Copernicus. It is unlikely that Galileo did in fact murmur the famous sentence "And yet they do move" which has been attributed to him. Nevertheless these words do capture the inner essence of a man who remained deeply convinced that one day truth would triumph. Ultimately of course this assessment was proved correct, even though the writings of Copernicus were not removed from the Index until 1835 – and the interdict on Galileo not officially lifted until 1993.

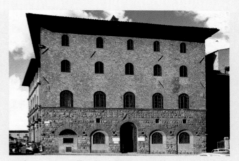

Palazzo Castellani – Museo della Storia della Scienza

The sham declarations Galileo was forced to make in 1633 may not have entirely convinced the assembled church dignitaries, but they did preserve the accused from a much worse fate. The authorities were content to place him under strict house arrest for the rest of his life. As much as he remained vulnerable to the suspicions of his enemies, they were unable to prevent him continuing his research during the eight remaining years of his life. Galileo had been allowed to retire to his country estate in Arcetri near Florence where, in spite of the onset of blindness, he soon wrote *Discorsi e demonstrazioni matematiche intorno a due nuove scienze* (Discourse and mathematical demonstration of two new sciences). In this, his last scientific work, he drew together the sum of the research he had conducted throughout his life into mechanics and the laws of motion. With this treatise Galileo created a memorial to himself as both the founder of modern physics and the father of empirical science.

Galileo died on 8 January 1642. In Florence, where the native Pisan had lived for several years as a youth and which became home to him again in 1610 after he returned from years of teaching and research in Venice, Pisa and Padua, a tomb was built for him in the church of Santa Croce. In the rooms devoted to Galileo at the Museo di Storia della Scienza in the Palazzo Castellani there are a number of fascinating exhibits on the life and work of this extraordinary genius.

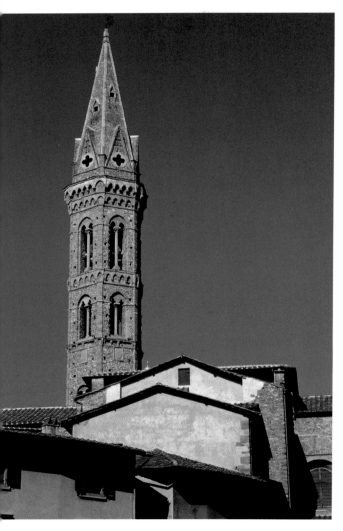

Badia Fiorentina

The church called the Badia ("abbey") has one of the richest traditions of all the city's churches. Benedictine monks founded the abbey in the 10th century from a generous endowment granted by Willa, the mother of the Margrave Ugo. The shape of the Badia today, however, was essentially defined by Matteo Segaloni's radical restructuring of 1627 which gave the building an entirely new appearance. In the course of this work the orientation of the church was turned 90° and a whole new choir area designed.

Traces can still be seen of the older, Ottonian structure which preceded the present church. Of the Gothic renovations by Arnolfo di Cambio (after 1285), parts of the walls and the former choir (today on the street frontage which faces onto the Via del Proconsolo) have survived. Around 1495 Benedetto da Rovezzano added a magnificent Renaissance portal to this side of the façade.

The hexagonal Gothic belltower of the Badia was built around 1330, probably even before Giotto's campanile for the cathedral. For many years it towered above the rest of the Florence skyline and it is still considered an impressive city landmark today.

Given that it was built during the Baroque era, the interior demonstrates a quite astonishingly restrained and simple design. The most interesting item in the interior, apart from the tomb of the Margrave Ugo created in the years 1469–81 by Mino da Fiesole, is a painting by Filippino Lippi showing St. Bernard and his vision of the Virgin Mary (1486).

Chiostro degli Aranci

The church is adjoined by a two-storied cloister, the so-called Chiostro degli Aranci (Cloister of the Oranges); the architecture (ca. 1435) has been attributed to Bernardo Rossellino. Shortly after it was completed a cycle of frescos depicting scenes from the life of Benedict, the order's founder, was painted on the upper floor of the cloister. These paintings show the influence of Paolo Uccello and Fra Angelico. The scene of St. Benedict in the thorn bush, on the other hand, is thought to be an early work by Agnolo Bronzino that was added retrospectively.

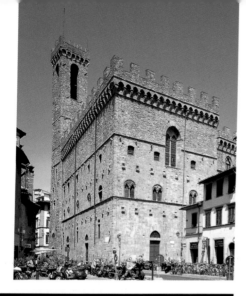

Bargello – Museo Nazionale del Bargello

With its battlements and the great tower which forms such an integral part of the city's skyline, the massive Palazzo del Bargello seems almost like a fortress in the middle of the city. Building work on the Palazzo was begun in 1255, and from 1261 the *Podestà* – the mayor of the city – had his offices here. This civic palace was later used as a prison and courtroom from 1502. The name commonly used for the building today only dates back to 1574 when the city's first police chief, the *Bargello* ("bailiff, henchman") moved in. In 1859 its rooms were used to house the National Museum of Sculpture and Crafts in order to relieve the overburdened Uffizi.

Inner courtyard

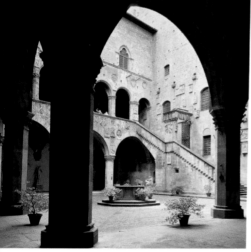

From the inner courtyard of the Bargello – itself worth a close look – an open staircase leads up to the exhibition spaces on the second floor. The courtyard is lined on three sides by a gallery which is supported by solid columns separated by wide, rounded arches. Numerous coats of arms from the various Podestà, the districts of the city and chief judges are testimony to the diverse functions the building has served over time. However, there are hardly any signs that this atmospheric setting was the scene for numerous

executions up until the late 18th century: the scaffold was located beside the fountain in the middle of the courtyard.

Michelangelo Buonarroti: Bacchus, 1496/97
Marble, h 184 cm

Along with other works by Michelangelo, the so-called *Drunken Bacchus* – made while the artist was still a young man – can be seen on the ground floor of the museum. This sculpture was probably created around 1496/97 and is therefore not only the first life-sized marble statue by the sculptor, but also one of the earliest monumental figures of a Classical god made in the modern era.

Free-standing and viewable from all sides, the work was quite deliberately created in an *all' antica* style; it is hardly surprising that even connoisseurs mistook the piece for an original from Classical antiquity. The sculptor, then just 22 years old, shows an expert handling of the *contrapposto* position of the figure; this motif is even exaggerated to some extent in order to illustrate the uncertain posture and slight swaying of the god of wine, tipsy from overindulgence. A small satyr, impishly chewing on some grapes, provides an optical balance for the entire work and also serves as a static support.

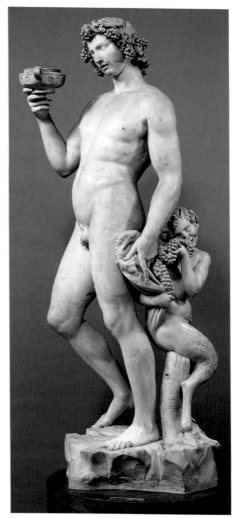

Loggia (second story)

The Bargello's attractive rooms and open loggias provide a wonderful ambiance in which to view the exhibits. The sheer wealth of sculptural masterpieces from the Renaissance and Mannerist era make the collection one of the most important of its kind anywhere in the world. In addition to works by Donatello and Michelangelo, Ghiberti and Verrocchio, the museum also houses impressive examples of art by figures such as Giambologna and Luca della Robbia, as well as many anonymous masters.

Various works by Giambologna are exhibited in the loggia of the second story (pictured here). He created a series of delightfully naturalistic bronze animals as well as the marble allegory of architecture in the middle of the room.

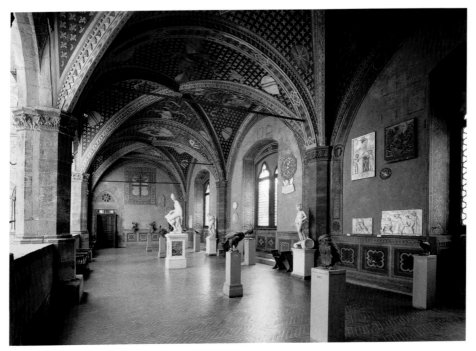

Giambologna: Mercury, 1564–80

Bronze, h 180 cm

This sculpture of Mercury in flight represents the peak of Giambologna's career. All the laws of gravity are suspended in this life-sized figure which was created for a fountain of the Villa Medici. With wings on his helmet and feet and holding the staff of Aesculapius, Mercury – the messenger of the Gods – seems as if he had been lifted into the air on a breath of wind. Completed in 1580, the sculpture shows little sign that it was preceded by almost two decades of detailed studies and model casts. It can be viewed from all angles, Giambologna was able to create the effect of twisting the figure up and around its own axis. The body expresses a dynamic upwards movement which begins with the tip of the left foot – which offers the scantiest of supporting surfaces – only ending in the outstretched index finger of the right hand.

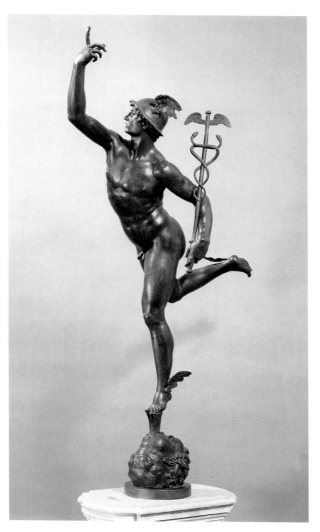

Great Council Chamber (second story)

The Salone del Consiglio Generale (Great Council Chamber) is now generally called the Donatello Chamber after the prominent early Renaissance sculptor. Important work from the various creative phases of the artist's career are exhibited here alongside other important Quattrocento sculptures.

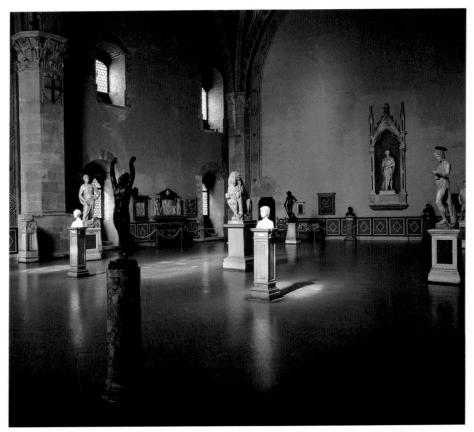

Donatello: St. George, ca. 1417
Marble, h 209 cm

The statue of St. George was made for the Guild of Armorers and Swordsmiths (Arte dei Corazzi e Spadai) and was originally displayed in their tabernacle in the Orsanmichele. It has since been replaced by a copy.

In this early sculpture Donatello portrayed the saint as a youthful hero and fearless knight. His gaze expresses courage and decisiveness and his posture with the legs apart and the feet planted firmly on the ground indicates a self-confident and intrepid nature. "In spite of being made from stone, this figure reflects a fiercely awesome vitality and a marvelous sense of movement". (Vasari).

Below the statue is a relief showing St. George's battle with the dragon. Donatello used a pioneering technique called the *rilievo schiacciato*, which involved the painstaking layering of finely graded surfaces. He succeeded in creating a piece which was to prove highly influential for the future direction of sculpture.

Donatello: David, ca. 1440
Bronze, h 158 cm

In Donatello's statue of David we encounter the earliest free-standing nude figure since antiquity. Its original purpose – it was probably made as the centerpiece for a fountain – and the precise date it was made are still disputed.

Donatello's admiration for the works of classical antiquity are conspicuous in their nudity and the harmonious manner of balancing the weight of the figure. However, the mysterious and thoughtful expression of the face, and the playful pose – the left foot resting on the battle trophy of Goliath's decapitated head – go far beyond any formal models from antiquity. David's striking helmet bears the laurel wreath of the victor, and his virtually androgynous and boyish body displays a flawlessly modeled beauty. It almost seems as if the figure were actually "formed over a living body" (Vasari).

**Andrea del Verrocchio:
David ca. 1475**
Bronze, h 158 cm

Andrea del Verrocchio's bronze of David also depicts the figure as a slightly-built youth. Verrocchio had thoroughly studied the works of his predecessor Donatello. Here, though, any thoughtfulness and melancholy give way to a much more child-like and even mocking expression. Elegant in its appearance but without the greater depth which is such an incomparable feature of Donatello's sculpture, the victorious boy poses with his chest thrust forwards and his arm resting casually on his hip. In triumph he lets the sword dangle loosely in his left hand as he stands proudly behind the head of the defeated tyrant Goliath. Verrocchio's David is still very much the shepherd boy who seems to be unaware of the burden of his calling to be the future king of Israel.

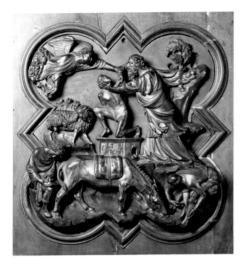

Filippo Brunelleschi: The Sacrifice of Isaac, 1401/02
Bronze (gilded), 45 x 38 cm

In order to obtain the services of the most talented master for the second portal of the city's Baptistery, the Florentine Guild of Merchants organized a competition in 1401 which was to have important ramifications for art history. Of the competition reliefs which various artists submitted to the commission, only those by Brunelleschi and Ghiberti have survived in the Bargello.

As laid down in the competition guidelines, Brunelleschi depicted Isaac's sacrifice within the framework of a Gothic quatrefoil. The formal reference point for this work was the older set of Baptistery doors of Andrea Pisano. Brunelleschi composed his relief by ordering and arranging the individual parts; at the bottom right he employed the well-known Classical motif of a boy pulling a thorn from his foot. The main event occurs at a moment of intense drama: it is only the physical intervention of the angel that saves Isaac as his father Abraham, intent on carrying out God's commandment, already has his knife at the boy's throat.

Lorenzo Ghiberti: The Sacrifice of Isaac, 1401/02
Bronze (gilded), 45 x 38 cm

In Ghiberti's version we encounter a denser and more integrated solution to the compositional problem. The main event is displaced to the side of the pictorial field; Abraham seems not yet to have noticed the angel sent to stop him.

The decision in favor of Ghiberti was probably based on the fact that his trial piece was made from a single cast, in contrast to Brunelleschi's which consisted of four separate sections. It was also more than 15 pounds (7 kilos) lighter, meaning that the clients would have expected to spend less on labor and materials for Ghiberti's work. It could be said, then, that Ghiberti's design represented the more economical option.

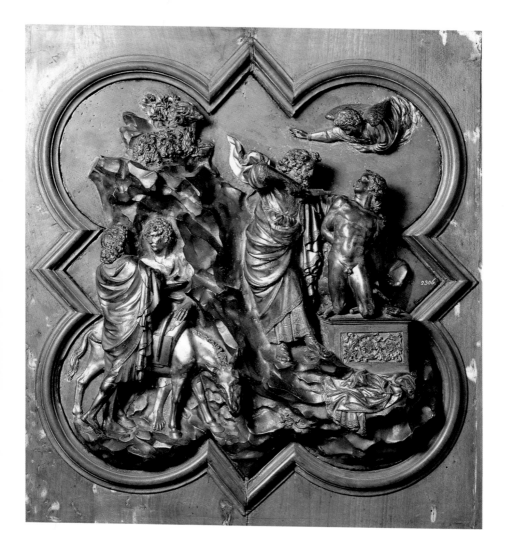

The Technique of Bronze Casting

Leonardo da Vinci: Notes for the casting of the Sforza Monument, ca. 1493, Codex Madrid I, fol. 1493, pen and ink on paper, 21 x 15 cm, Biblioteca Nacional, Madrid

In order to produce works in bronze the sculptors of the Classical era had already made use of a technique commonly employed during the Renaissance (and thereafter) called "the lost wax casting method" (French *cire perdu*). This method enabled the production of solid bronzes as well as hollow casts. The latter had the advantage of being lighter and using less material in proportion to the size, qualities which were of appreciable benefit – and not only if the work had to be transported from one place to another. From a technical point of view hollow casts also carried a much smaller risk of cracks forming in the metal: the thinner the final layer of bronze, the more reliably its rate of contraction could be predicted as the cast cooled down.

To make a hollow cast it was first necessary to roughly model a core of clay or plaster called an *anima* (Italian: "soul"). Over this core the artists formed an exact model of the desired sculpture in wax which was then encased in a fireproof layer (generally of clay). When heated, the wax melted and drained out through vents. The molten bronze alloy could then be poured into the space created between the core and its surrounding mold.

After the cast had cooled there was a tense moment as the outer casing of clay was removed – being irrevocably destroyed in the process – and the bronze emerged.

It was only now that the artist could examine the cast for defects and see whether cracks or bubbles had formed. A perfect cast then required further work before it could be considered a completed sculpture. First, the

bronze rods formed by the vents for the wax had to be sawn off and the still rough surface polished. Details – such as hair or the texture of materials – could only be worked into the metal once it was cold. Larger sculptures generally consisted of several cast pieces which then had to be assembled and joined together. By definition the lost wax method had the disadvantage that the original mold had necessarily to be destroyed and this meant that no exact copies could be made at a later point.

In the late 15th century, however, a more complicated casting method was developed which enabled the original model to be retained for the creation of additional, and virtually identical, casts.

Leonardo da Vinci: Cannon foundry, ca. 1487, pen and ink on paper (facsimile), Gabinetta dei Disegni e delle Stampe, Galleria degli Uffizi, Florence

Leonardo da Vinci: Notes for the negative of a cast for the Sforza Monument, ca. 1493, Codex Madrid I, fol. 157r, red chalk on paper, 21 x 15 cm, Biblioteca Nacional, Madrid

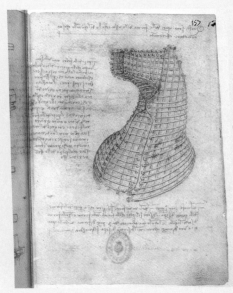

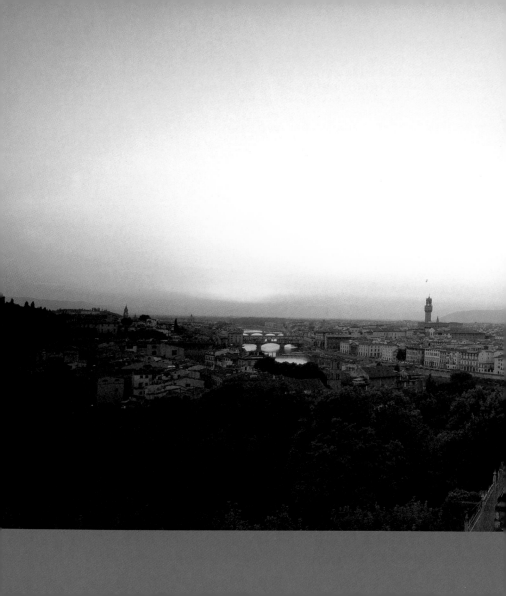

Oltrarno – beyond the Arno

Ponte Vecchio

The history – and prehistory – of the Ponte Vecchio dates back to Roman times when the ancient Via Cassia was provided with a crossing over the narrowest point of the river Arno (ca. 120 A.D.). The first bridges continually fell victim to the frequently disastrous floodwaters of the Arno but they always were patiently rebuilt, since the city only had this single river-crossing until the Ponte alla Carraia was built in 1218. Even as late as 1333, a stone bridge built in 1294 was completely swept away by the Arno. In 1345 the new structure was begun which forms the basis for the bridge as it exists today.

Records show that traders and artisans were conducting business on the bridge from as early as the 13th century. Apart from tanners – who needed the water provided by the Arno in order to pursue their trade – fishmongers also had their stalls here. Later, however, butchers gained the upper hand and began to spread out across the bridge. The waste products which accumulated in the course of their work were dealt with by "disposing" of them in the river. The individual *boteghe*, or shops, were at first arranged symmetrically on both sides of the bridge; this changed in 1495 when the city – until then the owner and lessor of the shops – found itself in tight financial straits and was forced to sell the individual plots. From that moment the

extensions and additions which still characterize the bridge's appearance began to mushroom – although Vasari's famous connecting walkway (the Corridoio Vasariano) between the Uffizi and Palazzo Pitti (ca. 1565) prevented buildings from rising any higher on the eastern side. Grand Duke Ferdinando I, a constant user of this "corridor," finally saw himself compelled to issue a decree in 1593 banishing the butchers from the Ponte Vecchio. The

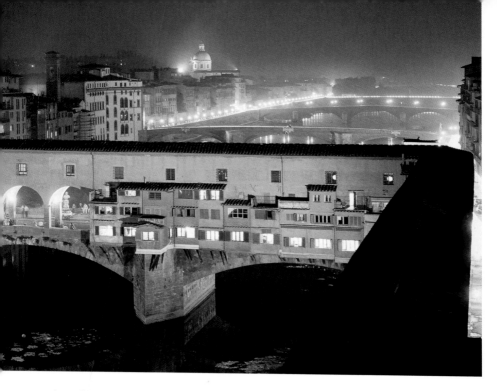

stench and mess had become unbearable, and he did not wish to impose them on visitors who were making their way directly to the Palazzo Pitti, the seat of the ducal family. From now on shops were to be reserved for the comparatively "clean" trades of the goldsmiths and dealers in precious stones, a state of affairs that continues to this day.

The Ponte Vecchio was the only bridge in Florence to be spared demolition when German troops retreated from the city in April 1944; the picturesque sight of the oldest and most famous of Florence's river crossings would otherwise surely have been lost forever.

A bronze bust by Raffaele Romanelli (1900) in the middle of the bridge is a memorial to Benvenuto Cellini (1500–1571), the city's most famous goldsmith.

San Miniato al Monte

St. Mennas (Italian: *Miniato*) was martyred in Florence in the year 250 AD under the Emperor Decius. A legend tells of how after his execution, carrying his own head, the saint climbed this hill south of the Arno. A shrine was supposedly erected to Mennas during the Carolingian era, and the rediscovery of his remains at the beginning of the 11th century was received as an occasion for building the Benedictine church of San Miniato al Monte on the model of the mother church at Cluny in France. The exact dates for the building work are not known; the year 1207 set into the floor of the church, however, indicates that work had largely been finished by this time.

As an outstanding example of the Florentine Proto-Renaissance, San Miniato al Monte is worthy of being mentioned in the same breath as the Baptistery of St. John's for its importance to architectural history. Like the Baptistery, San Miniato was thought during the Renaissance to be an antique building. Both structures make use of alternating green and white marble in the façade, as early and ground-breaking examples of the encrustation style typical of Florence. Three successive building phases – first story, second story and pediment – can be seen in San Miniato's imposing façade (begun ca. 1075). The first story area is divided into five blind arcades supported by demi-columns on a background of simple geometric forms. The story above (with a relief of Christ, the Virgin and St. Mennas) is more richly

ornamented and its form is less rigidly classical. Decorative elements assume an even greater prominence above in the triangular pediment. The eagle atop the pediment is the heraldic animal of the cloth merchants and a reminder that for a long period of time this guild financed the building of San Miniato.

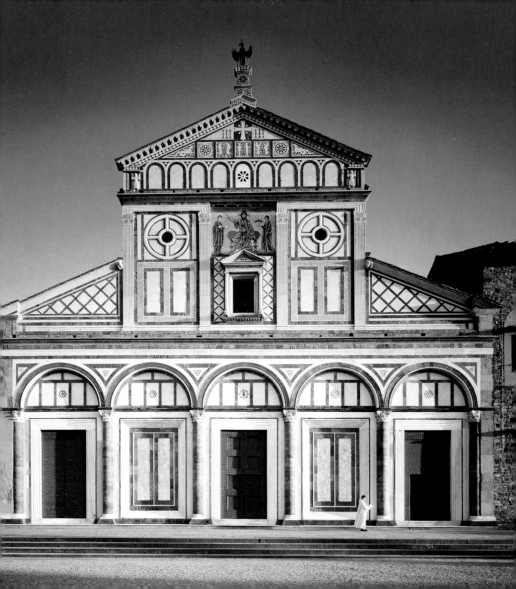

San Miniato al Monte

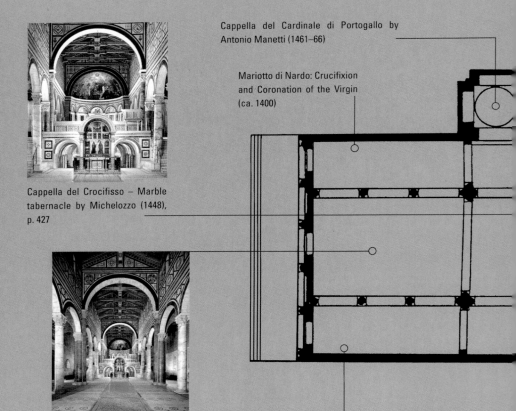

Cappella del Cardinale di Portogallo by
Antonio Manetti (1461–66)

Mariotto di Nardo: Crucifixion
and Coronation of the Virgin
(ca. 1400)

Cappella del Crocifisso – Marble
tabernacle by Michelozzo (1448),
p. 427

Nave, p. 427

Paolo Schiavo: Madonna Enthroned
with Saints (ca. 1436)

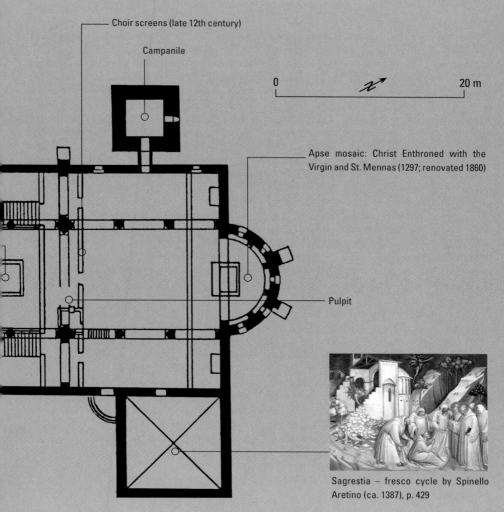

Choir screens (late 12th century)

Campanile

0 20 m

Apse mosaic: Christ Enthroned with the Virgin and St. Mennas (1297; renovated 1860)

Pulpit

Sagrestia – fresco cycle by Spinello Aretino (ca. 1387), p. 429

The interior

The abbey has been put to a wide variety of uses over the years, all of which have left their mark. The (unfinished) campanile, built by Baccio d'Agnolo in 1518 to replace an older belltower from 1499 which had collapsed, is said to have been covered with mattresses by Michelangelo in 1529 in order to protect it from the cannon fire of Imperial troops besieging the city. A short time later Grand Duke Cosimo I transformed the entire complex into a fortress because of its strategically favorable position above the city. During the epidemic of 1630, victims of the plague were accommodated in San Miniato, and in the following decades the city's homeless were also housed here. Today, the monastery is once again in the hands of the Benedictine congregation of the Olivetan order who had been based here in the early 15th century.

The ground plan of the church resembles that of a basilica with its nave, two aisles and lack of transepts. Below the open Gothic roof trusses the interior is divided by flying buttresses into three equal sections. These major spatial units are marked by piers between bays of three arches each which are supported by columns. Motifs from the façade are expressed here too. The individual capitals on the columns are varied in a quite remarkable way in that they all stem from different eras – the ones in the choir are older and are partly of Byzantine origin.

The choir was built – as tradition dictated – over the crypt in which St. Mennas' remains were interred. The massive choir screens are, like the chancel, ornamented with elaborate marble encrustation patterns. Michelozzo erected a barrel-vaulted marble ciborium for Piero de' Medici in 1448 directly in front of the choir and crypt incorporating into it older pieces of building material. Originally a crucifix was displayed here (kept today in Santa Trinità) which recalled a miracle from the life of St. Giovanni Gualberto. The individual altar panels on the rear wall of the tabernacle (ca. 1396) are by Agnolo Gaddi.

The impression of marble inlay on the walls of the nave is a *trompe l'œil* effect in paint which was only carried out in the course of comprehensive renovation work conducted between 1858 and 1861. At the same time, the columns of the nave were provided with imitation marble made from plaster. Large parts of the apse mosaic of *Christ Enthroned* were also renewed at this time, the original tesserae from the late 13th century being replaced with new ones.

The inlaid floor (ca. 1207) is also worthy of attention. Geometric and figurative motifs alternate according to the patterns of Eastern art (mimicking particularly the designs of carpets).

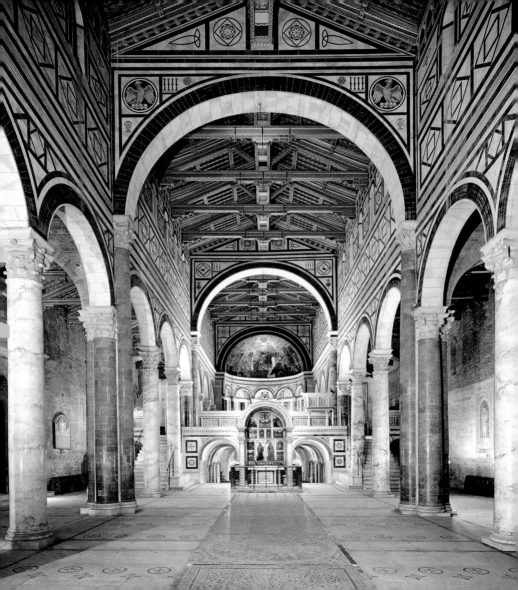

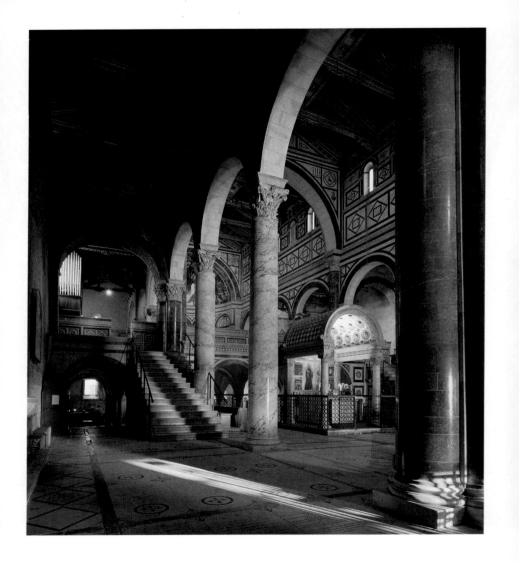

Spinello Aretino: St. Benedict Resurrects a Fellow Monk Buried Alive, ca. 1387
Fresco

Spinello Aretino, son of a goldsmith from Arezzo, executed a cycle of frescos in the sacristy of San Miniato al Monte which featured incidents from the life of St. Benedict. Almost half a century after the death of Giotto, Spinello was still very much influenced by his work – although he was unable to achieve the same unity of composition and setting. His picture surfaces tend to be filled with a cumulative series of individual observations. In this scene the saint is resurrecting a fellow monk who had been buried under rubble; the depictions of the figures as well as the views of architecture and landscape are marked by sharp contours.

The Stendhal Syndrome

The French writer Henri Beyle (1783-1842) achieved world renown under the pseudonym of Stendhal, the name of the town where the great German archeologist J.J. Winckelmann was born. While traveling to Florence he found himself unable to control the emotions which welled up in him in anticipation of the city's cultural pleasures; barely had he crossed the Apennines when he began to

Michelangelo Buonarroti: David (copy), 1501–04, marble, height 410 cm, Piazza della Signoria, Florence

Johan Olaf Södermark: Portrait of Stendhal, 1840, oil on canvas, 62 x 50 cm, Musée National du Château de Versailles

feel a strange inner turmoil. His racing heart and an increasing sense of confusion robbed him of his composure when his thoughts turned to Dante, Michelangelo, and Leonardo. Completely incapable of formulating his thoughts lucidly, he finally capitulated and gave himself up to his "delusions" which made him feel as though he were "at the side of a beloved woman."

Stendhal was similarly afflicted in Florence itself where the sight of artworks often transported him into a state of extreme agitation and even ecstasy. During some of these "nervous

attacks" he even feared he would lose consciousness there and then.

The symptoms Stendhal recorded in his travel journal *Rome, Florence and Naples* – an inner tension which even extended to physical exhaustion – are not unique. Anselm Feuerbach in 1856 suffered the same fate. In the Uffizi and in the Palazzo Pitti he found himself overwhelmed by tears and even called on the heavens to assist him: "May God direct my steps and give me the strength to endure all this like a man." The poet Rainer Maria Rilke found it temporarily difficult to breathe while in Florence, and he too was overcome by giddiness (1898) and became so confused that he thought he would be "submerged in a great surging wave of mysterious glory."

Sensations of this kind were not reserved for hypersensitive artistic temperaments. Indeed, the psychologist Graziella Magherini observed similar "symptoms" in the 1980s among numerous visitors to the city. Even today patients who respond in a similar way are still being treated in the psychiatric ward of S. Maria Nuova: 107 cases between 1978 and 1986. All of these patients temporarily suffered from what is called "Stendhal Syndrome." The trigger for this curious phenomenon is apparently an excessive exposure to art. But it is not just the sheer mass of paintings, sculptures and buildings that are packed into such a dense space in Florence that is responsible; interviews with patients indicate that it is generally only a few, and in the truest sense of the word "overpowering," master-pieces that obviously overtax some souls, rendering them helpless and disoriented. A brief spell in a city hospital, for example, may sometimes follow on from the encounter of an unprepared tourist with the works of Caravaggio, Michelangelo's *David* or Botticelli's *Venus*. Treatment in such cases is usually focused on the resulting manic or euphoric states though depression and panic attacks occur also; in extreme cases there have even been hallucinations. The victims are generally single, middle-aged people traveling on their own. No Italians have ever been affected.

Sandro Botticelli: Birth of Venus (Detail), ca. 1485, canvas, 172.5 x 278.5 cm, Galleria degli Uffizi, Florence

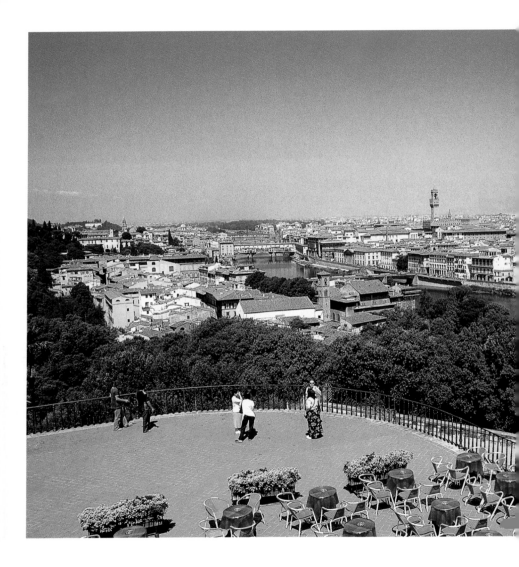

Piazzale Michelangelo

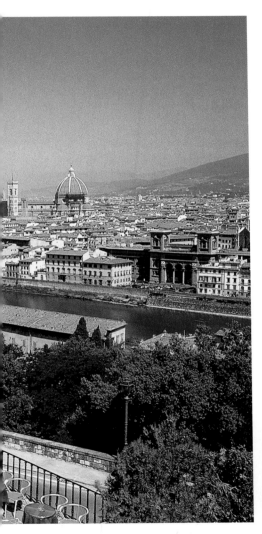

From the Piazzale Michelangelo – named after the most outstanding universal genius of the Renaissance – the visitor has an incomparable view over the city and the Arno valley. For the 400th anniversary of Michelangelo's birth, a memorial was erected on the square which combines copies of the statue of David with four figures representing the times of the day from the New Sacristy of San Lorenzo. It almost seems as if from this vantage point David, symbol of the Republic of Florence, stand guard over the city. Giuseppe Poggi designed the piazza between 1865 and 1871 when, for a time, Florence became the capital of a reunited Italy. Though planned for the far end of the square, the Michelangelo Museum was never realized.

Santa Felicita

Santa Felicita is probably the oldest-established church in the city, and its history dates back to the 4th century. The church did not attain its present shape until the period after 1736, when it was extensively remodeled by Ferdinando Ruggieri – though older parts of the church were incorporated into the new building. The portico has survived which was added by Vasari to support the Corridoio Vasariano – that famous corridor that runs above it connecting the Palazzo Vecchio with the Palazzo Pitti via the Ponte Vecchio. A gallery in the interior recalls the period in the 16th century when Santa Felicita was the court church of the Grand Duke's

Museo Bardini

The Museo Bardini is today accommodated in a late 19th-century palace. The items on display once belonged to the art dealer Stefano Bardini, who bequeathed his collection to the city in 1923. The museum's unusual form of presentation demonstrates collection practices at the end of the 19th century; virtually all genres of the arts and crafts and all historical periods are represented. Apart from furniture and carpets, the collection encompasses paintings and sculpture, musical instruments and weapons.

family. Through Vasari's corridor they were able to gain direct access to elevated positions in the church from the Palazzo Pitti, their residence, and thus attend Mass while still screened from the gaze of the congregation.

Capella Capponi

Pontormo: Entombment of Christ, ca. 1525
Oil on wood, 313 x 193 cm

In 1525 Pontormo received a commission for a series of paintings in the Capponi chapel. Apart from the quite remarkable fresco of the Annunciation, he completed an altarpiece depicting the Entombment of Christ. This panel painting is one of the most unusual early Mannerist creations in Florentine art. The garments are painted in bright, luminous colors which contrast with the body of Christ in the center of the composition. The array of gestures, movements, and contorted bodies gives no indication as to what course events will take. Nor can the figures' spatial position be fixed, given the lack of any reference point in landscape or architecture. It almost impossible to tell whether we are looking at a Deposition or an Entombment. Logic in the sense of a classical pictorial structure – has been sacrificed to achieve a more intense form of expression.

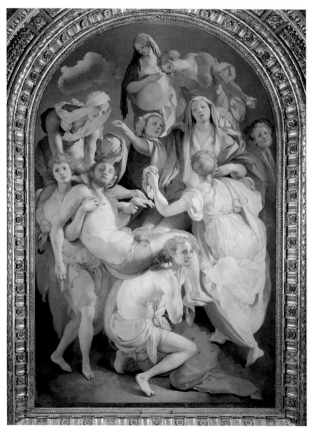

The Florentine Style of Encrustation

It may have been the desire to imitate a divine Jerusalem that made the architects of the Florentine Baptistery in the 11th/12th centuries clad the rough-hewn stones of the building's exterior in a "colorful robe of bright marble." The façade of St. John's was cloaked in strict geometrical patterns using green serpentine from Prato ("Verde di Prato") and slabs of white marble a mere $1\frac{1}{2}$ to 2 inches (4–5 cm) thick from the quarries of Carrara.

This laborious and costly method of cladding or ornamenting walls (and floors) with marble was called encrustation from the Latin root *crusta* (literally: rind, shell). Early examples of this peculiar kind of decoration can be found in Byzantine architecture and in Classical Roman

Marble quarry at Carrara

times. Murals in the so-called first Pompeian style in the first century B.C. had already imitated the color and pattern of marble, and walls, Roman baths and palaces had been elaborately ornamented with magnificent encrustations.

In sacral architecture, the 5th-century church of S. Vitale in Ravenna can be cited as a forerunner of the encrustation style which later flourished in Tuscany in the 11th and 12th centuries. In Florence, the builders of the Baptistery and the church of San Miniato on the hills above the city paved the way for this type of architectural design so characteristic of Florence. By employing a measured restraint and purity of line derived from the Classical tradition the city's builders succeeded in bringing the cool rationality of architectural structure into harmony with a polychromatic color scheme pleasing to the eye.

This balancing of surfaces and spaces patterned on antique models – and evidenced in the magnificent, contemporaneous façade of the Badia Fiesolana – was one of the factors which caused the 19th-century art historian Jakob Burkhardt to introduce the stylistic concept of the Proto-Renaissance (prior to the Renaissance proper).

The great architects of the Renaissance still believed buildings such as San Miniato to be perfect examples of architecture from the Classical era, and they continued to use the Florentine tradition of encrustation in a variety

Detail of the façade, Badia, Fiesole

of other projects including the cathedral, the campanile and Santa Maria Novella.

By incorporating other materials – such as red Maremma marble in the cathedral – the original two-tone color scheme was broadened into a greater polychromatic range. The encrustations of San Miniato al Monte and the Baptistery of St John's, however, remained unparalleled for their simple beauty. Leone Battista Alberti, in his famous treatise on architecture (*De re aedificatoria*, 1452), aptly called these architectural masterpieces "a concert of all their parts, arranged with moderation, thought and discourse."

Palazzo Pitti

In the construction of his family's residence, the prosperous merchant Luca Pitti sought to outdo in grandeur and glory all the other palaces in the city – in particular those of his rivals, the Medici. The original structure, built between 1557 and 1566, possibly after plans by Brunelleschi, at first only encompassed the three-story middle section with its seven central bays. After the financial ruin of the Pittis, the building was purchased by Eleonora of Toledo, wife of Cosimo I; she had Bartolomeo Ammanati extend the unfinished complex with two further wings at the rear. In the 17th century Giulio and Alfonso Parigi extended the palace's frontage to its final width of 674 feet (205 meters).

Until the 19th century the building served the Grand Dukes of the Medici and Lorraine as their residence. After the reunification of Italy the palace was occupied by members of the royal family.

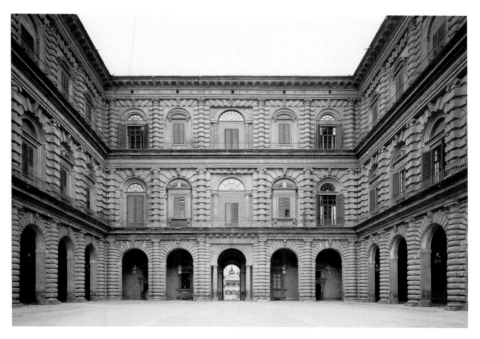

Courtyard

The courtyard of the Palazzo Pitti, designed by Bartolomeo Ammanati (1511–1592), is one of the most striking examples of Mannerist architecture in Florence. The graduated order of the columns – Doric at the bottom, Ionic in the middle, and Corinthian at the top – follows the Classical scheme. The three stories are separated from each other by cornices and each has its own character derived from the use of different types of stonework. The framing and overlaying of the demi-columns between the windows and arcades with rustication creates a very puzzling optical effect as if the façade were projecting out towards the viewer.

Oltrarno – beyond the Arno

Santa Spirito, Piazza S. Spirito 29, p. 476

Santa Maria del Carmine, Piazza del Carmine,
p. 497

Santa Felicita, Piazza S. Felicità, p. 435

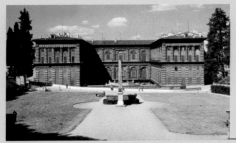

Palazzo Pitti, Piazza dei Pitti, p. 444

Ponte Vecchio, p. 420

Museo Bardini, Piazza de' Mozzi 1, p. 434

Piazzale Michelangelo, p. 433

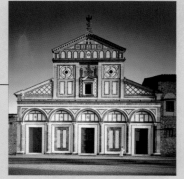
San Miniato al Monte, Viale Galileo Galilei, p. 423

Other sights:
1 Giardino di Boboli, p. 464
2 Forte di Belvedere, Costa di San Giorgio, p. 464

442

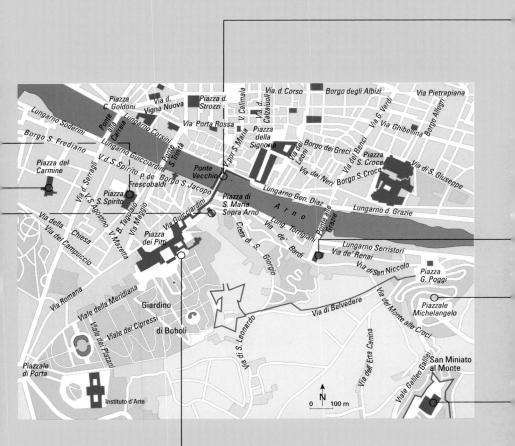

Lungarno Soderini

Borgo S. Frediano

Piazza del Carmine

Piazza C. Goldoni

Via d. Vigna Nuova

Ponte alla Carraia

Lungarno Corsini

Lungarno Guicciardini

V.d.S.Spirito

Via d. Serragli

Via S. Agostino

Piazza S. Spirito

P. de' Frescobaldi

Borgo S. Jacopo

B. Tegolaio

V. Mazeta

Via Maggio

Via Guicciardini

Piazza dei Pitti

Via della Chiesa

Via del Campuccio

Via Romana

Viale della Meridiana

Viale dei Cipressi

Viale dei Platani

Giardino di Boboli

Piazzale di Porta

Instituto d'Arte

Piazza d. Strozzi

Via Porta Rossa

V. Calimala

Via d. Calzaiuoli

Via d. Corso

Borgo degli Albizi

Via Pietrapiana

Via G. Verdi

Via Ghibellina

Borgo Allegri

Piazza della Signoria

V. por S. Maria

Ponte S. Trinita

Ponte Vecchio

Via dei Leoni

Borgo dei Greci

Via dei Banci

Piazza S. Croce

Via di S. Giuseppe

Via dei Neri

Borgo S. Croce

Piazza di S. Maria Sopra Arno

Lungarno Gen. Diaz

A r n o

Ponte alle Grazie

Lungarno d. Grazie

Lung. Torrigiani

Costa di S. Giorgio

Via de' Bardi

Lungarno Serristori

Via de' Renai

Via di San Niccolo

Piazza G. Poggi

Via di S. Leonardo

Via di Belvedere

Via del Monte alle Croci

Piazzale Michelangelo

Via dell' Erta Canina

Viale Galileo Galilei

San Miniato al Monte

N
0 100 m

The garden

To the rear of the courtyard are the adjoining Boboli Gardens. These reach far into the steeply rising countryside beyond the palace. Several museums are today housed in the interior of the Palazzo Pitti. The former summer apartments of the Medici on the first story are home to the Silver Museum (Museo degli Argenti). Its separate departments include a Porcelain Museum (Museo delle Porcellane in the Casino del Cavaliere of the Boboli Garden), Coach Museum (Museum delle Carrozze) and Costume Museum (Museo delle Costume in the Classical extension of the Palazzina della Meridiana).

On the second story of the south wing of the palace the Galleria Palatina (Palace

Gallery) is to be found. Facing the exhibition rooms of this famous collection of paintings are the so-called Appartamenti Reali – the former state apartments and reception areas of the grand ducal and Italian royal families. These at times can be viewed. The floor above provides access to the Galleria d'Arte Moderna.

Appartamenti Reali

The Appartamenti Reali – or Royal Apartments – of the Palazzo Pitti served their various occupants from the second half of the 16th century to the late 19th century as state reception rooms and living quarters. Here, high-ranking guests – among them popes, kings and foreign diplomats – were accommodated in the style to which they were accustomed. These rooms, which have now undergone

comprehensive restoration work, were therefore decorated magnificently over the course of three hundred years; the high quality of the interiors with their priceless furniture, sculptures, paintings and tapestries provides an overview of changing tastes and artistic endeavor over the four centuries.

Museo degli Argenti

The historic rooms of the Museo degli Argenti (Silver Museum) have also retained the opulent decorative scheme of former times. *Trompe l'œil* murals of the 17th century cover the walls and the décor is further enriched by valuable tapestries and furniture. Contrary to what might be expected from the museum's name, the displays do not focus exclusively on gold and silver: there are also exceptional examples of work from a broad range of other crafts. The exhibits include costly vessels made from the most diverse materials, a large number of ivories, precious stones and reliquaries as well as expertly ornamented weapons and fabrics.

Palazzo Pitti in 1922. Although the achievements of 19th-century Italian artists can scarcely compare with the glorious traditions of previous eras, several aspects of the collection are certainly worth special attention. As well as pictures from the Romantic era and Italian Historicism, the works of the so-called "blot painters" (*macchiaioli*) also have their own unique character. Telemaco Signorini, Silvestro Lega, and Giovanni Fattori are among the most well-known representatives of this anti-academic art movement from the second half of the 19th century. Despite the obvious similarities their style was in fact nurtured and developed largely independently of French Impressionism.

Galleria d'Arte Moderna

The Galleria d'Arte Moderna provides a comprehensive and chronological overview of Italian art from the Classicism of the late 18th century through to the works of the early 20th century (including those of Giorgio de Chirico). The collection was founded in 1784 by Leopold of Lorraine and since then it has been continually and extensively added to by gifts from individuals and state purchases.

The first exhibition rooms of the Gallery of Modern Art were opened two years after the royal family vacated their state apartments on the third story of the

Palazzo Pitti – Galleria Palatina and Appartamenti Reali

(Piano Nobile)

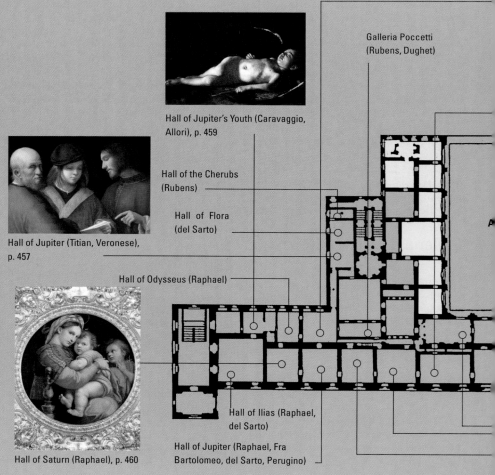

Hall of Jupiter's Youth (Caravaggio, Allori), p. 459

Galleria Poccetti (Rubens, Dughet)

Hall of the Cherubs (Rubens)

Hall of Flora (del Sarto)

Hall of Jupiter (Titian, Veronese), p. 457

Hall of Odysseus (Raphael)

Hall of Saturn (Raphael), p. 460

Hall of Ilias (Raphael, del Sarto)

Hall of Jupiter (Raphael, Fra Bartolomeo, del Sarto, Perugino)

Hall of Prometheus (Filippo Lippi, Botticelli), p. 461

Appartamenti Reali (Royal Apartments)

Volterrano Rooms

Hall of Venus (Rubens, Titian), p. 452

Giardino di Boboli

0 20 m

Hall of the Grooms, Anteroom

Statue Gallery

Castagnoli Room

Hall of Apollo (Titian, van Dyck, Fiorentino)

Hall of Mars (Rubens, van Dyck), p. 456

Galleria Palatina

Sala di Venere

Leopold II opened the Galleria Palatina to the public in 1828 and in the following years it was extended on a number of occasions. In general the paintings are from the collections of the Medici, but important pieces have been added through purchases made by the Dukes of Lorraine. The main masters of European Renaissance and Baroque painting are represented by their most impressive works in these splendidly decorated halls. In contrast to the didactic system of the Uffizi the pictures are not hung in chronological order; instead they are arranged in keeping with the gallery's décor to preserve the original character of the rooms.

The Hall of Venus, with its ornate ornamentation, is one of the largest and most striking rooms in the gallery. As in the neighboring rooms, the allegorical ceiling fresco in praise of the Medici family (1641) was painted by Pietro di Cortona. Today, the center of the room is occupied by the marble statue of the Italian *Venus*. Napoleon commissioned this from Antonio Canova in 1810 to replace the Medici *Venus* from the Uffizi Gallery, which was to be taken to Paris.

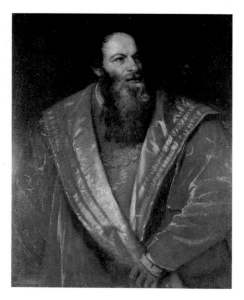

Titian: Portrait of Pietro Aretino, ca. 1545
Oil on canvas, 108 x 76 cm

Pietro Aretino (1492-1556), one of the most respected literary figures of his age, was feared for his vitriolic polemics. Titian painted his portrait around 1545 and the sitter gave the work to Cosimo I de' Medici soon afterwards.

Depicted in half-profile, the scholar's serious gaze seems to suggest a liberal nature and is marked by alertness and interest. His upper body occupies a large proportion of the picture space, and Titian's magnificent brushwork accurately recreates his reddish-brown cloak which shimmers with gold.

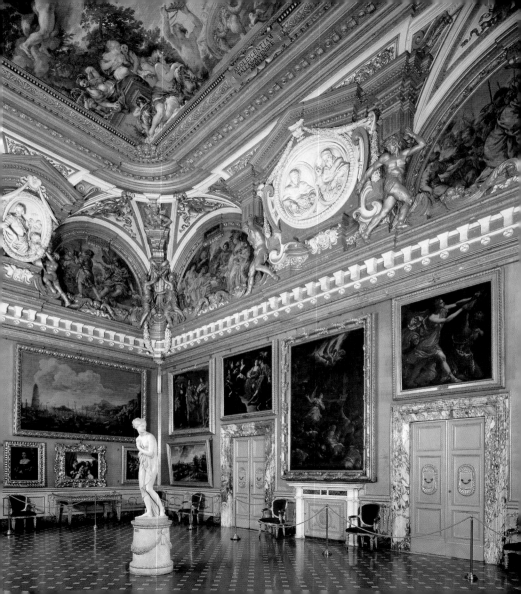

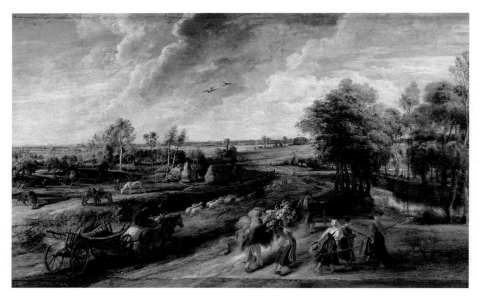

Peter Paul Rubens: The Return from the Harvest, ca. 1635-40
Oil on wood, 122 x 195 cm

The artist painted this scene of country folk returning from the harvest in the last years of his life (1635–40).

This painting executed on a wooden surface demonstrates Peter Paul Rubens' virtuoso skill as a painter of landscapes. The harmonious tones emanating from warm chords of color capture the dying light of a summer's day.

Rubens allowed himself a small "mistake" in the picture which the German writer Johann Wolfgang von Goethe remarked upon in his conversations with his secretary, Eckermann (though he willingly excused it as an example of artistic license): the group of trees on the right of the picture is lit from that side, while light falls on the rest of the landscape as well as the group of peasants in the foreground from the left. The peasants are pictured returning from their fields after a day's work and they seem to be eager to seek shelter from a storm whose approach is indicated by the dark clouds gathering on the horizon.

In this work landscape has become the expressive tool for a composition animated by drama and charged with atmosphere.

Titian: The Concert, ca. 1510
Oil on canvas, 109 x 123 cm

The painting was purchased by Cardinal Leopoldo de' Medici in 1654 as the work of Giorgione, though it is today generally attributed to the young Titian; whether it was a cooperative effort by the two artists is now almost impossible to verify.

The actual theme of the work also remains obscure; this gathering of three men does not seem to have been called for the purpose of playing music together, nor can it be explained as a concert performance as the usual title of the painting would suggest. With a spontaneous movement of the head the man in the center turns towards his older colleague who has placed his hand on his shoulder from behind. The intensity of their eye contact is just as puzzling as the expression of the youth in the conspicuous plumed headdress to the left who seems to be directing his gaze at the viewer.

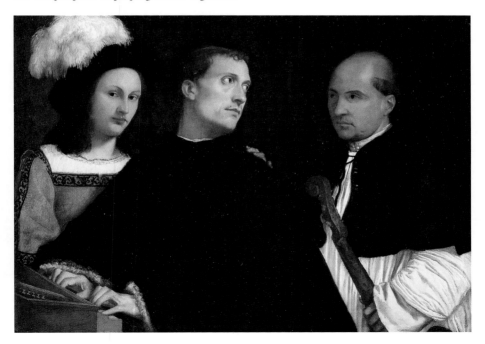

Peter Paul Rubens: The Consequences of War, ca. 1638

Oil on canvas, 206 x 345 cm

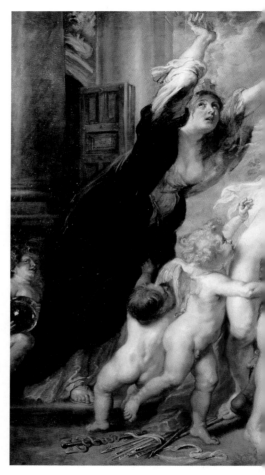

It is to Rubens himself that we owe an interpretation of this work; in 1638 he sent the painting to his Flemish colleague, Justus Sustermanns, describing it in detail in a letter. The gruesome events of the Thirty Years' War played an important part in the picture's genesis. In the center of the picture Venus tries in vain to restrain Mars, the God of War, but the power of Alecto, a Fury, is too great. Hunger and Pestilence are also dragging him away. At the left we can recognize the doors to the temple of Janus standing open; they were closed during times of peace and their open portals are therefore a symbol of war.

The dramatic composition vividly expresses the desolation and horrors of war which are lamented by the allegorical figure of Europa, her arms reaching desperately and imploringly towards heaven. It is not only Man who is pictured falling victim to this all-consuming violence; the arts and sciences are also laid low, aspects which are symbolized by a lute, the architect's instruments, a drawing, and the open book which Mars tramples underfoot. The darkly savage face of war transforms concord and love, harmony and beauty into destructive discord and hatred, blind devastation and chaos.

Rubens painted this image two years before his own death, and in it he succeeded in clearly articulating the inner nature of war. The fact that it does not depict actual incidents allows the painting

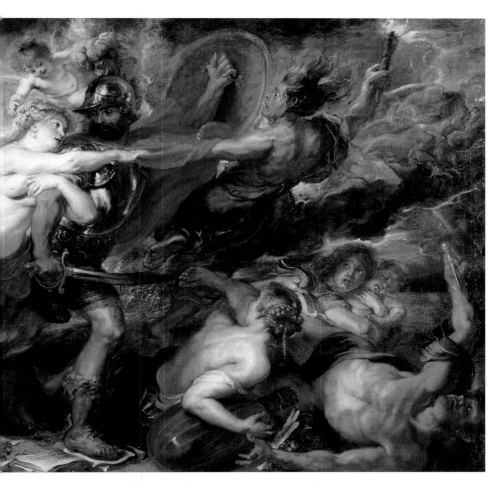

to retain its power for the modern viewer. In this respect the work anticipates the consequences of war as expressed in a comparable 20th-century masterpiece – Picasso's *Guernica*.

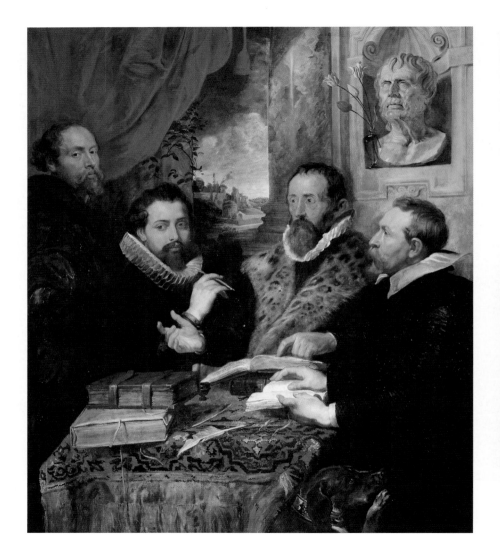

Peter Paul Rubens: The Four Philosophers, ca. 1611/12
Oil on canvas, 164 x 139 cm

Rubens' so-called "Four Philosophers" contains a self-portrait of the painter at the far left. In front of him stands his brother Philipp Rubens whose premature death in 1611 may have been the catalyst for the picture. If so, the work would have the character of a memorial and this would certainly explain the strangely rapt and abstractly spiritual mood of the group. At the far right is the humanist, Jan Wouverius, pictured holding an open book. The dominant figure in the group, however, is the famous philosopher Justus Lipsius who died in 1606. Here Lipsius is placed in the context of the philosophical tradition of the ancient Stoics whose most highly renowned representative, Seneca, is recalled in a portrait bust in the wall-niche behind him. As symbols of human mortality the pair of blooming tulips represent the two still living men, while the two closed flowers stand for the deceased. The antiquated ruffs worn by Lipsius and Philipp Rubens would have clearly marked them out to contemporary viewers of the painting as belonging to a bygone age.

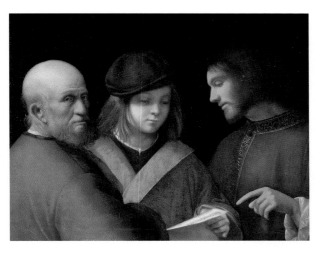

Giorgione: The Three Ages of Life, ca. 1505
Oil on wood, 62 x 77 cm

This famous painting is today most often attributed to the Venetian painter Giorgio da Castelfranco (called Giorgione, ca. 1477–1510). The remarkable atmosphere of Titian's *Concert* (see p. 453) seems to have been directly anticipated in this work. In both paintings the real theme remains a mystery, and it is unlikely that any hidden meaning intended by the artist can now be deciphered. It was previously thought to depict a young Mark Antony being tutored by two philosophers. The present title of the work makes it clear that the figures are now interpreted as symbols of youth, maturity and old age.

**Raphael: Madonna del Granduca,
ca. 1505**
Oil on canvas, 85 x 56 cm

The fame achieved by Raphael Santi (1483–1520) during his lifetime was in large measure based on his many inimitable pictures of the Madonna. In spite of the fact that the background has been painted over, this early work (ca. 1505) is considered one of the most outstanding examples of this kind of image. The painting enjoyed enormous popularity in the 19th century. The image radiates a sense of gentleness and melancholy, and though the structure of the composition seems simple it is in fact rich in the subtle nuances of the painter's technique. The Madonna is shown in three-quarter length, her head slightly inclined to one side, and a red shimmer plays over her features and those of her son. The Virgin has placed her hand under the body of the child in a supporting gesture of exceptional delicacy. The figures' contours have been rendered in such a way as to suggest gentle transitions and are seen as if viewed through a veil.

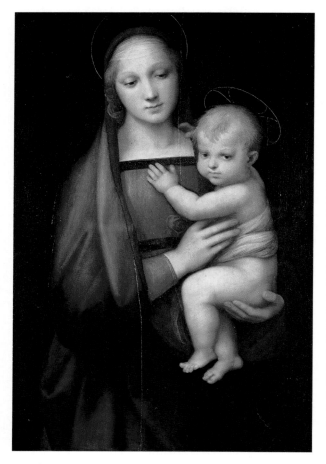

Caravaggio: Sleeping Cupid, ca. 1608
Oil on canvas, 71 x 105 cm

Michelangelo Merisi da Caravaggio (ca. 1571–1610) led a short but stormy life. In many of his often dramatically intense paintings one is tempted to see reflected something of the turbulent and quick-tempered nature of the artist himself. Such theories certainly do not apply to this rectangular canvas of a peacefully sleeping Cupid, which was probably painted in Malta where the artist had fled in 1607. The focus of the work is entirely on a nude depiction of the infant god of love, his body modeled with the extreme chiaroscuro effects so characteristic of Caravaggio. The source of the harsh light falling on the sleeping figure of Eros in this nocturnal scene – and which also mysteriously illuminates the edges of the wing at the rear – remains hidden from the viewer.

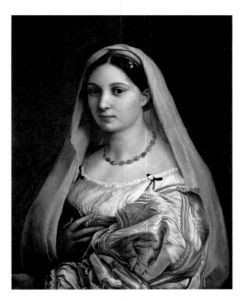

Raphael: La Velata, ca. 1516
Oil on canvas, 85 x 64 cm

In this portrait of a lady with a veil, we encounter Raphael at the height of his powers. The identity of the sitter – perhaps a Roman lady from the painter's own circle – remains unknown.

Raphael Santi executed this painting with the greatest care, constantly reworking and refining a number of areas. Today, this magnificent painting is justifiably considered one of the masterpieces of Italian High Renaissance art.

Raphael: Madonna della Seggiola, ca. 1515
Oil on wood, diameter 71 cm

Seated on a chair, the Virgin wraps her son in her arms as the child cuddles up to her. His hands raised in a gesture of prayer, the infant John the Baptist inclines his head towards them from the right. This round panel was probably used for private devotions. The religious theme is translated into an unusually naturalistic form with the Virgin wearing contemporary Roman clothing. The viewer feels strangely mesmerized by the Virgin's urgent and intense gaze and it almost seems as if she is trying to protect the child in her lap from any external harm. Here, Raphael succeeded brilliantly in harmonizing his composition with the round format of the tondo even though the large size of the figures means they almost completely occupy the picture surface.

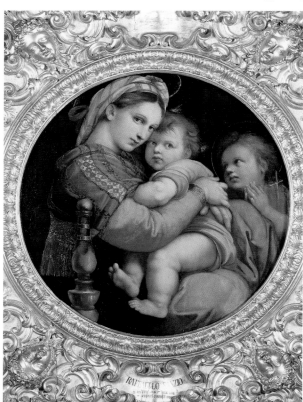

Filippo Lippi: Madonna and Child and Scenes from the Life of the Virgin, ca. 1450
Tempera on wood, diameter 135 cm

Filippo Lippi's tondo is one of the earliest examples of this type of picture. Visible in the background is the encounter between Anne and Joachim while to the left the birth of the Virgin is shown. The Madonna is positioned well to the fore of these events. Her face is that of a beautiful woman, and her clothing and headgear correspond to contemporary fashion. A premonition of Christ's Crucifixion can be detected in the expression on her face. The pomegranate held in the infant Christ's hand refers to the future fate of his Passion.

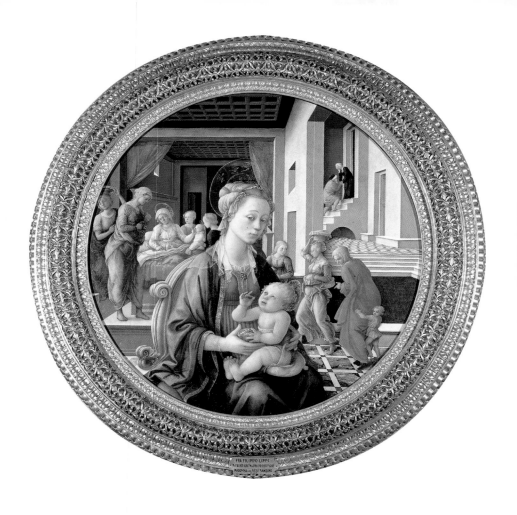

Giovanni Boccaccio – the Author of the *Decameron*

Giovanni Boccaccio was born in 1313 either in Florence or near the city (in Certaldo), the illegitimate son of the merchant and money-changer Boccaccino di Chellino. When his father moved to Naples in 1427 to become the representative of the Bardi banking house, Giovanni was expected to complete the commercial training he had begun in Florence in his new home. Against the express wishes of his father, however, the young Boccaccio increasingly followed his own interests; influenced by the circles around the Anjou court, whose immense library fascinated him, he began to study Classical languages and literature. Soon after he wrote the love story *Filiocolo* (1336), a novel, and this was quickly followed by his first poems in Latin. The most important event in his own life in those years, however, was his encounter with Fiammetta, and Boccaccio later made her the object of his love poetry just as Dante had earlier with Beatrice. When the Bardi bank collapsed in 1340 Boccaccio's family also got into financial difficulties and Giovanni was reluctantly forced to return to Florence. With the exception of his many journeys – including several to Naples – he was to remain in the city, where he devoted himself exclusively to the pursuit of literature. That he achieved a considerable reputation in his home town is demonstrated by the fact that in 1373, two years before his death, he was appointed to the first public academic post for the interpretation of Dante Alighieri's *Divina Commedia*. A decade earlier, Boccaccio had completed his remarkable *Vita di Dante*.

Giovanni Boccaccio's main claim to international fame however rests on his *Decameron* (Greek: *deka* = ten; *hemera* = day). The plot which frames this famous collection of tales is set in the plague year of 1348. Ten young people from the upper middle classes of society – seven men and three women – escape to a country estate near the city. To pass the time, each of them tells a story over the course of ten days, the dominant theme of these narratives being love. In a series of amusing episodes a panorama unfolds giving an insight into the 14th century's notions of love.

It is only due to the intervention of Petrarch, with whom Boccaccio had a long friendship, that this great work of world literature survived: Boccaccio himself had planned to destroy it.

Andrea del Castagno: Giovanni Boccaccio, ca. 1450, fresco (transferred to canvas), 245 x 165 cm, Galleria degli Uffizi, Florence

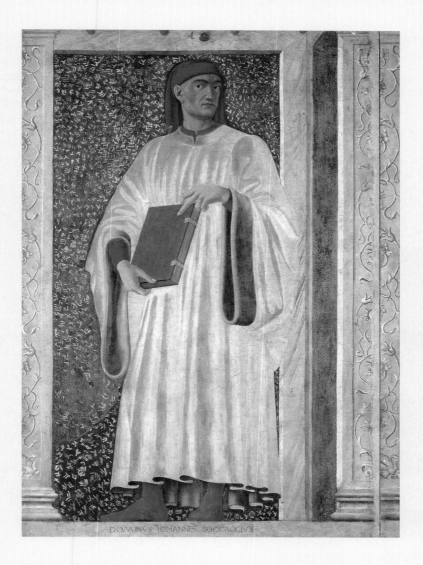

DOMINVS IOHANNES BOCCACCIVS

Giardino di Boboli

The sprawling complex of the Boboli Gardens (named after the Boboli family who were the previous owners of the land) extends over 53,000 square yards (45,000 square meters). This superb example of a *giardino all italiana* was begun for Eleonora of Toledo, the wife of Cosimo I, in around 1550 by Niccolò Pericoli (also known as Tribolo). The complex was then extended several times by the architects Bartolomeo Ammanati, Bernardo Buontalenti, and Alfonso Parigi.

Over the course of several centuries the garden developed into a unique and varied combination of art and nature – it contained an amphitheater, sculptures, fountains, buildings, and late Mannerist attractions such as the Buontalenti grotto – which attested to a joy in botanical experimentation as well as supporting the state and recreational functions which were demanded by the court.

Numerous fruit and plant varieties from throughout the world were grown here; the garden was the first in Italy to cultivate potatoes, and even silkworms were bred here at one time.

Forte di Belvedere

After an imposing fortress, called the Fortezza da Bassa, had been built in the north of the city (1534 – 45) by the architect Antonio da Sangallo, the Forte di Belvedere (1590 – 95) was built by Bernardo Buontalenti as the city's southern outpost at the instigation of Grand Duke Ferdinando I. The southern fortification was designed to provide military protection for the city of Florence and also for the ducal residence in the Palazzo Pitti.

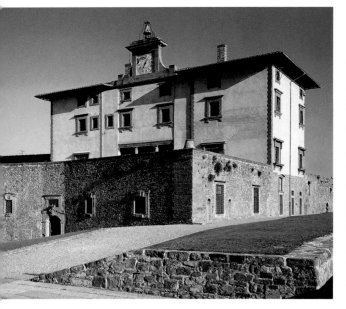

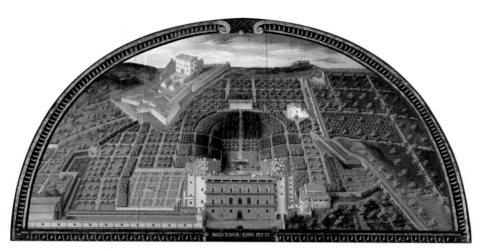

Located in the middle of this massive complex, the actual castle surprisingly bears more of a resemblance to a country villa. Right from the outset, it seems, Ferdinando I had harbored the idea of finding a safe refuge here in case of political unrest or public opinion swinging against the ruling family. That the cannons of the Fortezza were partly directed at the city of Florence itself is a further indication of this thinking. As is evident from the name Forte di Belvedere – which translates literally as "Fort of the Beautiful View" – the extensive terraces of the complex offer the visitor a magnificent view out over the city. The fortress is worth visiting, and not only because of the exhibitions held here.

Giusto Utens: Veduta of the Palazzo Pitti, the Giardino di Boboli and the Forte di Belvedere, 1599
Fresco

Along with other items illustrating the history of Florence the city's Museum of Local History (Museo di Firenze com'era) contains a series of lunette paintings from the Flemish artist Giusto Utens to which this charming veduta from 1599 belongs. The foreground shows the Palazzo Pitti as it previously appeared prior to its extension by Giulio Parigi (ca. 1620) At the upper left the Forte di Belvedere directly adjoins the Boboli Gardens which stretch from the amphitheater – yet to receive its final architectural shape – to the hills beyond the palace.

Giardino di Boboli

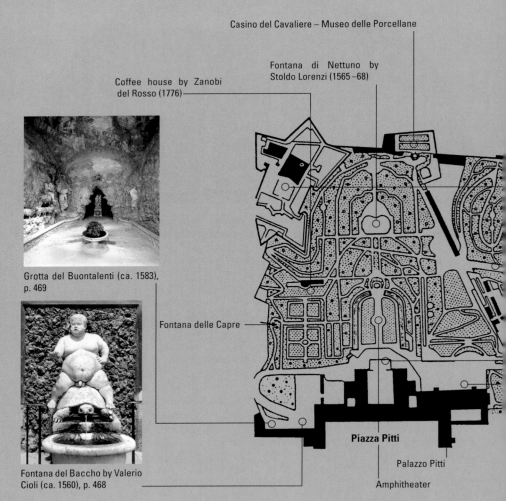

Casino del Cavaliere – Museo delle Porcellane

Fontana di Nettuno by Stoldo Lorenzi (1565–68)

Coffee house by Zanobi del Rosso (1776)

Grotta del Buontalenti (ca. 1583), p. 469

Fontana delle Capre

Fontana del Baccho by Valerio Cioli (ca. 1560), p. 468

Piazza Pitti

Palazzo Pitti

Amphitheater

Forte di Belvedere, p. 465

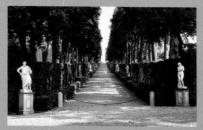

Il Viottolone, p. 470

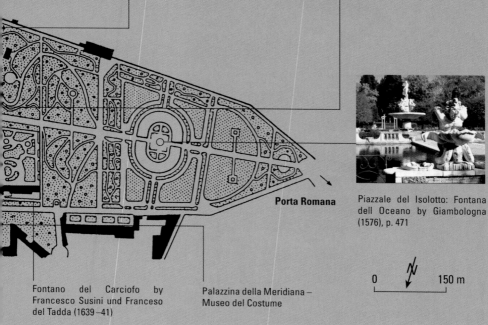

Piazzale del Isolotto: Fontana dell Oceano by Giambologna (1576), p. 471

Porta Romana

Fontano del Carciofo by Francesco Susini und Franceso del Tadda (1639–41)

Palazzina della Meridiana – Museo del Costume

0 150 m

Valerio Cioli: Fontana del Bacco, ca. 1560

This so-called Bacchus fountain is a monument to the Medici's court jester. The dwarf's appearances at court were extraordinarily popular and his portrait was painted by Vasari and Bronzino amongst others. Cioli depicted him in less flattering fashion: naked, obese, and riding a turtle.

Grotta del Buontalenti

The grotto owes its name to the Florentine architect Bernardo Buontalenti who designed it for Francesco de' Medici after 1583. Its three cave-like rooms reveal a grotesque play of imaginative drollery. This impression was once further enhanced by fountains and a crystal bowl fixed to the ceiling in which live fish swam. On closer examination the stalactite walls are revealed to be depictions of shepherds and their sheep. The sculptures in the grotto's rooms are also of a high standard. Giambologna's Venus dating from 1573 (innermost room) and the Paris and Helen group by Vincenzo de Rossi (ca. 1560) were displayed here, as were the slaves from the tomb of Pope Julius II by Michelangelo. Positioned in the corners of the foremost room by Cosimo I, they have since been replaced by copies; the originals have been housed in the Galleria dell Accademia since 1909.

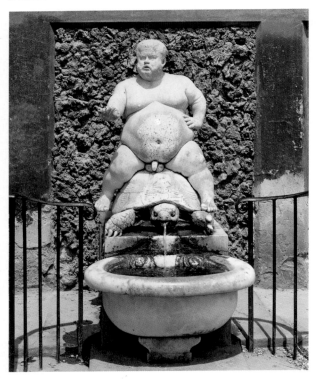

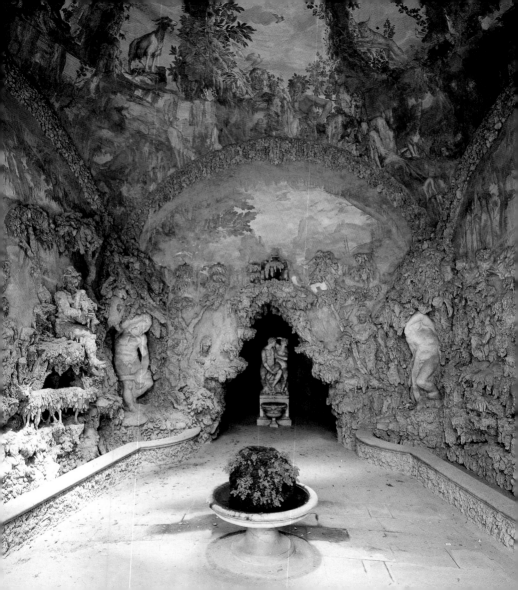

Il Viottolone

When the park was extended at the beginning of the 17th century a long alley called *Il Viottolone* (Italian: footpath) was laid out and lined with numerous statues. It runs through the park from east to west in line with the Porta Romana.

Originally the alley was lined along its sides with arbors, but in later years cypresses were planted on both sides of the path in order to provide shade.

In former times the main axis of the park was probably flanked by lively fountains such as those that can be found in large parts of the park today. Fish ponds, bird houses, and mazes constructed from hedges offered family members, house guests, and visitors strolling through the grounds varied forms of entertainment; a multitude of exotic plants were also cultivated for their pleasure.

Piazzale dell' Isolotto – the Fountain of Oceanus

From the higher regions of the park, the path leads down through the Viottolone to the *Isolotto* (little island), an open oval area surrounded by high hedges in whose center Pietro Tacca constructed a pond in 1618. In the middle of this pond can be found

Giambologna's *Fountain of Oceanus* (1576, copy of the original housed in the Bargello). The great German art historian Jacob Burkhardt thought this fountain "simply majestic, like no other in Italy or indeed in all of Europe." At the feet of the main figure are personifications of rivers – the Nile, the Ganges, and the Euphrates – which can be interpreted as symbols of the three phases of life (youth, maturity and old age).

Florence – the City of Festivals and Celebrations

Already in the Middle Ages Florence was a city of festivals and celebrations, processions and games. Indeed, even in the 15th century some years were so full of feast days of all sorts that it is difficult to imagine people leading a regular working life in the city. A glance at the calendar for 1457 at any rate reveals a total of 87 public holidays – and notes that work was only permitted on the other days if His Most Serene Highness had not ordered a festival.

The many equestrian competitions held in the city enjoyed increasing popularity. Until the 19th century the Piazza Santa Maria Novella was the setting for the annual *Palio dei Cocchi*, a

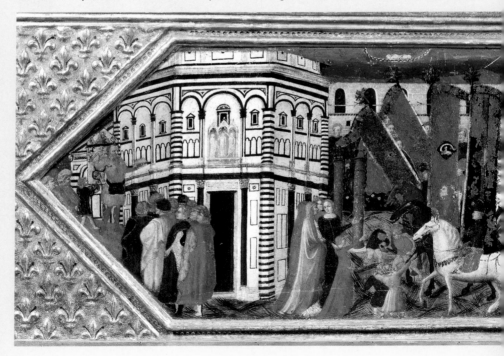

carriage race that Cosimo I had initiated in 1563 on the model of ancient Roman chariot racing. Processions and a race with Barbary horses were organized for the 24 June to honor the city's patron saint, John the Baptist. The victor was awarded the so-called *palio*, a velvet flag, as the prize.

While riding and equestrian competitions of this kind are today held only in Siena (and Arezzo), the feast day of St. John (Festa del Patrono) in Florence is still accompanied by a wide variety of different events. As well as traditional rowing regattas on the Arno, the culmination of the ancient *Calcio storico* is also held on this day. The finalists in this match of "historic soccer" are decided in a series of matches held in the preceding weekends during the month of June.

Dressed in historic costumes, and accompanied by flag-bearers and the sound of

Cassone with pictorial depiction of a mounted procession on the Feast Day of St. John, Museo Nazionale del Bargello, Florence

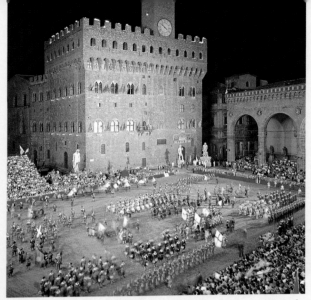

March past of the standard bearers during the Calcio storico on the Piazza della Signoria

fanfares, teams from the various city districts engage in bitter struggles on the Piazza Santa Croce (and occasionally on the Piazza della Signoria) in a game which bears little resemblance to the modern sport of soccer. The high point of the day is a gigantic firework display whose epicenter is the Piazzale Michelangelo.

On Easter Sunday, the annual *Scoppio del Carro* (literally: explosion of the cart) takes place. The origins of this festival stretch back to the 12th century when the crusader Pazzino de Pazzi brought back to Florence three pieces of flint said to be from the grave of Christ. The present form of the *Scoppio del Carro* dates back to the 16th century. An elaborately decorated cart bedecked with fireworks is drawn in a procession by two white oxen onto the Piazza del Duomo. Once there, a burning papier-mâché dove (called the *colombina*) is shot from the high altar of the cathedral down specially rigged ropes and onto the cart. If it ignites immediately then it bodes well for both the harvest and business; but if the cart does not go up in flames straight away the future is said to look bleak for the coming year.

On Ascension Day the Florentines head for the Cascine Park for the traditional cricket hunt. This undertaking is made considerably easier these days by the insects – an increasingly rare find – being available for sale in order to keep the children happy. The cricket hunt is accompanied by other attractions too so that the *Festa del Grillo* has developed into a popular and enjoyable carnival.

The *Festa della Rificulona* also has religious origins. On 7 September, the eve of the birth of the Virgin, the city's children gather in the evening for a procession with fantastically designed torches, lanterns, and lamps (*rificulone*).

Scoppio del Carro on the Piazza del Duomo

The most important Florentine festivals

- March/April on Easter Sunday: *Scoppio del Carro* (Burning of the wagon)
- 31 May: *Festa del Grillo* (Cricket Festival or Spring Festival in the Parco delle Cascine)
- June (over several weekends): *Calcio storico* (Historic soccer match) on the Piazza Santa Croce
- 24 June: *Festa di San Giovanni* (Feast Day of the city's patron saint, John the Baptist); Fireworks on the Piazzale Michelangelo
- 7 September: *Festa della Rificulone* (Lantern festival)

Jacques Callot: Calcio storico on the Piazza Santa Croce, Gabinetto dei Disegni e delle Stampe, Galleria degli Uffizi, Florence

Santo Spirito

Though the façade of Santo Spirito was once decoratively painted it is today covered in smooth plaster and, in spite of a gable with side volutes added in 1758, it has a decidedly plain appearance. Nevertheless, the building's interior remains an architectural gem from the early Renaissance in Florence.

Filippo Brunelleschi was appointed as architect by a specially convened commission in 1434; the new structure was to replace an older Augustinian complex from the 13th century. However, it was only in the year the architect died (1446) that the first columns for the new building were delivered and Brunelleschi himself only lived to see the very earliest phase of construction. His pupil, Antonio Manetti, was unable to prevent parts of his master's plans from being modified. Brunelleschi had originally intended, for example, for the side chapels to protrude beyond the external wall, rather than be enclosed flush within it, so that their curved surfaces would produce a strongly plastic effect on the building's mass.

In spite of later renovations Santo Spirito is still considered the Florentine church which most clearly expresses the architectural concepts of the early Renaissance as well as the most perfect of Brunelleschi's spatial designs. In 1484 work was brought to a conclusion with the vault for the dome although construction of the campanile – from plans by Baccio d'Agnolo – continued until 1566.

Interior

The ground plan of Santo Spirito is in the form of a Latin cross and the church was built as a flat-roofed basilica with a nave, two aisles and side chapels. The light-filled interior directly recalls the church of San Lorenzo. Filippo Brunelleschi, who had been appointed director of that building several years before, enjoyed greater

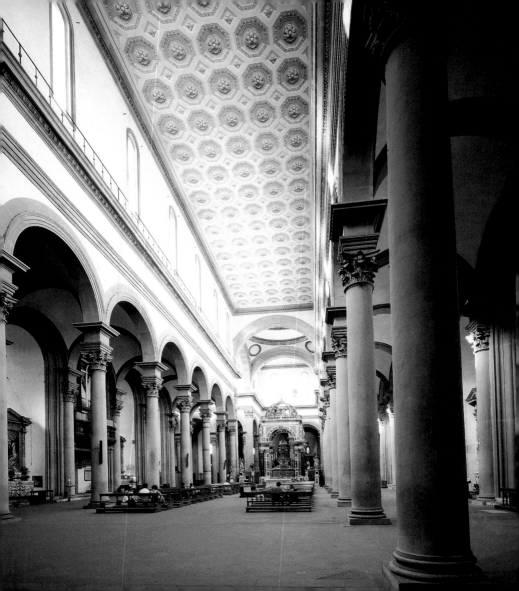

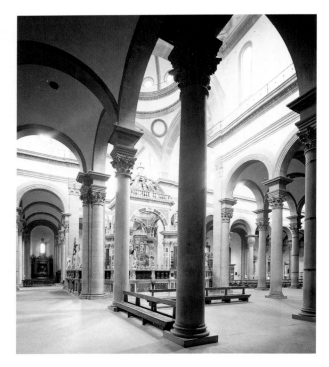

its sides of 22 Florentine cubits. The crossing's dimensions were applied to the design of the choir and the transepts; the nave itself (according to the original plans) is exactly four times as long as this standard measure. Each bay of the aisles corresponds to one-quarter of the crossing, while the adjoining chapels are one-half this size.

This approach – of meticulously constructing a ground plan based on accurate mathematical measurements – is consistently applied to the building's vertical surfaces too. The clerestory and triforium are 22 cubits in height which again matches the sides of the crossing. A geometrical system of almost analytical rigor forms the basis of the building, thereby uniting the totality of its parts in a network of logical relationships.

Brunelleschi's Santo Spirito is an epoch-making achievement. Ultimately it stems from the ideals of ancient Roman and Classical architecture as laid down in the ten volumes of Vitruvius' *De architectura*.

freedom with his design for Santo Spirito where he was able to develop a unified spatial solution which went well beyond the limitations of San Lorenzo.

Today, unfortunately, this impression of space is detracted from by Giovanni Battista Caccini's altar for the crossing (1599–1609).

The unit of measurement which forms the basis for the entire space is that of the square formed by the domed crossing with

Cenacolo di Santo Spirito – Museo della Fondazione Salvatore Romano

The Augustinian church of Santo Spirito is adjoined by a monastery which in the 13th century was one of the largest south of the Arno; sadly, it has not survived the passage of time intact.

Some of its more striking features are the frescos of the *Crucifixion* – unfortunately only in a fragmentary state – and the *Last Supper* by Andrea Orcagna (ca. 1360). The refectory is today home to the sculpture museum of the Salvatore Romano Foundation (Fondazione Romano nel Cenacolo di Santo Spirito).

Santo Spirito

Giovanni Battista Caccini:
Main altar (1599–1609)

Cappella Corbinelli: Andrea
Sansovino altar (ca. 1490)

Cappella Cavalcanti: Earliest Florentine
pietra dura decoration (1562)

Campanile (1571 completed from
plans by Baccio d'Agnolo)

Sagrestia (from plans by Giuliano da
Sangallo, 1488–96), p. 482

Secondo Chiostro (Bartolomeo
Ammanati, 1565)

Refectory – Museo della Fondazione
Salvatore Romano, p. 479

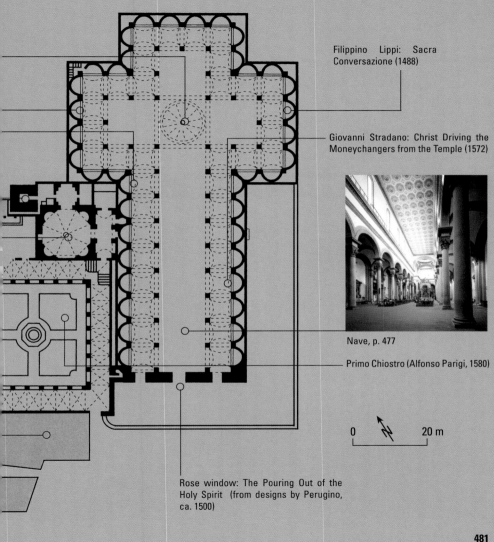

Filippino Lippi: Sacra Conversazione (1488)

Giovanni Stradano: Christ Driving the Moneychangers from the Temple (1572)

Nave, p. 477

Primo Chiostro (Alfonso Parigi, 1580)

0 20 m

Rose window: The Pouring Out of the Holy Spirit (from designs by Perugino, ca. 1500)

Sagrestia

The sacristy of Santo Spirito, built from 1488 to 1492 according to plans by Giuliano da Sangallo (1445–1516), is reached by passing through a barrel-vaulted anteroom. The architect's work shows him to be an expert in the traditions of Florentine architecture. Sangallo's octagonal, centrally planned space was clearly inspired by the Florence Baptistery, the cathedral and, most particularly, the work of Filippo Brunelleschi whose Old Sacristy of San Lorenzo might well have served as a model. The wall surfaces of Santo Spirito are, however, to provide a highly individual solution; divided into three levels articulated by powerful cornices, they were later to function as a source of inspiration for Michelangelo's work on the New Sacristy.

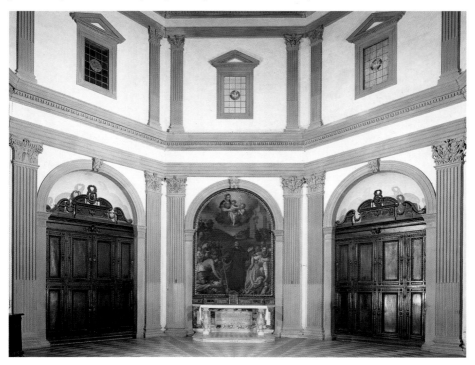

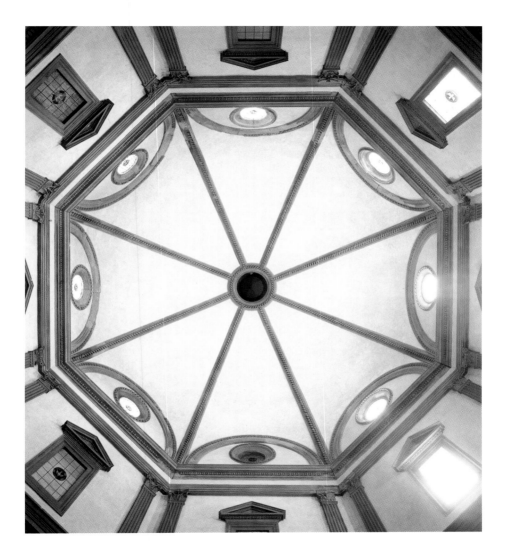

Santa Maria del Carmine

The Carmelite church of Santa Maria del Carmine owes its fame to the frescos by Masaccio and Masolino in the Cappella Brancacci. Situated at the far wall of the eastern transept the Brancacci chapel, like its western pendant the Corsini chapel, escaped damage in a disastrous fire which swept through large parts of the 13th-century Gothic church in 1771. In 1775 the building was renovated in the Baroque style and its interior redesigned by Giuseppe Ruggieri and Giulio Mannaioni. The façade has remained in an unadorned state until today and, like the church of San Lorenzo, it has a rather bare and unprepossessing appearance.

Interior

The interior was built on the ground plan of its Gothic predecessor as a single-nave church with transepts and a dome on the crossing. The long nave is flanked by chapels and enclosed by a barrel vault which Giuseppe Romei decorated with frescos depicting the Ascension and Transfiguration of Christ in 1782. The chapel of the patrician Corsini family at the far end of the western transept is also noteworthy. The Brancacci chapel – on the opposite side of the church – is no longer accessible via the church's interior; since renovation work finished in 1990 access has been limited to a separate entrance to the right of the façade.

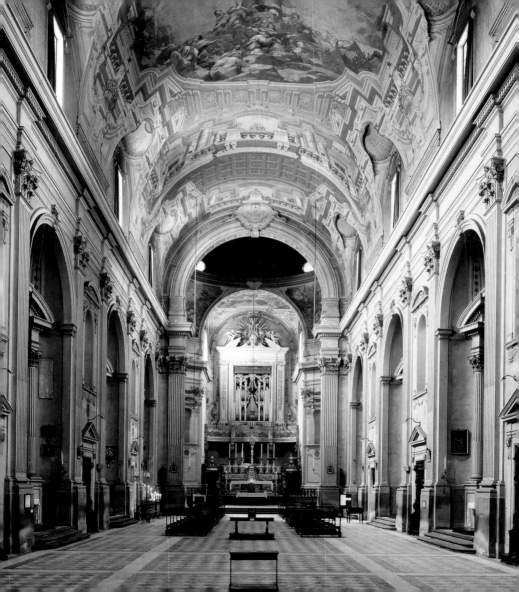

The Burdens of a Cultural Legacy – Problems of Conservation and Tourism

The crowds of art-loving tourists who make the pilgrimage to Florence keep getting bigger with every passing year; indeed in some areas they are turning the city into a kind of "cultural theme park." The numbers of residents in the historic inner city on the other hand are on the decline.

Masaccio: Giving of Alms (before restoration), ca. 1425, fresco, Cappella Brancacci, Santa Maria del Carmine, Florence

Like no other European city, the comparatively small town of Florence is compelled to walk the fine line between making itself attractive to tourists and preserving a sense of modern vitality. These considerations have led to the metropolis developing into a modern service economy, and the city has become a center for the conference and fashion industry which sets the pace for the region of Tuscany. Tourism has, in any case, long since become a crucial part of the local economy and one which provides a living to countless restaurant and boutique owners, souvenir sellers and hotel owners. The obligation to maintain its unique cultural monuments requires an enormous effort and great expenditure on the part of the Florentine municipality. The cost of entry tickets to view the city's many museums, churches, and tourist attractions has continually risen over the decades, but they are only able to cover a fraction of the costs necessary for the annual operation. Modern environmental influences have accelerated the decay of buildings, sculptures, and frescos, making management of these cultural resources an increasingly Sisyphean task.

As far back as 1872 Michelangelo's *David* had to be transferred to the Accademia to protect it from the elements; it was replaced by a copy on its original site. Since then innumerable sculptures have had to be placed in protective indoor environments to protect

them from the havoc wrought by acid rain and air pollution. Today only copies are often to be found at their original locations.

The efforts needed to restore the sculptures to their original condition are matched by the difficulties of conserving paintings. It is above all the countless frescos of the city which require the particular attention of the restorers; when dampness, exposure to water and other dangers threaten, murals frequently have to be transferred to another surface and, in some exceptional cases, even removed from the context of their original site.

A fate as drastic as this was avoided when restoration of the frescos in the Brancacci chapel could no longer be postponed in 1981. Including the preparatory stages, work on the Brancacci frescos continued until 1990 – and therefore paralleled that being

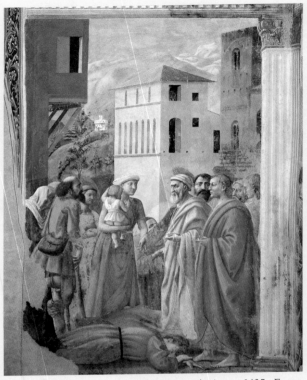

Masaccio: Giving of Alms (after restoration), ca. 1425, Fresco, Cappella Brancacci, Santa Maria del Carmine, Florence

undertaken on Michelangelo's paintings in the Sistine Chapel. The results in the Brancacci chapel, however, were unreservedly a major restoration success. The conservators made a number of spectacular discoveries in the course of their work which rendered obsolete several art historical axioms, and helped to revise a number of other opinions. The viewer is now finally able to see Adam in his original naked state – this sight had been denied to previous generations because an early censor had ordered his nakedness to be covered with painted foliage.

Cappella Brancacci

The famous frescos of the Cappella Brancacci or Brancacci chapel – pictured opposite in their much darkened, pre-restoration state – today once again dazzle the viewer with all their original brilliance. For almost a decade, from 1981 to 1990, an army of restorers devoted themselves to the detailed and painstaking work necessary to renovate these partly destroyed paintings. The realism of the frescos, their use of centralized perspective, the vivid individualism of the figures and the narrative drama of events derived from human emotions are all characteristics which help to make these frescos a milestone in the history of Western art.

The painting of the chapel was begun by Masolino da Panicale (1383–1440) in 1424 for the cloth merchant Felice Brancacci. Today the frescos are usually associated with the name of Masaccio, who was 18 years Panicale's junior. He may have had an equal part in the work from the very beginning, and he assumed direct control of the project from 1425 after Masolino had left the city.

In 1428, at the young age of 26, Masaccio died under mysterious circumstances while on a trip to Rome. At that time the paintings in the chapel were still not finished; the cycle was finally completed between 1481 and 1485 by Filippino Lippi who depicted incidents in the life of the apostle Peter.

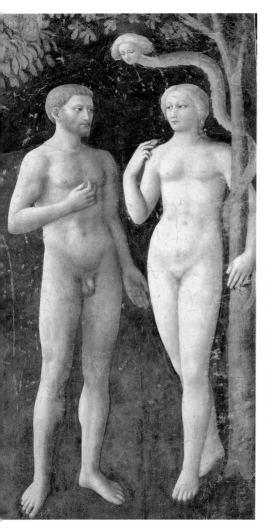

Masolino: The Fall, ca. 1425, detail
Fresco, 214 x 89 cm

The difference in the artistic temperaments of Masolino and Masaccio becomes clear in a comparison of these two paintings of the *Fall* and the *Expulsion from Paradise* which initiate the fresco cycle in the Brancacci chapel. Compared with Masaccio's dramatically animated scene, Masolino's fresco of the Fall, or the temptation of Adam, seems stiff and symbolic.

Rooted in a more traditional pictorial style, the work depicts Adam and Eve beneath the tree bearing the forbidden fruit. The two figures are standing opposite each other in graceful poses, their elongated bodies modeled in a sophisticated and elegant manner. It is only in Adam's subtle gestures and the look Eve directs at him that hints of emotional tension can be made out. Adam still seems torn by ambivalence as he oscillates between love for Eve and dread at her request to pluck the apple from the tree. The self-confident, almost domineering look on Eve's face, and the position of her left arm which connects her with the tree of knowledge and the serpent, leave no doubt as to the outcome of the incident.

Masolino's interest in a credible depiction of a real event remains limited, however, and he is unable to attain the narrative force of Masaccio.

Masaccio: The Expulsion from Paradise, ca. 1425

Fresco, 214 x 90 cm

With an unambiguous gesture an angel expels Adam and Eve from the Garden of Eden; both seem to have recognized the serious consequences of their error and, grief-stricken and gripped by inner turmoil, they accept their inevitable fate. As if the full measure of her actions had suddenly struck her, Eve throws her head back in an imploring gesture to the heavens and her mouth opens in an agonizing lament; overcome by shame, she attempts to conceal her nakedness. His head lowered, Adam walks beside her, his hands covering his face as if he can barely comprehend what is happening. The figures walk towards a light coming from the right of the picture which clearly casts shadows from their bodies, and this seems to be the closest that the painting comes to offering any hope.

Masaccio's fresco paved the way for a completely new pictorial language, and one which was entirely oriented towards the here and now. The scene radiates an unprecedented sense of drama, and the lifelike figures of Adam and Eve, whose physical appearance is made more palpable by effects of light and shadow, are a conspicuous expression of the self-confident view of Man typical for the Renaissance. Masaccio's narrative dynamism is revealed all the more clearly by a direct comparison with Masolino's depiction of the Fall.

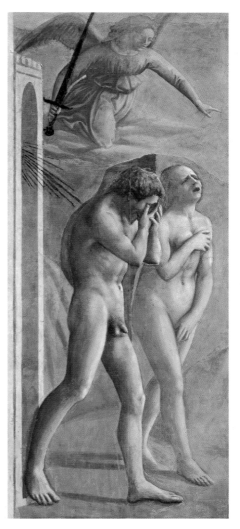

Masaccio: The Tribute Money, ca. 1425
Fresco, 247 x 597 cm

The scene of the tribute payment unites several successive events whose main character, St. Peter, consequently appears three times in the painting. Accosted before the gates of the city of Capernaum on the shores of the Sea of Galilee, Christ and his disciples (according to Matthew 17, 24–27) were required by a tax inspector to pay a double drachma as a tribute to the temple. Jesus instructs Peter to catch a fish in the lake, telling him that he will find a coin in its mouth with which he should pay the tribute money. Remarkably, the actual miracle is depicted as a subsidiary scene to the side of the painting, where Peter

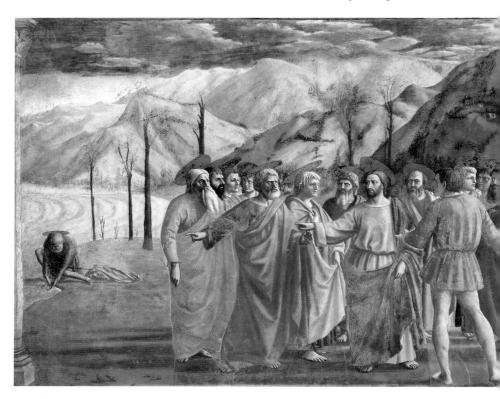

crouches on the shore of the lake as he carries out Christ's instructions.

At the right in the foreground we see him paying the temple tribute. The center of the painting, however, is dominated by the group of apostles gathered around Jesus. They listen to what they believe are the unjust demands of the tax collector, who has placed himself in their path, with grim expressions on their faces. It almost looks as if an argument is about to break out which Christ then prevents with his instructions.

The centralized perspective of the fresco shows a virtuoso handling of space within which the figures seem to move freely and with the greatest naturalness. Masaccio was able to illustrate the events convincingly and with only a few, very restrained gestures – a kind of lifelike quality that had never before been achieved in art.

The choice of this biblical theme, which had never before been depicted in such a controlled way and in such a large format, bore a close connection to political events of the day. In order to balance the city's budget and finance costly military campaigns, a tax increase was then being hotly debated in Florence: it was finally introduced in 1427 and affected especially the city's richer families.

Masolino: The Healing of a Cripple and the Resurrection of Tabitha, ca. 1425
Fresco, 247 x 597 cm

This picture combines two important episodes from the life of St. Peter – the miraculous healing of a lame man (Acts 3, 1–10) and the resurrection of Tabitha (Acts 9, 36–41) – though according to the scriptures these two events occurred at separate locations. On the left, Peter bends down towards the cripple but without taking his hand. The lame man still seems not to understand the meaning of the apostle's gesture which is indicating that he should rise. On the opposite side, however, the miracle of the resurrection is depicted as already having taken place; the painting directly recalls Giotto's previous depiction of the same event in Santa Croce. Two most elegantly attired men, who seem not to be involved in the miracles, act as intermediaries in the center of the composition between both scenes.

The fresco was long considered a joint effort by both Masolino and Masaccio. The hand of the former, it was thought, was recognizable in the comparatively traditional and somewhat awkward figures of the foreground. On the other hand only Masaccio, it was believed, could have contributed the charming view of a contemporary Florentine square in the background; it was constructed using centralized perspective and featured a

number of imaginative details. Recent scholarly work considers it more likely that the painting is by Masolino alone, although the possibility cannot be excluded that Masaccio assisted his colleague with advice, and that Masolino gladly accepted the suggestions of the younger man.

Masolino: Healing of a Cripple and Resurrection of Tabitha (detail)

Whether the imaginative use of detail in the background in this fresco really was executed by Masolino or ought to be attributed to Masaccio is an issue which will probably never be resolved satisfactorily. Whatever the case, it is worth casting one's eye over the open windows of the building in the center of the background. As well as bird cages and washing hung out of the windows to dry, there is also a monkey on the top floor of windows, which was obviously a pet and kept tied to the window ledge (see p.495).

Masaccio: The Sick Healed by St. Peter's Shadow, ca. 1425
Fresco, 232 x 162 cm

The setting is a Florentine street of the early 1400s. At the front left can be seen a typical Renaissance palace (with graduated rustication and a plinth bench), while at the right in the background parts of a church can be made out with antique columns, pediment, and campanile. It almost seems as if the viewer were witnessing an everyday event – a genre scene – showing wealthy citizens making their way through the city. But it is St. Peter who is in fact pictured here as he majestically strides ahead of two other apostles, apparently ignorant of the group of crippled beggars to his right.

The miracle of healing brought about by his shadow could hardly be depicted more vividly. The scene requires no pathetic or expansive gestures, nor even that the saint himself lay his hands on the afflicted. His shadow alone, falling on the lame men, is enough to cure them suddenly of their ills. One of the cripples is still crouching down at the front of the picture while another is pictured in the process of raising himself up in a gesture of humility. A third, whom Peter has just passed, has already been miraculously cured; released from his suffering, he raises his hands in a prayer of thanks. In this work Masaccio proved himself the creator – in more senses than one – of an innovative use of light which was to point the way for future painters.

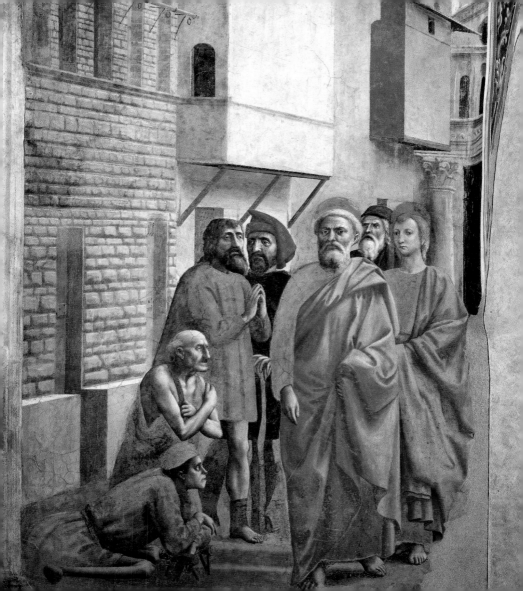

Appendix

Glossar

Academy (Latin *academia*, Greek *akademia*), body, institution, or society for the promotion of artistic or academic study and education. The most important Renaissance academies were created in conjunction with the schools of antiquity in Milan and Florence. The idea of the academy spread throughout Europe during the period of absolutism. The main models here are the Académie Française, which was founded in 1635, and the Académie Royale de Peinture et de Sculpture, which was established in 1648. The visual arts academy in Venice was not created until 1754. The term "academy" is believed to refer to a garden near Athens which was dedicated to the Attic hero Academus and contained facilities for gymnastic training. A favorite haunt of Plato, he named the school of philosophy which he established in 387 B.C after it.

Apse with altarpiece

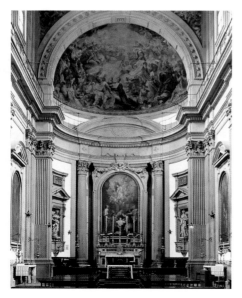

Alchemy (from the Greek *chimeia* and Arabic *alkimia* "chemistry") is the early medieval version of chemistry which was particularly concerned with finding a way to convert nonprecious materials into precious metals.

Al fresco (Italian "on the fresh"), fresco painting, wall painting on fresh wet plaster, the opposite of *secco* painting on dry plaster.

All' antica (Italian "in the antique manner"), a work that imitates the formal language of Classical antiquity. The period of Greek/Roman antiquity began in the second millennium B.C. and ended in 476 A.D. in the west and 529 A.D. in the east.

Allegory (Greek *allegoria* from *allegorein* "to depict differently"), the visualization of abstract concepts and ideas by means of symbolic representation, usually in the form of personification or staged situations.

Al secco (Italian "on the dry"), secco painting, wall painting on dry plaster, the opposite of fresco painting on wet plaster.

Altarpiece (Latin *altare* from *altus* "high"), also altar panel. Piece of sculpture which often adorned altars in the Middle Ages. The first altarpieces were executed in gold or sculpture and paintings were introduced later. An altarpiece can consist of a single work or multiple panels. A **rederos** is an altarpiece that rises from ground level and a **retable** is one that stands on the back of the altar or on a pedestal behind it; sometimes a single altar has both.

Anatomy (Greek *anatemnein* "to cut up/apart"), in medicine, the knowledge of human physiology gained from post mortem examinations. In the visual arts, anatomical representation is derived from a precise study of nature and of the human body and the attempt to gain a deep understanding of human body functions that determine the external form. The artists of the Renaissance had a keen scientific interest in the anatomically accurate proportioning of individual body parts and verisimilitude in the portrayal of muscle action.

Androgeny (Greek *androgynos* genitive of *aner* "man" and *gyne* "woman"), hermaphroditism, physical and spiritual mix of the sexes.

Annunciation, as described in the Gospel according to St. Luke (1, 26–38), the moment in which the angel Gabriel brings the news to Mary that she will be the mother of Jesus, the Son of God. The Annunciation was one of the most popular subjects of medieval and Renaissance art.

Antiquity (French *antique*, Latin *antiquus* "old"), Greek and Roman antiquity. This period began with the early Greek immigrations in the second millennium B.C. and ended in the west with the deposition of Emperor Romulus Augustulus (ca. 475/476 A.D.) and in the east with the closing of the Platonic Academy by Emperor Justinian (482–565 A.D.) in 529 A.D..

Apostle (Greek *apostolos* "messenger"), one of the Jesus's twelve disciples who were selected by him from his large group of followers to continue his work and spread the gospel.

Apse, apsis (Latin and Greek *hapsis* "arch," "vault"), a recess or niche, which may contain an altar, generally semicircular or polygonal in plan and vaulted. When it terminates the main choir or the choir area reserved for the clergy it is also known as the exhedra. Small side apses or apsidoles are often found along an ambulatory, transept, or side aisles.

Arabesque (from Italian *arabesco*, French *arabesque* "Arabic"), style of linear ornament that originated in Islamic art and is based on stylized interlaced and interwoven plant forms.

Arcade (Latin *arcus* "bow" (i.e. hunting weapon)) an arch or series of arches resting on columns or piers.

Arcadia, mountainous landscape in Greece. Arcadia has come to represent an idealized natural rural haven in pastoral literature from different periods. In Greek mythology the home of Pan.

Arch, structure made of truncated wedge-shaped blocks that spans an opening. It can be

load-bearing or deflect loads to piers and columns. The top of the arch with the keystone is known as the crown or vertex. The rise of an arch is the vertical distance between the crown and the springing line or impost (projecting member from which an arch springs). The inner curve of the arch is called the intrados, and the extrados refers to the upper or outer curve of the arch.

Architrave (from Greek *archein* "start," "control" and Latin *trabus* "beam"), a main horizontal beam that rests on vertical elements, e.g. columns, and supports the structure resting on it. It may be subdivided into (usually) three horizontal fasciae, each of which projects slightly further than the one below.

Armor (Latin *armatura* from *armare* "to arm"), protective metal covering, e.g. cuirass, a piece of armor consisting of a breastplate and backplate fastened together.

Atrium (from Latin "anteroom," "hall"), an open courtyard enclosed on three or four sides by an arcade or colonnaded walk and situated in front of the western end of a church. Atria often have fountains in the middle.

Attribute (Latin *attributum* "added"), a material object recognized as symbolic of a person, especially a conventional object used to identify a saint or mythical figure.

Augustinian order, medieval mendicant order whose members observe rules derived from the writings of St. Augustine of Hippo (354–430 A.D.). It was founded in 1256 and expanded in the 14th and 15th centuries following the congregation of church associations. As a result of the spread of Renaissance humanism, a philosophy based on the principles of true humanity, many supporters of the Early Reformation movement were members of the Augustinians, including its founding member Martin Luther (1483–1546). The order's main mission is in education.

Aureole (from Latin *aureolus* "golden"), circle of light surrounding the head or body of a person.

Baldachin (Italian *baldachino*), fabric cover above a throne or bed and a canopy carried in religious processions. In architecture, a balda-

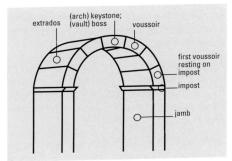

extrados — (arch) keystone; (vault) boss — voussoir

first voussoir resting on impost

impost

jamb

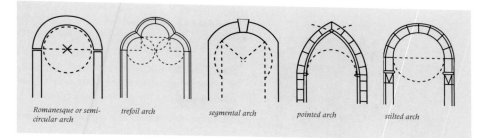

Romanesque or semi-circular arch trefoil arch segmental arch pointed arch stilted arch

chin is a permanent elaborately decorated canopy of timber or stone above a throne, bishop's throne, altar, catafalque, pulpit, or statue. The name refers to the precious silk interwoven with gold thread from Baghdad (Italian *Baldacco*) that was used to make the first canopies in Italy.

Baptistery (Latin and Greek *baptisterion* "bathing place," "swimming pool"), a separate usually octagonal centrally planned church building used for the sacrament of baptism. Baptisteries were often built on the west side of episcopal churches and dedicated to St. John the Baptist.

Baroque (Portuguese *barocco* "small irregular-shaped pearl"), period in European art between the end of Mannerism (ca. 1590) and the beginning of Rococo (ca. 1725). The term originates from the art of the goldsmith and was used to describe an irregular-shaped pearl.

Barrel vault (also tunnel vault) (medieval Latin *tunna* "cask"), simplest type of vault consisting of an elongated or continuous arch with a semi-circular or segmental section.

Basilica (Greek *stoa basilike* "kings' hall"), usually an east-facing church structure with a nave (central aisle), two or four lower aisles on each side, and an apse terminating the nave. A lateral transept may be located between the nave and side aisles and the chancel or choir, the part of the church east of the crossing (area where the nave intersects the transept) which is only accessible to the clergy. The basilica started out as an ancient Greek official building. It later became a Roman market and court building and was finally used as an assembly hall for gatherings of early Christians. The term is derived from the seat of the supreme judge Archon Basileus which was located on the market square in Athens.

Bay, regular structural subdivision of a building, e.g. church. In Classical buildings the bays may be marked by the use of different architectural orders, vaults, roof-trusses, or beams.

Bishop (Greek *episkopos* "overseer," "warden"), elevated ecclesiastical dignitary. In early Christian times, the bishop was the head of a congregation and later, as a successor of the apostles, the church-appointed head of a bishopric, diocese or parish. He is invested

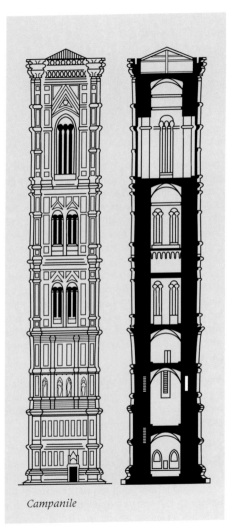

Campanile

with authority to teach, and perform priestly and pastoral duties, and is honored with the miter (tall headdress worn by bishops), bishop's staff, and golden ring.

Bust (French *buste* "picture of bust"), sculpture of the upper chest area, shoulders, and head of a person that generally stands on a pedestal.

Byzantine art, art of the ancient Byzantine Empire. This period started in ca. 330 A.D. when Constantinople (formerly Byzantium, now Istanbul) was dedicated as the capital of the Roman Empire in the East, and ended with the conquest of Constantinople by the Turks in 1453. In addition to being influenced by Greek and Roman antiquity and early Christian art, Byzantine artists also incorporated elements from oriental tradition in their work.

Camaldolites, Benedictine eremitical order founded in ca. 1000 by St. Romuald and named after a hermit colony near Camaldoli in Tuscany.

Campanile (from Italian *campana* "bell"), free-standing church bell tower.

Capital (Latin *capitulum* "small head"), head or topmost member of a column, pilaster, pier, etc. Capitals are distinguished in terms of their decoration, for example stiff-leaf, bud, Gothic crocket, etc.

Capriccio (Italian "mood," "caprice"), in art, the term used to describe compositions consisting of the arbitrary juxtaposition of fantasy or real and imaginary elements. The best-known capriccios include the paintings of Giuseppe Archimboldo (ca. 1527–1593) as well as the *caprichos* of Francisco de Goya (1746–1828).

Caravaggisti, painters who adopted the style of the artist Caravaggio (1571–1610). Their work is specifically characterized by the use of the strong contrast between brightly lit figures and dark backgrounds which was exploited to such effect by the artist himself.

Cardinal virtues (late Latin *cardinalis* "in the hinge"), Plato"s (427–347 B.C.) four basic virtues which were adopted in Christian ethics: *Temperantia* (Temperance), *Fortitudo* (Fortitude), *Prudentia* (Prudence) and *Justitia* (Justice). The three so-called theological virtues of *Fides* (Faith), *Spes* (Hope), and *Caritas* (Charity) were added to these by Gregory the Great (540-604 A.D.). The extension of the Christian system of virtues in the Middle Ages was based on this group of seven virtues.

Carthusian order (Latin *Ordo Cartusiensis*), Catholic eremitical order founded in 1084 by St. Bruno of Cologne (1032–1101) at La Grande Chartreuse near Grenoble. The order is based on a combination of eremitical and community life. In the 14th and 15th centuries, new Carthusian monasteries (monasteries with individual houses) were founded which embraced late medieval mysticism, the *devotio moderna* (new piety) and humanism, the quest for true humanity.

Caryatid (Greek *karyatides*), in architecture a stone carving of a draped female figure which is used as a pillar, column, or other architectural element to support the entablature of a building. The term most likely derives from the girls, specifically the temple dancers, in the Laconian town of Caryae near Sparta. The girls were sent into slavery as a punishment for the treacherous attitude of the village population in the Persian Wars (500–479 B.C.).

Cassone (from Italian *cassa* "large box"), a timber chest that is painted or decorated with inlay or carving. The *cassone* was a traditional wedding gift in the Middle Ages and Renaissance times.

Cathedral Opera (Latin *cathedra* "chair, bishop's throne", *opera* "work", "service"), association of all of the tradesmen, architects, and artists involved in the construction of an Italian cathedral, diocesan church, or main church in a town or city. The aim of setting up this organization

Choir seen from the nave

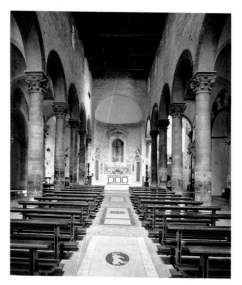

was to ensure consistency and order in the execution of the project.

Cathedral (Greek *cathedra* "bishop's throne"), name given to the principal church of a Catholic see or diocese.

Centaur (Greek *kentauros*), in Greek mythology creatures with the head, arms, and torso of a man and the body and legs of a horse.

Central composition (Latin *centralis*, "[lying] in the center" and *compositio*, from *componere*, "to put together"), focusing of all elements in a painting on a central event.

Central-plan (centrally planned) building, a building plan arranged around a central point as opposed to an axial plan (e.g. basilica). The central-plan building was a popular model in Renaissance architecture based on the example of the Pantheon in Rome.

Chancel (Latin *cancelli* "crossbars"), liturgical eastern part of a church reserved for the clergy and choir and typically separated from the nave by steps or a screen

Chapel (medieval Latin *cappella* "small cape"), small separate building or space for worship in churches. Also small church without the privileges of a parish church built for a specific purpose, e.g. baptism or funeral chapel. The word derives from the name given to a small sanctuary in the Sainte-Chapelle in Paris, in which the cloak of St. Martin of Tours (316/17–397 A.D.) was kept.

Chapter-house, chapter hall (Latin *capitulum* "small head"), room or building in a monastery used for assemblies of the chapter (governing body of a religious community) and usually located in the east wing of the cloister. It was also used for daily readings of chapters from the order rules and holy scripture.

Choir (Latin *chorus* and Greek *choros* "group of dancers and singers"), generally elevated, spatially differentiated area in a church interior which is reserved for common prayer of the clergy or choir singing. The term has been used since Carolingian times to describe the extension of the nave (central aisle) beyond the crossing (area where the nave intersects the transept), including the apse (semi-domed recess) which usually terminates the nave.

Choir rail or screen (Latin *chorus* and Greek *choros* "group of dancers and singers"), the wall, screen, or balustrade which separates the chancel and choir area, which is exclusively reserved for the praying or singing by clergy, from the nave. Often elaborately decorated.

Choir stalls, the rows of benches along the sides of the church choir which were originally reserved for the clergy and usually elaborately carved in wood.

Ciborium (Latin *ciborium* and Greek *kiborion*, "vessel" or "cup"), fixed canopy over a Christian altar, usually supported by four columns, resembling an inverted cup or chalice.

Cinquecento (Italian "five hundred"), Italian for 16th century.

Classicism (French *classique*, Latin *classicus* "exemplary," "first-class"), the artistic period from 1750 and 1840 which adopted Classical

antiquity (5th century B.C. to 4th century A.D.) as its model.

Clerestory (middle English "clear" + "story"), the upper part of the walls of the nave, choir, and transepts of a church, rising higher than the lean-to roofs of the aisles and pierced with windows to allow light to penetrate.

Codex (Latin *codex* "block of wood split into leaves or tablets for writing on"), collection of statutes or rules. Also ancient manuscript text in book form.

Column, load-bearing tapering structural element, usually circular in plan, which may be divided into a base (bottom), shaft (middle), and capital (top). Most names given to column types refer to the type of shaft, e.g. monolithic (made of one piece of stone), drum (constructed using drum-shaped sections of stone) or fluted (with vertical channels).

Compagnia (Italian "confraternity"), Catholic associations founded in early medieval times for the purpose of common prayer. Members were initially recruited only from the ranks of the monks and clergy but later also included lay people. The aim of the confraternities was to promote piety and charity.

Condottiere (Italian for leader), mercenary or military leader in 14th- and 15th-century Italy.

Confraternity, Catholic association founded in early medieval times for the purpose of common prayer. Members were initially recruited only from the ranks of the monks and the clergy but later also included lay people. The aim of the confraternities was to promote piety and charity.

Contrapposto, counterpoise (Latin *contrapositus* "opposite"), in figure sculpture, an asymmetrical standing pose in which the different movements of the human body are brought into a harmonious unity. The balancing of the weighing and supporting, still and dynamic forces in a figure are expressed in the engaged and standing legs. The *contrapposto* originates in ancient Greek sculpture and was a particularly popular feature in Renaissance sculpture.

Console (French *console*, derived from Latin *solidus* "solid"), molded or decorated horizontal element projecting from a wall as a support for an arch, cornice (horizontal molded projection), balcony, or statue.

Corbel, projection from the face of a wall that supports a structure above it, e.g. arch, beam, truss.

Entablature

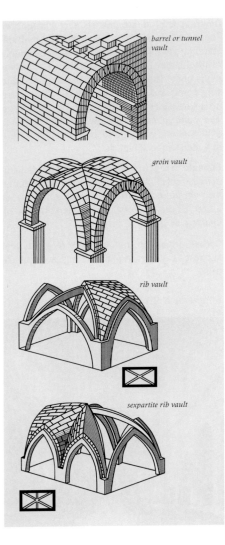

barrel or tunnel vault

groin vault

rib vault

sexpartite rib vault

Corinthian column, like the Ionic column, the Corinthian column consists of a supportive element with an Attic base, a slim shaft with flutes separated by fillets. However, its capital and abacus (top plate) are decorated with acanthus leaves, the characteristic decoration of the Corinthian order (classical Greek architectural system).

Council (Latin *concilium* "convocation," "assembly"), gathering of church dignitaries, mainly bishops.

Courtesan (from French *courtisane* and Italian *cortigiana*, feminine of *courtigiano* "courtier" derived from Italian *corte* "[royal] court"), a prostitute with wealthy or upper-class clients, lover of upper-class, aristocratic men.

Crossing, the area where the nave and transepts in a church intersect.

Crypt (Latin *crypta* and Greek *krypte* "covered corridor," "vault"), underground room or vault used as a chapel or burial place. The crypt is usually located under the church choir, the area of the church reserved for the clergy.

Cupola, dome (late Latin *cup(p)ola* "[upturned] small cask"), ceiling or roof form, vault on a circular, polygonal, or rectangular plan. The transition from the square plan to the circular cupola plan can be executed in the following ways: 1. by means of a sail dome, whereby the base of the dome circumscribes the square plan; 2. by means of pendentives, curved, almost triangular spandrels rising up from the four supporting piers to the circular or elliptical base of the drum or cupola; 3. by means of a hemi-

spherical dome, which is like a sail dome but is used when the space to be domed is smaller than the square plan.

Cycle (late Latin *cyclus* and Greek *kuklos* "circle"), in visual art a series of thematically related works.

Devotional picture, usually small image or piece used by an individual or group for private devotion.

Diptych (Latin *diptychum*, Greek *diptychos* "double-fold"), in Classical antiquity, the term used to describe a writing tablet. In medieval art, a painted or sculpted altarpiece consisting of two hinged panels without a secured central panel.

Disegno (Italian "drawing"), literally drawing, sketch, or draft. During the Renaissance, *disegno* became the subject of a comprehensive debate on the theory of art and was generally deemed to encompass *inter alia* the area of presentation of the artistic idea and the main design principles in the translation of a creative impulse (Vasari).

Dome, see Cupola

Dominican order (Latin *Ordo Fratum Praedicatorum* "order of preaching brothers"), order founded by St. Dominic (1170–1221) in Toulouse in 1216 which is dedicated to the spreading and defense of the faith through preaching and teaching. In 1232, the Dominicans were appointed by the Pope to carry out the Inquisition, the church tribunal established for the suppression of heresy.

Doric column, vertical member designed on the basis of the Doric classical order (Greek architectural system) which has no base, sharp arrises (edges), a fluted shaft, and a plain capital consisting of annulets (rings), an echinus (cushion-like molding), and square abacus (flat slab on top of a capital).

Dormitory (Latin *dormitorium* from *dormire* " to sleep"), sleeping quarters in convents and monasteries with the monks' and nuns' cells.

Drapery (from French *draperie* "cloth"), the

Gold background

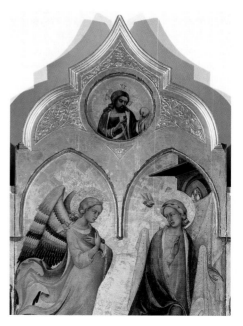

artistic arrangement of fabric or clothing in a sculpture or painting.

Drum, tambour (Arabic *tanbur* "drum"), cylindrical architectural element that carries a dome or cupola. It is usually pierced with windows and is used to raise the height of the space.

Duecento (Italian "two hundred"), Italian for the 13th century.

Duomo (Latin *domus Dei* "house of God"), i.e. cathedral, also known as a minster. The church containing the cathedra or seat of a bishop, therefore the principal church of the see or diocese.

Ecce homo (Latin exclamation "Behold the man!"), Pilate"s exclamation from the Gospel of St. John (19, 5) as he presents the scourged Jesus wearing a crown of thorns to the crowd. The scene of the presentation of Christ has been a popular subject in the visual arts.

Eclecticism (from Greek *eklegein* "select"), the practice of selecting different styles, characteristics, and features from various artists or periods and combining them. Although the term can be used neutrally, it has negative connotations and suggests a lack of originality.

Encyclopedia (from the Greek *enkyklios* "run in a circle", and *paideia* "education"), the term used since the 16th century for comprehensive systematic collections or representations of general bodies of knowledge (and also knowledge of a specific area) in the form of a lexicon.

Engaged, in architecture an element, e.g. column, pier, that is attached, inserted, or partly buried in a wall.

Ensemble (from the French "together," "association"), in visual art, a group of related works of different genres or works created using different techniques, e.g. chapel decoration.

Entablature, in the classical orders, the horizontal material carried on columns and pilasters consisting of the architrave (load-bearing lintel spanning between the columns), the frieze (horizontal central band) and the cornice (uppermost division in column order, crowning projecting molded horizontal top of a building or wall).

Este, one of the oldest Italian dynasty of princes (A.D. 972–1803) with seats in Ferrara, Modena, and Reggio. Isabella d'Este (1474-1539) from Naples, Duchess of Mantua from 1490, was the first major art collector.

Excommunication (Latin *excommunicatio*), expulsion from the church and hence from services and sacraments.

Exhedra (Greek "outdoor, concealed seat"; plural exhedrae), niche with a bench at the end of a colonnade, or column-lined walk. The term is also used to describe the apse, the altar niche at the top of the choir area reserved for the clergy, or any other semi-circular niche.

Fascia (plural "fasciae"), projecting bands on a classical architrave, often separated by enriched moldings.

Fathers of the Church (Latin *patres ecclesiae*), early Christian theologians whose writings are deemed authoritative for the Christian faith and church ethics. The four Roman Fathers of the Church are: St. Ambrose, St. Augustine, St. Jerome, and Gregory the Great.

Figura serpentinata (Italian "snake-formed twisted figure"), a spiral, twisted, upward-thrusting figure or group of figures. Especially in 16th-century sculpture (Mannerism), the *figura serpentinata* allowed the closest possible realization of the ideal of the perfectly rounded sculpture.

Faience (French *faience*, from Faïence, the French name for Faenza), colorful glazed earthenware, named after the Italian town of Faenza which has been famous for this pottery since the 16th century.

Finish, surface appearance of a work of art, such as painting or sculpture, or another object, such as a sheet of paper or a piece of furniture, e.g. glossy finish, rough finish, smooth finish, or matte finish.

Florin (Italian *florino d'oro* "little gold flower"), 13th-century Florentine gold coin which bears the city"s lily coat-of-arms.

Flute, vertical, concave channel in a column shaft, pier, or pilaster. Flutes can meet in sharp crease-like edges or be separated by fillets.

Franciscan order (Latin *Ordo Fratrum Minorum* "Order of Minor Brothers"), mendicant order founded by St. Francis of Assisi (1181/2–1226) in 1209 (1223) which is particularly dedicated to asceticism and poverty. The most ardent venerators of the Virgin Mary in the Middle Ages, the Franciscans place their order under the protection of the Mother of God.

Fresco (Italian *fresco* "fresh"), wall painting which is painted on the final layer of lime plaster before it dries.

Capital

Fresco painting (Italian *fresco*), wall painting technique whereby the paint is applied to the final layer of lime plaster before it dries. As the plaster dries very quickly, only small parts of the wall can be plastered which the artist can paint in one day. This is known as the *giornate*, i.e. literally "day." Compared with *secco* painting, which is executed on dry plaster, frescos are extremely durable in favorable climatic conditions.

Frieze (medieval Latin *frisium* "fringe," "tip"), painted or sculpted continuous strip-like horizontal wall decoration which is used to decorate, articulate, or enliven a wall surface.

Genesis (from the Greek meaning "creation," "origin"), story of creation, Old Testament

account of the creation of the world and man by God (Book of Genesis 1 and 2).

Ghibellines, in Florence from 1212 to 1218, the supporters of the Hohenstaufen Emperor Frederick II (1194–1250). In the power struggle between papal and secular authority, the Ghibellines were the bitter opponents of the Guelphs who supported Otto IV (1198–1218) and the Pope. Their opposition lasted beyond the rule of the Hohenstaufen right up to the 16th century.

Glory (Latin *gloria* "glory," "heavenly majesty"), also aureole, halo which generally surrounds the entire body in images of God, the Holy Ghost, and Mary.

Gold background, a background partly or completely covered in gilt or gold leaf.

Gonfaloniere (Italian "standard bearer"), most senior official in medieval and early modern Italian towns and cities.

Golden Legend, The (Latin *Legenda aurea*), collection of saints' lives written in the 13th century by the Dominican monk Jacobus de Voragine (1228/29–1298). A particularly important textual source for Christian art since the Middle Ages.

Gothic (Italian *gotico* "of or relating to the Goths," "not Classical"), the style of architecture prevalent in western Europe in the Middle Ages. It originated in northern France in the 11th century and ended there in ca. 1400 but endured in other countries until the early 16th century. The term is derived from the name of the Germanic tribe of the Goths. The specific features of this style include the introduction of the pointed arch (with pointed vetex), the rib vault (formed by the right-angled intersection of two tunnel vaults of equal size), and the transfer of buttressing to the building exterior so that arches and piers support the vaulting and roof as well as the walls. The general appearance of Gothic buildings is characterized by soaring verticality and the extensive piercing and opening of wall surfaces. The main building associated with Gothic architecture is the cathedral. The style is also closely associated with a style of sculpture characterized by an idealized natural attitude. The interplay of bodies and clothing – generally presented in exaggerated elongated proportions – is a main focus in Gothic artistic expression. Painting during this period was mainly executed on panels and glass.

Greek cross (Latin *crux*), cross with four arms of equal length. The preferred plan for Byzantine religious buildings.

Grisaille (from French *gris* "gray," and *grisailler*, "to paint gray"), monochrome painting which consciously rejects the use of color in favor of shades of stone tints, brown, and gray. It is particularly suited to the imitation of sculptural work in painting.

Guelphs (Italian "Guelfi"), in Florence from 1212 to 1218, supporters of Otto IV (1198–1218) and the Pope. In the power struggle between the papal and secular authority, the Guelphs were the bitter opponents of the Ghibellines who supported the Hohenstaufen Frederick II (1194–1250). Their enmity lasted right up to the 16th century.

Guild (Germanic origin, Middle Dutch *gilde*, "pay," "repay," related to "yield"), medieval

Hall church (Greek *kyriakon* "that which belongs to the Lord"), a church whose nave and aisles are of the same height and have one roof, i.e. with no clerestory. Hall churches do not usually have a transept. They are a common feature in German Gothic architecture.

Humanism (from Latin *humanus* "human"), an outlook originating in mid-14th-century Italy which, as a reflection of the revived interest in ancient Greek and Roman thought, turned away from medieval scholasticism and attached prime importance to human existence. As the characteristic intellectual movement of the Renaissance period, the main feature of humanism is the emancipation of man from God. It also inspired a new quest for intellectual and natural insights firmly rooted in this world as opposed to the next. The Renaissance humanists were particularly interested in the rediscovery and promotion of Greek and Latin languages and literature. In modern usage, the term still refers to an ideal marriage of an education based on a knowledge of the classics and the adoption of human values that are firmly rooted in reality.

Hydra, in Greek mythology, a nine-headed water snake. As two new heads grew for each one cut off, Hydra was deemed invincible but was finally overcome by Hercules and his companion Iolaos.

Iconography (from the Greek *eikon* "picture" and *graphein* "writing"), the study of the content, meaning, and symbolism of visual art, particularly in Christian art; originally the study of Classical portraits.

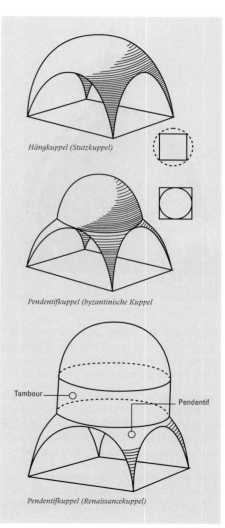

Hängkuppel (Stutzkuppel)

Pendentifkuppel (byzantinische Kuppel

Tambour — Pendentif

Pendentifkuppel (Renaissancekuppel)

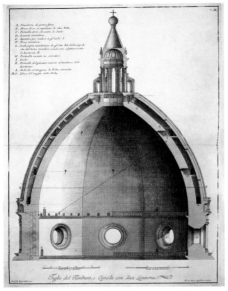

Dome drum and lantern

Illusionism (from the Latin *illusio* "irony," "mockery," "deception"), the use of pictorial and perspective techniques to create the illusion of three-dimensional reality in a work of art.

Incunabulum, pl. incunabula (from the Latin *incunabula* "cradle," "birthplace," "beginning"), an early printed book, especially one printed before 1500; works created during the earliest stages in the development of an art form or technique.

Inlaid work, inlay, the decoration of wall and floor surfaces with colored polished stone slabs – usually marble or porphyry – laid in patterns to articulate and enliven the surface.

Intarsia (from the Italian *intarsiare* "to apply inlaid work" and Arabic *tarsi* "laying," "placing"), inlaid work in wood, also ivory, mother-of-pearl, tortoise shell, and metal. The pattern is either carved into the wood and filled with another material or formed from small individual parts and applied to the surface.

Interior, artistic representation of the inside of a building or room.

Intrados, inner curve or underside of an arch, coincides with the soffit of the arch.

Ionic column, supportive element with an Attic base, a slim shaft with flutes separated by fillets, an ornamented egg-and-dart capital, volutes (spiral scrolls), and an abacus (upper member) which is of the Ionic order (Classical Greek architectural system).

Knights Hospitallers, various orders of the same origin, e.g. Knights of St. John, Knights of Rhodes, Knights of Malta. The earliest of the holy orders of knights which was founded in 1060 as part of a hospital in Jerusalem.

Lantern (Latin *la(n)terna* and Greek *lamptera* "lamp," "light"), a circular or polygonal structure pierced with windows rising above a dome or vault.

Latin cross (Latin *crux*), a cross in which the vertical part below the horizontal is longer than the other three parts. The most popular plan in medieval western churches.

Linear perspective (from medieval Latin *perspectiva (ars)* "science of optics"), representation of three-dimensional objects on a flat picture sur-

face. Filippo Brunelleschi (1376–1446) developed a scientific and mathematical method of perspectivist representation in the early 15th century. For the observer, all parallel lines converge on a central vanishing point. A three-dimensional illusion is conveyed on the two-dimensional picture surface by means of the precise foreshortening and proportioning of the depicted objects, landscapes, figures, and buildings.

Liturgy (Greek *leitourgia* "public service," "worship of the gods"), in the Roman Catholic and Orthodox churches, the form according to which public religious worship is conducted.

Loggia (Italian), open roofed structure supported by pillars or piers, i.e. a gallery, arcade, or colonnade.

Lunette (French "a small moon"), semicircular aperture bounded by an arch or vault above a door or window, usually elaborately decorated.

Maestà (Italian "majesty"), name given to religious painting of the enthroned Virgin and Child, surrounded by angels and saints. This motif is mainly found in 13th- and 14th-century Italian painting.

Maiolica (also known as majolica), Italian name for the white-glazed painted ceramics (fired clay). The Italian term is derived from the name of the island of Mallorca, where it was initially traded.

Mandorla (Italian "almond," also known as *vesica piscis* "fish's bladder"), almond-shaped aura of light surrounding the entire figure of Christ and Mary, often executed in the colors of the rainbow or blue, red, green and yellow. The almond-shaped halo is part of Christian light symbolism and is a reference to the incarnation of Christ and the virginity of Mary. In architecture, a mandorla is a pointed oval figure.

Mannerism (from French *manière* "manner," "way," derived from Latin *manuarius* "of the hand"), period in art between the Renaissance and Baroque, ca. 1520–1620. In Mannerism, the harmonious ideal forms, proportions, and compositions developed during the Renaissance were abandoned. Its most typical features in painting are an exceedingly dynamic style, the

Lunette above door with crossette

Medallion

elongation of the human body and its depiction in anatomically contradictory poses, a heightened complexity of composition, irrational and highly theatrical use of light, and the abandonment of strict association of color with objects.

Manuscript (Latin *manu scriptus* "written by hand"), hand-written book from antiquity or medieval times.

Martyr (Latin *martyrium*, Greek *martyrion*, "witness," "proof"), person killed or tortured because of religious or other beliefs.

Massacre of the Innocents, the murder of all boys of up to two years of age ordered by Herod the Great of Bethlehem out of fear of the newly born King of the Jews, Jesus Christ (Matthew 2, 16–18).

Medallion (French *médaillon*, "large medal"), painting or relief (carved, molded, or stamped depiction on a flat surface), in a circular or elliptical frame.

Medici, aristocratic family which ruled Florence from 1434 to 1737 and Tuscany from 1569 with short interruptions. One of the most influential members of the family was Lorenzo I, *Il Magnifico* ("the Magnificent") (1469–1492), who was an avid supporter of the arts and sciences and brought together leading humanists at the Platonic Academy in Florence. His son, Giovanni de' Medici (1475 to 1521), ruled from 1513–1521 as Pope Leo X in Rome.

Mendicant orders (from Latin *mendicare* "to beg"), religious orders based an ascetic lifestyle committed to the rejection of all property, which emerged in the 13th century in response to the secularization of the church. These orders are particularly concerned with the spiritual ministry, teaching, and missionary work. The mendicant orders include the Franciscans, Capuchins, Dominicans, Augustinians, and Carmelites.

Monochrome (from Greek *monos* "alone," "single," and *chroma* "color"), use of one color in a work of art. Opposite of polychrome "multicolored."

Monolith (from Greek *monos* "alone," "single," and *lithos* "stone"), in architecture, any element of a building made of one piece of stone (for example, column, pier, or dome plate). In sculpture, a monumental work carved from a single block of stone (e.g. obelisk).

Mosaic (from Greek *mousa* "muse," "art"),

decoration of a wall, dome, or floor with an image or decorative pattern made by setting small fragments of marble, glass, or ceramic materials into cement or plaster.

Naturalism, a style in the visual arts and literature which attempts to render subjects as accurately, objectively, and realistically as possible.

Nave, in churches with clearly identifiable longitudinal plans, the section between the western wall (façade) and crossing (intersection of nave and transept) and the chancel or choir, the liturgical eastern end of the church which is only accessible to the clergy. In hall churches and basilicas, the nave is flanked by side aisles.

Niche (from French), a semi-circular, rectangular, or polygonal covered recess in a wall or pier.

Noli me tangere (Latin "touch me not"), the comment addressed by the resurrected Christ to Mary Magdalene who initially does not recognize him, mistaking him for a gardener when she meets him at the graveside on Easter morning (St. John 20, 14–18). In religious art, elaborate portrayals of this event were created as early as the 4th century.

Non finito (Italian "unfinished," "incomplete"), the deliberate failure to finish a work of art as a means of heightening its expression.

Novitiate (from Latin *novicius* "novice"), period or state of being a novice, particularly in a religious order.

Obelisk (Latin *obeliscus* and Greek *obeliskos* "pointed pillar"), high – often monolithic – stone shaft on a square plan, tapering upwards and

pier *pilaster*

usually crowned with a small pyramid. Originally an ancient Egyptian symbol of the sun god, it has been adopted as a monumental and decorative form since the Renaissance.

Octagon (from Greek *okto* "eight" and *gonia* "corner"), an ancient eastern and Classical symbol for the perfection of the cosmos. In architecture, a building on a central plan with eight equal sides.

Oeuvre (French "work"), the complete work of an individual artist.

Order, any of the Classical styles of architecture based on the proportions and decoration of post-and-lintel systems comprising the column, capital, architrave (main load-bearing horizontal member), and cornice (horizontal projecting wall strip). The Doric, Ionic, and Corinthian orders originate from Greek architecture. These were adopted by the Romans who adapted the Doric

cross-plan pier *round pier*

version to form the very simple Tuscan order and combined features of the Ionic and Corinthian to form the highly ornate Composite order.

Palazzo (Italian "palace"), richly decorated and generously proportioned residence.

Panel painting, a small format painting executed on a rigid support of wood or copper. Panel paintings were developed in the 12th century and were very popular until the advent of canvas in the 16th century.

Pantheon (Latin *pantheum* and Greek *pantheion* "temple of all gods"), Classical religious building with wide-spanning cupola and octastyle (eight-column) portico. The Pantheon was built in A.D. 115-125 in Rome by Emperor Hadrian (A.D. 76–138) as a temple dedicated to all of the gods. It was consecrated as a Christian church in A.D. 609. Since the Renaissance, it has been used as the burial place of outstanding citizens of the city.

Pedestal, socle or substructure of a pier, column, or statue.

Pediment, top part of the wall of a building, closing the end of a pitched roof. Also an element crowning a door, window, or niche. Pediments can be triangular or segmental (with curved top) and can be broken or open, with a gap at the bottom or top respectively. They are characteristics of Classical, Rennaissance, and Baroque architecture. The enclosed surface, the tympanum, is often elaborately decorated.

Pendant (French "hanging"), work of art created to complement or match another.

Pendentive (from French *pendentif* "hanging down") curved, almost triangular spandrels rising up from the four supporting piers to the circular or elliptical base of the drum or cupola.

Personification (from Latin *persona* "human being" and *facere* "to make"), attribution of human characteristics to gods, concepts, or objects.

Perspective (from medieval Latin *perspectiva (ars)* "science of optics"), representation of three-dimensional objects on a flat picture surface. Objects and figures are represented as far as possible in accordance with the optical conditions under which they would appear to an observer in reality.

Physiognomy (*from Greek physis* "nature and *gnonai* "recognize"), external appearance of a person, particularly the face.

Pier (from Latin *pila* "pillar"), vertical support with square, rectangular, or polygonal cross-

section. It can be subdivided into a base (bottom), shaft (middle), and capital (top). Depending on the position and form, it is possible to make a distinction between free-standing, engaged, and corner piers and pier buttresses (pier on the exterior of a building which resists the thrust of a flying buttress).

Pietà (Italian "pity," "sympathy" from Latin *pietas* "piety"), a picture or sculpture of the Virgin mourning the body of Christ on her lap or in her arms.

Pilaster (Italian *pilastro*; from Latin *pila* "pillar"), rectangular, only slightly projecting vertical wall element with a base (bottom), shaft (middle), and capital (top) which articulates a wall surface and sometimes provides additional support. It is often fluted, i.e. with vertical channels.

Pointed arch, characteristic element of vertical emphasis in Gothic architecture. Unlike the semicircular Romanesque arch, the pointed arch is produced by two curves meeting in a point at the top.

Polychrome (Greek *poly* "many" and *chroma* "color"), multi-colored. The opposite of monochrome (single color).

Pontificate (Latin *pontificatus* "the dignity of the senior priest"), the office of a pope or bishop in the Roman Catholic church.

Porch, covered entrance attached to a building and projecting in front of it.

Portal (medieval Latin *portale* "like a gate"), decorated monumental entrance to a building. The model for the portal in western architecture is the Roman triumphal arch, a free-standing gate structure erected to honor a military commander.

Portico (Latin *porticus* "porch"), structure consisting of a roof supported by columns at regular intervals, typically attached as a porch to a building and often crowned with a gable or pediment.

Predella (Italian "pedestal," "foot bench"), pedestal-like substructure of a winged altarpiece which also serves for the storage of relics (part of a deceased holy person's body or belongings kept as an object of reverence) and is often elaborately decorated.

Presbytery (Greek *presbyterion* "elder"), elevated east end of a church at the top of the nave where the main altar is located, also known as the sanctuary.

Prologue (Greek *prologus* "before saying"), introduction or foreword to a literary work.

Relief

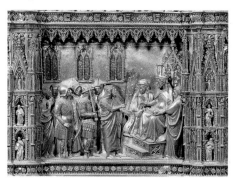

Proportion (Latin *proportio* "share"), in painting, sculpture, and architecture, the relationship of individual elements to each other and to the whole. The main sets of rules of proportion are:

1. The canon, based on the relationships of the parts of the human body and ratio of each part to the whole mass and form, the ratio of the head to the body is generally defined as 1:7 or 1:10;

2. The Golden Section (Latin *sectio aurea*) whereby a line (A) is divided into a smaller part (C) and bigger part (B) giving A:B equal to B:C;

3. Quadrature (medieval Italian *quadratura* "squaring") whereby the square is the basic form;

4. Triangulation, whereby an equilateral triangle (Latin *tri* "three," and *angulus* "angle," "corner") is used as a basis for the definition of important points in a structure; 5. Harmonic proportion, where the ratio between string length and oscillation as calculated for musical intervals is transferred to architectural proportions, e.g. the octave = 1:2; fifth = 2:3, and fourth = 3:4.

Putto (Italian "small child," "little boy," from Latin *putus* "boy"), figure of a (generally naked) child angel.

Quatrefoil (Old French *quatre* "four," and *foil* "leaf), decorative motif from Gothic art which consists of four equal-sized lobes or leaves and resembles a flower or clover leaf.

Quattrocento (Italian "four hundred"), Italian for the 15th century.

Radiography (from Latin *radius* "beam," and Greek *graphien* "write," "draw"), x-ray test. In painting, scientific method for analyzing paintings used specifically to reveal over-paintings and additions.

Refectory (medieval Latin *refectorium* from Latin *reficere* "to restore"), dining room in a convent or monastery.

Register (medieval Latin *registrum*, *regerere* "to record," "to enter"), list, index: in painting, one section portraying an individual event in a sequence of related incidents, such as for example the legends surrounding a saint.

Relic (from Latin *reliquiae* "remainder," "left-behind"), part of a deceased holy person's body or belongings kept as an object of reverence.

Relief (French, from Latin *relevare* "to raise"), a carved, molded, or stamped depiction on a flat surface. Depending on the depth and prominence of the carving, molding, etc. referred to as low, half, and high relief.

Reliquary (from Latin *reliquiae* "remainder," "left-behind"), usually decorated container for relics, objects, or body parts of a saint.

Renaissance (French, Italian *rinascimento* "rebirth"), the cultural process that started in Italy and took place during the 15th and 16th centuries. The late phase from 1530 to 1600 is also known as Mannerism. The term originates from the concept *rinascita* (rebirth) coined in 1550 by Giorgio Vasari (1511–1574) and initially referred to a movement away from medieval art to the models of Classical antiquity. The key motif of the *uomo universalis*, the intellectual and physical all-round developed person, emerged through humanism, which – in

reference to the model of Classical antiquity — promoted the creation of a new image of man, nature, and the world that was focused on the here and now. Thus, the visual arts were elevated from the level of mere trade to that of the liberal arts: artists enjoyed unprecedented prestige and social status and developed greater self-confidence. Art and science were directly linked and made to interact, as demonstrated, for example, in the discovery of mathematically calculable laws of perspective or anatomical insights. Architecture looked back to the theories of Vitruvius (ca. 84 B.C.) and was mainly characterized by the use of antique architectural features and the development of palace and castle architecture. The central-plan building was one of the typical elements of Renaissance architecture.

Replica (French *réplique* "reply," "repeat," "imitate"), an exact copy of a work of art executed by the artist or his studio.

Repoussoir (from French *repousser* "to push back"), the placing of figures or objects at the front of a picture, e.g. tree trunks or architectural fragments, to create an illusion of spatial depth. These partially introduce the main event represented in the background.

Reredos (Old French *areredos*, from *arere*, "behind" and *dos* "back"), ornamental facing or screen behind an altar, free-standing or forming part of the retable. The triptych is a medieval form of reredos.

Retable (French *rétable*; Latin *retrotabulum* "rear table"), screen to the rear of an altar, rising up behind it, often richly decorated and carved.

The retable includes the reredos. Also a shelf or ornamental setting for panels behind an altar.

Rilievo schiacciato (Italian, literally crushed, flattened relief), the name of the technique developed by Donatello (1386–1466) for the use of special artistic effects to achieve distance and perspective by optical suggestion rather than sculptural projection.

Romanesque (from Latin *Romanus* "Roman"), a term coined in the first third of the 19th century in France for early medieval architecture (arches, piers, columns, vaults) which was derived from the repertoire of forms in ancient Roman architecture. It covers the period from ca. 1000 (in France; in Germany, from the mid-11th century) up to the mid-13th century. In central France it was replaced by the early Gothic style in the mid-12th century. Individual versions and features were developed in many countries. In England the style is usually called Norman. The Romanesque period was particularly fertile in Burgundy, Normandy, north Italy, and Tuscany. The church was the main focus in architecture and Romanesque churches are characterized by the addition of individual sculpturally formed elements and the lively interaction between cylindrical and cubic forms.

Roof cornice, projecting molded horizontal strip between the wall and the roof.

Rotunda (Italian *rotonda*, "round"), building shaped like a cylinder with a central, circular plan. Also a cylindrical room within a building.

Rustication (Latin *rusticus* "the country," "rural"), masonry constructed using stones

Still life

whose faces have been roughened to form a contrast with dressed ashlar (finished stone).

Sacra Conversazione (Italian "holy conversation"), representation of the Virgin and several saints. The term is misleading as although the figures are united in a single group they are not portrayed in conversation.

Sacristy (medieval Latin *sacristia* based on Latin *sacer* "sacred"), room in a church where a priest dresses and prepares for service and where vestments and other items used in worship are kept.

Sarcophagus (Greek *sarkophagos* "flesh-consuming"), richly decorated timber, metal, pottery, or stone coffin.

Satyr, in Greek mythology lustful, lascivious creatures in the form of men with animal characteristics who were followers of Dionysus.

Schism (Greek *skhisma* "cleft"), the formal separation of a church into two churches or secession of a group owing to doctrinal and other differences. The period between 1378–1417 when the western church was divided by the reign of two popes in Rome and Avignon is known as the Great Western Schism.

Scholasticism (from Latin *scholasticus* "belonging to school"), medieval system of theology and philosophy based on Aristotelian logic, the dogmatic exegesis of Holy Scripture and the writings of early Christian Fathers.

Scorcio (Italian "foreshortening"), in painting and graphics an extreme perspectivist reduction of a depicted object.

Secular building/architecture, building used for worldly, non-religious purposes. The opposite of religious building/architecture.

Sepulchre, elaborate, often independent structure for the interment of a human corpse, for example funerary chapel, mausoleum. Many elaborate tombs and monuments can be found in churches and cloisters.

Sforza, aristocratic Italian family who, as Dukes of Milan, ruled large parts of Lombardy from 1450 to 1535

Sfumato, (from Italian *sfumare* "to cover in smoke"), painting technique generally ascribed to Leonardo da Vinci (1452–1519) whereby tones and colors are allowed to shade gradually into one another, producing softened outlines or hazy forms.

Sibyl (Greek *sibulla* "prophetess"), a woman in ancient times who could predict the future and who is said to have predicted the birth, passion, and resurrection of Christ. Classical texts originally refer to one sibyl and then ten. In early Christianity, the number was extended to twelve, on the model of the twelve prophets of the Old Testament.

Signoria (Italian "lordship"), from the late Middle Ages, the ruling council or government in Italian towns and cities. Usually presided over by a single family, e.g. the Medici.

Sinopia (sinope, sinaper, or sinopis) (Italian "reddish-brown earth"), the original to scale drawing for a fresco, a wall painting applied on wet plaster. The term is derived from the Syrian town of Sinope on the Black Sea where the reddish-brown earth was obtained.

Socle (Italian *zoccolo* and Latin *socculus* "wooden/small shoe"), in architecture, an unadorned block or plinth that projects at the bottom of a column or structure. Also the base course of a wall.

Sopraporta (Italian "above the door), decorative area above a door, sometimes containing a panel with a painting or relief.

Spandrel, triangular space between one side of the outer curve or an arch, a wall, and the ceiling or framework. Pendentives are curved, almost triangular spandrels rising up from the four sup-

Tondo

porting piers to the circular or elliptical base of the drum or cupola.

St. Luke's Guild, religious association of artists and artisans originating in the Middle Ages and named after their patron saint St. Luke.

Stalactite (Greek *stalaktos* "dripping"), tapering structure hanging from the roof of a cave formed of calcium salts deposited by dripping water. Opposite of stalagmite, a similar structure rising from the floor.

Stigmatization (from Greek *stigma* "mark," "dot," "burn wound"), in the Catholic faith the appearance of the stigmata, the five marks left on Christ's body by the Crucifixion, on the Virgin Mary, saints, or other persons.

Still life (from Dutch *still-leven*), also known as *nature morte* (French) and *natura morta* (Italian), visual representation of artistically arranged inanimate objects, e.g. flowers, fruit, books, vessels, and dead animals. It emerged as an independent genre in the 14th century and reached its zenith in 17th-century Dutch painting.

String course, horizontal projecting band or molding on a wall or façade that delineates the horizontal zones.

Tabernacle (Latin *tabernaculum* "small tent," "small hut"), in architecture, a canopied niche in a church containing an image or statue. Also a cupboard with doors containing the consecrated Host on an altar.

Tambour, also drum (Arabic *tanbur* "drum"), cylindrical architectural element that carries a dome or cupola. It is usually pierced with windows and is used to raise the height of the space.

Tectonic (Greek *tecktonikos* from *tekton* "carpenter," "builder"), of or relating to building or construction.

Tempera (Italian from Latin *temperare* "to mix," "combine"), a painting technique, replaced by oil painting from the 15th century but rediscovered towards the end of the 19th century, that uses colors whose pigments (colored powder) are mixed with a binder made from egg, gum, or casein (the main protein present in milk). Once applied to the underpainting, the tempera color dries very quickly, and so cannot be used for wet-into-wet painting. Hence, nuances of color and atmosphere have to be executed by means of multiple layers of simultaneously applied strokes. Color differences between the wet and dry tempera make it very difficult to chieve the same tone in overpainting.

Terracotta (Italian, from Latin *terra* "earth" and Italian *cotta* "cooked" or "baked"), fired unglazed pottery widely used since ancient times as a material for architectural elements and in the decorative arts, including reliefs and small sculptures. Terracotta was a popular material used to create bust sculptures in the 19th century (Auguste Rodin).

Toga (Latin *tegere* "to cover"), a loose flowing outer garment worn by citizens in the ancient city of Rome.

Tondo (Italian "round object"), circular painting or relief.

Topography (from Greek *topos* "place" and *graphia* "written"), description of a geographical location with precise indication of all details.

Torso (Italian, literally "stalk" or "stump"), originally an unfinished or mutilated antique statue. Since the 16th century, the torso also exists as a sculptural figure deliberately created without a head or limbs.

Trefoil, decorative motif from Gothic art which consists of three-lobed, clover-shaped leaf pattern.

Trinity (Latin *trinitas* "group of three"), a group of three persons or things. In the Christian faith, the doctrine whereby God is considered as existing in the three persons of God the Father, God the Son, and the Holy Spirit.

Triptych (Greek *triptychos* "three-layered," "triple"), a picture or relief carving on three panels, particularly a medieval altarpiece consisting of a center panel and two lateral hinged panels.

Triumphal arch (Latin *triumphus* "victory procession"), since the second century B.C. a type of formal gateway consisting of a single arch or a large arch flanked by two smaller and lower arches and built in honor of an emperor or commander.

Tympan, tympanum (Greek *tumpanon* "drum"), area above a portal between lintel and arch, triangular or segmental space forming the center of a gable pediment.

uomo universale (Italian), the all-round intellectually and physically talented man who was the cultural icon of the Renaissance.

Vanishing point, in linear perspective, the central point at which parallel lines converge in an image.

Vault, ceiling over a space constructed using wedge-shaped stones. Unlike a dome, it is also used to cover rectangular spaces. The thrust and shear of the vault is deflected by the abutments, e.g. walls or piers.

veduta, (Italian "view," "panorama"), genre in landscape painting which reproduces a landscape, town or cityscape with maximum verisimilitude. In contrast, a *veduta ideata* (i.e. ideal *veduta*) is a painting of an imaginary city or landscape.

Volute (Latin *voluta* from *volvere* "to roll"), spiral scrolling ornament and architectural element. It is mainly found on capitals, particularly on Ionic columns, and pediments and is also used to link horizontal and vertical elements.

Veduta

Biographies of the artists

Alberti, Leon Battista (1404 Genoa or Venice – 1472 Rome). Battista personified the concept of the *uomo universale*, the universally talented humanist scholar. He lived from 1432 to 1434 in Rome and afterwards in Bologna, Mantua and Ferrara. From 1443 he was mainly resident in Rome. Alberti was active as an adviser to the wealthy princely houses of Italy; he was the architect of the Palazzo Ruccellai and the façade of S. Maria Novella in Florence, as well as of S. Andrea in Mantua. The best known of his writings are *Ten Books on Architecture*, which established his reputation as the most important aesthetic theorist of the 15th century.

Ammanati, Bartolomeo (1511 Settignano near Florence – 1592 Florence). Ammanati was trained as a sculptor by Baccio Bandinelli and Jacopo Sansovino in Venice. He then returned to Florence where – apart from sojourns in Venice, Padua, Rome, Pisa and Naples – he lived until his death. A Mannerist sculptor in the style of Michelangelo, he mainly worked on fountains and tombs. Ammanati was one of the most important of Italian early Baroque architects. He established his reputation with his work on the façade of the Collegio Romano in Rome, as well as the Ponte Trinità and the garden frontage of the Palazzo Pitti in Florence which had been started by Brunelleschi.

Andrea del Castagno (ca. 1422 Castagno – 1457 Florence). Castagno was probably a pupil of the provincial painter Paolo Schiavo. As a favorite of Bernadetto de' Medici he may have been introduced into the circle of Florentine painters at the end of the 1430s. Inspired by Masaccio, and especially by the sculptor Donatello (1386–1466), he developed a highly individualistic style which had enormous influence on Florentine painters. His art is characterized by sharply outlined, muscular figures full of inner tension, their physicality intensified by both a tight use of space and an overarching perspective. In some of his paintings the power of the figures is moderated by the use of light and the application of paint in larger surfaces or by their individualized traits.

Andrea del Sarto (1486 Florence – 1530 Florence), real name Andrea d'Agnolo di Francesco. Del Sarto probably trained with Piero di Cosimo. He gained an artistic reputation early in his career for his frescos in the monastery of SS. Annunziata (1509–15) and the paintings in the Chiostro allo Scalzo (1511–23) in Florence. In 1518, at the invitation of François I, he went to the French king's château at Fontainebleau but he returned to his home town a year later. Andrea del Sarto is one of the most prominent masters of the High Renaissance in Florence.

Arnolfo di Cambio (ca.1245 Colle Val d'Elsa – ca. 1305 Florence). Di Cambio was trained in the 1260s in the workshop of Nicola Pisano in Pisa and Siena. From 1276 he lived in Rome where he made, amongst other thing, tombs for Cardinal

Annibaldi in S. Giovanni in Laterano and for Pope Hadrian V in S. Francesco at Viterbo. In 1281 Arnolfo worked in Perugia, 1282 in Orvieto and afterwards again in Rome. In 1296 he returned to Florence. There, he held various positions included that of sculptor and architect for the new cathedral.

Bellini, Jacopo (ca. 1400 Venice – 1471 Venice). Bellini was a pupil of Gentile da Fabriano. He followed his teacher to Florence (1423–25) where he had the opportunity to study the work of the city's early Renaissance art. His own style marks a transition in Venetian painting from a soft style to that of the early Renaissance. Bellini's paintings evince a great sense of plasticity which he achieved not only by distributing light as in drawing but also by transitions of color. He therefore laid the groundwork for Venetian Renaissance painting up until the time of Giorgione and Titian. His drawings also show evidence of exceptional talent. His sketch books, today in London and Paris, show a confident control of centralized perspective and a great interest in antiquity.

Bellini, Giovanni (ca. 1430 Venice – 1516 Venice). Giovanni was the younger brother of Gentile; he was taught by his father and later by his brother-in-law Mantegna in Padua. He worked mainly in Venice where he had his own workshop, and where he was appointed official city painter in 1483. Through the influence of Mantegna and his study of Flemish painting he arrived at a unique treatment of light and natural atmosphere. His colors are glowing and warm, and forms, figures and space are interwoven in an animated atmosphere. Titian and Giorgione were among his most talented pupils.

Boccaccio, Giovanni (1313 Paris – 1375 Certaldo). After an apprenticeship as a merchant, Boccaccio studied law in Naples. From 1348 on he lived in Florence as an independent poet and scholar. He spent the last years of his life in seclusion on his estate in Certaldo. In 1374 he traveled to Florence for the last time in order to hold the first public lectures on Dante's *Divine Comedy*. Boccaccio, whose epic poetry reached its highest point in his work *The Decameron*, is together with Petrarch considered to be one of the first great scholars of Humanism. As a scholar, he wrote many innovative books on the Classical age.

Andrea del Sarto

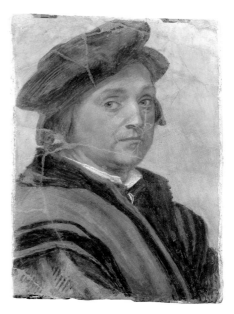

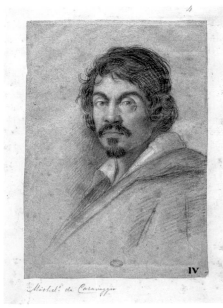

Michelangelo Merisi, Caravaggio

Botticelli, Sandro (1445 Florence – 1510 Florence), real name Alessandro di Mariano Filipepi. Botticelli was active mainly in Florence. After an apprenticeship as a goldsmith he became a pupil of Filippino Lippi's in the 1460s. He was inspired by Pollaiuolo and Verrocchio, later by Ghirlandaio and Perugino and stimulated by the humanist circles around Lorenzo de' Medici (1469–1492). Botticelli developed an animated, classicizing form of mythological imagery with powerful fantasy figures. Around 1482 he received a commission for three large frescos in the Sistine Chapel in the Vatican.

Bronzino, Agnolo (1503 Monticelli near Florence – 1572 Florence), real name Agnolo di Cosimo di Maiano, also Agnolo Tori. Bronzino was a pupil of Raffellino del Garbo and Pontormo. He encountered the work of Michelangelo on a trip to Rome in 1546/47 and from 1530 to 1533 he painted for the Duke of Umbria in Pesaro. After returning to Florence he became court painter to the Medici. He is one of the best known representatives of Florentine Mannerism. His individualistic use of color allowed him to endow his paintings with a cool quality but not at the expense of a plastic and physical presence.

Canaletto (1697 Venice – 1768 Venice), real name Giovanni Antonio Canal. Canaletto was taught the art of stage painting by his father. He was influenced by the work of Pannini and especially that of Luca Carlesvarijs, the painter of landscapes. Fundamental to his painting is a schooled approach to perspective and a precise eye for nature. His topographic city views capture with feeling the beauties of architecture and combine this with an accurate depiction of light and mood. Canaletto, who worked mainly in London from 1746 to 1753, helped Venetian landscape painting to achieve a flowering beyond the borders of Italy.

Caravaggio (1571 Milan (?) – 1610 Porto d'Ercole), real name Michelangelo Merisi. Caravaggio trained in Milan from 1584 to 1588 under Simone Peterzano and later worked in Bergamo. In about 1592 he went to Rome where he was active in several workshops and found patrons in the Vatican. He was imprisoned several times in 1604 and spent his remaining years on the run. His work is characterized by

realism, dramatic chiaroscuro and a strong sense of detail. Rejected by many of his contemporaries, Caravaggio had a great influence on many artists in both northern and southern Europe.

Carracci, Annibale (1560 Bologna – 1609 Rome). Carracci first worked with his brother Agostino in the workshop of his cousin Ludovico Carracci, who was probably his master. Around 1585 he was one of the co-founders of the Accademia dei Desiderosi (Academy of the Aspiring) in Bologna and later of the Accademia degli Incamminati (Academy of the Progressives) in Rome where he settled in 1594. He achieved a harmonious and direct style of painting through an intense study of nature. Annibale Carracci was one of the leading proponents of an art which looked back to antiquity and the High Renaissance, and therefore broke with Mannerism.

Cellini, Benvenuto (1500 Florence – 1571 Florence) settled in Rome in 1519 after serving an apprenticeship as a goldsmith. He remained there – with the exception of sojourns in Florence, Naples, Venice and Paris – until 1540, when he went to the court of the French king, François I. In 1545 he returned to Florence and entered the service of Cosimo I de' Medici. Cellini, one of the most prominent sculptors of the 16th century, wrote his autobiography from 1559 as well as two treatises on sculpture and the art of the goldsmith.

Cimabue (probably ca. 1240 – (?)), real name Cenno di Pepo. Cimabue probably worked around 1260 in the mosaic workshop of the Florence Baptistery. He is recorded as having been in Rome in 1272 and in Pisa in 1301/02. Cimabue began to break with the tradition of Byzantine art by introducing three-dimensionality and a greater level of dynamism in his figures. He moved away from medieval traditions, so achieving a less stylized depiction of monumentality and intensity. This new approach made him one of the forerunners of the new Italian painting.

Correggio (ca. 1489 Correggio near Modena – 1534 Correggio), real name Antonio Allegri. Correggio was one of the most important painters of the High Renaissance, active in Rome, Parma, and Correggio; he was probably

Annibale Carracci

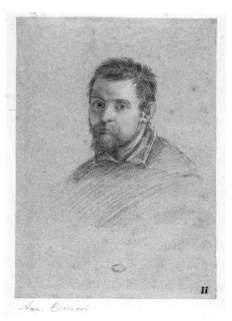

Ann. Carracci

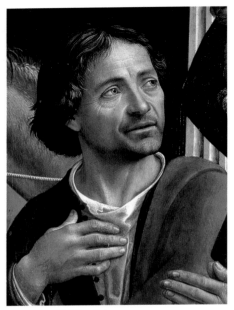

Domenico Ghirlandaio

a pupil of Francesco Bianchi Ferrari. His efforts to express lightness and grace made him a master of illusionist painting. His work counterbalanced forms with light and color, and he developed innovative chiaroscuro effects. Correggio evoked plasticity in his compositions with abrupt foreshortenings and overlaps. His pictures display a great depth of space – produced through the use of light and diagonals.

Donatello (1386 Florence – 1466 Florence), real name Donato di Niccolò di Betto Bardi. Donatello was probably a pupil of Lorenzo Ghiberti and Nanni di Banco in Florence. Generally active in his home town, he also worked in other parts of Italy. Considered the greatest sculptor of the 15th century, the diversity and innovative quality of his extensive body of work are unequaled by that of any other artist. In his early period he mainly concentrated on making standing figures in marble, but from the 1420s on he largely produced bronzes.

Duccio di Buoninsegna (ca. 1250–60 Siena –1318/19 Siena). Duccio was first of all a painter of coffers and furniture, and a book illuminator; his work can be followed from 1278 in Siena. He worked in Florence and probably also on the frescos in the upper church of S. Francesco in Assisi. Duccio was inspired by the Siennese school and by Cimabue. Though he still worked in the shadow of Byzantine art he adopted elements of the new stylistic movements to develop a modern pictorial language. His works are characterized by a fine use of line and a bright coloration, as well as a bold modeling of his figures in which they and the entire picture surface are rhythmically composed.

Fra Angelico (ca. 1397 Vicchio di Mugello near Florence – 1455 Rome), real name Guido di Piero, also Beato Angelico. Fra Angelico was a prominent painter in the period between the Late Gothic and Early Renaissance. He entered the Dominican monastery in Fiesole as a qualified painter at the age of 20. In 1436 he moved with the entire monastery to S. Marco in Florence which had been donated to the order by Cosimo de' Medici. In 1447/48 and from 1452 he worked for the Vatican in Rome and also in Orvieto. He adopted the new Renaissance forms in his frescos and panel paintings.

Gentile da Fabriano (ca. 1370 Fabriano – 1427 Rome), real name Gentile di Niccolò di Giovanni Massi. Fabriano was a leading master of the Italian Late Gothic era. His presence in Venice is documented from 1408. Between 1414 and 1419 he worked for Pandolfo Malatesta in Brescia. He then went to Florence where he became a member of the Guild of St. Luke, and in 1422 of the Guild of Physicians and Apothecaries. Travels took him to Siena and Orvieto in 1425 and to Rome in 1427. His elegant style is marked by attractive effects of color and gilding.

Ghiberti, Lorenzo (1378 Florence – 1455 Florence). Ghiberti received his education in the workshops of his step-father, the goldsmith Bartolo di Michele (Bartoluccio) and he was probably trained as a painter. In 1424/25 he visited Venice and from 1425–30 he lived in Rome. His workshop in Florence, in which numerous artists were trained, was one of the greatest bronze foundries of the 15th century. In the last years of his life Ghiberti wrote the *Commentarii*, which contain a history of Italian art, as well as the autobiography of this universal artist.

Ghirlandaio, Domenico (1449 Florence – 1494 Florence), real name Domenico di Tommaso Bigordi. Along with Botticelli, Ghirlandaio was the leading fresco painter of the Early Renaissance in Florence. After completing an apprenticeship as a goldsmith, he was trained by Alesso Baldovinetti. His style is marked by a strong sense of plasticity and emphatic contours. He was a master at arranging crowd scenes in religious pictures to emphasize the secular world by depicting important Florentine personalities as participants in biblical events –

a technique which anticipated genre painting. Michelangelo was trained in Ghirlandaio's workshop.

Giorgione (ca. 1477 Castelfranco Veneto – 1510 Venice), real name Giorgio da Castelfranco, also Giorgio Barbarelli. Giorgio probably received his training together with Titian in the workshop of Giovanni Bellini in Venice. He was influenced by Carpaccio, Antonello da Messinas, Leonardo, and the Flemish painters. He abandoned outlines in favor of color to portray distinctions between objects, and so concentrated upon emphasizing the real appearance of things.

Benozzo Gozzoli

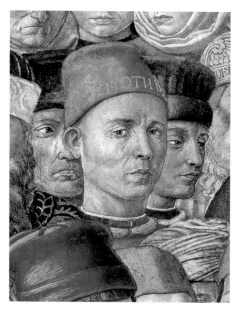

His figures move freely in space, and he depicted landscape largely for its atmospheric effects.

Gozzoli, Benozzo (1420 Florence – 1497 Pistoia), real name Benozzo di Lese. Gozzoli combined the painting styles of Tuscany and Umbria and in so doing he bridged the Gothic and the Renaissance eras. In 1444 he worked together with the sculptor Lorenzo Ghiberti in Florence, and around 1448 with Fra Angelico in the Vatican. Thereafter he was active as an independent master in Montefalco, S. Gimignano, Florence and Pisa. Gozzoli also executed panel paintings as well fresco cycles. A lively narrative style which depicted sequences of events and a fresh use of color are characteristic of his paintings.

Leonardo da Vinci (1452 Vinci near Empoli – 1519 Cloux near Amboise). Leonardo was a pupil of Verrocchio's from around 1468, and later worked for his master from around 1477. He was a member of the Florentine painters' guild from 1472. From 1482/83 until 1499 he worked for Ludovico il Moro in Milan where he returned in 1506 after periods in Mantua, Venice, and Florence. In 1513 he went to Rome and three years later, in 1516, he accepted an invitation from François I to go to France. Leonardo worked as a painter, sculptor, architect, and engineer, and undertook scientific as well as artistic studies. He embodied the Renaissance ideal of the universally educated artist who practiced in all genres.

Lippi, Filippino (ca. 1457 Prato – 1504 Florence). Filippino Lippi was the son and pupil of the painter Fra Filippo Lippi. After the death of his father in 1469, he completed an apprenticeship with Sandro Botticelli in Florence, along with whom he is considered the most important Florentine painter during the transition from the Early to the High Renaissance. His most productive period was during the 1490s. Filippino painted large altar pieces, individual allegorical depictions and portraits, but was also an outstanding fresco painter.

Lippi, Fra Filippo (ca. 1406 Florence – 1469 Spoleto). Fra Filippo Lippi was accepted into the Carmelite order in 1421 and lived in the monastery of S. Maria del Carmine in Florence until 1432. He was mentioned for the first time in documents as a painter in 1431. After periods in Padua and Venice he was entrusted

Fillipino Lippi

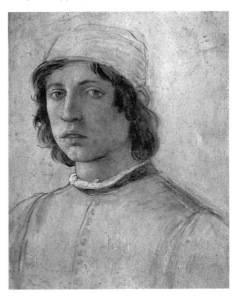

with numerous commissions by the Medici in Florence from 1437. He was resident in Prato from 1452 where he executed the large murals in the main choir of the cathedral with scenes from the life of John the Baptist and St. Stephen. From 1467 he worked on frescos in the cathedral at Spoleto.

Mantegna, Andrea (1431 Isola di Carturo near Padua – 1506 Mantua). Mantegna began an apprenticeship with Squarcione in Padua in 1441, where he came into contact with the art of antiquity. The most crucial influences on him however were the sculptures of Donatello and the pictures of del Castagno and Jacopo Bellini. He worked independently from 1448 and was called to the court of the Gonzaga dynasty in Mantua in 1460. His work is characterized by anatomically correct figures, a careful eye for detail and a brilliantly constructed use of perspective. These innovations were later to have a major influence on Gentile and Giovanni Bellini.

Marini, Marino (1901 Pistoia – 1980 Viareggio). Marini studied sculpture and painting at the Florentine Academy of Art from 1917. He taught at the Art School of the Villa Reale in Monza from 1929 to 1940. In 1940 he became professor of sculpture at the Accademia di Brera in Milan. Marini often traveled to Paris where he met with avant-garde artists like Kandinsky, Maillol, Braque, and Picasso; he also had sojourns in England, Holland, Germany, Greece, and the USA. In 1952 he received the Grand Prix for sculpture at the Venice Biennale. In 1962 the first great retrospective of his work was held in Zurich. Marini's work encompasses portraits and figurative depictions.

Martini, Simone (ca. 1284 Siena – 1344 Avignon). Martini was one of the leading masters of Gothic painting in Siena; he was in the service both of his home town and of Robert d'Anjou in Naples. In around 1339 he traveled to the papal court in Avignon where he became friends with the poet and scholar Francesco Petrarca (Petrarch). Martini's work was inspired by Duccio, Giotto, and the sculptor Giovanni Pisano, as well as contemporary developments in French art. His painting is marked by elegance, sensitivity and a gentle.

Masaccio (1401 S. Giovanni Valdarno, Arezzo –1428 Rome), real name Tommaso di Ser Giovanni Cassai. Masaccio was one of the most revolutionary artists of his age. In 1422 he entered the Florentine Guild of Physicians and Apothecaries and in 1424 the Guild of St. Luke. During this time he worked closely with Masolino. At the end of 1427, shortly before he died, he traveled to Rome. He was the first to combine an emphatically plastic figurative technique with a thorough use of spatial perspective; he also depicted architecture and landscape in a realistic fashion.

Masolino (1383 Panicale near Perugia – 1440 Florence), real name Tommaso di Cristofano di Fino. The first documentary evidence of Masolino is from 1423 when he entered the Florentine Guild of *medici e speziali*, to which painters then belonged. From 1425 to 1427 he was court painter in Budapest. After his return, and together with his pupil Masaccio, he worked on the frescos from the life of St. Peter in the Brancacci Chapel of S. Maria del Carmine in Florence. From 1428 he lived in Rome where he painted the frescos in S. Clemente and a double-sided altarpiece for S. Maria Maggiore.

Michelangelo Buonarroti (1475 Caprese, Tuscany – 1564 Rome), real name Michelangelo di Ludovico di Lionardo di Buonarroti Simoni. Michelangelo studied sculpture around 1490 in the workshop of Bertoldo di Giovanni after first being taught painting by Ghirlandaio in Florence. Stimulated by the scholars around Lorenzo de Medici, he studied antique sculpture and philosophy. During a period in Rome, 1496–1501, he devoted himself to a study of sculpture. His first paintings were made after his return to Florence. Michelangelo was employed by the Vatican from 1505–1520 and again from 1534; he was appointed head architect, sculptor and painter to the Vatican in 1535. He developed new expressive possibilities in his painting, and created unique spiritualized figures of great plastic intensity.

Michelozzo di Bartolomeo Michelozzi (1396 Florence – 1472 Florence). Michelozzo received his sculptural training from Lorenzo Ghiberti in whose workshop his presence has been documented from 1417 to 1424 and from 1437 to 1442; he worked with Donatello from 1424 to 1433. Although he was active as a sculptor until the end of his life, his greatest achievements were as an architect; in 1446 he was named Brunelleschi's successor as chief architect for Florence cathedral. Between 1430 and 1455 there were hardly any large construction projects in the city in which he did not have some active part. His major works include the Palazzo Medici, the library of S. Marco, and the church of SS. Annunziata in Florence.

Nanni di Banco (ca. 1375 Florence – 1421 Florence). Nanni was the son of Antonio di Banco with whom he worked as a sculptor on the site of the cathedral in Florence. In spite of the curved ornamental characteristics of the then popular International Style, Nanni's early work was inspired by the heavy pathos of Classical sculpture. In his mature, later works he strove for a more pronounced dynamism in his figures and an innovative illusion of space. His expressive forms are revolutionary and were well ahead of their time.

Parmigianino (1503 Parma – 1540 Casal Maggiore), real name Girolamo Francesco Maria Mazzola. Parmigianino was active mainly in Parma. He lived from 1523 to 1527 in Rome and thereafter in Bologna; in 1531 he returned to Parma. The last years before his premature X Parmigianino completed panel paintings and extensive fresco commissions, and is considered one of the precursors of Mannerism. The figures in his work are marked by elongated proportions and iridescent, even harsh, coloring.

Perugino, Pietro (ca. 1448 Città della Pieve near Perugia – 1523 Fontignano), real name Pietro di Cristoforo Vannucci. Perugino was a leading master of the Umbrian School, and probably completed his apprenticeship in Perugia. From 1472 he was a member of the painters' guild in Florence, where he may have been a pupil of Verrocchio and Piero della Francesca. His harmonious and self-contained compositions manifest a soft and unified coloring. He worked in Umbria, Venice, and Tuscany, though he was active in Rome on several occasions between 1478 and 1492, after which time he worked mainly in Florence. Raphael trained in his workshop.

Pisano, Andrea (ca. 1290 Pontedera – ca. 1349 Orvieto) came from Pisa to Florence around 1330 where his work on the south portal of the

Baptistery was first documented in 1330. After Giotto died in 1337, Andrea Pisano took over as director of construction for the campanile of the cathedral of S. Maria del Fiore in Florence; in 1340 he is mentioned for the first time as the cathedral architect. From 1343 to 1347 he seems to have managed a workshop in Pisa together with his son Nino to whom he transferred the duties of *capomaestro* (head of building) in Orvieto in 1349. Andrea Pisano most likely died shortly after and, according to Giorgio Vasari, is buried in the cathedral at Florence.

Pollaiolo, Antonio del (1431 Florence – 1498 Rome).

Raffaello Santi

Pollaiuolo began his artistic career as a gold-smith before turning to painting in 1460. He lived in Rome from 1484, where he became one of the leading sculptors of the 1400s. As a painter he mainly worked in the fresco and panel format. His style is characterized by highly animated forms and a lucid use of line. One of the first Italian artists of the Early Renaissance, this wide-ranging master also produced copper-plate engravings.

Pontormo (1494 Pontormo near Empoli – 1557 Florence), real name Jacopo Carrucci. Pontormo arrived in Florence in 1508 where he remained for the rest of his life. After his first artistic encounters with Leonardo da Vinci and Piero di Cosimo he probably received his training under Fra Bartolomeo and, in 1512–13, under Andrea del Sarto. Around 1520 he achieved a new expressiveness which transcended the classical style of the High Renaissance. Along with Rosso Fiorentino he is considered the main representative of the first phase of Mannerism.

Raphael (1483 Urbino – 1520 Rome), real name Raffaello Santi. Raphael was first taught by his father, the painter and poet Giovanni Santi, before training with Pietro Perugino in Perugia from 1500. In 1504 he went to Florence and in 1508 he was summoned by Pope Julius II to Rome. From 1509 his projects in Rome included the frescos in the *stanze* of the Vatican. After the death of Bramante in 1514, he became director of building work at St. Peter's Cathedral. In 1515 he was appointed conservator of Roman antiquities. Raphael is the greatest painter of the High Renaissance.

Rembrandt Harmenszoon van Rijn (1606 Leyden

Peter Paul Rubens

– 1669 Amsterdam). Rembrandt trained with Jacob van Swanenburgh in Leyden and Pieter Lastman in Amsterdam. From around 1625 he worked in Leyden in a cooperative workshop with Jan Lievens. About the year 1631 he moved to Amsterdam, where he lived until his death. Owing to financial difficulties, the artist was forced to sell his collection of art and other rarities in 1656. Rembrandt is the greatest and most varied of Dutch painters and etchers of the 17th century.

Robbia, Luca della (1399/1400 Florence – 1482 Florence). Little is known about Robbia's artistic origins; he was first mentioned in documents in Florence in 1431. As well as being a sculptor, he developed a technique for producing glazed terracotta sculptures which he mainly used to decorate tondi and lunettes with colored reliefs. Luca dell Robbia is one of the most outstanding sculptors of the 1400s and, along with Lorenzo Ghiberti and Donatello, he was one of the founders of the Florentine Early Renaissance.

Rubens, Peter Paul (1577 Siegen – 1640 Antwerp). Rubens trained with Tobias Verhaecht, Adam van Noort and Otto van Veen in Antwerp, where in 1598 he was accepted as a master into the Guild of St. Luke. From 1600 to 1608 he was court painter of Vicenzo Gonzaga II, the Duke of Mantua, after which he settled again in Antwerp. In 1609 he became painter at the court of Archduke Albrecht and his wife, Isabella, in Brussels, though he continued to reside in Antwerp. Rubens is one of the greatest Flemish painters of the Baroque era.

Tintoretto (1518 Venice – 1594 Venice), real name Jacopo Robusti. Apart from a journey he may have undertaken to Rome in 1547/48, Tintoretto spent his entire life in Venice, where he had already become a master in 1539. His early works were influenced by Roman Renaissance painting. From around 1560 his use of light as a means of expression in his paintings became ever more prominent. Tintoretto is one of the main representatives of Venetian Mannerism; together with Titian and Veronese he is one of the three great Venetian painters of the 16th century.

Titian (1488/90 Pieve di Cadore – 1576 Venice), real name Tiziano Vecellio. Titian was probably trained by Giovanni Bellini in Venice. From 1515

he worked for the most influential clients of his age, including the d'Este, Gonzaga, Furnace, and Rovere dynasties as well as King François I of France. In 1533 he became the court painter to Emperor Charles V and received the Order of the Golden Fleece. In 1545 he worked for Pope Paul III in Rome. In his late period Titian was almost exclusively in the service of Philip II. He is considered the greatest Venetian painter of the 16th century.

Vasari, Giorgio (1511 Arezzo – 1574 Florence), Vasari arrived in Florence at the age of 13 and there he received a wide-ranging humanist education. From 1531 he lived variously in Rome and Florence. On his many journeys throughout Italy he studied art from antiquity up to his own day. As a painter he was indebted to Mannerism, and he completed frescos as well as panel paintings. Among his most important projects as an architect was the Uffizi in Florence. His extraordinary reputation, however, is based on his *Lives of the most excellent painters, sculptors and architects* (1550/68), the most important source work in Italian art history.

Veronese, Paolo (1528 Verona – 1588 Venice), real name Paolo Caliari. Veronese arrived in Venice in 1553 where he stayed to the end of his life, apart from a sojourn in Rome in 1560/61. From 1553 he worked on the palace of the Doge and from 1555 on the paintings in S. Sebastiano, his most important work. The oeuvre of this versatile artist – along with Tintoretto the most important Venetian painter of the Late Renaissance – includes ceiling frescos, altarpieces, mythological histories, and portraits.

Verrocchio, Andrea del (1436 Florence – 1488 Venice), real name Andrea de' Cioni. Verrocchio became the leading master of Florentine sculpture after the death of Donatello. In Florence he mainly produced works in a small format, and sculptures for buildings. In 1486 Verrocchio went to Venice, where he created the complex equestrian statue of the condottiere Bartolomeo Colleoni, which was erected on the Piazza in front of the church of SS. Giovanni e Paolo. Of his paintings only the Baptism of Christ, made together with his pupil Leonardo da Vinci and housed in the Uffizi (ca. 1470/80), can be attributed to him with any certainty.

Tiziano Veccellio

Further Reading

Alberti, Leone Battista: *On Painting* (translated by Cecil Grayson), London 1972

Baxandall, Michael: *Painting and Experience in 15th century Italy. A Primer in the Social History of Pictorial Style*, Oxford 1972

Beuys, Barbara: *Florenz. Stadtwelt -Weltstadt*, Hamburg 1992

Beyer, Andreas (ed.): *Florenz. Lesarten einer Stadt*, Frankfurt/Main 1983

Breidecker, Volker: *Florenz oder: Die Rede, die zum Auge spricht. Kunst, Fest und Macht im Ambiente der Stadt*, Munich 1990

Broke, Peter: *Tradition and Innovation in Renaissance Italy – A Sociological Approach*, London 1974

Burckhardt, Jacob: *Die Kultur der Renaissance in Italien*, Munich 1988

Burckhardt, Jacob: *Cicerone. Eine Anleitung zum Genuß der Kunstwerke*, Stuttgart 1964

Chastel, Andre and **Mandel**, Gabriele: *Botticelli*, Paris 1968

Davidsohn, Robert: *Die Geschichte von Florenz* (4 vols), Berlin 1896–1927

Freedberg, S.J.: *Painting in Italy 1500–1600*, Harmondsworth 1983

Gombrich, Ernst: *Norm and Form*, London 1966

Gombrich, Ernst: *The Story of Art*, London 1995

Grote, Andreas: *Florenz. Gestalt und Geschichte eines Gemeinwesens*, Munich 1980

Hager, Serafina (ed.): *Leonardo, Michelangelo and Raphael in Renaissance Florence from 1500–1508*, Washington 1992

Hale, John R.: *Florence and the Medici*, London 1977

Jäger, Michael: *Die Theorie des Schönen in der Renaissance*, Cologne 1998

Krämer, Thomas: *Florenz und die Geburt der Individualität*, Stuttgart 1992

Martinelli, Giuseppe (ed.): *Tutto su Firenze Rinascimentale*, Florence 1968, English translation *The World of Renaissance Florence*, 1968

McCarthy, Mary: *The Stones of Florence*, 1959

McWilliam, G.H.: *Boccaccio's Decameron*, London 1972

Paatz, Walter and Elisabeth: *Die Kirchen von Florence* (4 vols.), Frankfurt/Main 1940–53

Paatz, Walter and Elisabeth: *Die Kunst der Renaissance in Italien*, Stuttgart 1953

Panofsky, Erwin: *Renaissance and Renascences in Western Art*, Stockholm 1960

Pope-Hennessy, John: *Donatello*, Florence 1986

Pope-Hennessy, John: *Italian Renaissance Sculpture*, Oxford 1986

Pope-Hennessy, John: *Italian Gothic Sculpture*, Oxford 1986

Querman, Andreas: *Domenico Ghirlandaio*, Cologne 1998

Rosci, Marco: *The Uffizzi and Pitti Galleries*, English translation 1964

Rubinstein, Nicolai: *Florentine Government under the Medici 1434–1494*, Oxford 1966

Ryan, W.G.: *The Golden Legend*, translated from the Latin *Legenda Aurea* by Jacopus de Voragine, Princeton 1993

Saalman, Howard: *Filippo Brunelleschi. The Buildings*, London 1993

Schevill, Ferdinand: *Medieval and Renaissance Florence* (2 vols), 1963

Sinclair, John D. (ed.) *The Divine Comedy of Dante Alighieri*, London 1971

Toman, Rolf (ed.) *The Art of the Italian Renaissance, Architecture, Sculpture, Painting, Drawing*, Cologne 1995

Vasari, Giorgio: *Lives of the Artists*, translated by George Ball, London (Penguin) 1965

Vasari, Giorgio: *Le vite de' più eccellenti pittore, scultori e architettori*, Florence 1878

Weinstein, Donald: *Savonarola and Florence – Prophecy and Patriotism in the Renaissance*, Princeton 1970

Following pages: Family tree of the Medici family of Cafaggiolo, Biblioteca Riccardiana, Florence